WORK AND THE IMAGE II

Work and the Image I

Work, Craft and Labour
Visual Representations in Changing Histories
Edited by Valerie Mainz and Griselda Pollock

Work and the Image II

Work in Modern Times

Visual Mediations and Social Processes

Edited by Valerie Mainz and Griselda Pollock

ASHGATE

Published by

Ashgate Publishing Limited Ashgate Publishing Company
Gower House 131 Main Street
Croft Road Burlington
Aldershot Vermont 05401–5600
Hants GU11 3HR USA
England

Ashgate website: http://www.ashgate.com

British Library Cataloguing in Publication Data

Work and the Image
 Vol. II: Work in Modern Times: Visual Mediations and
 Social Processes.
 1. Work—Philosophy. 2. Work in art—History. 3. Work—
 Social aspects.
 I. Mainz, Valerie, 1951– . II. Pollock, Griselda, 1949– .
 306.3'6

Library of Congress Cataloging-in-Publication Data

Work and the image/edited by Valerie Mainz and Griselda Pollock.
 p. cm.
 Includes bibliographical references and index.
 Vol. I. Work, craft and labour: visual representations in changing histories.
 Vol. II. Work in modern times: visual mediations and social processes.
 ISBN 0–7546–0232–X (v. I: alk. paper)
 ISBN 0–7546–0233–8 (v. II: alk. paper)
 1. Labor in art. 2. Work in art. 3. Arts and society. 4. Arts, Modern—19th
century—Social aspects. 5. Arts, Modern—20th century. I. Mainz, Valerie.
II. Pollock, Griselda.
 NX650.L32W67 2000
 704.9'49331—dc21 00–40610

ISBN 0 7546 0233 8
 0 7546 0234 6 (two-volume set)

This book is printed on acid-free paper

Typeset in Palatino by Manton Typesetters, Louth, Lincolnshire, UK and printed in Great Britain by The University Press, Cambridge.

Contents

Contributors

NANCY BARTON is an artist and educator who directs the Undergraduate Program in Studio Art at New York University. Her work has been exhibited widely at venues including MOMA New York, Long Beach Museum of Art, American Fine Arts, Shoshana Wayne and Christopher Grimes galleries.

ELIZABETH COWIE is Reader in Film Studies in the School of Drama, Film and Visual Arts at the University of Kent, Canterbury, and one of the founding editors, in 1978, of the feminist theory journal, *m/f*. She has published *Representing the Woman: Cinema and Psychoanalysis* (1997), and edited, with Parveen Adams, *The Woman in Question: m/f* (1990). She has also published on film noir and on the documentary film.

MARTIN IGNATIUS GAUGHAN is Subject Leader in the History and Theory of Art, University of Wales Institute, Cardiff. He is presently co-editing a volume on 'New York Dada' in the series 'Crisis and The Arts: The History of Dada', and has contributed two chapters to earlier volumes in the series.

ANNIE GÉRIN is Assistant Professor in the Department of Visual Arts at the University of Regina, Saskatchewan, Canada. She was educated in the fields of Russian Studies and Art History in Canada, Russia and England. She is now working on legitimation strategies in Soviet monumental art and material culture.

KRISTINA HUNEAULT is engaged in continuing research on the representation of women workers in British and Canadian visual culture. She has published on the subject in the *Journal of Canadian Art History* and *RACAR* (*Revue d'art Canadien/Canadian Art Review*). Dr Huneault teaches at Concordia University in Montreal, Canada.

VALERIE MAINZ is a Lecturer in Art History and Jewish Studies at the University of Leeds. She curated the exhibition *L'Image du Travail et la Révolution française* for the Musée de la Révolution française in Vizille, France, and has published widely on visual representation in the revolutionary period.

CLAUDINE MITCHELL is Associate Lecturer at the University of Leeds. She was elected the first Henry Moore Scholar there. She is the author of *On the Representation of Time* (1985) and *On the Brink?* (1992). She is a contributor to *Reflections of Revolution* (1993), *The Dictionary of Women Artists* (1997), and the journals *Art History, The Feminist Review, Sculp'Age* and *The Oxford Art Journal*. Her book on Rodin is in preparation.

GRISELDA POLLOCK is Professor of Social and Cultural Histories of Art at the University of Leeds. She has published extensively on issues of class and gender in visual representation and on contemporary visual art, cinema and feminist cultural theory. Her latest book is *Differencing the Canon: Feminist Desire and the Writing of Art's Histories* (1999).

MO PRICE lectures in History of Art and Design at Birkbeck College, University of London, and in the Department of Visual Arts, Goldsmiths College, London.

VIVIAN REHBERG specializes in painting and politics in twentieth-century Europe, and is particularly interested in questions of figuration, tradition, temporality and historicism. She lives and works in Paris.

JOHN C. WELCHMAN is Professor of Modern and Contemporary Art at the University of California, San Diego. He is author of *Invisible Colors* (1997), *Modernism: Relocated* (1995) and *Art after Appropriation* (2000), and editor of *Rethinking Borders* (1996). His 'Survey' of the work of Mike Kelley was published in Phaidon's 'Contemporary Artists' series, 1999.

Figures

Introduction: trauma and subjectivity in work and worklessness

Valerie Mainz and Griselda Pollock

Our stern and chilling subject is work, the real and symbolic site of exploitation, political resistance, as well as of social identity and self-definition. Work is also the context of complex formations of class and gender, sexuality and social discipline. In contemporary cultural analysis or studies in art history and visual culture, work competes with the more popular and 'sexy' themes indicative of our changing concerns and preoccupations. Sexuality, Pleasure, Identity, the Body are current objects of widespread analysis in ways that are shaped by the post-structuralist attentiveness to many vital areas that fell below the theoretical threshold of the major modernist theorizations of culture, society, ideology and history in which work featured so centrally, notably Marxism. At this historical moment, however, when the possession of a credit card seems more critical to social participation and recognition than a stake in relations of production, and when most forms of labour, artistic and academic included, are dissipated into the commodified gloss of entertainment, behind which lies the global intensification of proletarianization and commodification, it seems provocative and important to turn our attention in historical retrospect to a dimension of social relations and economic processes as well as of symbolic meaning and structures of identity, to work, that having once been so cogent and predominant in social experience, political organization, communal life and theoretical paradigm, has ceased to be the focus of cutting-edge analysis.

Work and worklessness are, nonetheless, still critical dimensions and factors in all our lives, locally as well as globally, despite the fact that the often illusory field of cultural and political discourse may have turned to consumption, spectacle, virtuality and the pleasured rather than labouring body. The considerable success at the box office of two British films, *Brassed Off* and *The Full Monty*, whose themes were the desolation of working communities through the cessation of the manufacturing industries in which

the majority of the adult male population worked, exposes exactly the paradox. The transformation of the working masculine body into the stripper revealed ultimately how fragile are the bases for any of the fictions of identity – be those of class or gender – when the inexorable demands of capital redefine whose body, labour, energy will have social value.

To refocus on questions of work and its social meanings negotiated through visual representation across an expanded geographical field and diverse domains of practice is not nostalgia for a time when work worked for us in Britain or the West, when workplaces were stable enough and secure enough for unionization to be resistance rather than negotiated management, and when workplaces were significant sources of collective social and personal identities whatever the terms of exploitation involved. Work is or can be, amongst many other things, something that gives meaning to life, marks its rhythms and stages, fulfils ambitions, offers concrete rewards. It can provide a sense of pride in earning one's own way. Work is not what most people want to avoid even if they struggle rightly to improve its terms. Despite the real dangers and stresses of its conditions, and the inequality, in capitalist societies, of its relations, work does offer a potential site of social and personal meaning. In the contemporary world, it is lack of work that constitutes for too many a social tragedy and personal desolation. Without its function as a social passport, the unemployed suffer the anguish of social invisibility. We daily witness the atrocity of declaring citizens of industrial societies redundant, surplus to need, only because the possibilities of a particular kind of productive labour have moved geographically with the process of globalization to recruit ever cheaper armies of temporary, deskilled labour. Thus a paradox emerges. If the spectre of worklessness haunts the countries that first experienced the industrial revolution that socialized and harnessed labour, the radical restructuring of the so-called developing countries draws new populations into the relations of production that shift the traditional functions, meanings and effects of their work in these regions and cultures. Does it follow, therefore, that modernization and a radical transformation of the meanings of work are intimately related? What is work in modern times? How have its processes and meanings been mediated to us by visual imagery from advertising to cinema?

In 1994 the French artist Christian Boltanski was commissioned to do a project for the Henry Moore Studio at Dean Clough in a once heavily industrialized city, Halifax, in the north of England. With an untypically empty installation, Boltanski initiated a permanent archive that he titled *Lost Workers: The Work People of Halifax 1877–1982*, in 1994 (Figures 0.1 and 0.2). This project is composed of stacks of cardboard boxes each bearing a label with the name of one of the people who once worked in the carpet factories

of Dean Clough before that industry came to an end and the almost derelict but still monumental factory buildings were transformed into a postmodern confection of art gallery, craft workshops and restaurants. Investigators were sent out to track down surviving members of this defunct workforce with the request for some personal souvenirs to deposit in this self-assembling docu/monument. Boltanski frankly describes his project:

On another occasion I was working in Halifax in the north of England and one of the pieces I did there was about the carpet workers who were sacked after a factory shut down. What I did was to create a room for them, and each worker had his own box into which he could put some kind of souvenir of his past at the factory. This piece was not that good, but what was interesting was that someone was prepared to go and speak to them and find out about them. They had all left the factory by then and this was the first time they returned and it felt like the factory belonged to them. The room is still there and I'm sure that no one knows it's one of my pieces but that's not of any importance. I saw it about a year ago and around half the boxes were full.[1]

Boltanski insists that what he does is not art. In the many pieces that he has done in Germany and around the themes of loss, disappearance and oblivion, Boltanski has used photographs or other remnants of the past that linger in the present in order to ask questions about missing people, people whose lives and worlds were usually ended by a crime, social or individual. Thus, in a project for the city of Vienna, Boltanksi used television and media outlets to screen photographs of disappeared people. The images were accompanied by a request to write to the artist if any one recognized any of the faces. Boltanski states that this device was a way to confront the Austrians with the question: 'What have you done with your Jewish people?'

What does it mean to take a format developed within what Ernst van Alphen has named the 'Holocaust effect'[2] and use it of communities of British industrial workers rendered 'redundant' by the global restructuring of the world economy? Is Boltanski asking the British to face the question: 'What have you done with your workers?' Certainly they have not been gassed or shot en masse. But that does not mean that there is no trauma associated with the process of historical transformation of work. For what emerges in the meditations on cultural representations of work in modern times is the deep sense of the relations between work and subjectivity, work and social identity, work and a sense of personal history, work and the function of time caught between past and future. It is significant that Boltanski calls his piece 'Lost workers'. Does that mean misplaced and not be refound? This cannot be, for somebody deposited the souvenirs in their individually named boxes. Yet we still need to reconsider in what sense were the people, as workers, found when, as work people, they were traced by the project and invited to leave within their one-time factory now international art

forum some memento, some proof of their individual existence whose productive relation to this space has been erased by the move from industrial modernity to post-industrial postmodernity?

The trope of the archive is not an uncommon one within Boltanski's work nor within conceptual artworks. Information collected and collated can, however, be forgotten in surrogate bodies of the filing cabinet or archive box. The labouring body and mind, its personalized living social subjectivity can, in a disciplinary society, be erased before the bureaucratic traces that replace the subjectivity we inhabit with only administrative rationality's category – the named, numbered, itemized, policed individual, as on an identity document or passport, social services record or hospital file. The contents of Boltanski's empty boxes were occupied with something distinct and personal drawn from and indexing a different kind of individuality, something of that person beyond the identity defined by their clocking-in card. Does this artwork create a pacifying metonymy of the missing person who has not been wiped out by genocidal murder, but has ceased to be a worker, hence was about to become forgotten as a social individual too? Boltanski's piece is typical of a postmodern musealizing consciousness that indicates the current crisis around historical memory and personal memorability because of the suspension of an imaginable future. Dispossessed of the dreams of forward movement created either by the modernist myths of progress or the revolutionary dreams of liberation, in which, at the beginning of this century, the heroic figure of the muscular industrial worker was the key icon, we cling to the mere deposit of a fragmented and dispersed history, in which work, once the knowable means of organizing our understanding of modes of social belonging via class, community, indeed via relations and identities, itself becomes the object of an artist's self-deprecating gesture of ghostly evocation.

Each box rightly bears the traces of individual lives shaped and emptied around the complex polarities of work and home within advanced capitalist societies and its erosion by the decline of manufacture. Without falling prey to the nineteenth-century moralist's alibis for capitalism, we can still admit the social democrat's view that work lent a certain dignity to every individual. As a means of finding a place within a social space, it offers a paradoxical structure for borrowing an identity from even what William Morris named useless toil. Yet work within capitalist modes of production exacts the penalty of alienation and relentless exploitation buffered by the post-war promises of access, if never to self-realization, at least to the increased consumption that was needed to fend off the disasters that had almost destroyed Europe in the 1930s when economic collapse and mass unemployment created a terrible trauma of hunger and starvation as well as raising the hope of radical social transformation. Lived out, disemployment cracks the fragile

materials out of which both social communities and individual subjectivities are put together.

For all the unlikeliness of Boltanski's viring of his practice from Holocaust memorial to the disemployment of industrial labour, what it reveals is an important and almost erased dimension of trauma that repeats the terms of so much of the discourse and imagery of the coming of capitalism. In Volume 1 of *Das Capital*, Marx was unflinching in his evocation of the pain of social and economic transformation, a trauma that is experienced by the bodies of those who became the workers that capitalism then equally traumatically shed:

World history offers no spectacle more frightful than the gradual extinction of the handloom weavers: this tragedy dragged on for decades, finally coming to an end in 1848. Many of the weavers died of starvation, many vegetated in their families for a long period on 2½d. [pence] a day. In India on the other hand, the English cotton machinery produced an acute effect. The Governor General reported as follows in 1834–5: 'The misery hardly finds parallel in the history of commerce. The bones of the cotton weavers are bleaching the plains of India.'[3]

What is interesting about this passage is Marx's use of a visual metaphor, spectacle, as if he wanted to ensure that the long, slow social process of industrialization could be evoked as a vivid and compelling image in which the reality of bodily human suffering would breach the political economist's shield of unquestioned belief in progress to which these weavers were sacrificed.

In planning this volume, we had not anticipated focusing on issues of trauma and violence in relation to histories of work and its representations, to labour and subjectivities. But this was prompted by thinking about the disconcerting emptiness of the Boltanski work and its title: in what sense are the workers lost – and found? How does this work link with the notion of losing one's job and finding work – the job seekers allowance, welfare to work, social democratic economic manipulations of deindustrializing Western economies where the end of work discipline or the disciplinary functions of the socialization of labour and the lifetime insertion of men into the structures of the patriarchal family wage collapse before the unstable and mobile proletarianization of Third World women, the emergence of women as the core breadwinners of millions of so called single-parent families, the total failure to confront the eradication of a social, economic function for young men that has released on to the streets unmanageable forms of urban violence matched only by the degree of violation that is inflicted upon these young men declared structurally redundant to the needs of capital even as a traditional form of reserve army of the temporarily unemployed?

Assembled here as the products of social history, cultural analysis and artistic practice, this collection has its own work to do: analytical, historical,

critical. The point of convergence is a belief in the value and necessity of historical understanding that acknowledges, however, that history is the fabrication of its representations. These representations are, nonetheless, determined by complex social and economic forces that form the conditions of our existence. Yet despite our knowledge of determination, we cling to the possibility of intervention shaped by critical self-reflection – by analysis and by the artistic work of counter-representation. This collection straddles the fields of historical discourse and the practices of visual representation that themselves underwent transformation with the coming of modernity. Modernity encompasses here the impact of the first industrialized war, as well as Taylorization of industrial production. The chapters also address the modernization of the languages of art, what we call the avant-garde in Italy or Paris, in Futurism and Cubism, and how they engaged with the outward signs of modernization in the city and its machine aesthetic. Modernity has also been the moment of the revolutionary in which whole nations and cultures grappled with the challenges of radical social redefinition and reorganization. How did art in the Soviet Union configure its relations to the new bodies of technological modernity? While modernism engaged in vanguard tropes with industry and labour, a realist aesthetic continued to claim its inevitability for any representation of the social reality of work and working in the almost mythic sites of industrial modernity – the mines.

The form of representation that itself encodes the industrial transformation of cultural production into visual spectacle, the cinema, is a necessary site of reflection upon the meanings of work in the twentieth century. The tensions between the documentary models and those of avant-garde poetics form a necessary element of this analysis of work in modern times, revealing the contradiction that Boltanski's work has already opened between the social space of work and the subjectivity of the working person. If we propose any specificity for the view from now upon the question of work in modern times, it will rest upon this postmodern preoccupation with subjectivity. Attention to the subjective moment wishes to restore to the necessary debates about structures, relations and historical shifts within the processes of production that govern both work and worklessness, the inflection of lived praxis through the sensing, suffering and thinking subject. This returns us not to a fetishization of the individual outside society, for whom work is only a temporary and shifting means to live. It brings us to the site of artistic work as a singular and necessary space of critical reflection, dissonance and research into the complexities of working people in twentieth-century modernity.

Notes

1. Christian Boltanski in 'Tamar Garb in conversation with Christian Boltanski', in T. Garb and D. Kuspit, *Christian Boltanski* (London: Phaidon Press, 1997), p. 40.

2. Alphen, Ernst van, *Caught by History: Holocaust Effects in Contemporary Art, Literature and Theory* (Stanford, CA: University of Stanford Press, 1997).

3. Marx, K., *Capital, Vol. 1*, (London: Penguin Books, 1992), p. 557.

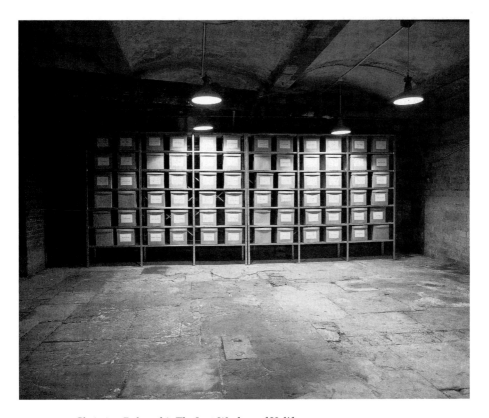

0.1 Christian Boltanski, *The Lost Workers of Halifax*, 1994

0.2 Christian Boltanski, *The Lost Workers of Halifax*, detail, 1994

'Living tableaux of misery and oppression': sweated labour on tour[1]

Kristina Huneault

Sweated labour. This evocative term signalling extremely long hours of work in unsanitary conditions and for a fraction of subsistence wages, was, throughout the nineteenth and early twentieth centuries, at the centre one of the most provocative aspects of the labour question in Britain: women's employment. The conjunction of discourses of sweating and femininity in representational practices as diverse as Academic painting, graphic illus-tration, and trade union demonstrations, is well recogized.[2] Its visual cues, first developed in the 1840s, had always been highly emotive: haggard women in ragged clothes were depicted hunched over light manufacturing tasks in dwellings characterized by dilapidated furniture, broken crockery and leaking roofs (Figure 1.1). In 1906, however, the emotive currency of this imagery was rapidly inflated, as the visual representation of sweating took a new, performative, twist.

For six weeks at the end of the London season, well-dressed visitors thronged to the newly built Queen's Hall, where they paid a shilling admission fee to see 'human and industrial samples' of the sweating system at work.[3] Under the auspices of the *Daily News*, displays of sweated goods were combined with the home-workers who made them: 42 women and two men actually labouring at their daily quotas. Placards provided spectators with personal information on workers' rates of pay, their rent, working hours and family histories. The event was a hit. Thirty thousand people attended, the illustrated handbook sold out in ten days, and the exhibition itself was lengthened to accommodate viewer demand. The *Daily News* congratulated itself on what it termed 'an enormously successful run'.[4] Taking up the theatrical metaphor in the socialist paper, the *Clarion*, R. B. Suthers closed his review with a sardonic endorsement: 'I take off my hat to the organisers – It will make new conscience. They must take it on tour.'[5] While it has not been previously acknowledged, Suthers's words were

prophetic. The *Daily News* exhibition sparked a vogue for such events, and from 1906 to 1914 over a hundred British towns and cities held their own exposés of sweated workers.[6]

To think about these exhibitions is, inevitably, to wonder: why did these extraordinary spectacles take place? At one level, the *Daily News* made its motivations clear: it aimed to open eyes and quicken consciences in order to obtain a remedy for a national evil.[7] The exhibition led to the formation of a powerful lobby group dedicated to the establishment of a legislated minimum wage. This National Anti-Sweating League (ASL) continued to launch similar displays as part of a concerted public opinion campaign to secure demand for the institution of regulatory trade boards. With the passage of the Trade Boards Act in 1909, the ASL proudly credited its national programme of exhibitions as contributing to this success.[8] For a time, the exhibitions declined, but they resurfaced in force in 1912, when a movement to extend the number of trades under regulation gained momentum.

Against this legislative rationale, however, fundamental questions remain untouched. Why exhibitions? And why people? Why did this specific visual format present itself as such an ideal vehicle for the promotion of economic reform? My analysis in the following pages shall focus on the aspects of vision and representation that these questions raise. While the organizational histories and political implications of the exhibitions far exceed these limitations, it is, nevertheless, from their particular strategy of vision that the events gained their impact.[9] Writing on the need for sweated industries exhibitions, the ASL secretary, J. J. Mallon, emphasized the special place of visuality in accessing the imagination:

The truth is that most of us lack imagination. When we read that a woman shirt worker earns one penny an hour we have to be assisted to understand a thing so monstrous. We have to see before us a veritable woman, to watch her sustained and anxious toil ... perceive for ourselves the weariness of her body. Only then are many of us fired by the horror of what is known as sweating.[10]

Similar logic had underpinned more conventional visual images, among them the string of mid-century 'Song of the Shirt' paintings inspired by the verse of Thomas Hood. The intervening 60 years, however, had provided ample proof that mere poetry and pigment had not succeeded in 'firing a horror' sufficient to induce change. Too easily relegated to the domain of creative licence, fine art alone had had little effect on the economic realities of power distribution in the workforce.

Photography held out a limited possibility for changing this scenario. Its privileged access to the material conditions of lived experience increasingly brought visual culture into the realm of social administration, and revitalized the reformist desire to 'see before us a veritable woman'.[11] By the first decades of the twentieth century, however, the photograph had lost much of its claim

to absolute realism. The technical inability of photography to accurately capture the extremities of sweated existence was articulated by J. Reade, a social worker and 'Slumland photographer', when he was accused of faking a photograph of sweated workers. Admitting that the image in question had been 'touched-up', Reade nevertheless defended his practice: 'When a photograph is taken of poverty it is so unlike the real thing that one sees with the naked eye that the photographic defects have to be remedied ... No photographic apparatus or lens can reproduce the awful conditions that are to be seen.'[12] To support his assertion that the camera could lie, Reade recounted the case of a prematurely born child – which had been placed on a hotplate to keep it alive while he photographed it – appearing as a plump and healthy baby on the negative. Other critics, too, decried the existence of 'realistic lying photographs which are as blind to suffering as a human being'.[13]

The truthfulness of the photography of poverty thus partly discredited, it was necessary to find another way to bring the 'veritable' sweated woman into the public gaze. Social exploration, of the Henry Mayhew, Charles Booth and Jack London tradition, offered one alternative model, and sweated industries exhibitions capitalized on its potential to let a mass of people 'see with their eyes and hear with their ears' the realities of poverty.[14] By the early twentieth century, however, social exploration – the realm of a few brave souls – had been significantly affected by an increasing institutionalization. The professionalization of 'social science' gave rise to an increased public awareness of its goals; familiarity, in turn, led to popularization. The advent of the sweated industries exhibition may partly be understood in this context: as a 'do it yourself' opportunity for the amateur sociologist, complete with fieldwork. But if the professionalization of sociology had brought a greater measure of public conversance with its aims, it also worked to distance the populace from its methods. As the intrepid explorer gave way to the expert scientist, the language employed within the discipline became increasingly rarefied: cool, technical and detached. In Peter Keating's words, the 'graphic vignette [made] way for a statistical table', and a manner of calm, studied objectivity came to replace the role of passionate engagement.[15]

It was precisely this passionate involvement that visitors to sweated industries exhibitions were invited to reinstate. They were asked to con-summate the visual experience with an act of imaginary identification. 'As we look at these examples of how sweated work is done,' encouraged Viscount Wolmer at the opening of the Letchworth exhibition, 'we should try to imagine what it would be if we ourselves had to work under these conditions.'[16] Repeatedly, sweated industries exhibitions were assessed in terms of their ability to make viewers actually '*feel* what such conditions really mean' (italics added).[17]

In their bid to wear down the emotional and imaginary distance between viewer and viewed, subject and object, sweated industries exhibitions were predicated on a modality of vision determined by pathos. Theorized by Mikhail Bakhtin as a primarily literary effect, the function of pathos in the visual domain has been developed by Mary Anne Doane.[18] Both scholars locate the crux of pathetic discourse in its cultivation of a sense of proximity between reader and text, spectator and spectacle. With pathos, Bakhtin writes, the subject 'completely immerses himself ... there is no distance, there are no reservations'. As such, the pathetic gaze was ideally suited to further the sense of connection between viewer and viewed that Viscount Wolmer enjoined. The formal mechanisms of pathos are fully apparent within the framework of sweated industries exhibitions. In addition to the expected elements of helplessness and weakness, the exhibitions included that foregrounding of intimate particulars which Bakhtin identifies as necessary to 'descend to the depths of everyday life'.[19] Such a descent was integral to the establishment of connection, for it was not merely the quotidian drudgery of the sweated that came through in the details, but the extent to which the daily comforts of the consumer were dependent upon that labour. In the face of displays of the minutiae of sweating – the hooks and eyes, the matchboxes, the paper-bags – viewers were confronted with their complicity in sweated production. 'The first thing one notices,' commented the *Manchester Guardian*, 'is that they are things of which we all have some about us in our daily lives'.[20] Here too, despite their position within public halls and auditoriums, was Bakhtin's emphasis on the 'special organisation of space' to foster a sense of intimate surroundings[21] – a tactic readily apparent in the provision of special enclosed stalls for each worker. Most importantly, in their offer of 'face to face'[22] contact, the exhibitions conformed to the primary task of pathetic discourse: to present itself as an 'unmediated ... impression from the object or from life, one unencumbered by any ideological presuppositions'.[23]

In the promise of direct access lay the exhibitions' main appeal. To many viewers, these were 'the actual living facts,' and their immediacy claimed for itself the authority of truth.[24] 'It was the truth which we saw in the faces of those women-workers ... and we knew it', wrote one Southampton journalist.[25] The same reporter accorded these 'living pictures' of poverty and misery all the weight of 'evidence'. His language is unintentionally revealing, for, despite the fact that living people had supplanted two-dimensional images, sweated industries exhibitions provided just this: *pictures*, representations, visual texts.

A text, to borrow loosely from Mieke Bal, is a presentationally coherent combination of elements leading to the production of meaning.[26] Though they were presented as unified experiences of material reality, sweated industries exhibitions offered precisely such a combination of semiotic

elements including opening pageantry, speeches, handbooks, slide-shows, music, poetry, bookstalls, floral arrays and displays of artwork. In Tonbridge, Croydon and Southampton, local ladies gave 'moving' recitations of 'The Song of the Shirt'. At Ilford the Imperial Ladies' Orchestra provided musical accompaniment to vocal performances of 'The Worker', 'The Heart Bow'd Down' and 'The Toilers'. Here, too, the walls were adorned with colour illustrations of sweated workers by R. F. Ruttley, a local artist.[27] Oxyhydrogen lantern shows of workers' homes were a regular feature of most exhibitions. In the midst of all of this, viewers' acts of making sense of sweated labour were not only a process of direct interaction with the 'actual' goods and workers, but with the whole rhetorical structure of the exhibition as text. Nevertheless, if the illusory proximity fostered by the exhibitions' mimetic claims was to be maintained, it was precisely this textual element that needed to be hidden behind claims of 'truth' and 'evidence'.

At issue here is the central role of realism within the sweated industries exhibition. For the exhibitions' aura of unimpeded access to reality to endure, the processes through which signification was produced had to be sufficiently transparent that the meaning could seem to present itself.[28] This semiotic strategy appeared most vividly in the relative journalistic silence surrounding the conditions under which women workers participated in the exhibitions. While thousands of words were devoted to detailing the realities *behind* the exhibitions – i.e. sweated labour as experienced by women in their homes – the realities *of* the exhibitions themselves, as experienced by these women in public halls around Britain, merited no more than an occasional passing mention.[29] A similar pattern characterized visual coverage. While two articles in the *Daily News* did include photographs of the workers in the Queen's Hall, these close-focus images gave only a vague impression of what the stalls were like, and no sense at all of the general exhibition environment (Figure 1.2).[30] Even this practice soon ceased however, and the vast majority of journalistic and handbook photographs portrayed the workers in their homes (Figure 1.3).[31]

At root I am describing a kind of magic trick. For exhibitions to maximize the potential of the pathetic gaze, to make good on their promise to bring spectators together with their objects of vision through the provision of unmediated impressions from life itself – to accomplish all of this, they would have had to make themselves invisible. The trick did not come off. The exhibitions could not hide their essential artificiality.

Location was a key factor in this. Visitors commented on the 'air of unreality' produced by the experience of viewing sweated workers in social spaces dedicated to pleasure, wealth or civic power.[32] Exhibitions were held in town halls, libraries, ballrooms, roller-rinks and music halls. In such surroundings the connective project was reduced to absurdity for some. The

Clarion's R. B. Suthers gauged the *Daily News* exhibition against the implicit promises of its publicity:

Outside, the [handbills] bore a picture of a matchmaker's room, in which were two gaunt women and two famished babies. Ugh! I nearly turned back. I scented horrors. Sweaters' dens, and all the sickening, disgusting, angering sights, and sounds, and smells. I took a deep draught of fresh air, and mounted the stairs. And when I entered the hall, and glanced round, my … dream vanished. That lurid picture at the door was a fraud. A lure. A simulacrum. My foot fell silently on a soft carpeted floor. Around the walls were neat varnished stalls displaying goods, as [if] it might have been a fancy fair or a bazaar … It was so sadly funny that I laughed. I thought of what the projectors wanted to achieve by the exhibition, and how feebly futile the means were. They did their best; but the thing is impossible.[33]

Organizers were thoroughly conscious of these limitations, and looked for ways to counteract them. At Earl's Court in 1909 special interest was aroused by the presence of women chainmakers working 'on actual forges exactly like those in their domestic workshops at Cradley Heath'.[34] Exhibitions in Glasgow and Edinburgh included facsimiles of a sweated dwelling, complete with 'broken panes stuffed with rags and paper … broken dishes, a fireplace choked with ashes, debris, and lidless pots, a filthy mattress jammed beneath the sloping attic roof, the walls hanging with torn paper and begrimed with smoke and filth'.[35] Yet even this was insufficient to fulfil the professed desire of visitors for an exhibition that could re-create the experience of sweated labour. 'Large and varied though the exhibition was,' concluded the *Glasgow Herald*, 'it was still an imperfect and fragmentary exposure of the evils of sweating … which it was impossible to exhibit there.'[36]

In this insurmountable gap between the thing seen and the thing experienced lay the root of a distancing between viewer and worker, spectator and spectacle. This distancing closely shadowed all claims to verisimilitude; visibility, it seems, was insufficient as a guarantee. One reaction to this element of distantiation was outright disbelief. Despite the presence of 'the women themselves', a few sceptical visitors wrote letters to their local papers bemoaning 'the entire absence of anything in the shape of what could be called reliable proof'.[37] More common, however, was the proliferation of an uncritical voyeurism, the very precondition of which was the distance between subject and object that was foregrounded by the exhibitions' failure to fully disguise their signifying process. Once this distance was established, the voyeuristic mode of vision, in which an active, knowing subject took pleasure in the sight of an object conceived of as passive and known, was in danger of becoming viewers' overruling scopic experience.

The presence of this element of enjoyment was inadvertently acknowledged by the chairperson of the High Wycombe exhibition, who opened that event with the wish that 'all would have pleasure in looking round'.[38] Suddenly

conscious of the inappropriateness of such a response, the speaker immediately qualified her statement to say that, of course, 'pleasure was hardly the word'. I would argue, however, that her initial impulse was not so far wide of the mark. There *were* multiple avenues of pleasure available to visitors at sweated industries exhibitions. There was the pleasure of sociability remarked on by the Southampton reporter who found 'very little to suggest pain' upon first entering 'the large, airy room where a number of women were talking in that easy, interested manner which marks comradeship in a cause'.[39] There was also pleasure in the presence of aristocratic and even royal patrons, who gave some exhibitions the air of 'a Society crush'.[40] Most of all, there was the pleasure of the safely distanced horror, the evident enjoyment of which was only thinly masked behind professions of dread such as that of Lady Isabel Margesson, who opened the Worcester exhibition by saying that she 'was almost too terrified to go round the exhibition and see the dreadful revelations' it would contain.[41] While it was no doubt true, as the *Daily News* proclaimed, that 'Society came, saw, and shuddered,' this terror bore more than a passing resemblance to the carnivalesque thrill.[42] Indeed, the *Manchester City News* described that city's exhibition as an 'Industrial Chamber of Horrors,' and the *Labour Leader* lost no time in ironically pointing out that after visiting the Queen's Hall exhibition, Princess Ena had continued her day with a visit to a waxwork display.[43]

The self-gratifying voyeurism of wealthy spectators who came to 'feast their eyes' on suffering and degradation, was savaged by the socialist press, which condemned the events as empty spectacles 'to thrill the nerves of dainty dames and damsels', and mocked the 'beautifully dressed ladies' who were 'set half-crying when they hear how hard it is to earn sixpence'.[44] Extending its critique to the broader exhibiting culture, the *Labour Leader* drew unfavourable comparisons between the 'sights' on offer at the Queen's Hall and the concurrent Crystal Palace display of lavish expenditure on pet dogs with jewelled collars.[45]

Such criticisms strike a chord with much late twentieth-century sensibility, to which the spectacular exhibition of living human beings is intrinsically distasteful. Yet at the beginning of the century such criticisms remained on the margins of public reaction. While mainstream papers sometimes challenged the exhibitions' effectiveness, they never questioned the basic stratagem of putting the working poor 'on show'. In seeking to comprehend such widespread approbation, it is helpful to place these events within the standards and practices of a specifically exhibitionary decorum. The performative aspects of sweated industries exhibitions may be seen as part of a whole range of late-Victorian and Edwardian exhibiting practices which sought to rehabilitate *for* culture the somewhat peripheral and possibly troubling figure of the woman worker. International, colonial, employer and

special interest exhibitions all frequently included women workers in displays which ranged from demonstrations of appropriately feminine handicraft, to showcases of technological wizardry, to the 'native villages' analysed by Annie Coombes.[46] Most showed working women in a highly positive light, presenting them as 'happy and willing participants in British Imperial life'.[47] This, certainly, was the approach adopted by a small but publicity hungry charity known as the Watercress and Flower Girls' Christian Mission, which specialized in the reformation of street sellers. From 1899, the mission's founder, John Groom, held a series of travelling fund-raising displays of the charity's beneficiaries, who were shown at work making artificial flowers. Many of the young women and girls selected for the exhibitions had physical disabilities. The events received royal patronage, and raised substantial amounts of money. As an official from the Charity Organization Society (COS) commented, Groom knew 'what charitable people like – a touch of pathos, a pretty show, and a general atmosphere of doing good without much trouble'.[48]

Where pathos ceased and distastefulness began was a contested point, however. Some local residents complained about the spectacular nature of the affairs, and the COS responded with sympathetic frustration. 'It is difficult to see what action you can take in the matter. Objectionable as is the practice of making an exhibition of the crippled children, such devices appeal to inconsiderate charitable sentiment.'[49] The emphasis given in this reply to the disabled status of the flower-makers indicates the main focus of concern; Groom's exhibitions of working women were objectionable because they played blatantly on the *difference* of physical disability. Such displays engaged the voyeurism of a public which could indulge in a titillating glimpse of otherness while hiding its self-congratulatory pleasure in its own 'normalcy' behind a guise of charity.

Yet Groom himself was not entirely insensible to exhibitionary codes of decorum. The issue arises in one of the mission's own illustrated pamphlets, which tells the story of a child called 'Limping Ferret,' who is 'rescued' from the streets into a life of artificial flower-making. The booklet's chief illustration (Figure 1.4) depicts a girl on crutches performing in the street while a man collects money from the crowd. It is accompanied by a condemnatory caption: 'Such an exhibition in the streets of any English town is an outrage upon English law. Alas! the wonder of the public who witness such scenes … make[s] it difficult for the police to act.'[50] While Groom admitted no similarity between such spectacles and his own orderly exhibits of neatly clad girls performing appropriately feminine labour in the enclosed spaces of town halls, it is impossible to overlook the parallels between the censuring voice of the mission's pamphlet and COS criticisms of Groom's own floral exhibitions as objectionable but irremediable spectacles that appealed to an

indiscriminate public. A question, then, emerges: what distinction enabled Groom to insist on the difference between these two spectacular displays, rallying public indignation over the fictional exhibition of 'Limping Ferret', while counting upon public approbation for his actual displays of disabled flower-makers?

I suggest that the crucial difference – more important than the transformation from rags to pinafores, or from city streets to city hall (though these are undoubtedly significant) – was Groom's activation of a discourse of productive employment. From its place at the absolute centre of the modern social and economic formation, the discourse of *work* enabled Groom to reclaim for the *inside* the outcast figure of the impoverished 'cripple', the barely disguised mendicity of the street performer, uncomfortable reminder of that which remained external to modern relations of production and exchange based on efficiency and regularity. By contrast with 'Limping Ferret', the women in Groom's exhibitions had succeeded 'in making for themselves a sphere of usefulness … in an age of competition'.[51] No longer lost in the economic wasteland of marginal subsistence, the women and girls in Groom's exhibitions were positioned as living demonstrations that through 'will', 'skill' and 'industry' it was possible to rehabilitate into the national economic and social body that which was previously held to be outside of it. A rhetoric thus based on breaking down positions of otherness or exteriority was well placed to counter charges of voyeuristic inappropriateness. Thus, with respect to the display of actual women and girls, it would seem that codes of exhibitionary propriety were poised on a knife-edge. To the extent that exhibitions rendered their subjects Other and distanced them from the people who looked at them, such displays risked crossing the boundaries of good taste. But to the extent that these same exhibitions established a terrain of commonality between viewer and viewed by bringing their subjects into the accepted hegemonic formation, they were valuable contributors to a cohesive social order.

Returning to sweated industries exhibitions, this precariously poised – but for that reason compelling – play of connection and rejection, proximity and distance, will be familiar. The compulsion was psychically charged. Classic psychoanalytic theory posits that human subjectivity is formulated through the dual processes of identification with that which we resemble (connection), and desire for that from which we differ (distance). As Griselda Pollock's work on the Arthur Munby archive has demonstrated, women workers occupied an ambiguous place within the bourgeois psyche, constantly shunted back and forth from one of these extremes to the other.[52] Yet the contrapuntal workings of desire and identification are not quite adequate to the psychic dynamic apparent in visual encounters with sweated women. The failure of sweated industries exhibitions to foster identification has been

thoroughly explored; likewise, the conspicuous absence of overt sexualization in sweating discourse suggests that its fascination did not reside comfortably on the level of desire. Rather, the pattern of psychic investment apparent in the visual discourse of sweating must be situated somewhere between these two positions. In this, it intriguingly parallels the Kristevan formulation of abjection – that 'twisted braid of affects and thoughts' that is situated in a 'vortex of summons and repulsion'.[53] It is this dynamic – this simultaneous pull of intrigue and recoil of horror – that most obviously signals the place of abjection within sweated industries exhibitions.

The abject, following Kristeva, is that which beckons to us, that which 'beseeches, worries, and fascinates desire, which, nevertheless, does not let itself be seduced. Apprehensive desire turns aside; sickened, it rejects'. At the root of this vacillation is the abject's undecideable position between the self and the other, the subject and the object. Like bodily wastes, the abject is something that was once familiar, but which 'now harries me as radically separate, loathsome. Not me. Not that'. And yet though I reject it, I cannot part from it, for it remains the precondition of material existence. In the abject, I recognize 'what I permanently thrust aside in order to live … [It is] the place where I am not and which permits me to be'.[54] In this dependence resides horror for a subject who suddenly recognizes, *within* itself, the role of the impossible, the intolerable, the unthinkable.

Sweating provoked precisely such a recognition at the level of political conscience.[55] Exhibition commentators repeatedly stressed that viewers 'were all … involved, whether they liked it or not, in the system of sweating'. No matter how 'great the individual struggle against it might be … [consumers] could not avoid profiting from the products of [a] trade' which was connected 'with almost everything they used in daily life'.[56] This seemingly irrepressible presence of sweated articles served as a sign of viewers' connection with the exorbitant detritus of the market economy, reminding visitors that sweated women workers, in all their unthinkable poverty and intolerable degradation, were that which consumer society thrust aside in order to live in its comparative opulence. To see these women at their worthless (yet so costly) tasks, was to acknowledge, as Kristeva would have it, that 'such wastes drop so that I might live'.[57]

Considered in this light, the performative nature of the sweated industries exhibition is more readily comprehensible, for abjection is fundamentally theatrical – that which shows me directly. In Kristeva's words it is 'true theatre, without makeup or masks'; it exceeds signification, goes beyond representation, to present itself in all immediacy.[58] The point here is this: because it is not clearly an object – distinct and other – the abject cannot be held within the symbolic order. For this reason it cannot be fully encompassed within the domain of representation. Images alone are insufficient. Its true

domain, Kristeva argues, is that of the act rather than that of the symbol. Here, then, is one explanation for the shift, in 1906, from graphic images of sweating to its performative display: sweated industries exhibitions provided, for the first time, adequate scope for the *act* of facing the most abject of women workers.

At the same time, the exhibitions also provided a prime opportunity to exercise that long-standing socialized response to abjection: the ritual of purification. With their repetition of the same elements (the partitioned booths, the speeches, the lantern-slides, the songs, the factual placards, even the same workers) time and time again, in city after city, sweated industries exhibitions became national rituals of political and economic purification – designed to expunge the 'diseased' parts of the social body through the thoroughly modern incantation of the minimum wage. As with all purification rituals, their key function was to ward off contamination through acts of separation and distinction. Again the individual booths, the categorization of information, come to the fore. In this way sweated industries exhibitions attempted to harness the forces of ambiguity that they themselves re-enacted, by re-establishing borders between self and other: me on this side looking, you on that side being looked at. Viewed from the perspective of Kristevan abjection, however, their inability to entirely do so was a foregone conclusion, for abjection defies borders. It is 'an impossible object, still part of the subject: an object the subject strives to expel but which is ineliminable'.[59] Sweated women workers were sometimes *this* and sometimes *that*; now connected to their viewers, now distanced from them. In enabling this fundamental ambiguity to be theorized, the notion of abjection goes some way towards accounting for the exhibitions' continued appeal to viewers, many of whom, it is clear, were truly repulsed by what they saw. These women – and especially these women in their homes, in their malnutrition, in their physical deterioration, in the grinding monotony of their labour, so closely linked to public patterns of consumption – were the social abjects of Edwardian capitalism; these exhibitions were a practised purification response, always already doomed to fail in their project of securing the boundaries of an object detached from the viewing subject.

If there were psychic bases for the exhibitions' fascination, however, there were also political grounds. These raise the question of the relation of exhibitionary vision to the structures of social power, and here, too, the dual dynamic of connection and distance can be observed. It surfaces most clearly in the exhibitions' incorporation of elements from two distinct interpretative models for the role of vision in public display. The first, that of Tony Bennett, addresses the ways in which power was made visible to the people through exhibitions; the second, that of Michel Foucault, assesses the use of exhibitionary strategies to make the people visible to power.[60]

Inclusion and division are encapsulated in these differing perspectives, and, true to form, the sweated industries exhibition straddles tellingly between them.

In his work on the utopian commercial exhibitions of the nineteenth century, Bennett posits the exhibition as an 'object lesson in power – the power to command and arrange things and bodies for pubic display' – arrayed in splendour for the people. By taking exhibited objects out of the closed private domain and displaying them to an ever increasing public, he argues that exhibitions were concerned to 'allow the people, and *en masse* rather than individually, to know rather than be known, to become the subjects rather than the objects of knowledge ... [and] in seeing themselves from the side of power ... [to] interioriz[e] its gaze as a principle of self-surveillance and, hence, self-regulation'. The promise held out by such exhibitions was that they could place 'the people – conceived as a nationalized citizenry – on this side of power, both its subject and its beneficiary'.[61]

In an age of increasing democracy, Bennett argues convincingly that utopian commercial exhibitions played a vital role in enlisting their viewers' 'active popular support for the values and objectives enshrined in the state'.[62] Sweated industries exhibitions, with their dystopian vision of the excesses of existing power differentials, took this process a step further, calling on public opinion not simply to support, but to actively *shape* these values and objectives. Exhibition visitors, proclaimed Constance Smith of the Christian Social Union, 'must let their servants in Parliament know that the people are the State, and that they must have no delay in registering the people's intentions' to put an end to sweating.[63] This is exhibition as civics lesson, in which a people positioned as self-identical to the State were, as Bennett argues, placed on the side of power and entreated to apply the knowledge stemming from their new-found vision to the process of collective and legislated self-regulation. Even classes of school children, the citizens of tomorrow, were brought to see the exhibitions and encouraged to contribute their ideas for a solution through an essay competition.[64]

But in discussing the role of exhibitions in placing the people on the side of power it is necessary to ask who is meant by 'the people'. Are they the people looking, or the people being seen? In the case of sweated industries exhibitions, they were quite patently not one and the same. For Bennett, 'the people' are conceived as a 'national citizenry,' but Edwardian citizenship was always qualified by the identification of those who were deemed unfit for participation. The division is encapsulated in one visitor's letter to the *Manchester Guardian*:

From the great interest it has aroused ... [the exhibition] clearly meets an earnest desire of many of the citizens of Manchester ... to know more [about] the poorest and most helpless of the workers. It has been said that 'half the world does not

know how the other half lives.' By this exhibition the veil has been lifted from the situation of those at the very bottom of the industrial scale.[65]

Citizens and helpless workers, viewers and viewed, one half the world and the other: placed in a distinctly hierarchical relation. If sweated industries exhibitions were about knowledge *for* the people, they were also about knowledge *of* the people.

This is the territory of surveillance, so influentially delineated by Michel Foucault as a lowering of the 'threshold of description' to bring new strata of individuals under the regime of the gaze during the modern period. As vision became 'a means of control and a method of domination', description was 'no longer a monument for future memory, but a document for future use'. Observation came to be understood as 'the fixing, at once ritual and "scientific," of individual differences, as the pinning down of each individual in his own particularity … the features, the measurements, the gaps, the "marks" that characterize him and make him a "case"'.[66] The visual records of Victorian social explorers, whether Henry Mayhew, Gustave Doré, John Thomson or Thomas Annan, have been addressed in this language – their photographs and drawings analysed in terms of their separation of impoverished workers from their surroundings in order to render them up on clean white pages as individualized pieces of data for an evolving social administration.[67]

This element of surveillance remains achingly apparent in the visual format of sweated industries displays, which broke down the undifferentiated masses of the sweated neatly by trade and placed them individually in stalls, with 'clean-papered divisions between them', underneath systematically drawn up placards that reduced the complex jumble of personal histories to a standardized collection of uniformly presented 'cases'.[68] Such partitioning undoubtedly made the problem seem tractable. No longer were the sweated an unknown throng, a 'vast dread army' of women 'hidden away in dank dismal alleys … where the sun never shines, and where, if it did, it could never penetrate into the interiors'.[69] Like all forms of surveillance, these events were about countering such forces of opacity with the aim of 'transforming highly disruptive economic … disorder into quasi-technical or moral problems for social administration'.[70] In the words of one London clergyman:

[the sweated industries exhibition] was not a show, or a Royal Academy display of portraits and landscapes; it was rather an unveiling of the hidden things of dishonesty and misery. It … disclosed facts which we ought to investigate, conditions which we ought to alter, and problems which we ought to seek to solve along the lines of Jesus Christ.[71]

Moreover, it was argued that the knowledge gained through vision could, if extended to more rigorous and interventionary forms of surveillance, itself

be part of the solution. Exhibitions were used to promote long-term monitoring of sweated workers, their homes, and families. The Women's Industrial Council and the Scottish Council for Women's Trades argued for the sanitary inspection and licensing of sweated workers' homes.[72] The Manchester exhibition was a catalyst to calls for a register of sweated labourers 'so that touch might be maintained with all the workers'.[73] Bristol chairman, Dr E. H. Cook, opened that city's exhibition with a plea that the programme of enforced medical examination of children in schools should be extended into the home.[74]

In the context of sweated industries exhibitions, then, the two modalities of vision described by Bennett and Foucault were fully imbricated with each other. Knowledge *of* and knowledge *for* coexisted. It is fitting that this should be so, for there was an intricate matrix of visuality at play during these events; their relations of social power, like their manipulation of psychic subjectivity, and their position in relation to exhibitionary decorum, were inscribed along two familiar axes: on the one hand a relation of connection, a self-identity of subject and object brought about by vision, on the other an irreducible separation which vision helped to sustain. This complex play is at the heart of the fascination which explains the extensive appeal of the sweated industries exhibition to viewers caught within the contradictions of commodity capitalism and social conscience.

Notes

1. The phrase is from the *Daily News*, 18 September 1907, clipping in Tuckwell, G., *Women, Industry and Trade Unionism: The Gertrude Tuckwell Collection 1890–1920* (Brighton: Harvester Microform Publications, 1981), 217/15. Subsequent references to this collection will be listed as 'Tuckwell archive'. This chapter is adapted from my doctoral thesis, 'Women workers and visual culture in late-Victorian and Edwardian Britain', University of Manchester, 1998. I would like to thank Deborah Cherry for her guidance and wisdom, and the Social Sciences and Humanities Research Council of Canada and the Commonwealth Scholarship Commission for their support.

2. Edelstein, T. J., 'They Sang "The Song of the Shirt": The Visual Iconology of the Seamstress', *Victorian Studies*, **23**, Winter (1980), pp. 183–210; Thom, D., 'Free from Chains? The Image of Women's Labour in London, 1900–1920', in D. Feldman and G. Stedman Jones (eds), *Metropolis London: Histories and Representations since 1800*, (London: Routledge, 1989), pp. 85–99, and by the same author, 'The Bundle of Sticks: Women, Trade Unionists and Collective Organisation before 1918,' in A. V. John (ed.), *Unequal Opportunities: Women's Employment in England 1800–1918* (Oxford: Blackwell, 1988), pp. 261–89.

3. The exhibition ran from 2 May to 13 June. *Daily News*, 2 May 1906, p. 6.

4. *Daily News*, 13 June 1906, p. 6.

5. Suthers, R. B, 'The Cannibal Exhibition', *Clarion*, 18 May 1906, p. 5. *Daily News*, 5 June 1906, p. 9, raised this possibility without irony: 'A frequent query was whether the Exhibition would be seen in the country. The question can be answered in the affirmative. "Take this to every town and city," recommended one visitor.'

6. Press clippings in the Tuckwell archive, and the annual reports of the National Anti-Sweating League, 1907–13, are the most important sources of references to these exhibitions.

7. *Daily News*, 13 June 1906, p. 13.

8. ASL, *Third Annual Report*, 1908–09, p. 6.

9. For the only secondary account which emphasizes the visual component of the *Daily News* exhibition see Beckett, J. and Cherry, D., 'Working Women', in J. Beckett and D. Cherry (eds), *The Edwardian Era* (Oxford: Phaidon with the Barbican Art Gallery, 1987), pp. 71–4. Beckett and Cherry's important early analysis has provided both inspiration and information for the present chapter; I am indebted to the authors. On the political impact of the first exhibition see Morris, J., *Women Workers and the Sweated Trades: The Origins of Minimum Wage Legislation* (Aldershot: Gower, 1986), pp. 196–9; and Schmeichen, J., *Sweated Industries and Sweated Labour* (London: Croom Helm, 1978), pp. 164–5.

10. Mallon, J. J., 'The Need for Exhibitions of Sweated Industries', in *Handbook of the Sweated Industries Exhibition*, Ilford, 28–31 October 1908, p. 7.

11. On photography of the poor and social administration see Tagg, J., *The Burden of Representation: Essays on Photographies and Histories* (London: Macmillan, 1988), and also Lalvani, S., *Photography, Vision, and the Production of Modern Bodies*, (Albany, NY: State University of New York, 1996).

12. 'Mr. Belcher's Fake', *Truth*, 18 February 1914, p. 369, in Tuckwell archives, 362/28. Reade's photographs were used by the British Federation for the Emancipation of Sweated Women, a charity of dubious standing which was vigorously opposed by the ASL in the pages of the *Westminster Gazette*, and accused by *Truth* of ineffectualness at best and corruption at worst. The institution's self-defence may be found in its official publication, *Humanity*.

13. Suthers, 'Cannibal Exhibition' p. 5. As early as 1877 Dr Barnardo had been brought to court by the Charity Organization Society for his dishonest use of photography in the representation of poverty. See Tagg, *Burden of Representation* p. 85.

14. *Epsom and Ewell Advertiser*, 6 March 1914, p. 5; thanks to J. Walsh of the Ewell Library for this reference.

15. Keating, P., *Into Unknown England 1866–1913: Selections from the Social Explorers* (Glasgow: Fontana/Collins, 1976), pp. 26–7.

16. *Citizen* (Letchworth), 29 May 1914, p. 3. A similar message was conveyed to visitors at the Epsom exhibition, as reported in the *Epsom and Ewell Advertiser*, 6 March 1914, p. 5.

17. Suthers, 'Cannibal Exhibition' p. 5.

18. Doane, M. A., *The Desire to Desire: The Woman's Film of the 1940s* (London: Macmillan, 1987), p. 177; Bakhtin, M., *The Dialogic Imagination*, trans. C. Emerson and M. Holquist (Austin, TX: University of Texas, 1981).

19. Bakhtin, *Dialogic Imagination*, pp. 394 and 396.

20. *Manchester Guardian*, 9 October 1906, p. 6.

21. Bakhtin, *Dialogic Imagination*, p. 397.

22. *Leicester Daily Post*, 3 October 1906, p. 4.

23. Bakhtin, *Dialogic Imagination*, p. 398.

24. *Daily News*, 3 May 1906, p. 6.

25. *Southampton Times*, 27 November 1913, p. 7; thanks to H. A. Richards of the Southampton City Library.

26. Bal, M., 'De-disciplining the Eye', *Critical Inquiry*, **16**, Spring (1990), p. 511.

27. *Tonbridge Free Press*, 22 May 1914, p. 3; *Handbook of the Sweated Industries Exhibition*. Further enquiries have not resulted in any additional information on Ruttley, although I am grateful to Ian Dowling of the Ilford Central Library for his assistance. *Daily News*, 5 May 1906, p. 9 records that the artist Felix Moscheles lent his painting *Sweating* for the paper's 1906 exhibition. Thanks to Hilary Streeter of the Tonbridge Library for the first reference.

28. This approach to realism is developed by Tagg, *Burden of Representation*, p. 99.

29. From these brief mentions we know that the same workers participated in many exhibitions, where they were paid a pound a week – far in excess of their usual wages. Transportation and lodging costs were paid for out-of-town workers, and some childcare was available. Participants had to be indemnified against victimization by their employers, and at least one lost her job after the *Daily News* exhibition. Occasional entertainment was also arranged for the workers. These details are taken from the following sources: *Manchester Evening Chronicle*, 9 October 1906, p. 4; *Daily News*, 12 May 1906, p. 4; Manchester, Salford and District Women's Trades Union Council, and the 'Daily News', *Handbook of the Manchester Sweated Industries Exhibition* (Manchester:

William Morris Press, 1906), p. 8; *Daily News*, 16 May 1906, p. 12; *Recorder* (Ilford), 6 November 1908, p. 5.

30. *Daily News*, 5 May 1906, p. 9, and 7 May 1906, p. 9.

31. For example, *Eastbourne Gazette*, 11 March 1914, p. 3, has two images of 'Sweated Workers' Homes'.

32. *Manchester Guardian*, 24 October 1906, p. 12.

33. Suthers, 'Cannibal Exhibition', p. 5.

34. *Daily Chronicle*, 8 July 1909, in Tuckwell archives, 217/35.

35. *Glasgow Herald*, 5 March 1913, p. 13; thanks to Anne Escott and Margaret Connolly of the Mitchell Library. *Women's Industrial News*, **40**, September (1907), p. 565, records that the Chicago Industrial Exhibition of 1907 took the process a step further by presenting women at work in 'exact reproductions' of tenement slums. The Scottish Council for Women's Trades had always prioritized the question of sanitary conditions. The possibility of including a facsimile dwelling had been raised as early as the Manchester exhibition of 1906.

36. *Glasgow Herald*, 5 March 1913, p. 13.

37. *Glasgow Herald*, 28 March 1913, p. 11. Similar responses to the Bristol exhibition were published on the letter pages of the *Western Daily Press*, on 25 and 26 March 1908.

38. *South Bucks Free Press*, 21 February 1913, p. 2; thanks to Martin Rickard of the High Wycombe Reference Library for this reference.

39. *Glasgow Herald*, 6 March 1913, p. 11.

40. *Daily News*, 4 May 1906, in Tuckwell archives, 217/3.

41. *Worcester Journal*, 26 October 1912, in Tuckwell archives, 217/43.

42. *Daily News*, 4 May 1906, p. 7. Similar mentions of viewers' 'horror' are made in the *Leicester Daily Post*, 3 October 1906, p. 4; the *Croydon Advertiser*, 24 February 1912, p. 6; and the *Dundee Advertiser*, 20 June 1913, in Tuckwell archives, 217/54. Thanks to Steve Roud of the Croydon Local Studies Library and Archives Service for his help.

43. *Woman*, 23 May 1906, p. 11; *Labour Leader*, 11 May 1906, p. 744.

44. *Justice*, 12 May 1906, p. 4; *Socialist*, June 1906, p. 4.

45. *Labour Leader*, 1906, p. 744.

46. See Greenhalgh, P., *Ephemeral Vistas, The Expositions Universelles, Great Exhibitions and World's Fairs, 1851–1939* (Manchester: Manchester University Press, 1988), p. 184; Beckett and Cherry, *Edwardian Era*, pp. 73 and 168; Kinchin, P., *Glasgow's Great Exhibitions: 1888, 1901, 1911, 1939, 1988* (Wendlebury: White Cockade, 1988), pp. 30, 36, 40, 70–73, 109; 'Women's Arts and Industries', *Art Journal*, extra number devoted to the Glasgow International Exhibition, 1888, p. 9; Black, C., 'Match-Box Making at Home', *English Illustrated Magazine* **9**, May (1892), pp. 627–8; Coombes, A. E., *Reinventing Africa: Museums, Material Culture and Popular Imagination in Late Victorian and Edwardian England* (New Haven, CT: Yale University Press, 1994), pp. 99–100 and *passim*.

47. Greenhalgh, *Ephemeral Vistas*, p. 184.

48. E. C. Price to William Walsh, 30 March 1903. This and subsequently cited primary sources on the Mission are held in the COS Collection of the London Metropolitan Archives (LMA) ref. A/FWA/C/D85.

49. C. S. Loch to Edith Bullar, 31 May 1899 (LMA).

50. Watercress and Flower Girls' Christian Mission, *Limping Ferret* (London: Watercress and Flower Girls' Christian Mission, n.d.), cover (LMA).

51. Watercress and Flower Girls' Christian Mission, *25th Annual Report and Balance Sheet*, 1890–91, pp. 41–2 (LMA).

52. Pollock, G., '"With My Own Eyes": Fetishism, the Labouring Body and the Colour of its Sex', *Art History*, **17** (3), September (1994), pp. 342–82.

53. J. Kristeva, *The Powers of Horror: An Essay on Abjection*, trans. L. Roudiez (New York: Columbia University Press, 1982), p. 1

54. Ibid., pp. 1, 2 and 3.

55. Abjection's tie to conscience is intimated by Kristeva's own positioning of it in the realm of the superego: 'To each ego its object, to each superego its abject' (Kristeva, *Powers of Horror*, p. 1). Nor is the jump from personal to political identity a leap too far; for an instance of its effective utilisation see Moruzzi, N. C., 'National Abjects: Julia Kristeva on the Process of Political Self-Identification', in K. Oliver (ed.), *Ethics, Politics and Difference in Julia Kristeva's Writing* (London: Routledge, 1993), pp. 135–47. John Lechte, in *Julia Kristeva*, (London: Routledge, 1990), p. 160, also comments on the socialized appearance of abjection at the level of politics.

56. *Western Daily Press* (Bristol), 21 March 1908, p. 6. Thanks to Elizabeth Jeffery of the Bristol reference library for this reference. The most powerful statement of the inescapable presence of sweated goods in the consumer's life is provided in 'Sweating', an unpublished typescript by R. Mudie-Smith, in the Mudie-Smith Archive at the London School of Economics, misc. 736.9, p. 4. The lengthy passage traces a man's life from birth to the grave, by recounting the different sweated articles he uses.

57. Kristeva, *Powers of Horror*, p. 3.

58. Ibid. Kristeva gives as an example the difference between the 'signified death' of a flat encephalograph and the presence of a corpse.

59. Wright, E. (ed). *Feminism and Psychoanalysis: A Critical Dictionary* (Oxford: Blackwell, 1992), s.v. 'Kristeva, Julia,' by E. Grosz, p. 200.

60. Bennett, T., 'The Exhibitionary Complex,' in T. Bennett *The Birth of the Museum* (London: Routledge, 1995), pp. 59–88. The relevant aspect of Foucault's thought is developed in *Discipline and Punish, The Birth of the Prison*, trans. A. Sheridan (Harmondsworth: Penguin, 1981), and in 'The Eye of Power', in his *Power/Knowledge: Selected Interviews and Other Writings 1972–1977*, ed. C. Gordon, (New York: Pantheon, 1980), pp. 146–65.

61. Bennett, 'Exhibitionary Complex', pp. 63 and 67.

62. Ibid., p. 87.

63. *Recorder* (Ilford), 6 November 1908, p. 5.

64. Ibid.

65. *Manchester Guardian*, 20 October 1906, p. 5.

66. Foucault, *Discipline and Punish*, p. 191. The passage is frequently quoted, and I am indebted to the work of Tagg, *Burden of Representation*, pp. 89–92; D. Cherry, *Painting Women: Victorian Women Artists*, (London: Routledge, 1993), p. 142; and G. Pollock, 'Feminism/Foucault – Surveillance/Sexuality', in M. A. Holly, K. Moxey and N. Bryson (eds), *Visual Culture* (Hanover, NH: Wesleyan University Press, 1994), p. 37, for bringing it to my attention.

67. Pollock, G., 'Power and Visibility in the City', *Art History*, **11**, June (1988), p. 281; Tagg, *Burden of Representation*, p. 92.

68. 'What Can be Seen at the Manchester Exhibition,' unidentified clipping in Tuckwell archives, 217/11.

69. *Justice*, 12 May 1906, p. 4; *Manchester Weekly Times*, 22 September 1906, in Tuckwell archives, 217/2.

70. Minson, J., *Genealogies of Morals: Neitzsche, Foucault, Donzelot and the Eccentricity of Ethics* (London: Macmillan, 1985), p. 24; quoted in Bennett, 'Exhibitionary Complex', p. 62.

71. *Daily News*, 7 May 1906, in Tuckwell archives, 217/5. The value of the exhibitions as visual disclosures of the 'hidden' residuum was also the theme of Prof. G. Hare Leonard's lecture at the Bristol exhibition, 'Out of Sight, Out of Mind'. See *Bristol Times and Mirror*, 25 March 1908, p. 4.

72. A bill to this effect was introduced by J. H. Tennant. See G. Tuckwell, 'Preface,' in R. Mudie-Smith (ed.), *Sweated Industries: Being a Handbook of the 'Daily News' Exhibition* (London: Daily News, 1906), pp. 15–16.

73. 'Sweated Industries,' unidentified clipping in Tuckwell archives, 217/1.

74. *Western Daily Press*, 24 March 1908, p. 9.

1.1 William Hatherell, *A Match-Box Maker at Work*, 1891

1.2 *Clay-Pipe Making, 1906*

1.3 *Men's Coat Makers, 1906*

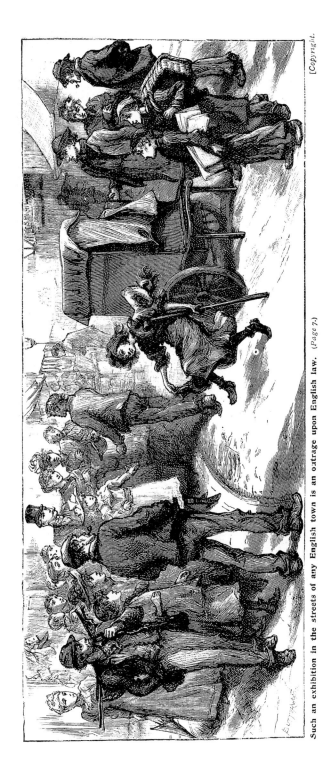

Such an exhibition in the streets of any English town is an outrage upon English law. *(Page 7.)* [Copyright.]

1.4 Butterworth, untitled illustration, n.d.

Facing horror: women's work, sculptural practice and the Great War

Claudine Mitchell

In spring 1918, the American sculptor Anna Coleman Ladd and the French sculptor Jane Poupelet opened, in Paris, the Studio for Portrait Masks to help restore the features of soldiers who had suffered severe facial injuries during the First World War. Working in collaboration with military hospitals the women sculptors crafted prostheses of a very special kind, a metallic simulacrum of the missing section of the wounded soldier's face which could be worn, like a mask, over the injury.[1]

This chapter addresses several diverse but interweaving themes. One of the concerns is the politics of representation of women's work. I want to use the archives to question what might constitute significant art practice in terms of pre-war and post-war feminism. Another concern is the issue of work as humanitarian service and how this notion might lead us to reread commemorative artistic practice. The central section of the chapter documents a phase in the history of medicine when the collaboration between sculptors and surgeons endowed the notions of representation and identity with a perplexing degree of materiality. I would like to expose how women sculptors experienced the suffering of the masculine mutilated face and how such work experience affected their post-war sculptural practice. Although such study inevitably recalls the bloody cataclysm of 1914–18, its frame of reference is neither the current debate on 'modern memory' nor the history of medicine.[2] I set in parallel women's endeavour to gain some measure of control over the course of history through their work undertaken in conditions of war and the problematic of commemorating women's work in the history of sculptural practice.

Before I look in detail at the Studio for Portrait Masks, I want to introduce a sculptural event in the wake of the First World War which poses the issue of interpretation and cultural reception. In 1923 a new artists' association, le Salon des Tuileries, was launched in Paris. One of its co-founders was Jane

Poupelet (1874–1932) whose main contribution, that year, was a sculpture entitled *Femme endormie* (Figure 2.1).[3] This features a woman lying on her side, stretched across the flat surface of a rectangular block. Her eyes are closed as are her lips. Her face is without tension or emotion. Her hands are joined in a position of prayer. As far as a state of sleep might be defined as an absence or an interruption of conscious processes of thought, the title *Femme endormie* seemed to validate a formalist interpretation, apparently inviting the viewer to consider the emotionless face as a blank semantic space. The sculpture could be seen to exemplify the formalist ethos: all narrative levels in the art object are suppressed. In the years leading to the First World War the sculpture of Jane Poupelet had become the focus of the exponents of a certain formalism, for example, critics such as Louis Vauxcelles. Notwithstanding the sacrosanct history of Modernism, such critics believed formalism did not have to lead to abstraction.[4] The State offered to purchase *Femme endormie*. Jane Poupelet did not accept their proposal.[5]

Was the subject of the work really a woman asleep? Could it not have been interpreted in other ways? Might not such an image evoke a definite subject matter, grief for instance, the theme of death and the desire for oblivion. More subtly, one might question whether its composition had not been intended as a reflection on the impossibility of constructing meaning to commemorate women's work and the war.

Researching an oeuvre which as yet does not have a clear position in the public domain presents the art historian with a whole set of problems. There are practical ones in our attempt to track down relevant material. Then there are conceptual problems in the necessity to retrieve appropriate frames of interpretation. In the case of Jane Poupelet this is further complicated by the nature of her formal vocabulary. Neoclassical sculpture has been so firmly attached to the history of the inter-war period, with all its negative connotations and troubled memories, that whatever meanings might have been attached to a sculpture like *Femme endormie* at the time of its creation are largely inaccessible to us.[6] We need to question the assumptions concerning the interconnections between formal language and political ideologies, humanitarian concerns and political positions. It is my strong belief that it is not possible for us to understand the practice of women artists of the recent past without a clear knowledge of the specificity of feminist language and conceptualization in that period.

I begin by revisiting the work of Jane Poupelet within the tradition of women sculptors in the burgeoning feminist culture of the pre-First World War period. Though more akin to an historical fresque than a detailed analysis, this timescale illuminates the continuity of feminist thinking on the sociology of women's work through dramatically changing historical circumstances. In turn the feminist legacy enables me to uncover the real constraints

dominant ideologies set to the project of representing women's work in sculptural practice.

Prologue: women, culture and the demise of L'Art Social

At the turn of the century, when Poupelet came to Paris to complete her studies in the circle of Auguste Rodin, two women presented powerful models to women art practitioners: the sculptor, Marie Cazin, and the feminist thinker, Hubertine Auclert. Marie Cazin (1844–1924) had succeeded in accomplishing what any sculptor, male or female, might possibly wish to achieve, a major monument developing a theme that seemed at the forefront of contemporary culture. Marie Cazin's monument to *Science et Charité* celebrated the growing medical institutions of Berck-sur-Mer which specialized in children's health and the cure of tuberculosis of the bones.[7] The now dismantled sculpture consisted of a group of three free-standing figures, still *in situ* in Berck, and a bronze high relief attached to the pedestal. The relief showed a contemporary hospital scene, featuring a nurse dressed in lay uniform attending to the daily consultation conducted by the two specialists who had established Berck hospital, Doctors Cazin and Perrochaud.[8] The sculpture thus documented how state-sponsored institutions had assumed responsibility for medicine. Cazin had adopted themes for sculpture that reflected foremost political issues of the Third Republic: the State's founding of l'Assistance Publique and a 'free and compulsory' education system.[9]

Constantin Meunier's *Le Grisou* (*Fire damp*) and Jules Adler's *La Grève* (*Strike*) had defined the project of L'Art Social by representing work as the distinctive mark of a social class.[10] The workers' suffering and claims were seen to condemn the existing social order. Cazin contributed a different perspective. In giving prominence to two sides of the female character Science/Charity, her memorial revisited the traditional notions of woman as healer and as mother. The first is shown in her professional role, applying a dressing to the arm of the sick boy: the other is shown keeping close physical contact with the child whom she tenderly comforts. In dominant culture, women's relations to work were generally perceived in terms of care, concern and duty. Cazin presented a new definition of woman's professional identity by emphasizing the intellectual concentration, skills and confidence of a medical woman.[11]

French feminists of the late nineteenth-century campaigned to ensure women's access to the public sphere, focusing their activism on the issues of education, employment and political rights. Hubertine Auclert (1848–1914), the eminent women's suffrage campaigner, began her political career in 1876, by insisting on the principle of equal pay for equal work.[12] This

was a profoundly subversive policy in a social system which, while claiming that woman's place was in the home, depended on the exploitation of a huge female workforce paid half the salary of men. In the late 1890s, Auclert's reflections concentrated more on the issue of maternity as a social function. Since financial independence seemed the prerequisite of women's independence, she asked that maternity be legalized as employment, irrespective of marital status. She advocated that mothers receive a salary and a state pension. If pregnancy or childbirth caused damage to health, the victims would be entitled to compensation. To change woman's status in the law, Auclert also advocated that children take the name of their mother.[13]

When Jane Poupelet contacted Hubertine Auclert in the late 1890s, she felt confident the intellectual feminist legacy could be brought to bear on the practice of sculpture.[14] Her first ambitious composition, a work akin to a degree show, tackled a social subject that she felt relevant to women and to the rural community of her childhood: the *Burial of a Child in Dordogne*.[15] Having as its focal point the figure of a young woman standing a little apart, head raised, thinking and questioning, the design privileged female viewers who might readily identify the questions the composition raised . The serial sculpture of eight figures encompassed the cycle of life and placed grief at the core of human experience. The absence of the mother in the child's funeral procession, echoed feminist discussions on the dangers women suffered in childbirth.

As Poupelet was soon to discover, the art establishment of the early twentieth-century was not prepared to endorse the feminist agenda. When exhibited at the Paris Salon of 1904, *Burial of a Child in Dordogne* attracted an adverse critical reception that influenced her later career. The period of L'Art Social was now clearly over. More sharply, she understood that if she hoped to make a prestigious career, any subject that seemed closely related to feminist preoccupations would have to be discarded. The priority for sculpture was to reconcile formalist research with a definition of abstract conceptions.[16] Her answer, formulated in the period 1906–10, was to take up a position in the neoclassical movement which, around the personality of Aristide Maillol, was considered the avant-garde of sculptural practice.[17] Drawing on the intellectual legacy of Hubertine Auclert, Poupelet would develop a two-sided language which enabled her female audience to recognize their aspirations for emancipation within and beyond formalist concerns.

Hubertine Auclert had had to go over a great deal of conceptual ground to articulate her position. She had offered a way to describe the social order that was fundamentally different from the dominant economic, political and cultural mode. In dominant culture, 'Woman' was defined exclusively in relation to man as mother, wife, companion or educator. Man was the 'norm'

to which the entire social order was related. Auclert, on the contrary, posited 'women' as autonomous beings. This was the overriding feminist principle which informed Poupelet's sculptural practice. *Femme à sa toilette* (Figure 2.2), for instance, proceeded from an attempt to unify the intellectual and the physical dimensions of femininity.[18] It offered a positive image of woman as self-contained and endowed with some of the muscular body and the intellectual power women needed to act effectively in the outer world. Her practice had thus created a cultural space where the relations between the intellectual and the corporeal within the subjectivity of women could begin to be reinscribed in language, through aesthetic representation.[19]

In reply to the politicians who denied women's political rights on the grounds that women did not risk their lives on the battlefield, Hubertine Auclert had argued that childbirth had cost and continued to cost the lives of many women. Maternity should, therefore, be considered women's contribution to the perpetuation of the State: 'tax on life', as military service was men's contribution to its defence: 'tax on blood'.[20] Auclert and some of her feminist colleagues had further advocated that young women, like young men, underwent a period of National Service which was compulsory in France. They proposed to call it *'Service Humanitaire'*. This idea formed part of the Women's Electoral Programme Auclert had drafted on the occasion of the parliamentary elections of 1910. Six months after Auclert's death, in April 1914, the first argument had become unutterable.

Men without faces

With the outbreak of the First World War, the feminist concept of women's *Humanitarian Service* could no longer remain a hypothetical idea. The confidence that women might turn sculpture into a social practice was dramatically put to the test as women sculptors came to collaborate with the medical profession. Anna Ladd and Jane Poupelet were affiliated to the Bureau for Reconstruction and Re-education of the American Red Cross in Paris. They produced facial masks to assist the facially wounded, the bearers of the horror of war, back into the world.

Looked at in the medium of old photographs, these masks may take on uncanny connotations in our imagination enriched by the intellectual adventures of surrealist art. But for the sculptors who modelled them, these prostheses were deeply embedded in a socio-historical process and in human relationships that gave them their sole significance. In the following pages I examine the set of beliefs which sustained the idea that women sculptors might work to 'reconstruct' the face of mutilated soldiers and 're-educate' them to a new sense of identity.

Anna Ladd's press interviews and her correspondence with Jane Poupelet provide information about the working practice of the Studio for Portrait Masks. Ladd's statements are factual, in control: the women sculptors remained determinedly silent on many issues. To place their practice in the history of medicine and the First World War without displacing the focus away from the subject of women's work, I have used the testimonies of two other Red Cross volunteers. One is the report of Hélène Baillaud, a nurse attached to the facial surgical unit of the hospital du Val-de-Grâce in Paris throughout the war years. The other is Vera Brittain's autobiography, *Testament of Youth*, first published in 1933.

RECONSTRUCTION

The first soldiers who called upon the expertise of the women sculptors came from the Val-de-Grâce, where Professor Hippolyte Morestin (1869–1919) had created in the summer of 1914 the then well-known *5e Division des Blèssés*. Hélène Baillaud who was attached to that Division has left a graphic account of the work they were to carry out for the facially wounded. She remembered the soldiers' faces as they arrived from the front: 'They had no nose, no mouth, no jaw, no hard palate, only a hole in the middle of the face.'[21] Her statement characteristically repressed any emotion and recorded only a void. Quickly Baillaud's report moves from a notion of medicine that aims to save life, to an account of the surgery concerned with the re-construction of the physiognomy:

As soon as their life was out of danger and that they could move about, we began the task of restoring their appearance. There was no question of leaving them with a hole in the middle of their face. After thirty or so operations, the great specialist Doctor Morestin, remade the nose they lacked and gave them back their human appearance. He achieved this using the skin of their forehead and a fragment of cartilage from their rib cage. The surgeon's skill was truly great and we were full of admiration.[22]

Baillaud's account of the skin-grafting and bone-transplanting operations that were developed during the First World War might seem reassuring. The photographs published in Morestin's 1917 survey of facial surgery would tend to confirm the nurse's reassuring testimony.[23] Yet, the global situation was otherwise. The medical institutions were confronted with a disaster on a magnitude that had seemed unthinkable, a direct consequence of the nature of warfare that had no historical precedents. It is relevant to recall the massive deployment of the artillery and the new technology of weaponry – bullets shaped to tear flesh apart, shells with new devices so that fragments would spread over longer distances – and the politics of attrition, pursuing the strategy of offensive on the Western Front, where 'Men were fed in day after

day on a narrow fortified front'.[24] In France alone, 3 million injured were treated in military hospitals, 500 000 of whom suffered from head injuries. With the progress made in antisepsis and serotherapy, even though penicillin was not yet known, injuries of the frontal part of the head, however deep, were no longer mortal. In France, the facially wounded who survived their treatments were to constitute a category of 20 000 disabled.[25]

Facial surgery which had not existed as an autonomous discipline in 1914, developed as a consequence of the type and magnitude of war wounds.[26] As we can now better understand, the institution of the Portrait Masks grew on the margins of this new science that was proud of its achievements but constrained to recognize its limitations. Its practice was sustained by a particular set of ideological positions concerning the war and its consequences which, I believe, amounted to the refusal to accept the fact that a social order – call it Nation, Motherland or Republic – which took away from the subjects devoted to its defence so much of their life substance, would remain powerless to restore some of that life to them. Such was the ideological standpoint which inspired Hélène Baillaud's report and, indeed, inspired the activism of many women who volunteered to work in medical institutions.

It is entirely due to American sculptor Anna Coleman Ladd (1878–1939), her energy and enterprise, that the Studio for Portraits Masks was ever established.[27] When the USA entered the war, in spring 1917, she determined to do active service in France where she had lived for many years. Having learned of the English sculptor Francis Derwent Wood and of the Masks for Facial Disfigurements Department he had recently established in the Third London General Hospital, she convinced the American War Department to let her create an equivalent institution in Paris. In the first months of 1918 she learned the technique, on the basis of the information Derwent Wood had published in *The Lancet*.[28] She found the institutional structures that would finance the enterprise and give it the scientific status and prestige it needed to develop. The Hospital of Val-de-Grâce proved co-operative from the start, allowing her to practise on two of their patients. Subsequent to a series of lectures Ladd gave at l'Institut Pasteur, the French Service de Santé authorized her to practise in the Miltitary Regions and undertook to provide 16 hospital beds to her work as well as authorizing soldiers to journey to Paris for their treatment.[29] A publication in the May issue of *La Presse Médicale* publicized the Studio for Portraits Masks amongst the medical profession. The innovatory surgeon Léon Dufourmentel, who had become convinced of the necessity to collaborate with sculptors and develop the use of sculptural prostheses, subsequently invited Ladd officially to take part in the Congress of Surgeons held in Rennes in September 1918.[30] Having gained scientific respectability, Anna Ladd well understood that her oeuvre could only succeed if it became known and was attractive to the wounded soldiers. Greatly

skilled in public relations, she was able to interest major newspapers and gave a series of press interviews. By mid-September 1918, 94 soldiers had already applied for the services of the women sculptors as had two women civilians badly burned during a bombardment.

The functioning and development of the Studio of Portrait Masks was very much a collective working practice. Jane Poupelet's contract with the American Red Cross, drafted on 18 March 1918, stipulated that she would take on the direction of the Studio during Anna Ladd's absence. Ladd worked mostly in the field, visiting hospitals in the Military Regions of France, seeking potential patients in the *centres maxillo-faciaux*, the surgical units that specialized in the treatment of facial and jaw injuries.[31] Poupelet was effectively the co-director of the Paris Studio and was to supervise the day-to-day administrative and financial aspects of the enterprise. For her part, this was a totally voluntary activity, taking every afternoon for six days a week, except the month of August, and for which, she received 400 francs a month to cover her work expenses, without being granted board or lodgings as the Voluntary Detachment Nurses were. By Autumn 1918, the staff of the Studio of Portrait Masks had grown to four sculptors and one researcher. In June, French sculptor Robert Wlérick, a close friend of Poupelet, had been detached from the facial surgical unit of Professor Moure in Bordeaux. Diana Blair, curator of specimen at Harvard Medical Laboratory came to help develop the method of galvano production. Marie Louise Brent who had served as the Secretary to the American Fund for French Wounded in Lorraine, became the Studio Secretary in September.

The fabrication of the prostheses involved four distinct stages which Anna Ladd recorded as follows:

A plaster cast is taken of the disfigured man's face after it is quite healed. On this is modelled, in white plasticine, the features as they were before the war, using photographs of that time, – or psychological insight when these are lacking. A wax mould of this reconstituted face is then placed in an electric bath of sulphate copper, and a thin deposit forms on the surface; which is later painted to reproduce exactly his colouring, with freckles, shaved beard, etc. It is affixed by spectacles or invisible wires behind the ears. It is easily removed and can contain surgical dressings. Moustaches or beards are sewn on; the lips are slightly open to help naturalness in looks, breathing, speaking and smoking. Eyelashes are cut out of fine metal; artificial eyes carefully matched, and shaded by modelled lids.[32]

The first stage, that of preparing a cast of the mutilated face, was initiated by Anna Ladd during her visits to the *centres maxillo-faciaux* of the Military Regions. The production of a life-mask, through the method of 'casting from life' well known in sculptor's studios, had to be rigorously achieved in several stages. A negative shell in plaster of Paris was transposed into a positive image by the casting process. Portraitist skills were called upon, for

instance, to open the eyes and redefine anatomical volumes so as to obtain an exact likeness of the mutilated face.

The second stage, modelling on the life-mask the missing features of the patient as they were before the injury, involved all the artistic skills of the portraitist. The system of proportion had to be rigorously applied so that the anatomical volumes of the final mask would fit exactly to the maimed face. The modelled mask involved that dimension of psychology and human understanding Rodin had always considered the artistic side of portraiture. As Ladd said, 'My objective was not simply to provide a man with a mask to hide his awful mutilation but to put in the mask part of the man himself – that is the man he had been before the tragedy'.[33] As we can see from the photograph of Poupelet at work (Figure 2.3), the prosthesis was modelled in the Paris Studio and required the patient's presence.

The third stage, the making of the galvanized copper prosthesis was carried out by the reputed Paris firm of silversmiths, Christofle. One of the main problems the Studio had to resolve was that of heat radiation, while another was to reduce the weight of the prosthesis. The fourth stage, adjusting the copper mask to the patient's face required utmost competence in chiselling technique, so that the edge would fit exactly the line of the scar, conceal it, and yet not rub against the patient's skin (Figure 2.4). The unalterable and washable enamel paint the Studio had received from America was considered one of the factors that made the masks of superior quality. The Studio delivered 67 such prostheses in 1918, and 153 in 1919. The sculptors aimed to achieve the highest possible degree of verisimilitude: 'At a slight distance, so harmonious are both the moulding and the tinting, it is impossible to detect the join where the live skin of cheek or nose leaves off and the imitation complexion of the mask begins.'[34]

In October 1919, the French Service de Santé granted the Studio for Portrait Masks new premises within the Hospital du Val-de-Grâce. It is an index to its reputation that the Studio continued to function after the armistice of November 1918. Before returning to America in January 1919, Ladd had insured that the American Red Cross would continue to administrate and finance the Studio through 1919, a role the Oeuvre des Blessés au Travail was to take on in 1920.[35] Wlérick and Poupelet insured the continuity of the practice, he until September 1919, she until winter 1920 when she offered to pass on the technique to another person.

In his publication of 1919, 'La part respective de la plastique chirurgicale et de la plastique artistique dans le traitement terminal des grandes mutilations de la face', Dufourmentel defined the sculptor's field as that of 'aesthetic restoration'.[36] The role of the sculptor was not simply that of producing the models of the anatomical parts the surgeon was to 'reconstruct' but to provide the terminal treatment in plastic surgery, for specific cases of

severe mutilation. This was one of the first publications, in France, to call attention to the necessity to develop a surgery that would deal specifically with physical appearance – that which would become cosmetic surgery – as distinct from a surgery that aimed to save life or restore the bodily functions of breathing, mastication and articulation.

RE-EDUCATION

As the medical profession is now well aware, disfigurement involves a fundamental loss of personal and social identity. The scientific publications, in France, in the period of the First World War give no insight on how that issue was then understood. On the one hand, publications on facial surgery focused on questions of emergency measures, on the development of reconstructive techniques or the treatments for the recovery of bodily functions such as mastication and speech. On the other hand, psychiatry and neurology dealt essentially with the notion of 'commotion' and its multiple effects, comparable to the notion of shell-shock in England.[37] In this domain, a regime of auto-censorship seemed to have prevailed since the state sponsored publications were led to conclude that the war had caused no significant increase in the number of mental illnesses and that most cases of war psychosis were curable.[38] Yet, it was on the basis of their working experience with the facially mutilated soldiers that surgeons were able to lay out the series of arguments that helped to win the battle to legalize the practice of cosmetic surgery in the late 1920s. Dufourmentel argued on three grounds. The first consideration was general, he explained that the conception of physical beauty was not simply a function of sexuality, as he used to think, but a fundamental part of the instincts for life or death. Another argument was sociological in kind, concerning the reintroduction into society of subjects who had suffered facial disfigurement. His third argument bore specifically on the relation he believed existed between the subject's mental health and the subject's perception of his or her physical appearance, a domain in which the surgeon collaborated with psychoanalysts. It was for such reasons that, in the aftermath of the war, surgeons had endeavoured to develop techniques to help improve the physical appearance of facially mutilated soldiers, Dufourmentel added.[39]

The institution of the Portrait Masks provides some insight in the formation of a new understanding of the relation between mental health and physical appearance. The practice of portraiture, nurtured by nineteenth-century notions of psychology which posited close relations between the facial mask and psychic identity, had prepared the sculptors to deal with facial wounds as a mental and a moral problem.[40] What did Anna Ladd mean when she claimed that they were able 'to give the mutilated, disheartened man back

his personality, and his hopes and ambitions'?[41] How did the sculptors envisaged their social role in the *Department of 're-education'*? One way for us to tease out what was understood by 're-education', is to investigate how these sculptors thought of their work in relation to the hospital ward. Hélène Baillaud's report on the Val-de-Grâce gives interesting evidence on the therapeutic activities they undertook and the spirit in which these were carried out. She presents the work of the nurses as a constant struggle against suffering, as they tried to alleviate physical suffering in collaboration with the medics and, equally important to them, as they tried to alleviate mental suffering. It was essential, she writes, 'to prove to our wounded men that their life had not come to a tragic end'.[42] The objectives were to build the confidence that a return to civil life was possible and help their patients to become self-sufficient.

All kind of activities took place in the ward. The nurses taught Braille to all their blind patients. Specialists teachers came to train the soldiers in a variety of professional skills and craft. As most of these men came from rural France, with very varying degrees of literacy, Hélène Bailllaud felt it helped to open their mind to the world of literature and intellectual pursuits.[43] The hospital, on the other hand, seemed to have had no consistent policy for dealing with the facially wounded's specific and major problem, that of coming to terms with their new physical appearance. This was a threefold problem.

Mirrors were banished from the ward. The confrontation with the mirror was postponed, as much as possible, until the end of the treatment, without preparing the patient in any particular way, for the moment when 'surgery at last has washed its hands of him'.[44] Another phase was the confrontation with the gaze of anonymous people. Hyppolite Morestin had a definite policy in this respect and prescribed that his convalescent patients took a daily walk in the streets of Paris, an activity which a team of very young volunteer women made possible. The effect this initial confrontation with the outer world had on the life of these men, and the pain it caused, is told in some of the pages of the little review Val-de-Grâce patients managed to put in print, *La Greffe Générale*. These are narratives about the Medusa effect, of the onlooker turned frozen in awe.[45] As a rule the pain and the violence are transposed in acerbic humour and the grotesque. There could be no possible visual representation of that experience, and the face of the soldier drawn on the front page of their review is perfectly 'normal' and expressionless. The third phase, and that was considered a determining one, was the confrontation with relatives. Parents' visits were not encouraged and leave carefully monitored. If this failed, as Baillaud observed, the patient might lose all desire to try to confront the outside world again. The soldier who could not come to terms with the sight of his mutilated face plunged into deep

depression, 'walled in his self imposed prison' as one soldier put it, remembering a more desperate comrade.[46] The policy of the hospital ward, it would seem, consisted mostly in postponing rather than dealing with the question of facial identity.

The sculptors of the Studio for Portrait Masks thought of themselves as continuing the work of the hospital ward, taking the convalescents at a point where they were declared 'medically cured', and providing the service which dealt with the major problem, self-image. The Studio offered a transitional space where the mutilated could find another expression of the spirit of solidarity that was at the core of their recovery.[47] The sculptors made the studio feel warm and artistic, as Ladd recalled: 'They were never treated as though anything were the matter with them. We laughed with them and helped them to forget. That is what they longed for and deeply appreciated.'[48]

Such pretence that 'nothing was the matter' characterizes very well, in my opinion, the concept of 're-education' at this historical moment. The overriding principle was that of a return to normality. The mutilated would smoothly fall back into the social space they had occupied before the war, that of work and family.

The facially wounded who opted for the services of the women sculptors had already taken the decision that they would try to confront the outside world, and this surely must be one of the reasons why the masks seemed to answer their immediate problems. Initially the test of a successful return to 'normality' was the street, walking in the street without being noticed. The clientele of the Studio grew on the strength of soldiers who reported that they had walked in the street and yet *nobody had looked at them*. Beyond the phase of convalescence, Ladd claimed that, after the war, 'many of these soldiers have returned back to wife, children or family, slipping back into their former places in society, able to work and derive a bit of happiness out of life'.[49] The archives of Anna Ladd contain several letters of gratitude corroborating her statement. For instance, on the part of one who worked as a local postman, and another who believed that, without the possibility of wearing the mask, he would have remained confined in the backyard of a military hospital for the remainder of his life.

The notion of a possible return to civil life endorsed by the women sculptors was a humanitarian concept. They were thinking ahead of the military whose official purpose, from autumn 1914 (when the first *centres maxillo-faciaux* came into being) until November 1918, had been to return the wounded soldiers to the front. In the aftermath of the war, surgeon Dufourmentel called attention on the economic implication of facial disfigurement for post-war society. He located the problem of the mutilated in the behavioural reactions of other people: 'It is sadly certain that a disfigured face inspiring disgust or horror, in spite of the pity and respect we owe to the victims of the

Great War, can cause these men considerable prejudices.'[50] Dufourmentel's main argument was that the nation could not dispense with the labour of disfigured men, since so many men had died, and that they would be badly discriminated against when seeking employment. At that stage no solution to the problem of severe facial disfigurement was envisaged other than wearing the facial mask at times when 'the wounded is exposed to the gaze of strangers who might express with more or less discretion their surprise or repulsion'.[51]

The war ended, the State discharged the convalescents from military hospitals without providing any resources to continue the facial surgical treatments in progress.[52] As the facially mutilated discovered, their status in the law did not entitle them to any substantial pension scheme either. Organizing themselves into an association called l'Union des Blessés de la Face 'les Gueules Cassées', they campaigned to obtain their rights as disabled persons. These claims were recognized in principle in 1925, but the struggle to obtain proper means of survival had to continue through the 1930s. During this period of militancy against the State there developed a new conception of mutilation and a new language to represent it. Only then did it become possible to articulate the experience of horror. Some felt it urgent to spell it out: 'the distinctive quality of our wounds which constitutes properly speaking Horror itself ... we are not afraid of facing reality, let us not be afraid of language'.[53]

THE SCHOOL OF HORRORS

When I undertook this whole research on medical work and the mutilated masculine image, I had hoped to find consequential evidence on how the problematic of representation had been conceptualized. In particular, I wanted to investigate the repercussions the experience of controlling the masculine image might have had on the women sculptors' conceptions of the politics of representation. In this respect the archives did not prove as informative as I had hoped. The correspondence of Anna Ladd and Jane Poupelet confronts us with the same veil of silence that we can observe in the writing of Hélène Baillaud. I came to realize that my expectations had been mistaken, and that such a veil of silence measured the depth of the utter distress. The portrait mask, point of encounter between the subject and the outer world, though purporting to assist the wounded soldiers into re-entering the world that lay outside the hospital ward, effectively worked to conceal the magnitude of horror. It could be seen to stand as an appropriate metaphor for the unutterable. Only once did Poupelet and Ladd discuss their experience of the suffering masculine subject in their correspondence, in January 1920. Spoken in retrospect a brief statement becomes more portentous. Both artists

acknowledged that the *'magnitude of suffering'* they had witnessed would irrevocably alter the course of their sculptural practice.[54] And there is some evidence in the form of women's testimony about the traumatic dimension of the encounter with the wounded. This enables us to situate our investigation within a political framework.

In her autobiography, *Testament of Youth,* Vera Brittain removes all sentimentality from the experiences which women who worked in medical services encountered. She documents the amazing workload and responsibilities young volunteers assumed in the General Hospital of Etaples which was situated near the Front in Northern France. She was working there, in what had virtually become a Casualty Clearing Station, during the German offensive of spring 1918. She explains how she learned to build that 'psychological distance' without which it would have been impossible to carry out medical work. Although Brittain gives vivid descriptions of the surgical ward at Etaples, nowhere does she disclose to her readers what sights there were to be seen underneath each brown blanket as the convoys arrived from the Front. Only once, does she allow herself to recall those sights, upon hearing the news that a close friend had been wounded. What comes first in the hierarchy of horror are the facially wounded: 'After the Somme I had seen *men without faces*, without eyes, without limbs, men almost disembowelled, men with hideous truncated stumps of bodies.'[55] In the early 1920s Brittain, like many nurses, suffered hallucinations and recurrent nightmares. Again it was the facially mutilated that haunted her most.[56]

Brittain shows no complacency in analysing the motivations which had led her to decide that she would leave Oxford and her studies to enrol as a Voluntary Aid Detachment nurse in 1915. It was not patriotism, nor even a quest for heroism. Rather, the state of permanent anxiety the war had brought about made sheer physical hard work seem an easier course to follow than intellectual pursuits.[57] It is through her indignant observations of the waste of human resources and talent by the State, as much as her denunciation of the 'wholesale murder' military strategies and trench warfare amounted to, that her position, initially characterized by individualism, transformed itself into political consciousness. Her feminist sympathies quickly sharpened as she observed attitudes to women. She shows how conservative ideologies lingered on. In spite of changing attitudes to women through the war years, Brittain remained convinced that, apart from the demand for doctors and nurses: 'women in war seemed to be at a discount except as the appendages of soldiers'.[58]

Vera Brittain's political insights could be usefully contrasted to the positions of French feminist Madeleine Pelletier. A qualified general practitioner, notwithstanding her modest social class background, Pelletier believed that only a dangerous post near the front line would serve the feminist cause.

Having enrolled with the Red Cross at the beginning of the war only to be denied the type of responsibility she sought to undertake, she decided to resign her contract soon after. She used the spare time the lull in political militancy left her during the war years to complete a degree in chemistry.[59] A political figure of the extreme left, Pelletier argued that wars formed part of the strategies capitalist states used to safeguard their economic system and maintain their positions of power.[60] The pacifist cause that formed the forefront of Vera Brittain's political activism in the inter-war period was also on Pelletier's agenda, as a member of the newly constituted Communist Party.

The position of Jane Poupelet was unlike that of either Brittain or Pelletier. She was anxious not to appear to have any definite political image. Having made sculptural practice the core of her life, she strongly believed that for a woman to make a successful career it was essential to force the critics out of their habit of confusing the image of the woman artist with her oeuvre. Accordingly, she put a veil of silence over her war work, as she did for all other events which she considered formed part of her personal life. As a feminist however, it was clear to her that history was to be struggled against. The fact of war had to be confronted, and so she undertook various forms of activity that called upon her sculptural practice. When the opportunity to work for the facially wounded was offered to her in 1918, she assumed that responsibility.

Women's active service was generally considered a matter of individual conscience on which the considerable pressures of such patriotic ideologies as 'the war effort' could be exercised. As these three contrasted case studies show, the decision to take up work under war conditions did not stem from any unified political consciousness on women's part. However, we may expect that the confrontation between their respective aspirations and state ideologies in wartime would contribute to the development or dramatically alter their political consciousness as sculptor, writer or social worker. I shall take up this question in the concluding section of my chapter, as I cement together the pattern of intersections between the historical, political and aesthetic paths of my research.

Epilogue: the unfinished *Monument to Women*

After the war, the practice of Anna Ladd and that of Jane Poupelet followed divergent paths. Ladd sailed back to the USA determined to obtain proper recognition, as a sculptor, for the medical work she had created in Paris. Throughout 1919 she gave a series of public lectures and press interviews, ostensibly as a fund-raising activity for the Paris Studio. She was always

careful to present the war prostheses as developing from her expertise as a sculptor of portrait busts. During the inter-war period Ladd's practice covered the full range of subject matter of monumental statuary. She undertook a variety of commemorative works, war memorials for public spaces, monuments to war heroes such as *General Pershing*, as well as funerary art for private patrons. *The Price of Victory* which stands in the cemetery of Beverly Farms, Massachusetts, combines two male nudes of differing size. The dominant figure with angel wings unfolded around a kneeling dying youth superimposes the representation of the fatherland with that of death in one disturbing image. The *Manchester War Memorial* in Rosedale cemetery, Massachusetts, also works on a thematic antinomy, this one with a utopian message. The bronze relief *Night* features the decaying corpse of a soldier hanging on barbed wire, whilst *Dawn* shows two athletic youths rising from the dead on the battlefield, one guiding his companion towards the future, the rising sun. Ladd's iconography responded to the making and development of dominant international political ideologies in the 1920s. *Peace* was accordingly represented by her as the potency of the State in the guise of an athletic masculine nude. *La Belle Alliance* represented the international agenda which she saw emerging between the USA, France and Great Britain, as three draped female figures holding hands in a circular composition.[61]

Poupelet never considered the work she carried out for the Studio of Portrait Masks had formed part of her career as a sculptor. Nor did she feel it was her responsibility to use the practice of sculpture to commemorate the mutilated soldiers for posterity. When The American Red Cross offered a commission, she declined it. The portrait masks had been a form of personal engagement with history when history had left no alternative.

Let me now return to the sculpture entitled *Femme endormie* which I discussed at the beginning of the chapter. It had undeniably been conceptualized as a *Monument to Women*. Its imagery followed a long-established tradition in funerary art, developing the metaphorical link between sleep and death.[62] In medieval or Renaissance statuary, the deceased person was represented lying on her or his back, while the hands, joined in prayer position on the breast, signified the state of death. Jane Poupelet's sculpture could be seen in this tradition. We could set it in parallel to the recently retrieved early seventeenth-century poem by Lady Mary Wroth which articulates the same symbolism between death, sleep and identity:

> When night's blacke Mantle could most darknesse proue,
> And sleepe (deaths Image) did my senses hyre,
> From Knowlege of my selfe, then thoughts did moue.[63]

Poupelet's composition articulates a symbolic order as the rectangular base 'separates' the female figure from the world of matter and the rectangular

block 'elevates' her to the sphere of abstract ideas. The generalizing qualities of the neoclassical nude combine with the abstract qualities of the pedestal to cement the values of grandeur and dignity in the representation of the female body. These abstract qualities were not a means to distance sculpture from language. On the contrary, the generalizing mode of the sculptural technique offered a field of interpretation to each individual member of Poupelet's female audience. It is not possible for me to look at that sculpture today without evoking the pages of Vera Brittain's autobiography where she defines her state of mind at the beginning of the 1920s:

it all seemed to have meant one thing and one thing only, 'a striving, and a striving, and an ending in nothing'. And now there were no more disasters to dread and no friends left to wait for; with the ending of apprehension had come a deep, nullifying blankness, a sense of walking in a thick mist which hid all sights and muffled all sounds.[64]

As Sally Alexander reminds us, the imaginative presence of death haunted all aspects of the society of the early 1920s.[65]

The design of Poupelet's projected memorial, consisting of a single female nude, was embedded in the same overriding feminist conception of woman's autonomy which had inspired her pre-war sculpture. And it is at that level that her practice had become fundamentally in conflict with post-war society. In memorial art of the 1920s, as we may observe, the female figure is always related to the representation of an abstract conception of masculine sacrifice and masculine heroism. Featured standing and wearing draperies the neoclassical female figure would be understood as representing the idea of the nation. Dressed in contemporary costume, the figure would stand for woman as mother or wife or represent a medical woman. For her part, Anna Ladd respected these codes. In Ladd's commemorative plaque to the *Women Munitions Workers*, the 'worker' is equally defined as wife and mother by including the figure of a child and that of a departing soldier. Ladd, too, conceptualized a project for a *Monument to Woman*. It featured a female figure, standing, draped in the stylized uniform of a Red Cross nurse. The design of the figure as well as the reverberating quality of the white material connoted a lighthouse. Ladd did not omit to include a dead soldier laying naked but for a war helmet. The composition thus anchored both the representation of woman's work and that of the relation nation-soldier in the tradition of the Mater Dolorosa. Poupelet's representation of an abstract conception of women's sacrifice and heroism via a single female figure, on the contrary, presupposed the conception of woman as an absolute. It sabotaged the ideology of national reconstruction which requested women's return to traditional positions of subservience within the family.

If the feelings of comradeship that had existed during the war years might have deluded feminists as to what exact position women held in the State,

such delusion could no longer be entertained in 1923. When war began, French suffragist associations resolved to cease campaigning for women's rights so as to dedicate all their energy to the State. In May 1919 their strategy had been rewarded, it seemed, when the Chamber of Deputies voted overwhelmingly in favour of women's suffrage. However the Senate postponed for a period of three years the time at which it seemed appropriate to debate the issue and turn to draft the project for a new law on women's suffrage. During this period all the old conservative arguments concerning woman's special relation to the family, employment and the Church were voiced again. It was even said that women had carried out their 'war effort' for the love of La Patrie, not in expectation of any 'reward'. There was noticeably one new spectre in that whole debate, the Russian Revolution. Feminists were represented as revolutionaries.[66] Madeleine Pelletier similarly observed that in the political working class, men often voiced their fear that Bolshevism brought about the breakdown of the family. What these men really feared, she wrote, was the loss of their unpaid domestic worker.[67] All the arguments which Hubertine Auclert and pre-war feminist thinkers had painstakingly compiled proved to no avail. Their legacy was wiped out. In November 1922 the Upper Chamber of Parliament overwhelmingly voted against granting French women their political rights. Following from some 130 years of feminist struggle, this verdict of male politicians was an incomprehensible defeat and a symbolic humiliation. Bourgeois feminists who had persisted in believing that women's entry to the public sphere could be achieved without a fundamental transformation of the social order were left in a particularly untenable position.

In 1923 Poupelet's *Femme endormie* had become only too real a symbol of the position women occupied in French culture, allowed to have visions and generate ideas but only of the kind that caused no disturbance of the dominant social order. At this historical moment silence seemed more dignified. And so the woman sculptor determined that her work should not be misinterpreted in the art spaces of Modernism and she withdraw it from the public arena.

Acknowledgements

Many persons and institutions have made this research possible. It has been enabled by a grant generously awarded by the Henry Moore Foundation. I am particularly grateful to Madame Hélène Wapler and Monsieur Vincent Wapler who catalogued the archives of Jane Poupelet, to Dr Joyce Tyler and Dr Judy Throm, Chief of Reference at the Archives of American Art, to Monsieur Camille Gargar of the Archives of the Val-de-Grâce and to Monsieur Philippe Camin, Conservateur Départemental des Musées des Landes. Le

Médecin Colonel Ferrandis, Conservateur du Musée et des Archives du Service de Santé des Armées at the Val-de-Grâce has been very generous with his time and advice. I also wish to thank Geoffrey Mitchell and Professor Griselda Pollock for their critical comments and support.

Notes

1. Archives of Jane Poupelet, private collection. Archives of Anna Coleman Ladd, Archives of American Art, Washington, DC, donated in 1991 by the late Robert Edward.

2. See Winter, J., *Sites of Memory, Sites of Mourning*, (Cambridge: Cambridge University Press, 1995), pp. 2–5. In his important book, Winter challenges the appropriation of the system of values of Modernism for the cultural history of the First World War. He offers a new model of understanding in which the concepts of grief, mourning and healing play a central role. His chapter on commemorative monumental practice (pp. 78–116) is accordingly integrated in a complex and varied discussion of the various modes in which contemporaries attempted to comprehend and transcend the irradicable trauma of the First Word War.

3. *Femme Endormie*, private collection. 25 cm × 42.6 × 31.3. See Wapler, V., *Jane Poupelet Scuplteur*, Mémoire de Maîtrise, Université de Lille III, 1973, *Catalogue Raisonné*, no. 61, pp. 212–13. Mitchell, C., *Inventaire des Plâtres du Sudio Jane Poupelet*, Musée Despiau-Wlérick à Mont-de-Marsan, 1992, nos JP 32–5

4. Vauxcelles, L., *Gil Blas*, 14 April 1909 and 16 April 1910. For the politics of Vauxcelles see Green, C., *Cubism and its Enemies* (New Haven, CT, and London: Yale University Press, 1987), p. 190.

5. Archives Nationales, Paris, F21 4259. For a brief account of Jane Poupelet's career see my entry in *Dictionary of Women Artists*, D. Gaze (ed.), (London: Fitzroy Dearborn, 1997), vol. 2, pp. 1112–14.

6. For comparison see Silver, K. E., *Esprit de Corps: The Art of the Parisian Avant Garde and the First World War 1914–1925* (Princeton, NJ, and London: Thames and Hudson, 1989). See for instance how he relates the interest in classicism to the nationalist discourse generated by the ravages of war (pp. 89–105), or his brief reference to the facially wounded (pp. 188–9).

7. For a brief account of Marie Cazin's career see my entry in *Dictionary of Women Artists*, vol. I, pp. 375–7. Cazin's monument was unveiled at Berk on 23 August 1893. See *L'Illustration*, 26 August 1893, p.172.

8. For the history of the profession of nursing in France, see Knibiehler, Y. (ed.), *Cornettes et blouses blanches* (Paris: Hachette, 1984).

9. It was during the Second Republic, in 1849, that the State created the Assistance Publique. It took control of several major Parisian Hospitals and created the Berk Children's Hospital in 1865–69. Whilst the law of 1895 ensured medical care to the poor and the elderly, a number of institutions were created in the 1890s to ensure the regular health control and proper feeding of young children. See Simon-Dhouailly, N., catalogue of the *Musée de l'Assistance Publique de Paris*, 1998. See also Bec, C., 'De la charité à l'assistance: le parcours républicain', and introduction in A. Nardin (ed.), *Depuis 100 ans, La société, l'hôpital [et les pauvres]* (Musée de l'Assistance Publique-Hôpitaux de Paris: Doin editeurs, 1996), pp. 39–52.

10. Constantin Meunier (1831–1905): *Le Grisou*, 1888–89, Musées Royaux de Belgique, Brussels. Jules Adler (1865–1952): *La Grève (Le Creusot)*, 1889, Musée des Beaux Arts de Pau. The same thematic preoccupied sculptors, painters and writers, such as Émile Zola in *Germinal* (1885) or Camille Lemonnier in *Happe Chair* (1886).

11. The 1880s and 1890s witnessed women's campaign to have access to higher education and the professions. In the 1880s there were three areas of higher education opened to women: teacher-training, the faculty of letters and the faculty of medicine. According to statistics published in Auclert's paper, *La Citoyenne*, there were 103 women amongst the 4000 medical students in 1886. In 1884–85, male students boycotted the Faculty of Medicine to safeguard their prerogative of hospital work.

12. The clause on equal pay for equal work was included in the programme Auclert drafted for *Le Droit des femmes* in 1877, and again in the electoral programme she drafted in 1885. Like many

ideas formulated by nineteenth-century feminists it became law much later, in 1972! Auclert's early militancy and her relation to the socialist movement is well documented in the Archives de la Préfecture de Police (file Ba/ 885) as she was under constant surveillance. It is Auclert who put the women's question (nominally) on the agenda of the Congrès Ouvrier Socialiste in 1879, see Rebérioux, M., Dufrancatel, C., and Salma, B., 'Hubertine Auclert et la question des Femmes à l'immortel congrès', *Romantisme* (1976), pp. 124–42 and Auclert, H., *Le Droit politique des femmes* (Paris: 1878). For a selection Auclert's editorials see Taïb, E., *La Citoyenne* (Paris: Syros, 1982). For a biography of Auclert see, Hause, S., *Hubertine Auclert. The French Suffragette* (New Haven, CT: Yale University Press, 1987).

13. In 1896–1902 Auclert contributed a series of articles to *Le Radical* in which she formulated the basic concepts of matriarchy, departing from the positions she had taken in the 1880s in *La Citoyenne*. An important selection of her later articles was published posthumously in *Les Femmes au Gouvernail* (Paris: Giard, 1923). The 1910 Women's Electoral Programme drafted by Auclert contained the clause: 'All mothers, married or unmarried, will be allocated a benefit called maternal benefit.'

14. Correspondence Auclert to Poupelet, September 1896, archives Jane Poupelet.

15. *Enterrement d'un enfant en Dordogne.* Group in plaster of eight figures. Musée de Périgueux. L 100 cm × l 50 cm × h 30 cm. V. Wapler, *Catalogue Raisonné*, pp. 98–104.

16. R. Miles, 'Société Nationale', *Éclair*, 16 April 1904.

17. See Elizabeth Cowling's introductory essay to the catalogue of the exhibition *On Classical Ground*, Tate Gallery, London, 1990, pp.11–30.

18. *Femme à sa Toilette*, H. 42.5 cm × L. 61 × 23 Musée des Beaux-Arts et de la Dentelle de Calais, on loan from the Musée National d'Art Moderne; other bronze casts in The Metropolitan Museum of Art, New York and the Art Institute of Chicago. Catalogue Wapler, *Catalogue Raisonné*, no. 36; Inventory Claudine Mitchell: JP01(a–d)–JP04.

19. This aspect of my study on Poupelet is developed in my forthcoming 'Style/Ecriture: On the Classical Ethos, Women's Sculptural Practice and Pre-First World War Feminism', first delivered as a paper at the Conference of the Associated of Art Historians, Edinburgh, April 2000. It further develops the argument introduced in my 'Intellectuality/Sexuality: Camille Claudel, the Fin de Siècle Sculptress', *Art History*, **12**, December (1989), pp. 419–46.

20. Auclert, H., 'Faut-il se battre pour voter', *La Citoyenne*, 20 March 1881.

21. Baillaud, H., *Mémoires d'une infirmière du Val-de-Grâce*, 11 pp., Archives du Val-de-Grâce, Carton 169, p. 4. The collections of the Musée du Service de Santé des Armées au Val-de-Grâce which opened in spring 1998, together with its rich archives concerning the development of the medical sciences during the First World War grew from a state decision of May 1916. See Médecin Colonel Ferrandis, *Le Service de santé de la guerre de 1914–1918*, Conservation du musée du Service de santé des armées.

22. Baillaud, *Mémoires*, p. 7.

23. Morestin, H., 'Les Blessures de la face', in *Science et dévouement, le Service de Santé, la Croix-Rouge* (Paris: Quillet, 1918), pp. 137–60. State sponsored publication of collected essays giving an overview of the development and functioning of all branches of medical sciences during the war.

24. Taylor, A. J. P, *The First World War* (Harmondsworth: Penguin, 1967), p. 37.

25. *Bulletin de l'Union des blessés de la face, 'Les Gueules cassées'*, July 1921, p. 1. Sophie Delaporte (see note 26) gives the figure of 15 000.

26. See Delaporte, S., *Les Gueules Cassées. Les Blessés de la face de la Grande Guerre* (Paris: Noêsis, 1996), Delaporte's compelling book documents how the military medical institution functioned, from the site of trauma on the battlefield where emergency measures were administered, to the specialized hospitals where the facially wounded underwent long-term treatment. She critically examines the development of facial surgery, taking as case studies the centres of Amiens and Vichy (chapters 2 and 3). Delaporte raises the ethical issue of the experimental nature of reconstuctive facial surgery and the suffering it inflicted on the patients for limited results (chapter 4). Her final chapters raise the issue of identity and document the creation of the association of the facially mutilated. The facial masks are only mentioned negatively (pp. 118–20).

27. Ladd's practice was first documented by S. Romm and J. Zacher in 'Anna Coleman Ladd: Maker of Masks for the Facially Mutilated', *Plastic and Reconstuctive Surgery*, **70** (1), (1982), pp. 104–11. Ladd is also recorded in Gavin, L., *American Women in World War I* (Niwot, CO: University Press

of Colorado, 1996), pp. 195–7, 206–7. Neither studies explain how the Paris Studio functioned within the French medical institution or the collective nature of the practice. Gavin's sincere and representative book documents the activisim of the Red Cross volunteers within the range of working practices of the nine areas of service, using a rich corpus of women's testimonies and photographs.

28. Derwent Wood, F., 'Masks for Facial Wounds', *The Lancet*, June (1917), pp. 949–51. Sarah Crellin, doctoral candidate at the University of Leeds, is currently researching the English visual artists who collaborated to facial surgery during the war, including the sculptor Kathleen Scott.

29. Records of the American Red Cross, World War I, Commission to France: File 942. 52, The National Archives, College Park, Maryland. Reports of Anna Ladd and Grace Harper, August and November 1918.

30. Dufourmentel and jaw surgeon Frison had directed the centre of Châlons, catering for the Verdun sector, until its bombardment in June 1918. They took over the centre of Rennes, Dufourmentel with the ambition to transform it into one of the leading *Centre de restauration faciale* (Val-de-Grâce, cartons 122 and 123). Dufourmentel's reports on the situation in Rennes provides a disturbing picture of the conditions of work. He points out, for instance, that practically all the dressings – and these were particularly complex in the case of facial injuries – were carried out by voluntary nurses, yet another evidence of the crucial responsibilities women took on. The monthly reports of the *centres maxillaux-faciaux* for 1918 concur in calling attention not simply to the increase in the numbers of patients – consequent on the culmination of military offensives, that of Nivelle in spring 1917, the massive German offensive of Spring 1918, and that of the Allies in the summer – but on the increase in the gravity of the cases they had to deal with. These reports also bring into evidence the disfunctioning of the military institution. In 1918, for instance, Professor Lemaître of Vichy still had to advocate the idea of having teams specializing in facial surgey sent to the Military Zones at times of emergency. They complained that non-specialized surgeons set jaw fractures wrongly and did not know how to preserve flesh tissues (carton 121). The alarming situation of 1918 contributes to explain why, at that historical moment, the sculptural prostheses gained the support of facial surgeons.

31. Anna Ladd established work with the *centre maxillaux-faciaux* of Rennes, Le Mans, Bordeaux and Vichy, and at the Hospital Chaptal in Paris. The American Hospital of Neuilly provided five beds for her work and the Studio received applications from the American Base Hospital No 1. Anna Ladd also visited the hospitals in the Military Zone of Eastern France where her husband, Boston paediatrician Maynard Ladd, established a chain of relief stations for women and children in the Nancy area.

32. Records of the American Red Cross, Ladd's August 1918 report, p. 2.

33. Ladd, A., 'How Wounded Soldiers Have Faced the World Again with "Portrait Masks", interview by P. King, *St. Louis Post Dispatch*, 26 March 1933, clipping in Ladd's archives.

34. Ward Muir, 'The Men with the New Faces', *The Nineteenth Century*, October (1917), p. 752, article in Ladd's archives.

35. Records of the American Red Cross, correspondence November 1918 to November 1920 and the monthly report for October 1919. In 1919, Poupelet and Wlérick worked on a part-time basis of five hours a day, to enable them to pursue their own career as sculptors, for a salary of 450 francs a month.

36. *Paris Médical*, no. 12, 22 March 1919, pp. 229–31. In 'L'Oto-rhino-larygologie en 1919', Dufourmentel dated the beginning of cosmetic surgery to 1917, when Passot published his operation on wrinkles. See *Paris Médical*, **36**, September (1919), pp. 184–92.

37. Delaporte, S., 'Le discours médical sur les blessures et les maladies pendant la *Première Guerre Mondiale*', doctoral thesis, Université de Picardie Jules Verne, December 1998, three volumes. See 'Les souffrances de l'âme', vol. 2, pp. 434–67, and her detailed bibliography, vol. 3, pp. 201–6. Delaporte compares the situation in England, Italy and France. She shows that some development took place in the range of therapeutic methods deployed. She points out that First World War psychiatric medicine in France has not as yet been the subject of comprehensive contemporary study.

38. Dr A. Dumas and Dr A. Delmas, 'Les troubles mentaux de guerre', in *Science et dévouement, le Service de Santé la Croix-Rouge* (Paris: Quillet, 1918), pp. 201–6.

39. Dufourmentel, L., *Les complexes esthétiques et la chirurgie* (Paris: Béranger, 1957), Dufourmentel recalls the arguments he had published in the press in 1929, subsequent to a court case that had aimed to restrict the practice of plastic surgery (pp. 28–32). See chapters 'Valeur thérapeutique des opérations esthétiques' (pp. 26–39) and 'Une théorie de la beauté' (pp. 11–19).

40. Rodin's discussion of portraiture with Paul Gsell exemplifies the belief in the *'psychological'* understanding of the artist who knows how to *'read behind the facial mask'* and how to convey the sitter's persona in representing physical appearance. See *L'Art*, (Paris: Grasset and Fasquelle, 1911), ch. 7, pp. 124–9.

41. Ladd, 'How Wounded Soldiers Have Faced the World Again'.

42. Baillaud, *Mémoires*, p. 8.

43. Ibid., pp. 8–10.

44. Ward Muir, 'The Men with the New Faces' p. 747.

45. 'Le Chasseur Bélagnon', *La Greffe Générale*, G. Malécot, M. Stenay and M. Mime (eds), May 1918, no. 7, pp. 25–6.

46. Finaud, G.,'Les mutilés de la face', *Bulletin de l'Union des Blessés de la Face*, September (1923), p. 1. Finaud recalls the fate of a patient from Châlons who refused to let his mother see him even though she had jouneyed across France; Baillaud reports a similar case of a young soldier who determined not to go home again, because his mother 'had not recognized him' *Mémoires* (p. 10). Ladd records the same case in her August 1918 report (p. 2).

47. Solidarity and the conviction of constituting 'a family' permeate the *Bulletins de L'Union des Blessés de la face* through the 1920s and 1930s. See also M. Dugain, *La Chambre des Officiers* (Paris: Lattès, 1998). This novel, based on the testimony of Dugain's grandfather, gives an insight on what it had meant to attempt to reconstruct a sense of identity.

48. 'Woman Who Remade Soldiers' Injured Faces', interview by M. Caswall, *Boston Sunday Post*, 16 February 1919. Clipping in Ladd's archives.

49. Ladd, 'How Wounded Soldiers Have Faced the World Again'.

50. Dufourmentel, L., 'La part respective de la plastique chirurgicale et de la plastique artistique dans le traitement des grandes mutilations de la face', *Paris médical*, **12**, March (1919), pp. 229–31.

51. Ibid., p. 231.

52. *Bulletin de l'Union des Blessés de la Face*, **5**, September (1922), p. 5.

53. 'Des emplois S.V.P?', *Bulletin de l'Union des Blessés de la Face*, September (1923).

54. Correspondence Ladd to Poupelet, 8 January 1920, archives Jane Poupelet.

55. Brittain, V., *Testament of Youth* (London: Virago Press, 1993), reprint, p. 339.

56. Ibid., p. 496.

57. Ibid., p. 146.

58. Ibid., p. 195.

59. Madeleine Pelletier' s correspondence to Aria Ly, 21 December 1914, 7 February 1916, 2 August 1917, Fonds Bouglé, Bibliothèque Historique de la Ville de Paris. In the pre-war years Pelletier had endorsed the notion of women's National Service in her paper *La Suffragiste*, clashing head on with her left-wing male colleagues who insisted she should retract her position in *La Guerre Sociale*, which she refused to do. For Pelletier political philosophy see my 'Madeleine Pelletier (1874–1939): The Politics of Sexual Oppression', *Feminist Review*, **33**, Autumn (1989), pp. 72–3.

60. For the positions and dilemmas of the diverse Left, see Becker, J.-J., *La France en Guerre (1914–1918), La grande mutation* (Paris: Editions Complexes, 1988).

61. *The Work of Anna Coleman Ladd* (Boston: Seaver-Howland Press, 1920), Photographic reproductions with a commentary by Anna Ladd. The content of Ladd's studio in Beverly Farms, Massachusetts, which the late Robert Edward had maintained *in situ* until the early 1980s was sold at auction in 1983.

62. David Lomas has similarly used the concepts of trauma and memory to give a radically new interpretation of the post-war neoclassicism of Picasso in *Family by the Sea* of 1922 (Musée Picasso MP. 80); paper delivered at the conference 'Face Figure, Rrepresentation' held at the University of Edinburgh in May 1999. David Lomas is currently researching the subject of male hysteria during the First World War, as an extension of his work on André Breton.

63. Mary Wroth (1587?–1651/3), *Pamphilia to Amphilantus*, NA f.1686, in S. Gilbert and S. Gubar *Literature by Women* (New York: Norton, 1996).

64. Brittain, *Testamant of Youth*, p. 458.

65. Alexander, Sally, 'Women's Work and Men's Fears: Unemploymment and Subjectivity', Work and the Image Conference, 19 April 1998.

66. Hause, S. and Kenny, A., *Women's Suffrage and Social Politics in the French Third Republic* (Princeton, NJ: Princeton University Press, 1984), pp. 235–51.

67. Correspondence Pelletier to Aria Ly, 6 June 1921.

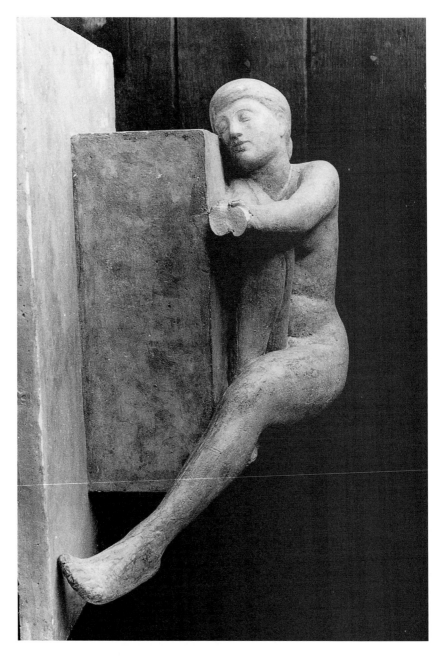

2.1 Jane Poupelet, *Femme endormie*, 1923

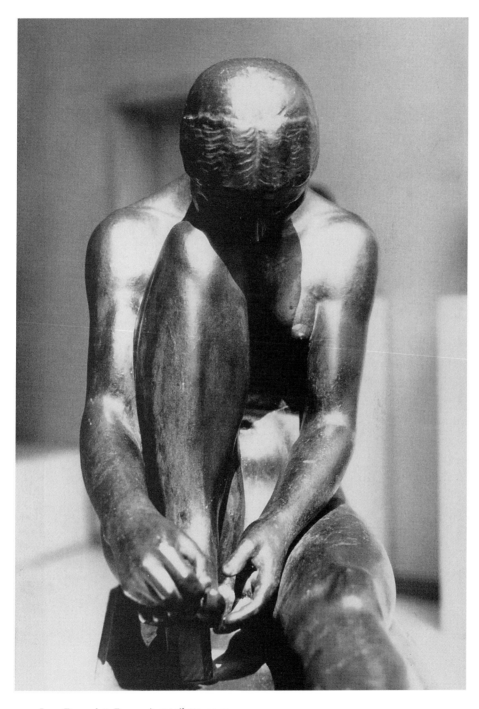

2.2 Jane Poupelet, *Femme à sa toilette*, 1910

2.3 *Jane Poupelet and soldier at the Studio for Portrait Masks*, 1919

2.4 *Patient of the Studio for Portrait Masks, 1918–1919*

Colour, light and labour: Futurism and the dissolution of work

John C. Welchman

When a newly independent art paints its world in brilliant colors, then a moment of life has grown old.[1]

the State apparatus, in the eighteenth and nineteenth centuries, found a new way of appropriating the war machine: by subjecting it before all else to the Work-model of the construction site and factory … [2]

Debord's suggestive idea about the colourful ageing of life by art is perhaps nowhere better attested than in the beguiling, prismatic sublimation of work – as both motif and pressing social issue – in the avant-garde paintings of Umberto Boccioni and his Italian Futurist colleagues during the decade and a half leading up to the First World War. Taking my lead from Futurism's protracted struggle with colour, dynamism and social action, I am concerned here with some of the intersections and mutual crises staged between emergent modernist theory and traditions of the visualization of labour in the early years of the twentieth century. This period witnessed the overlay and dispersion of a number of key issues in the representation of working places and bodies, as they were taken up by painters associated with the largely Paris-based avant-garde. Rehearsed here in loose chronological order, elements inherited by this discourse include the heroically mundane rural-worker patterned after Millet and his followers; pastoral forms of neoclassicism, such as Puvis de Chavanne's atopical *The Poor Fisherman* (1881); and frank images of urban labour (Degas' laundresses, and marginal participants in fringe – and mainstream – 'entertainment' industries – Toulouse-Lautrec's bordello workers, Degas' ballerinas, Picasso's acrobats and harlequins). The various forms and contexts that framed these working bodies are legible, of course, only as they are read against the emergent lineage of the modernist image: peopleless landscapes, scenes of bourgeois leisure and amusement, and representations, such as Seurat's *La Grande Jatte* (1884–85), that assembled both working- and middle-class subjects on a

Sunday, the traditional, if still contested, day of rest. Though contemporary and immediate, such scenes of modernist leisure, and their accompanying landscapes, were associated by the Futurists with the triple evils of stasis (static representation, and life without movement), pacifism and vapid bourgeois recreation. They campaigned especially against the indulgence in museums, and the romanticized countryside, but also criticized recent avant-garde genres of art themselves, up to and including Cubism.

My focus on the development of Umberto Boccioni's paintings during the last six or so years of his life (he died in 1916), and on related work during the same years by other leading Futurist painters, attends, of course, to a foundational moment in modern art. For in these years both the Cubist and Futurist movements are developed, and profound changes take place in German Expressionism and the Soviet avant-garde, including the articulation of a theory-practice of non-iconic abstraction. The iconography of Boccioni, and to an extent of Futurism as a whole, is unique, however, in that it opens continually on to a wider range of social and situational concerns than, say, the still-lives and portraits of Picasso and Braque, the residually post-Impressionist iconography of the Fauves, or the bohemian outdoors, urban street scenes and biblical-mythological subjects of the Expressionists. Following Boccioni, I trace the blurred shift in Futurist rhetoric – more apparent in its images than its manifestos – from earlier works which engaged the social representation of manual labour to later images which participate in the Futurists' grand vibrational *theatricum* of synaesthetic modernity. Such a move delivers human labour to a kind of extra-material transcendence, substituting for the routine-bound rituals of its unitary actions, the consecration of an impossibly pure vision of abstract violence (against the ineffable negativity of the past) within which the social can be redeemed only as an endless series of aestheticized effects, unstoppably rendered by the seduction of modernity's machinic performance.

The seeds of this profound desocialization are apparent in both the social ideas and iconographic choices of the future Futurists during the early years of twentieth century, when the mutual crisis staged between their political and stylistic commitments is first apparent. They are clearly sown in Marinetti's early poetry and writings and recur with particular vigour – and confusion – in the *Founding Manifesto of Futurism* (1909), the *First* (1909) and *Second* (11 October 1911) *Political Manifestoes of Futurism*, and the *Futurist Political Programme* of 1913, which culminated in the founding of a Futurist Political Party in 1918. Marinetti's reaction to the labour disturbances in Milan in 1898, as he withdraws from the streets to observe the scene 'from the height on my balcony', is emblematic of a spectacularist politics – driven by his fascination for disturbance and direct action, but deliberately and progressively withdrawn from it – that would inform virtually all Futurist representations of labour.

Marinetti's conflicted politics are nowhere more ambiguously veined with his adoration of spectacle, violence – and disembodied abstraction – than in the powerfully compressed metaphors of the *Founding Manifesto*. For in addition to its essentially referenceless confection of abstract ideas – those self-fulfilling quanta of energy, aggression and speed which enable its author to claim that 'already we live in the absolute' – Marinetti images work and production as a poeticized mass. Workers are pluralized into urban 'crowds,' whose agitational signs are present only as forms of 'excitement' and 'enthusiasm.' The industrial base is metaphorized in striking inversions, which untether factories from their grounds ('suspended from the clouds by their strings of smoke'). Heavy industry collapses its leading signals of production ('greedy stations swallowing smoking snakes') so that its units ingest rather than exhale the waste of manufacture. Its urban topographies are reallocated into a bizarre, post-Whistlerian industrial nocturne ('the nocturnal vibrations of arsenals and workshops beneath their violent electric moons'), in which even the electricity that supplies them is rewired as a post-picturesque lunar effect.[3] According to this logic, the sprawling spaces of manufacturing industry are image-generators, which fire-up their own spectacle, and the burdens of labour are commuted into the synaesthetic armatures of the crowd. What results is an absolute aesthetic rediagramming of production, which freezes and disarms its social referents.

The paradoxes invested by Marinetti in his politicized poetics open onto wider questions that need to be discussed as we approach the Futurist representation of labour. These include the history and shifting contexts of the Futurists' political affiliations; and the specific conjunctions between visual art and social commitment in Milan, Rome and Paris. Revisionist studies, including Günter Berghaus's *Futurism and Politics*, have de-emphasized the 'crypto-Fascism' often deduced from the supposed association of Marinetti and Benito Mussolini after 1915, stressing instead the 'left-wing dimensions of the First Futurist movement and … the anti-Fascist sector within the Second Futurist generation'.[4] The early paintings of Carlo Carrà, Boccioni, Giacomo Balla, Luigi Russolo and, less markedly, of Gino Severinni, were made in the context of a national entity that had been unified only for a generation, and which had endured poverty, debt and stagnation during the global economic downturn of the 1880s. These artists were part of a restless second generation of urban and suburban Italians, influenced to varying degrees by irredentism, aggressive nationalism (Marinetti and Boccioni attended the founding congress of the Italian Nationalist Association held in Rome in December 1910) and anti-parliamentary sentiment. They were supplied with colonialist fantasies, vaguely committed to a generalized activism (the 'interventismo rivoluzione'), and caught up in the political foment of Lombard *scapigliatura* and analogous agitations. As Marinetti put

it in his lecture 'Beauty and the Necessity of Violence', some form of 'hygienic bloodshed'[5] was deemed necessary to achieve the passage to 'a possible and desirable anarchy.' Most of the founding Futurist painters were touched by the radical tradition of anarchist and syndicalist actions (what Marinetti approvingly termed 'the destructive arm of the Anarchist')[6] – strikes, protests and ideas of contra-statist worker autonomy – derived from writers such as Proudhon and Georges Sorel, admixed with Nietzschean radical individualism, Unanimism and strains of Tolstoyian Socialism, and associated, both in social and pictorial terms, with the incendiary and the explosive.

Of the major Futurist painters, Gino Severini was clearly least interested in social and political questions, and made the fewest works representing labour or social unrest. An oil dated to 1903–04, *Al Solco*, shows a Tuscan peasant at the plough, pulled by two white bulls, offering a rare reference to Severini's 'cultura machiaiola'.[7] In 1908, around the time Boccioni was working up his masterpieces of the *periferia*, Severini made a smallish pastel called *La Grue* or *Il Cantiere* (*The Crane*). Probably inspired by a chance early morning encounter with roadworks on the Boulevard Raspail in Paris about which he wrote later, Severini's imagination was caught by 'un bellisimo e caotico cantiere',[8] offering him an image that was striking and angular, but formally isolated from the strenuous effort of the road labourers, who had not yet arrived on the site. *Les Pierres*, another pastel made in the same year and in a similar style, continues Severini's fleeting interest in the static form of the apparatuses of labour, imaging two carts loaded with broken stones for road or pavement construction. Once more neither workers nor horses are represented, the activities of labour seeming extraneous to the simple presencing of the carts.

As in his art, Severini is also rather evasive and oblique on the subject of labour and social relations in his autobiographical reflections. Recalling his earliest days in Rome, he writes of the growing 'moral awareness' in the city, and of how the social activist Mosone Pietrosalvo made him and Boccioni 'read books and pamphlets by Karl Marx, Bakunin, Engels, Labriola'. In the paragraphs that follow and conclude the autobiography's solitary extended reference to art and society in the pre-1914 years, Severini somewhat confusingly asserts that while 'social and communist politics were becoming seriously influential' at a time of 'strikes, quelled by violent acts of repression', 'as for the relationship between the artist and society, I must confess that was of little interest to any of us' – a sentiment he underlines a few sentences later: 'In spite of all this, the notion of a "social art" never entered our minds.'[9] This retrospective disavowal may have fitted in with Severini's own political neutrality, but it does not accord with the known interests and activities of the other Futurists – a discrepancy that can be explained only (and in part) if Severini is referring here to the very first years of the twentieth

century, before Boccioni (if not the older Carrà) had shown any definite inclination towards socialist, anarchist or nationalist politics.

By the time that Severini returned to the representation of the street in, for example, his famous *Le Boulevard* (1911), the coordinates of Futurism's most consistent aestheticist vision were firmly in place. The jigsaw tessellation of trees, strollers and urban landscape of *Le Boulevard* is described in the catalogue of the Sackville exhibition in London (1912) as the product of 'light and shadow' which 'cut up the bustle of the boulevard into geometric shapes'. Subsequent work, dominated by dancers, cafés and Parisian figures, but also including a cluster of images of urban transport – buses, trams and trains – , is organized in a series of 'plastic rhythms' and 'syntheses', culminating in the artist's quest for the 'Plastic Absolute' signalled in quasi-algebraic equations and analogies, and focused on what critics have identified as his 'overpowering need for abstraction'.[10] The iconography of industrial life only reappears once more in Severini's avant-gardist years in a loose series of works that troublingly collides plastic synthesis with the idea of war. In *Synthèse Plastique de L'Idée 'Guère'* (1914–15), an anti-humanist slogan cohabits with a chimney and pylon – chief symbols, respectively, of Boccioni's suburbanism and Marinetti's electrical modernity – and is set, more chillingly, against notations for 'gas,' the leading agent of post-artillery warfare. With its quasi-invisible agency, capricious, weather-bound action and blanket destruction, gas signalled the end of the first era of modern conflict – just, perhaps, as its aesthetic correlates, light and velocity, precipitated the final breakup of the image and the pictorial cultivation of generalized feelings. In war, both shell and rifle, and horse and tank are bypassed at the threshold of a new – still unfolding – era, of aerial, electronic and chemical combat. In art, materiality, mechanical labour, the scenes of production, even corporeality itself, are surrendered to the uncertain psychological vectors of sensation and effect.

The passage of the other Futurist painters through the first decade and a half of the twentieth century opened up several stronger engagements with political activism, ideas of the social and the representation of labour and its margins. As the senior artist of Futurist painting, and mentor in Rome to the young Boccioni and Carrà, Giacomo Balla set the tone for many of these encounters. Contributing to *L'Avanti della Domenica*, the illustrated Sunday supplement of the left-leaning *L'Avanti*, published in Rome between 1903 and 1907, he negotiated a socially conscious, if politically unassertive, art that answered in his own terms to the Roman 'humanitarian socialism' of Alberto Dazzi, Giovanni Prini, Duilio Cambellotti and others, who made works such as the bronze *Builders* (Dazzi) and *Polyptych of Work* (Cambellotti). Following his remarkable *Fallimento* (*Bankruptcy*, 1902–03), with its cropped, close-up view of an abandoned store on the Via Veneto scrawled over with

chalk graffiti, Balla painted a series of works, which, with increasing directness, addressed the concerns of contemporary working life. Possibly begun in the same year as *Fallimento*, but exhibited as a four-part work within a single frame only in 1909 at the Amatori e Culturi exhibition in Milan, *The Living* shifts the stylistically verist, peopleless abstraction of *Bankruptcy* into the language of Symbolist personification. Its panels, subsequently separated, represent four experiences of social marginality – *The Madwoman, The Sick, The Peasant, The Beggar* – translated, in part, at least, from Balla's immediate environment (the first depicted Matilde Garbini, a neighbourhood woman, the third a rural labourer who worked in fields adjacent to the artist's studio).[11] They are, in a sense, peripheral figures who answer to the marginal landscapes foregrounded (and in the background) of a notable sequence of paintings by Balla and Boccioni made between 1904 and 1910. The four protagonists are aligned along a gradient that descends from the minimal conditions of poverty associated with the Italian rural labourer, the only figure whose life is conditioned by a normative, if grinding and seasonal, cycle of work. If the peasant labours on a border line subsistence economy, the beggar, of course, sidesteps the structures of salaried production, living entirely from the gift, while the infirm and the insane (the former perhaps temporarily, the latter probably for the long term) are stranded outside the domains of labouring, profit and loss, and remaindered, according to their circumstances, in various conditions of social dependency.

Two paintings by Balla approach closer still to the bodies and circumstances of labour. The first, another figureless allegory, called *Il Lavoro* (*Work*, 1902), exhibited in 1904, centres on a burning street lamp, suggesting the nocturnal duration of anonymous work, set amidst dark, unparticularized buildings. As Susan Robinson suggests, the effect recalls the 'silent aura of an empty nighttime corner of the city'.[12] If *Bankruptcy* offers a rather estranged testimony to the aftermath of a small business defaulting on its obligations within the urban profit economy, then abandoned outside it, and *The Living* returns a miniature gallery of four figures, half types, half individuals, who are similarly relegated, *Work* relies on the mood-seeking language of Symbolist suggestion to imagine one facet of what will become the leading concern of the proto-Futurist's visualization of work inside the urban economy: its temporal extension and remorseless repetition. The result, however, is a painting that rejects virtually all the elements and devices associated with nineteenth-century – and earlier – traditions of representing labour. There are no factories, chimneys or machinery, no labourers either at work or journeying to work, or represented with their instruments or families, and no allegorical embodiment. Instead the lamp becomes a solitary icon of laborious nocturnal duration, and artificial light itself the sign of labour's ineffable continuity. Soon to become one of the privileged motifs of Futurist theory and practice,

the journey of this sign from its symbolic illumination of the labour question to a spectacular orb emitting glorious auras of decorative luminescence is one of the ghost stories of visual modernism – with labour cast first as its invisible protagonist and then as its phantom.

While all the Futurist painters made works that focused on street lights, sometimes correlating them, directly or obliquely, with labour, it was Balla who traced the most direct route from light-enhanced work and public places to extreme forms of luminous abstraction. So preoccupied with night-time effects that he was dubbed 'Giacomo the night-bird,' in 1902 he painted *Roman Night Scene with Street Lamp*, and approximately two years later made *Lamp on a Construction Site*, a pastel that offers a cropped view of the top three floors of a low-rise apartment or office block clad in scaffolding, with a metal-framed, glass-enclosed lamp dominating the centre of the composition. Once again Balla explicitly links the site of work with a source of light, though in this instance it remains unilluminated. In 1909, by contrast, he painted one of the great icons of artificial illumination, the Museum of Modern Art's *Lampada ad arco*, whose molten white and yellow core spews forth a pulsating mosaic of arrowheads and hatches in red, purple, green and orange, a face of riotously emanating light bounded by a cool coastline of blackish arcs beyond it's skull-like periphery. Following this mantra of non-figurative incandescence, Balla's retreat after 1910 from the social predicates of light and temporality could not have been more headlong and irreversible. His quest for abstract speed and the effects of pure light drove him ever closer to the ultimate origin of natural light itself, culminating in the pseudo-astral visions of *Mercury Passing in Front of the Sun Seen Through a Telescope* (1914) and *Celestial Orbits* (c. 1914).

The second painting, *La giornata dell'operaio* (*The Worker's Day*, 1904, Figure 3.1), may be considered as the founding image of a more explicit concern with the duration of labour, now associated not solely with artificial light, but with the whole cycle of the working day. Exhibited at the Amatori e Culturi exhibition in Milan in 1907 with the sequential title *They Work, They Eat, They Return*,[13] the triptych conjugates contemporary social debate about the number of hours that should constitute the labourer's day, the suburban site of this labour, and the shifting, elemental conditions of 'day' itself as it is first resolved from and then dissolved back into the darkness. Not unexpectedly, half the image is constituted by the right panel, representing a five-storey, scaffolding-clad building in the evening, fronted by a lit street lamp which barely illuminates a group of dark, hunched labourers commencing their homeward journey. The upper of the two left panels shows an angled, close-up, early morning view of the top two storeys of what might be the same edifice (though is probably a different, smaller building). Wrapped in an intricate bramble of scaffolding, it seems to represent that still moment just before work begins. The lower quarter

on the left pans down to the foot of the building, and then away from it, depicting a swathe of stony construction site ground, painted in small, Divisionist-style flecks, presided over by an incomplete brick wall and entranceway, a pile of new bricks and four disengaged workers sitting in the sun at their midday meal break. Cleverly signalling his solidarity with the labour represented, Balla literally immures the triptych with pictorial signs of the basic units of construction: the top and bottom of the triptych are edged with a course of *trompe l'oeil*, cemented brickwork, and the left and right bounding edges are banded to suggest an infinite column of piled bricks. The bricks thus become itemized tokens of the daily shift-working system: like the rhythm of successive workdays, they are repetitive, patterned and unmovable; like gilt and wood for a painting, they constitute the frames for the built environment; and like the dots and dashes of the Divisionist style, they are the elemental units that articulate built space. At this stage in Balla's career, work, duration, light and location seem part of the same representational thread, none of them separable from the others, and each dependent on the coordinates of their mutual articulation. Some commentators, however, already detect the beginnings of the anti-social drift that would relegate then explode the materiality of labour in the explicitly Futurist works achieved between 1910 and 1915, referring the signifying force of *The Worker's Day* to the primary agent of Futurist iconography: 'The subject is not the working man ... but the arc of the day – in other words light.'[14]

The contradictions inscribed in Balla's struggle are everywhere apparent in the work of the other Futurists, especially Boccioni. In his early career, Boccioni experimented with a variety of languorous, *fin-de-siècle* stylizations, including the impeccable and lucidly decorous pseudo-Divisionism of *The Grand Canal in Venice* (1907), a work devoted to that famously privileged aqueous fragment of the historical Italy against which the Futurists would later issue a furious invective.[15] His portraits and landscapes, part naturalistic, part impressionist, were understated compared to the painterly pyrotechnics of the Fauves. Among them is an odd double-sided pair of self-portraits (1905–08), one of the artist in a middle-class interior clutching a fistful of brushes, the other with Boccioni looming into the picture frame in front of an enclave of the middle-rise, scaffold-clad apartment buildings set in that atmospherically ill-defined suburban space which was the iconographic hallmark of pre-Futurism. The remaindered environment in this self-portrait houses tiny, dark, cattle picked out on a vivid green pasture which contrasts with the over-wide, car-ready, roadway dominating the foreground. In other works of 1908, such as *Countryside with Trees*, Boccioni seems to achieve something of a Pissarro-like resolution of the new suburban environment, but without the structural conflicts and tensions marked by the earlier artist's arcing pathways and strangely conjugated rooftops. In *The Sculptor* (1907),

the artist and his bust are enclosed by the rather cute formalism of a painted frame-within-a-frame, and set-off against another obtrusive glimpse of Milanese suburbia sharply focused in front of the silhouette of a classic Italianate skyline – cupolas and campanile – that almost dissolves into a feathery mist-like whiteness at the upper extremity of the image. The architectural coordinates of history and modernity face off here in a conflict that will be won only by the agency, light itself, that renders both visible.

The city, the suburb and the domestic interior portrait were Boccioni's main thematic coordinates before 1910. In all three subject areas we witness the beginnings of a defining conflict between form and 'emotional effect,' on the one hand, and narrative and social specificity on the other, which came to a head in *The City Rises* (Figure 3.2), and was continually renegotiated by Boccioni and his Futurist colleagues during the next five or six years. We can follow some of the psychological implications of this struggle in the artist's diary entries. Boccioni wrote in 1907 'that I seek, seek and seek and do not find … I feel that I wish to paint the new, the fruits of our industrial age, I am nauseated by old walls, and old palaces, and by old motifs, by reminiscences. I wish to have the life of today in front of my eyes'.[16] Boccioni's list of the pictorial subjects which bored and sickened him is revealing, for in addition to the 'fields … little houses, [and] woods', of the Impressionist landscape tradition, the 'quiet things', of still-life, and the 'faces flushed and strong' of modern portraiture, what he termed 'that whole storehouse of modern sentimentalism' also contained 'worker's limbs, weary horses etc.',[17] defining elements in the long and complexly threaded tradition of post-Romantic, Realist and Symbolist depictions of labour.

Boccioni's pervasive dissatisfaction surely embraced his own earlier works, beginning around 1904 – as well as those of his contemporaries – that comment directly on labour and its environments. *Mungitura* is a rare, but conventionally conceived, sketch of a rural worker milking a cow. It joins with Boccioni's representation of the Italian countryside and its activities in works such as *Lombard Landscape* (1908). Following a long tradition of rural representation, the gleaners are brought into line and scrupulously articulated along a diagonal as if to compensate for the relative disorder of the 'long, frayed brushstrokes' which constitute their milieu. *Lavatore*, which relates stylistically to other temperas from 1904, though thematically to *The City Rises*, renders a worker, possibly brandishing a whip, posed in front of a single storey factory, behind whom a large horse's head looms into the composition. This image is the first of Boccioni's contributions to that powerful cluster of works directly engaging the topic of labour, which includes Balla's *Il Lavoro* (*Work*, 1902) and *The Worker's Day* (1904), aspects of which are discussed above, and Carlo Carrà's *Allegoria del lavoro* (1905), commissioned by the Federazione delle Cooperative Pittori e Imbiancatori di Milano. Carrà's

allegory is one of the most insistent of these Symbolist-oriented confections. It images a dark, forge-like space presided over by a naked figure with a luminous reddish torso who triumphantly braces his hammer on an anvil while two men and a half-naked woman look on. Work here is the symbolic residue of heroic, masculine effort, a synthesis of musculature and metal, effected by a grandly singular bodily presence, and set in a zone of darkly burnished pictorial indistinction. The mythology of Vulcan commingles with abstract intimations of sweat and effort to produce labour as a mystical transfiguration with the anvil and hammer as its altar and symbolic instruments. It is this kind of epiphanic vision with its 'flushed', 'strong' expressionism and immaculately robust 'limbs' and torsos, that seems most troubling to Boccioni. For while it does not lapse into the quietism and reverie of sub-Impressionist landscape, or what he saw as the passivity of conventional portraiture, the allegorical vision it subtends precisely relegated the kind of direct energy and vigorous contemporaneity for which he was searching.

Boccioni's solution to the representational impasse in which he found himself around 1907–08 took several forms – which first converge on the issue of work, then seemingly abandon it. A rather literal, stylistically neo-Realist, strategy, readily apparent only in one print, *Il disastro minerario di Rabdob in Westfalia* (1908), was to offer a reportorial account of a specific incident in the working community, in this case a mining accident in Westphalia, which was front-page news in the European papers at the time. He made a more consolidated effort to rekindle his pictorial passions and unite them with his social convictions in a second strategy, which seems to have originated in the figural cancellation of the genre that he found most inert – portraiture. Commenting on the *Self-Portrait* of 1908, apparently painted from a room in his mother's suburban house, Boccioni complained that the final product left him 'completely indifferent', exhausted, and drained of all 'ideas'. He reacted to this emptiness by erasing the portrait subject and concentrating on the 'periferia milanese' – elements of which he drew in his sketchbooks from 1905 – that stretched out around and behind him, an environment that was as much a part of his own subjective landscape as it was a key correlate of modern urban extension. Boccioni's imaging of Milanese suburbia gave rise to as many as dozen works, including *Sera d'aprile* (1908), which pictures a walled garden with trees, industrial buildings and chimney stacks in the background; the bleak, hazy, wasteland of *Compagnia di periferia* (1908); and a drypoint and several oil paintings all titled *Periferia*, made between 1908 and 1909, which image scrubby, half-industrial, quasi-rural locations, set with tracks, furrows and belching smokestacks and traversed by darkly figured workers or commuters entirely drained of the drama, scale and muscularity of their appearance in Carrà's *Allegory of Work*.

This response reaches a climax with an important group of three works representing the burgeoning industrial outskirts of Milan, *Morning, Twilight, Factories at Porta Romana*, which Boccioni painted in 1909. Possibly conceived as a response to Balla's serial imaging of the working day,[18] they picture spewing smokestacks set in a crepuscular gloom which underlines the travails of labour, yet at the same time physically effaces the places and conditions of work: we are reminded once again that day and night are as much the determining brackets for the events of labour as they are the preconditioned fringes of the emergence of light. The peripheral zone of the suburb clearly occupies a special place in both the formation of industrial Europe and in the development of Futurist iconography. For Boccioni, at least, paintings of the Milanese suburbs were his leading subject in precisely the years when the Futurist movement was launched by Marinetti in Paris, and around Western Europe (1909–10). Suburbs, of course, are ambiguous and conflicted spaces. In Italy, where national consolidation, industrialization and suburbanization arrived later than in France, Britain and Germany, what Fernand Braudel called 'that "demolition-and-building-site" look'[19] obsessively rendered by Boccioni arrived wholesale only in the last years of the nineteenth and the first decade of the twentieth centuries. The *periferia* was a zone of financial speculation, labour opportunity (and exploitation) and social indeterminacy and Boccioni represents all aspects of its profile. On the one hand the five- or six-floor apartment and office buildings going up along the edges of new wide boulevards were destined to become middle-class enclaves as burgeoning cities sprawled beyond their ancient walls and into the surrounding countryside. Different parts of the periphery, on the other, became polluted wastelands, scarred by heavy industrial plants and poorly served by public transport. While other sectors, removed yet further from the main arteries of suburbanization, were given over to allotments, storage facilities and occasional light industry.

Mediating between rural and urban space, historical density and the extra-urban heartland, the periphery is the place where modernity inscribes its forms and structures most efficiently and consistently. The construction of suburban Milan in the first decade of the twentieth century took place a generation before the era of modernist big-city high-rises, towering headquarters and colossal project housing – what Adorno and Horkheimer term 'the huge gleaming towers' unleashed by the 'entrepreneurial system'. They were also, of course, conceived on an altogether different model than the extra-suburban drift of the 1930s and 1950s and 1960s, which, especially in northern Europe and the USA, produced a rash of 'flimsy' 'bungalows'[20] made with almost discardable materials. Instead, the solid, mid-rise brick constructions pictured by Boccioni relate to the lingering dream of a medium-density, nineteenth-century boulevard culture, realized mostly

completely in Paris, and celebrated, inside and out, by Marcel Proust and Walter Benjamin.

The final response offered by Boccioni to the general lassitude and loss of energy he felt in relation to his self-portrait suggests a regrouping of two of the very elements that he had earlier associated with 'modern sentimentalism': the working body and the horse. No longer weak or 'weary', on the one hand, or gratuitously ennobled on the other, the artist's key image of labour, *La Città Sale* (*The City Rises*, 1910) (Figure 3.2) gathered up the representational coordinates of the suburb, the working man, the horse and construction, delivering them with a monumental energy that rose up in the artist, just as the city itself was also rising and extending. In January 1908 Boccioni wrote of the nagging 'doubt and discontent [that] are always with me' and of how 'I should like to rise, rise, rise!'[21] There seems little doubt that this painting sutured the psychological and material aspects of urban construction and artistic creation.

The cycle of changes, modifications and developments to *The City Rises* marks a crucial moment in the elaboration not only of Futurism, but also of the shifting social concerns of visual modernism at large.[22] Planned and executed with vigour and deliberation, *The City Rises* was clearly invested with special significance. According to Boccioni's own account, he worked on the concept, preparatory studies and the final, large-scale, painting for as long as a year.[23] The original Italian title of what became known, presumably with artist's sanction, as *The City Rises*, was 'Il Lavoro' (Labour or Work), the change of name ensuing as the work circulated in several European cities before being purchased in Berlin by the pianist and collector, Ferruccio Busoni, who would remain a patron until the end of the artist's life. We will see that the renomination is a leading indicator of the wider shift in Boccioni's equivocal negotiation between human labour, the visualization of construction and manufacturing industries, and the aestheticized spectacle of modernity.

The labour spelled-out in the image's first name is inscribed in *The City Rises* across several registers. Most immediate, perhaps, is the laborious effort that Boccioni himself put into the design and surface of the painting, which he describes as 'feverish' and immersive – a complete reversal from the doubt, discontent and nausea of 1907–08: 'The way I am working now resembles the way I worked on only two or three works in my life. Now I understand the fever, passion, love, violence meant when one says to oneself: Create!'[24] Conjugating emotive expressivity with physical effort and crossing both with intimations of violence, the First Work on the image is Creation. Drawing on, and addressing, only himself, the artist works *ex machina*, assuming the role of a demiurge combining the transcendent origination of matter with a physical symptomatics. His work, then, was also spiritual, for the religiosity of Boccioni's pictorial passion, his worship before what he sought for above all else in 1908 – the 'creation' of a 'tangible symbol' before which he could 'burn incense,

kneel down and worship'[25] – is undisguised. This spiritual investment, and the chief object of the 'tangible' symbolism it celebrates – the rearing, whirling horse that centres the composition – remind us that Boccioni had by no means abandoned the modern sentimentality about which he complained in his diary or, for that matter, the residually nineteenth-century elements of boulevard culture and horse-drawn transport. Furthermore, labour itself, whether the artist's or the worker's, is rendered in this image as still transcendent and extra-material. Its destiny in Boccioni's art was only to journey further into these domains. The colouristically pulverized body of the horse itself stands at the centre of the painting's signifying ambiguity. For while it may be viewed as a 'tangible' symbol of work or city life, 'a glorification of animal force',[26] or a mere armature for the artist's newly assertive dynamic pictorialism, at the very moment *The City Rises* was made the flesh and blood of unitary horsepower was being transferred to mechanical, motorized surrogates; and roadways, construction and suburban space were commencing perhaps the most dramatic change in their history.

When Boccioni wrote of his painting's purpose, he carefully described it as 'a great synthesis of labour, light and movement'. A range of some dozen studies, coupled with elements in Boccioni's correspondence, reveal that 'labour', the first term in the artist's synthesis of values, as well as the original title of the work, was progressively eclipsed by a demand for emotive dynamism driven by 'light and movement'. Representation of the scene of labour was subordinated, then, to Boccioni's increasing insistence on 'purely pictorial sensations' and his conscious determination to invest his 'masterwork' with the abstract 'violence' and 'aggression' specifically prescribed by the Futurist kingpin, Marinetti, as appropriate to such an ambitious undertaking. It is clear, too, that lengthy deliberation on the painting gave rise to a sequence of ideas about urban and other environments that were competitive with the implications of the finished work. An important study in the Galleria de Arte Moderna in Turin offers to complement – even undermine – the project's emphasis on building and construction. Divided into three sections, the wings of *Giganti e Pigmei (La città que non monta)* feature large trees on one side and an astronomical dome housing a massive telescope attended by its miniscule operator on the other. Framed by natural symbols and intimations of astral voyeurism (which join the study with other Futurist cosmologies), the wider central image features an array of work horses and harnesses set against a more familiar view of half a dozen buildings under construction. Clearly the wings of the study with their suggestions of para-human scale and reach would be pared away leaving only the emerging cityscape and the sentient instruments of its creation. The visionary aspect with its clash of scales and mythological contra-modernity would be remaindered only in the correlation between work and colour.

By the time Boccioni had completed *The City Rises*, probably before March 1911, the critic Attilo Teglio reported his response to it in terms which foregrounded its 'horses launched at mad speed', but which left 'labour' (which the critic still chose to specify) in last place in a list of its other attributes – 'effort, and movement, and life and labour'. The key opposition suggested in Teglio's interview between the 'whirlwind of colours' and the possibilities and dangers of 'symbolic' and 'realistic details' was also developed in Boccioni's exchanges with another critic, his friend Nino Barbantini, who had faulted the painting precisely for its residual allegorizing, its lack of 'clarity and organic cohesion' and its inadequate 'preparatory studies'.[27] *The City Rises* stages a kind of apocalyptic trauma of labour, in which work is first displaced then dissolved by an equine flurry of brushstrokes, literally effaced by a rearguard action of horses. At the same time the scenes of labour are framed by the instruments and devices of work – scaffolding and palings – which, like Balla's bricking off of *The Worker's Day*, fence in the formal and colouristic turmoil, offering a silent commentary on its expressionist excess.

These devices allow us to measure the distance between *The City Rises* and other later – perhaps greater – images of the early twentieth-century European metropolis. In George Grosz's *Metropolis* (1916), for example, the dark canyons of the city's streets are peopled by a demonic portrait gallery of competitive types – an endless round of military, social and sexual protagonists – who throng together in a frenzied mosaic of caricatural particulars. Boccioni, of course, always foreclosed the eruption of such savage specificity in social space in favour of generalized sensations and colouristic effects. But the comparison between these two paintings is more telling, for Grosz also poses his traumatic crowd in the context of the transport systems which built, then mobilized, the fully formed but dysfunctionally populated urban space in which they circulate. In the upper left and right registers of *Metropolis* we encounter, respectively, a horse driven by a grotesque top-hatted skeleton, and a dragon-coloured city tram slicing along the diagonal of the street. Electricity, machines and locomotion are the spectres of modernity that haunt, dominate and somehow control both pedestrians and their domesticated animular antecedents. We are not set here in a zone of construction, but a live-wire theatre set of surging, diabolical use, and an anarchic parade ground for the display of social defects.

Yet Boccioni's painting, its studies and the debate around it, constitute an important site of struggle between the inheritance of the avant-garde (Realism, Symbolism, Pointillism) and the Futurist desire to *go further* – into pure 'intuition' and as far as the brink of 'madness', to search out a newly efficacious but decisively abstract representation of feeling. What Boccioni and his critics played out here was, among other things, a struggle between

sociality and what we can call 'effectualism' – the residues of the effects of the social on the individual psyche which the artist could fracture into sensations of colour, light and movement. Boccioni points to the beginning stages of this tendency, a sort of movement towards movement, in his correspondence, writing that he hopes 'to put across in even the smallest figure that feeling of doggedly going ahead that crowds have when at work'.[28] The slightly unconvincing association of labour with the 'crowd' is an attempt to mask what is in fact a retreat from a direct concern with work and its specific, unitary and repetitive actions towards an enveloping interest in the visual energy of the mass, especially as it mirrors the introspective processes of the participant or onlooker. It is in the service of this shift that Boccioni and his critics emphasize the effects of 'noise', 'tumult' and the 'whirlwind of colours' which commence their signifying journey in the construction site, but are swiftly transposed ('even more' emphatically) to the interior workings 'of a man's thought'. Defending the painting against the criticism of Barbantini, Boccioni sidesteps the charge that he has over-allegorized the representation of labour, admitting that its only 'defect' 'is a slight insistence on realistic details in a work which is entirely a mental vision that grew out of reality'.[29] The experience of making *The City Rises* and the criticisms of it convinced Boccioni that he had finally to break from the haunting impinge-ment of recent representational traditions, to exorcise what he nicely termed 'my realism symbolism objectivism subjectivism and similar isms'.[30] The all too real 'tangible symbol[s]' of labour had to be sacrificed to a visual 'exaltation' of modern life whose intensities transformed but paralleled those historical forms of 'religious contemplation' and 'divine mystery' which he also sought. Yet the escape from history and tangibility into emotive transcendence was not an easy one.

Writing for *Gil Blas* in February 1912, the critic Georges-Michel wittily pressed home the metaphorical implications of Boccioni's tussle with history and religious intensity as he sketched out the vaporous lineage of the spectral avant-garde:

Oh Cubists, insignificant pompiers! Cézanne, old fogey! Van Gogh, or Van Dongen, shameful stick-in-the-muds! Monet, Renoir, Manet, phantoms of the past … Vanish! Even your fiery spirit, Oh De Groux, is melancholy compared with this horse [he is referring to the central motif of *The City Rises*], red as hell itself which is dragged along by human serpents togged out as ditchdiggers and which, in a puff of smoke, makes palaces rise tall.[31]

The mobilization of the ghost metaphor here commences with the simple transference of phantasmal attributes onto the Impressionist and post-Impressionist antecedents of Boccioni's Divisionist pyrotechnics. But though admonished to flee and 'vanish' it is, of course, the characteristic of haunting spirits that when they disappear through one set of frames or walls, they

will return again by another means. And this is clearly what they do – doubly – in the reading of the Parisian exhibition offered by the reviewer. First, far from dissipating the ghosts of the past, Boccioni's work actually out-haunts the underworld of pictorial spirits which precedes him, standing in effect as 'hell itself', the putative source of all that is dark or negative in the universe of ghosts and precedents. A second reversal takes us back to the spectral effects of capital famously metaphorized by Marx (and teased out by Derrida), for the critic happily evaporates the social effort of the labour represented in the image, suggesting in another ghostly metaphor, first that it is not the working men (mere 'human serpents togged out as ditchdiggers') who construct the scaffolding-clad buildings (suburban apartments and offices, of course, not 'palaces'), but the hellish horse which they serve; and second, that the 'rising' of the city is magical and instantaneous, it happens 'in a puff'. This literal sublimation of labour, rendering it sudden and immaterial, conjured up by some demonic sleight of hand, is typical both of the spectral instrumentality of capital suggested by Marx, and of the avant-garde appropriation of phantasmal exchange.

What we learn from this moment of reckoning with the historical avant-garde is that the spectral past is rarely exorcised, even within the successivist rhetoric of avant-garde discourse. The spectral is thus a kind of unhappy conscience for the art world, predicated on the eternal recurrence of ghostly dispatches from the past, and the shifty infiltration of phantasmal experience into the future present. The spectral, in fact, is a name for that process which moves almost magically around, through and outside the solid coordinates of space and time, mysteriously connecting the future with a past it often refuses to acknowledge. Georges-Michel's commentary permits us, then, to grasp another key scene in the visual contestation of labour's materiality and duration, as the ghostly effects of Boccioni's visual inheritances join with the black magic of infernal construction in a process that is as haunted and back to front as the spectral effects identified by Marx in the wider capitalist system that sustains it.

As the first major Futurist exhibition made the rounds of European capitals in 1912, another form of spectral reversion appeared in the commentaries, catalogues and reviews that accompanied it. Answering in territorial terms to the ghostly shift towards colour, form and abstraction on the image's surface, Futurist criticism invented an extra-European, almost para-national, location for what the Sackville Gallery catalogue text termed 'the overwhelming vortex of modernity'. Clearly at odds with the movement's ardent, if intermittent, political nationalism, the call arose to 'Americanize ourselves'; for only by looking to the ebulliently mechanized modernity of the new world could the menu of disruptive modern experiences and 'antiartistic aspects of our time' be properly apprehended. 'American'

experience supposedly offered more intensive variants of the repertoire of subjects, including 'crowds', 'telegraphs', 'sounds', 'violence' and 'bare, lower class neighbourhoods', attended to by Boccioni and his colleagues. But local instances, whether fetched from Rome, Milan, or even Paris, were now subordinated to a larger, transatlantic, modernist mythology. The greatest inversions could only take place in this giant spectral vortex; only under the sign of 'America' could art dissolve into 'antiart'; and work be happily eviscerated by what the catalogue defiantly termed 'cynicism' and 'implacable careerism'.[32]

In 1910 Boccioni's struggle was staged between the emerging demands of colour, form and movement and their conflictual relation to social life. It was already evident that formalism and colourism were going to determine the pictorial in the first – and last – instances, but the visual debate was at this time still being performed on and represented in the street – not merely from the inner recesses of the mind. Another important work of 1910 *Riot in the Galleria* (reproduced on the catalogue cover of the Metropolitan Museum's 1988 Boccioni retrospective exhibition) raises the stakes of the debate, deliberately exploiting its politically sensitive subject matter in order to solicit a bravura technical display of the luminescence of street lamps and café lights, and of complex floral hats careening here and there atop their animated bourgeois owners. Marinetti himself seemed to sanction precisely this kind of subordination of the social and political meaningfulness of 'riot' to the exuberant commutivities of colour, when in the only mention of colour and its effects in his *Foundation and Manifesto of Futurism* he proclaims that 'we will sing the multicoloured and polyphonic surf of revolutions in modern capitals'.

The April 1910 *Technical Manifesto* of Futurist painting (signed by Boccioni) transposed the song into a litany, declaring that 'innate [or congenital] complementarity is an absolute necessity' and offering up a hymn of perceptual abandonment to colouristic sensations with their 'untold charms, voluptuous and caressing'. Eventually, by 1912 (in the catalogue introduction to an exhibition at Bernheim-Jeune in February), colour effects were mobilized on behalf of an 'emotive ambience, seeking by intuition the sympathies and the links which exist between the exterior (concrete) scene and the interior (abstract) emotion. Those lines, those spots, those zones of colour, apparently illogical and meaningless, are the mysterious keys to our pictures'. For the Futurists, colour had now devolved into two extremes, of utter subjectivity ('the part most essential to the *I* of the painter', suggested Carrà), and visual aggression ('the note of a coloured plane will accentuate with violence the abstract significance of the plastic reality', as Boccioni put it in his 1912 *Technical Manifesto of Futurist Sculpture*). In the process its earlier connections to work and the environments of labour have been almost entirely severed.

In 1911, Boccioni painted a whole reprise of his visual interests, turning to the street in the expressionist urban convolutions of *Simultaneous Visions*; to the interior in the crudely faceted Bergsonian café-bar of *The Laugh*; back to the portrait in the ecstatically iridescent *Modern Idol*; and to the interior, mental, landscape in the darker-toned *States of Mind* series with their Rayonnist-like paint creases and dim, occluded narratives. But it was his decisive encounter with Cubism in 1912 that led Boccioni towards a more formulaic abstraction. His works from this time are often explicitly titled or subtitled after formal designs and their effects, or after their subject matter listed in alphabetic sequence: *Horizontal Volumes*, *Woman in Cafe*, *Compenetrations of Lights and Planes*, *Abstract Dimensions* or *Horse + Rider + Houses*. *Horizontal Volumes* is even supplied with mathematical notations and measurements along the edges of its recessional facets.

Some works from 1912 and 1913 are nothing more than Cubist exercises, but others are built up from juxtapositions of almost illegible coloured volumes, substituting contiguous dabs of little modified colour for the more scrupulous division of tones of the Pointillists. The ink and gouache studies for *Dynamism of the Human Body*, like many of those for *The City Rises*, reveal a curious tension between the uncoloured volumetric analyses of the body as facet planes, and the devastating impact of solid colour 'infill' in the finished work. The radical disruption between these possibilities offers a detour for Boccioni's spatial articulation, and a decompression for the palpabilitites of the represented body, for as marks they construct little more than the particular space they themselves occupy, eventually becoming effects of the surface, not of volume or contortion.

If the crisis between abstract 'effectualism' and social reference was heralded in Boccioni's work of 1910 and played out for three or four years thereafter – mostly to the detriment of sociality – a somewhat controversial, though often neglected work, *I Selciatori* (*The Street Pavers*, variously dated by Futurist scholars between 1909 and 1914, Figure 3.3), returns us directly to the theme of labour, increasingly relegated by the artist in favour of the representation of speed and light. *The Street Pavers* is a scrappy work, unresolved at its peripheries, and supplied with patches, blobs and stripes of colour unevenly disposed across the surface. In a sense the activity of work is again effaced, but on this occasion more by formal and technical uncertainties than virtuoso display. On the other hand, the subject matter of three (?) workers stooping at their labour (two ink on paper studies pick them out with more clarity) is itself uncomfortable and unresolved. One cannot help contrasting the modest dynamism and reduced torsion of the relatively static, yet back-breaking effort of constructing a roadway, with the more spectacular possibilities, ostentatiously solicited by Boccioni elsewhere, of cars (or horses) running (or rearing) over the finished surface.

The close-up angle of vision does not permit the background buildings to carve up the middle distance of the image as often in Boccioni – though the visual confusion of the upper third of the canvas is such that it is almost impossible to construe exactly what activity transpires. Instead we are invited to focus in on the small-scale stone cracking and setting achieved by the pavers with their bright green, handheld pickaxes, a strenuous activity that glimpses unmistakably at two key images of back-breaking labour: Caillebotte's floor-scrapers stooped on their knees as they delayer an interior wooden surface, and Courbet's stone-breakers, bending and flexing as they decimate rocks to form a bed for the construction of a highway. The interpretation and dating of *The Street Pavers* has been controversial. According to one historian, post-Symbolist musical analogizing of the kind Boccioni and the other Futurists often alluded to, offered yet another conduit that channelled the image towards spectral immateriality and social abstraction. Marianne Martin suggests that Boccioni was influenced by Luigi Russolo, particularly his *La Musica*, in his 'decision to create a visual analogue of the total effect of the street paver's activity'. Dating the work to the summer of 1911, she distinguishes it from *The City Rises*, suggesting that the artist's 'interpretation of … [this] working scene had no anecdotal overtones', but instead issues in 'a crescendo of syncopated, sharp-edged forms, expressing the irregular but continuous chipping and clanking of the pick-axes, which revolve around the purple-black, quasi-oval of the labourer's hat'.[33] If the later date for this work were correct (Esther Coen's contention that 'style and form … make the later dating of 1914 more probable', is not irresistible) then *The Street Pavers* would seem to mark a final return in Boccioni's oeuvre to the problematic of labour. His production of yet another work concerned with this subject indicates that he may have been more preoccupied with the imaging of work than either the rhetoric of the Futurist manifestos or the predominantly formalist interpretations of his earlier works would suggest.

What emerges, even if distractedly, from Boccioni's revisitation of the street as a leading site of modern labour, is not just the ambiguous surrender of the representation of work to the colouristic dispersal of laborious effects and sensations, but a premonition of what Guy Debord described as the spectacular annihilation of the street itself: 'The effort,' he writes in thesis 172 of *The Society of the Spectacle*, referring to the pseudo-communities engineered by late modern urbanism, 'of all established powers, since the experience of the French Revolution, to augment their means of keeping order in the street has eventually culminated in the suppression of the street itself'.[34] Boccioni's labourers engage in an activity whose chief object – fast, transversal, mechanized communication – and whose stylistic order – Cubo-Futurist divisionism – actively participate in the final demise of unalienated labour and the ritual sites of social communality – and protest. Technical and

social abstractions precipitate the larger dystopia of an *'authoritarian decision-making process* that abstractly develops any environment into an environment of abstraction'.[35] One destiny of work in Boccioni's painting, then, is its premonitory encoding of what Jean Baudrillard called the 'immense *ritual of the signs of labour'* which 'extends across the whole of society'.[36]

In any event, the paintings Boccioni made during the last two years of his life (he died in August 1916 following – ironically – a fall from a horse while on active duty in the Italian army) return to the portrait genre that half a decade previously he had dismantled in favour of a new suburban vision. His diluted *rappel à Cézanne*, worked out while Grosz and the Dada artists were moving in an opposite direction, rehearses just one of the many calls to order initiated in European culture during the First World War. Woven together by a crude, if striking, hatchwork of blues and greens, the portrait of composer Ferruccio Busoni (1916), the collector who purchased *The City Rises* in Berlin, exudes modernist obviousness and insouciance. The artist, the trees and the water, take centre stage as Boccioni holds on to the comforting spatial niceties of the classical balustrade. Reassuringly traditional coordinates of pictoriality have finally replaced the intrusions of suburbia and the turmoil and concentration of labour – even the faint melancholy of Boccioni's represented faces has shifted into expressions torn between confidence and resignation. Work, light, speed and sensation – lost in this order, it appears – are finally all worn out. And the artist seems to have returned to the lethargy, pictorial exhaustion and generic delimitation that had been anathema to him at the beginning of his brief avant-gardist journey.

I want to offer three concluding remarks. Two look backwards, then forwards, from the Futurist visualization of labour, while the third takes brief stock of wider social and theoretical questions in the formation and representation of modern work. My first suggestion is that while Boccioni and his colleagues pursued the sublimation of labour into light and colour in spectacular and clinching style, they had no monopoly on the conflicting terms they mobilized, nor on the strategies by which the latter eventually eclipsed, then overwhelmed, the former. Half a century before Boccioni painted *The City Rises*, the lengthy catalogue text that accompanied the first public exhibition of Ford Madox Brown's *Work* (1852–65) – 'among the first serious attempts by a British artist to represent the working class in an urban environment, as against the innumerable portrayals of agricultural activity'[37] – isolates the oppositional emphases discussed above. Madox Brown's paean to 'the British excavator, or navy … in the full swing of his activity' carefully picks out his subject, depicting him with 'his manly and picturesque costume, and with the rich glow of colour which exercise under a hot sun will impart'. This double coding of the colourful worker, who is dressed in colour but who also literally exudes colour, refracted from his own sweat, connects the formations of the coloured

body to the shifting immediacies of the skin: the clothes that sit on it, the fluids that pass through it and the colours it thus takes on. Lodged in proximal relation to the defining edges of the working body, and clearly caught up in the rhetoric of national, racial and class-determined typologies, the intrinsic colourism of the mid-nineteenth century is displaced in the work of Boccioni and the Futurist painters, by the interferences of colour as a more abstractly extrinsic force, propelled by light, and blurred across bodies, objects and places by the confusions of movement. What Madox Brown identified quite precisely as 'the outward and visible type'[38] rendered by labour-specific coloured signs on the surface of the body, and coupled with the sentimentalized, Carlylian heroism of the national worker, has given way half a century later to new imperatives of the surface. A pictorial skin substitutes for bodily mass, social hierarchy is displaced by the order of events and narrative compartmentalization by the vertiginous dynamism of a city 'rising'.

In the years after Futurism's heyday the direct depiction of labour was in large part foreclosed in avant-garde representation. Indeed it might be claimed that, with the exception of a number of Soviet and German images from the 1920s, and the distinctive efforts of Fernand Léger, it was in the works of Boccioni and his fellow Futurists made between 1905 and around 1912, that the visualization of labour enjoyed its last sustained expression in European vanguard art. Following the First World War the visual rhetoric of work was largely confined to recidivist neo-Realist stylizations associated with Socialist Realism, their allied tendencies in the West, particularly in the USA during the 1930s, and to right-wing heroicization of the worker, above all in Germany and Italy, funded by rhetorics of nationalism and racial purity. In Italy a number of attenuated reconfigurations of labour, loosely aligned with Fascist aesthetics, were attempted both by second and third generation Futurists and by surviving members of the original pre-war group. Carlo Carrà's works on 'L'industria del marmo' (the marble industry) in the 1930s are a case in point. Following his period of metaphysical symbolism between 1917 and 1919, and the furry, classicizing landscapes of the 1920s, the artist who painted a portrait of Engels in 1901 and the *Allegory of Labour* four years later, made an oblique return to the question of work in a series of temperas set in Italian marble quarries long famous for their production of raw material for the art of sculpture. Semi-nude, semi-classical figures, posed in attitudes of rest, work and contemplation, underline the languid cultural nationalism of marble production. Labour is now identified with a pre-industrial, Mediterranean golden age, giving rise not to cities but to building blocks for future cultural ornaments, which affirm Italy's destiny as the national embodiment of classical values.

Looking to the years after the First World War, it was Fernand Léger who delivered a final rationalization of the Futurist problematic of labour. The

social aesthetic he worked out in the mid-1920s is predicated on the Futurist's spectacularization of work, machinery and modern city life, but shorn of its strategies of sublimation. The result is a re-heroization of the static worker-object, now caught – almost bound – in a simultaneous but stable environment of contemporary plastic signs. Léger caught, fixed and stabilized that 'whirlwind' of colours that the Futurists permitted to spiral through and then evaporate the bodies and objects of work. He objectified and monu-mentalized the working body – or, more correctly, the bodies of workers – allowing their simplified contours and schematic features the dignity of taking a co-equal place among the symbols and abbreviations – machine parts, street signage, architectural details and the like – that stand in for modern urban life. While understated as a process of material transformation, in this vision work is not remaindered as an abstract series, before and apart from the products it engenders, but imaged as an inevitable function of their life and effect. Work is finally delivered not as a heroic unitary action, but as one implied element among others in the collective field of 'tangible symbols' which make up the modern city.

The sublimation of work, and actions in general, into luminous spectacle was not confined to the period before the Second World War. Indeed, we can follow an attenuating trail of the effectualism it engendered from the 1910s to the neo-avant-gardes of the 1950s and 1960s, and beyond. Artists associated with the new abstractions of the 1980s, for example, were criticized from some quarters on the grounds that they moved from the representation of spectacular effects to a form of meta-spectacle in which painting became a simulation of already mediated spectacles. Hal Foster notes this turn in the work of Jack Goldstein, 'who, after performances, films and paintings that stressed spectacular effects, turns to "abstract" paintings—or, more precisely, to paintings of abstracted images or events'.[39] Goldstein, in fact, raises the stakes of that which was already spectacular to embrace a mediated reconstitution of the astral visions reached for by Balla in his works of 1914, accompanied by a new vision of the sublimation of combustible discharge we witnessed in Marinetti's 1909 *Manifesto*. His pictorial subjects include 'a star formation represented via a computer as a series of tiny spectra, a wisp of smoke specially photographed in a chamber, the rings of Saturn mediated by an electronic telescope'.[40] But, as Foster further suggests, the shift apparent in 1980s abstraction disputes with what Frederic Jameson termed 'the old "futurist icons" of modernity (for example, the automobile, the aeroplane)', substituting instead 'new emblematic commodities (for example, the computer), which "are all sources of reproduction" rather than "production," and are no longer sculptural solids in space'.[41] The art of the 1990s develops the spectacularist imagination initiated by the Futurists in two directions. The first continues the trajectory mapped by Goldstein and James Welling, but substitutes for

their galactic iconography the body-bending vicissitudes of virtual reality and the infinite mutations of computer generated image manipulation. Another attends to the visceral effects of intensified spectacle, representing not the kind of abstract vision of vehicular velocity favoured by the Futurists as they moved away from the body, the worker, the street and crowd, but the aftermath of an impact it engenders, the obscene vivacity of the *crash*.[42]

With representation now firmly on the side of reproduction, the very grounds of production-oriented work have also shifted. Information takes the place of raw materials, and the picturing of abstract relations substitutes for the real-time imagery of labour. As Richard Sennett has recently demonstrated, this change is clearly registered in social and personal experiences of the work place in the last decade of the twentieth century.[43] And, in the narrower confines of the art world, positions have emerged in lockstep with the vaunted post-politicality of the 1990s and new theorizations of 'beauty', which return to a variant of the *fin-de-siècle* aestheticism within and against which the Futurists unevenly negotiated. Thus while left-oriented critics bemoan the 'confinement of the aesthetic' to 'anti-utilitarianism' and the resulting 'privilege of disembodiment (literally the freedom from manual labour and utilitarian function ...)';[44] others suggest that 'The work of art is work which is attached to that species of thought which has to do with not working, which is how and why the work of art is always ultimately responsible for and to irresponsibility'.[45]

In relation, finally, to what larger ideas and experiences of work, warfare, industrialization and technology can we situate this account of Boccioni and the Futurist's sublimation of the body of labour? The Futurist's elevation of voyeuristic consumption, their championship of violent action and their repudiation of the scene of unitary labour might appear to offer a reversal of the Hegelian model of the master and the slave; and its disavowal of the emancipatory potentials of labour, their counter-democratic rhetoric (miso-gynist, imperialist, Socialist and elitist, by turns) sanction a return to the predatory values of the master class. The Futurists desired to bracket out that historical sense of emancipation, that imaginative self-determination engendered in the slave which allowed him to think 'the abstract possibility of a free being with worth and dignity',[46] in favour of a surrender to the twin dictates of nationalism and mechanical modernity, whose speedy, spectacular effects its members would dutifully record or actively co-create.

Seen in this way the Futurist courting of violence and abstraction was an early response to the structural enervation of liberal-capitalist democracy, an attack on the dreaded lethargies and manly negations attendant on it. It was a rallying cry launched against the first manifestations of what Hannah Arendt describes as 'the deadliest, most sterile passivity history has ever known', as 'labour' is uniformly alienated, 'work' is alchemized into labour

and 'action' is defeated by leisure, routine and mass entertainment.[47] The same macro-social logic can be found in apologists for liberal-capitalism. Glossing Hegel's contention that periodic bouts of international warfare might rekindle the social self-respect of Western democratic societies, Fukuyama speculates that one motivation for the bellicose mass rallies of August 1914 staged in many industrial cities across Europe after a century without a large-scale European war, was a sheer 'boredom with peace and prosperity'[48] coupled with a sense of loss in the continent's reckoning with its self-worth and dignity.

In the second part of their two-volume study of capitalism and schizophrenia, Gilles Deleuze and Félix Guattari suggest that both 'the physicoscientific concept of Work' and the 'socioeconomic concept of labor-power or abstract labor,' modelled on the organization of the 'war machine', can be identified as fundamental, 'striated,' effects of the State apparatus, and thought over against the possibilities of 'free action' in smooth, or unhierarchized, space.[49] By the early 1900s, the great social abstractions that commence with surplus labour and its 'generalized operation of striation of space-time'[50] had rendered the unitary, separable actions of labour obsolete: to represent them in their former condition was, as Boccioni put it, wearying and 'sentimental'. The Futurists responded to the impossibility of such images by deterritorializing the scene of work, crossing it with lines of force and implosions of colour, and reterritorializing it with intimations of literal and emotive violence that once again connected labour to the war machine. Marinetti glimpsed the end product of the internalization of labour that resulted in 1920, when he attempted to imagine a new mode of artistic-totalitarian governance:

'All power to the artists! The vast proletariat of geniuses shall govern ... Thanks to us the time will come when life will not simply be a matter of break and toil or a life of leisure but when life will be itself a work of art ... We shall not have heaven on earth, but our economic hell will be reanimated and soothed by innumerable festivals of art.[52]

The only way out of the representational dilemma posed by the Futurists to work as an image is to short-circuit the category of production by equating the work of art with all that is life itself.

Notes

1. Debord, G., *The Society of the Spectacle*, trans. D. Nicholson-Smith (New York: Zone Books, 1997), p. 133.

2. Deleuze, G. and Guattari, F., *A Thousand Plateaus: Capitalism and Schizophrenia, Vol. II*, trans. B. Massumi (Minneapolis, MN: University of Minnesota Press, 1987), p. 490.

3. Marinetti specifically proscribed personal dramas played out under a romantic moon in his literary manifestos, where he identified 'Romantic sentimentalism streaming with moonlight' as

one of 'the four intellectual poisons that we must destroy at all costs'. *Le Futurisme*, cited in Rye, J., *Futurism*, (London: Studio Vista, 1972), p. 111.

4. Berghaus, G., *Futurism and Politics: Between Anarchist Rebellion and Fascist Reaction* (Providence, RI: Berghahn, 1996), p. vii

5. The lecture was delivered in Naples at the Chamber of Commerce on 26 June 1910, and again at the Sala d'Arte Moderna, Milan on 30 July. See Berghaus, *Futurism and Politics*, p. 37.

6. Marinetti, F. T., 'Foundation and Manifesto of Futurism', *Le Figaro* (Paris), 20 February 1909.

7. Fonti, D., *Severini: Catalogo ragionato* (Daverio: Milan, 1988), p. 76.

8. Ibid., p. 88.

9. Severini, G., *Life of a Painter: The Autobiography of Severini*, trans. J. Franchina (Princeton, NJ: Princeton University Press, 1995), pp. 10–11.

10. See, for example, Rye, *Futurism*.

11. Details of Balla's work during the first decade of the twentieth century, and of his political and social concerns, are drawn from Robinson, S. B., *Giacomo Balla: Divisionism and Futurism* (Ann Arbor, MI: UMI Research Press, 1981), esp. pp. 35, 46–7, 55. *The Living* was attacked, like Boccioni's *The City Rises* somewhat later, for its 'vacuous Symbolist' affinities; Serra, L., review in *Natura ed Arte*, cited by Robinson, p. 55.

12. Ibid., p. 35.

13. Ibid., pp. 45–7.

14. Fagiolo del'Arco, M. (ed.), *Balla: The Futurist* (Edinburgh: Scottish National Gallery of Modern Art; Milan: Mazzotta, 1987), p. 56.

15. Some 800 000 copies of the pamphlet manifesto 'Against *passéist* Italy' were hurled from the campanile in Piazza San Marco in July 1910.

16. Boccioni, U., from his diary (1907); cited in Rye, *Futurism*, pp. 26–7.

17. Boccioni, from his diary, cited in *Umberto Boccioni*, exhibition catalogue, (New York: Metropolitan Museum of Art, 1988), p. 256.

18. Robinson notes this possible influence, adding that according to a former owner, *Factories at Porta Romana* was originally called *Noon*, suggesting that it formed part of a symmetrical three-part response to Balla's triptych *The Worker's Day*, see Robinson, *Giacomo Balla*, pp. 47 f.

19. Braudel, F., *A History of Civilizations*, trans. R. Mayne (London: Penguin, 1993), p. 394.

20. Adorno, T. and Horkheimer, M., *Dialectic of Enlightenment*, trans. J. Cumming (London: Verso, 1979), p. 120.

21. *Umberto Boccioni*, exh. cat., p. 258.

22. The remarks on Boccioni that follow are adapted from my review of *Umberto Boccioni* at the Metropolitan Museum of Art (15 September 1988–8 January 1989), first published in *Art International* (6), (Paris, 1988–89). The exhibition was configured squarely in the format of the singular 'great artist' retrospective, or heroized blockbuster, and apart from a few contextual flourishes in the first of its seven rooms – a vitrine of catalogues and manifestos, a thickly impastoed palette redolent of the hard-won colouristic choices of the artist, and a pair of Boccioni-meets-Lautrec tempera 'cartoons' from 1904 (of automobiles careering through fox-hunts) – offered little evidence of any shift towards the critical parameters of what was then the 'new art history'. The catalogue followed suit, being mainly preoccupied with the predicates and appurtenances of the monograph – chronology, formal development and description – and managing even these in a rather routine fashion.

Paradoxically, however, single artist retrospectives such as this often furnish the very material that can undo the closures of the monograph, even as they strive to clinch them. For our general idea of the luminous avant-garde artist is constructed and governed with reference to a small number of prominent, well-disseminated key works, whose presence in a retrospective, surrounded by preparatory sketches and studies, disrupts the model economy of singular knowledge by giving us access to works that can not easily be fitted into the familiar evolutionary development of the artist, and that may be oblique or contradictory to received understanding. An important scene of rereading can thus occur even in relation to the *locus classicus* of the retrospective, the *primary* work, attended by a constellation of preparatory sketches and details. On the one hand, these 'studies' are usually arrayed in homage to the masterpiece, which is supposed to clinch, unify and transcend their itemized subordination. On

the other, the disparities, elisions and refusals that we encounter moving from 'study' to 'work,' and back, seem almost to turn against the declamatory authority of the final image and invite us to receive the work not as a solitary icon, but as a total production whose parts and supplements contend with and exceed the final frame-bound object. Such was the case with *La Città Sale* at the Metropolitan, where the iconic surpluses organized around it forced me to look repeatedly at this key transitional image in an attempt to comprehend its representational struggle between labour, light, colour and movement.

23. In his correspondence of 1910, Boccioni records that he had begun 'one picture measuring 2 by 3 metres', and, in another letter, that he was doing 'battle with my huge canvas'. Cited in *Umberto Boccioni*, exh. cat., p. 94.

24. Boccioni, letter to Ines (?), 1910; cited in ibid., p. 95.

25. Boccioni, from his diary, cited in ibid., p. 259.

26. This is Coen's view, stated at the end of her catalogue entry, in ibid., p. 97.

27. The interviews and criticism cited here derive from the useful catalogue entry on *The City Rises* and preparatory studies, in ibid., pp. 94–104.

28. Letter to Ines (?), cited in ibid., p. 94.

29. Letter to Barbantini, cited in ibid., p. 96.

30. Ibid.

31. Cited in ibid., p. 97

32. Cited in ibid., p. 132.

33. Martin, M. W., *Futurist Art and Theory: 1909–15* (Oxford: Oxford University Press, 1968), p. 106.

34. Debord, G., *The Society of the Spectacle*, pp. 121–2.

35. Ibid., pp. 122–3.

36. Baudrillard, J., 'The End of Production', in *Revenge of the Crystal: Selected Writings on the Modern Object and its Destiny, 1968–1983*, ed. and trans. P. Foss and J. Pefanis (Sydney: Pluto Press, 1990), p. 101.

37. Johnson, E. D. H., *Paintings of the British Social Scene from Hogarth to Sickert* (New York: Rizzoli, 1986), p. 211. My colleague at University of California, San Diego, Mary Vidal, kindly drew my attention to the Madox Brown painting.

38. Martin, *Futurist Art and Theory*, p. 106.

39. Foster, H., 'Signs Taken for Wonders', *Art in America*, July (1986); reprinted in Risatti, H., (ed.), *Postmodern Perspectives: Issues in Contemporary Art* (Engelwood Cliffs, NJ: Prentice-Hall, 1990), p. 153.

40. Foster also reminds us that James Welling 'borrows his dot motifs from computer graphics generated to objectify such fractals as lunar craters and galactic formations', ibid., p. 159.

41. Jameson, Frederic, cited by Foster in ibid., p. 159.

42. For further discussion of the spectacular in the art of the 1980s and 1990s, see the introduction to my *Art after Appropriation: Essays on Art in the 1990s* (Amsterdam: G & B Arts International, 2000). Two exhibitions – and their accompanying publications – at Thread Waxing space in New York attest to the fetishistic interest in crashes and disasters: *Crash: Nostalgia for the Absence of Cyberspace*, eds R. Reynolds, and T. Zummer, (New York: Thread Waxing Space, 1994); and *Spectacular Optical*, eds S. Antelo-Suarez, and M. M. Madore, (New York: Thread Waxing Space, 1998). In Italy a recent exhibition (*Minimalia: Da Giacomo Balla …*) within the 47th Venice Biennale (15 June–10 October 1997) at the Palazzo Querini Dubois, examined the internalist opposite to the cultivation of violent or sensational spectacle, claiming to trace a 'tradition' of 'art as an autonomous intellectual activity' developing from the work of Balla and the Futurists; see S. Santacatterina's review, *Third Text*, (40), Autumn (1997), pp. 105–8. Exhibitions of historical Futurism have also tended to bracket its concerns between spectacular (once more a function of light and outer space) and 'internalist' orientations. *Futurism: The Great Themes, 1909–1944*, at the Fondazione Antonio Mazzotta, Milan, 1998, for example, apportioned the movement between such categories as The Individual, The Cosmos and Speed.

43. See Sennett, R., *The Corrosion of Character: The Personal Consequences of Work in the New Capitalism* (New York: W. W. Norton, 1998).

44. Buchloh, B. H. D., 'Since Realism There Was … (on the current conditions of factographic art),'

Art & Ideology, exhibition catalogue, (New York: The New Museum of Contemporary Art, 1984), p. 17.

45. Gilbert-Rolfe, J., 'Seriousness and Difficulty in Contemporary Art and Criticism', in R. Hertz, (ed.), *Theories of Contemporary Art* (Engelwood Cliffs, NJ: Prentice-Hall, 1993), p. 154.

46. Fukuyama, F., *The End of History and the Last Man* (New York: Avon, 1992), p. 198.

47. See Arendt, H., *The Human Condition* (Chicago: University of Chicago Press, 1958), p. 322.

48. Ibid., pp. 330–31.

49. Deleuze and Guattari, *A Thousand Plateaus*, p. 490.

50. Ibid., pp. 490–91.

51. Cited in Rye, *Futurism*, p. 127.

3.1 Giacomo Balla, *La giornata dell'operaio (The Worker's Day)*, 1904

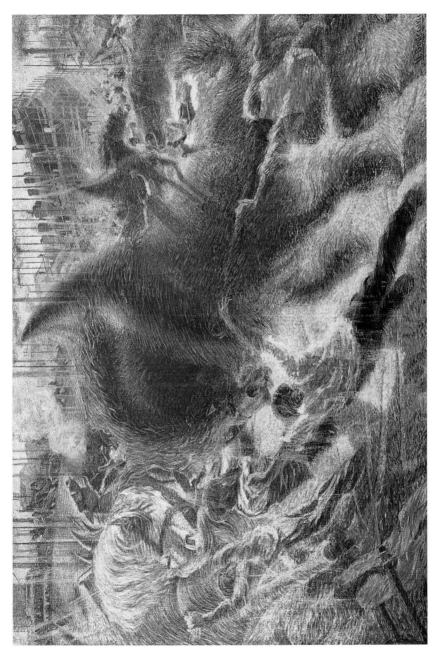

3.2 Umberto Boccioni, *La Città Sale* (*The City Rises*), 1910

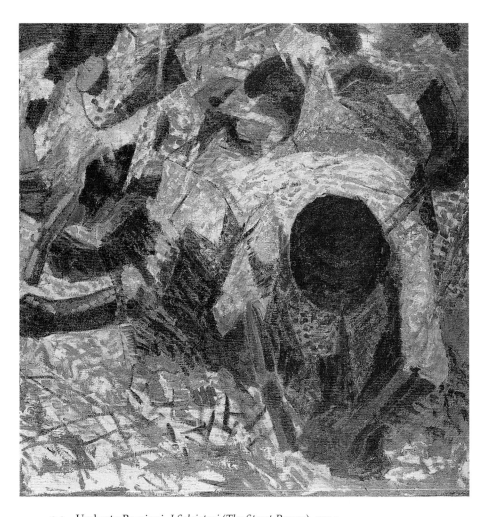

3.3 Umberto Boccioni, *I Selciatori* (*The Street Pavers*), 1914

The missing *mécanicienne*: gender, production and order in Léger's machine aesthetic

Mo Price

Soon after Léger arrived in New York in October 1935 to promote his exhibition at the Museum of Modern Art, he was pictured in the *New York Herald Tribune* above the headline, 'Léger Advises Painters Not To Use Beautiful Women as Their Models'.[1] In the accompanying report, Léger tried to explain the 'problem' of beautiful women by reference to a critical distinction between constructive art, in which the painting itself (as a material, concrete or 'plastic' form) constituted the object of beauty, and what he termed 'decadent art' in which the depicted subject matter carried the message of beauty. As he stated in the report, 'A painter should not try to reproduce a beautiful thing, but should make the painting itself a beautiful thing'. Implicit in this notion is his familiar analogy between creative and manufacturing processes, between artistic and industrial products. As Léger would have it, both artist and artisan put their sensibilities at the service of a job; both attempted to turn in a part that was nothing less than clean, polished and burnished and the product of their respective labours shared an aesthetic quality that overturned all received notions of beauty.[2] *Les Disques* (1918, Musée d'Art Moderne de la Ville de Paris), which is positioned behind Léger in the *Herald Tribune* photograph, and the thematic series relating to *Element Mécanique* (1924, Musée National d'Art Moderne, Centre Georges Pompidou, Paris) illustrate this ideal of 'production' and a new order of beauty through their particular combinations of formal and technical signifiers: strong geometric shapes, accentuated lines, bold commercial colours and technological motifs imaginatively and skilfully put together with consummate professionalism. The human figure, honed to precision, was often incorporated into Léger's scheme of representation but, as indicated in the *Herald Tribune* interview, the use of a woman as model created an obstacle for Léger's vision of modern production because of the centrality of that subject matter to an outmoded, but still persistent, order of pictorial beauty. The depicted figure of a woman created a strong tension in

the composition because it invoked a set of values, interests and meanings traditionally invested in artistic representations of woman.[3] Locked into a system of conventional ideas about beauty, this motif inevitably interfered with – indeed, competed against – the machine aesthete's concept of beauty, making it especially difficult to redraw the lines.

The statement reported by the *Herald Tribune* not only indicates Léger's acknowledgement of the disruptive effect of traditional constructs of femininity within his aesthetic scheme but also suggests that although he had taken up the challenge presented by the representation of woman some years earlier, he did not feel that he had resolved the problem by 1935. This issue is of critical importance in the discussion which follows for it impinges on the interpretation of the figure of woman in Léger's machine aesthetic works of the period 1920–25. In this chapter, I want to comment on the significance of woman as subject matter in Léger's machine imagery during those post-war years and to discuss the gender values inscribed in the artist's representations of technological production. My interest focuses on the ways in which Léger's images construct relationships between ideas of woman and ideas about production, producer and product. The concentration on areas and processes beyond the manufacturing plant – consumerism, leisure, domesticity – in Léger's imaging of woman prompts questions about the positioning of feminine agency and the gendering of the relationships between 'body' and 'machine' in this artist's conceptualization of industrial modernity. Any interpretation of Léger's representation of these relationships must take account of his perception of a fundamental collision of values centred on woman, as expressed in the *Herald Tribune* interview. Furthermore, Léger's problematizing of the representation of woman raises questions about how the sexual values underpinning his concept of a modern technological order might connect to broader contemporary discourses of sexuality and labour.

Any analysis of the gender values inscribed in Léger's imagery must engage the question of how his socialist allegiances shaped the representations. Although little was made of the political inflections of Léger's art during the course of the exhibition at the Museum of Modern Art, New York, organized by its Director, Alfred H. Barr, in 1935, when the painter publicly remarked on the problematic of woman, critics (and American politicians) increasingly treated the ideological premise of his practice as a matter of some importance.[4] Certainly, it is the combination of aesthetic and political concerns in Léger's works which have preoccupied art historians, and it is this understanding which leads the viewer to seek significance in his representations of social types. *Le Mécanicien* (1920, National Gallery of Canada, Ottawa) is probably the most widely known of the figure types and this portrayal of a working-class industrial labourer is often represented as the definitive image of an early phase of Léger's politically conscious art. The less familiar fresco (Figure

4.1) produced collaboratively by his studio for the Communist *Congrès de la Femme*, held at the Porte de Versailles in June 1948, three years after Léger had joined the Communist Party, testifies to the more public political agendas of his later practice. In both images, the subject matter is clearly legible and the figures portrayed are given identity according to their trades and occupations. The general characteristics of these examples – the clarity of the representational means and the direct references to popular experience and working-class culture – may be understood in terms of the 'modern realities' that Léger placed at the core of his practice after the First World War and they underpin his reputation as a socialist artist.[5]

It is important, however, to avoid over-sentimentalizing or oversimplifying the terms of the artist's engagement with popular experience. A critical perspective is needed when dealing with the claims made for and by Léger. In the existing literature on Léger, his career is said to have been 'shadowed by the Image of the People' following a moment of conversion prompted by encounters at the warfront.[6] Thereafter, by his own account, his ambition was for a pictorial system conceived to be progressive in its social and artistic outlooks, departing from but always extending the experience of the majority.[7] With this priority in mind, critical attention has traditionally centred on the task of positioning Léger's practice on the axes of modernist and socialist representation during the inter-war and cold war periods. But, in the process of defining and situating the practice, which often involves drawing implications about the artist's interests and allegiances from his deployment of a particular artistic mode or language, writers on Léger tend to overstate the apparently simple relationship between syntax and semantics in his representations. His concise mechanisms of signification are taken to construct ideas with a directness and lucidity which produces a transparency of meaning and frees the images from ambiguous or contradictory elements. It is sometimes presumed that there is no guile in the artist, no deviancy or complexity in his mediation, nothing to undermine or to complicate the affirmative qualities of his socialist idealism. John Berger, for instance, writing in 1960, encapsulates this view in his remarks about the sincerity and immediate comprehensibility of the work – factors which, he surmises, render the commentator redundant:

I always feel absurdly pretentious when trying to write about Léger. His works so clearly affirm themselves. In front of a painting by Picasso or Bonnard, one senses such an urgency of conflict that it seems quite appropriate to discuss the debate and plead for all the issues involved but in front of Léger one thinks: There it is. Take it or leave it.[8]

The artist's ideal of a technological order is treated as virtually un-nuanced and most critics, following Léger's theory of a geometric ordering principle drawn from the machine, stress the synthesizing and organizing qualities in

the paintings of the early 1920s (typified by *Le Mécanicien*), which are said to connote a fundamental sense of continuity and unity.[9] Even Kenneth Silver, whose study of this period of French cultural history has done most to unravel the myths of the cult of 'order' and to reveal the frailty of any sense of unity in the actual conditions of post-armistice France, thereby demonstrating the significance and the limits of the post-war aesthetics of order, nevertheless conforms to the usual view that all signs of dissonance disappear from Léger's imagery between 1920 and 1925.[10] It is important, however, to develop other perspectives on this question of order and harmony in the machine aesthetic works. As stated in my opening remarks, given the exceptionally disruptive effects that Léger attributed to the figure of woman, there is a problem with the interpretation of the human figure – especially the representation of the gendered body – in terms of a coherent or unified body–machine equivalence.

In his writings of the early 1920s Léger declared that the body was of no special significance in his works: 'a human figure, a body, is of no more significance than bicycles or nails. It is no more than a set of components possessing plastic significance'.[11] But in practice, the idea of the body is far from neutral in Léger's imagery. It operates with other signs to construct ideas of difference and hierarchy. The critic's task is to recognize and deal with the paradox of the simultaneous significance and insignificance of the body as imaged in this system of representation. This involves taking issue with the orthodox view that Léger's representations produced an unproblematic idea of unified, standardized figures homogenized within their industrial environments. By concentrating on his configurations of woman and machine, some of the paradoxes and ambiguities in this ideal of the unified body–machine are revealed. Furthermore, it is illuminating to consider the gendering of the body–machine concept – with its connotations of a sexually determined technological order – in relation to contemporary ideas about women's sexual and socio-economic roles. Thus, the question is: how do the sexes relate *differently* to the idea of the machine in Léger's conceptualizations and to what extent does the aesthetic construct challenge or reiterate gender values produced in the broader artistic and social realms?

The fresco panel for the Women's Congress (Figure 4.1) relates to a much later artistic and political phase and historical context than the machine aesthetic imagery of the 1920s, but it serves as a useful reference point by virtue of the relative diversity of the roles and occupations of women that it represents when compared to the narrower characterization of femininity in the earlier series, typified by *La Femme et l'Enfant*, completed in 1922 (Figure 4.2). The centrality of the maternal role is signified in the imagery of both epochs but the specific forms of skilled and semi-skilled women's labour represented in the fresco (the nurse, the landworkers, office/laboratory staff

and, most significantly and ironically, the *machine operator*) have no counter-parts in the visual works of the machine aesthetic. Thus, there is no equivalent to the later representation of the varied forms of women's productive work and no feminine equivalent to the masculine *mécanicien* in the technological modernity of the 1920s imagery, where the image of woman as industrial worker might be expected to appear. The congress for which the fresco was commissioned was staged four years after the achievement of women's suffrage in France (1944) and in a climate of intensified activism among women, especially within the Communist Party (which, as mentioned earlier, Léger himself had joined only three years before). Thus the shifts in his imaging of women's roles might be gauged as the product of a different moment not only in his own political development but also in women's history, one in which there was a heightened consciousness of their social and economic positions. Undoubtedly, this is the case.

Parallels can, however, be found in the earlier context: the question of women's suffrage emerged forcefully in the immediate aftermath of the First World War and the novelty of new industrial roles for women in the wartime factories had made a great impact as vast numbers were recruited for war work.[12] Despite an initial decline in the numbers of women employed in factories once the war ended, the trend began to reverse during the 1920s and the *proportion* of employed married women working in this sector continued to grow. This tendency was not stemmed by the official pro-natal policies of the period, which stressed the maternal role as a matter of urgency in the light of enormous wartime casualties. The context of intense public debate about the sexual division of labour in the post-armistice social order is of relevance to a critical understanding of Léger's machine aesthetic imagery – particularly the enigma of the absent woman factory hand – because it is possible to identify similarly contradictory attitudes pervading artistic and other public discourses of woman. The exercise which is arguably at the root of Léger's representations – a simultaneous reinforcement and disestablishment of fixed ideas about femininity – in various ways connects to disputations about the 'nature' and 'proper' roles of women conducted in the arenas of social, economic, political and cultural debates in post-armistice France. Léger's representations occupy a place in this broader historical construction of relationships between women, work and technology.

A survey of Léger's paintings of this period reveals that whereas masculine figures are usually depicted at work or rest in 'public' spaces connected to sites of heavy industry, engineering and manufacturing production (such as factories, workshops and docksides),[13] there are no signs of women's presence in the public sites of work and community. Instead, the feminine figures usually inhabit interior domestic spaces, and women are represented as creatures of leisure lounging decoratively amongst furniture and household

appliances. The relaxed maternal figure set in a modern kitchen, represented in *La Femme et l'Enfant* (Figure 4.2), characteristically embodies the home base which is implicitly the product of and reward for the *mécanicien*'s labours. There are few exceptions to this system of sexual division but a graphite sketch relating to the 1922 mother-and-child painting, *La Femme et l'Enfant* (1922, Louise Leiris Gallery, Paris) demonstrates that Léger considered including a father figure (significantly, positioned close to the boundary of the domestic space). The painting, however, excludes direct reference to the masculine producer whilst clearly connecting woman to ideas of reproduction and domesticity.

A sense of the masculine dominance of industrial production is achieved through a combination of representational means: in Léger's writings and lectures, there is a clear assumption of a masculine addressee and constant references to the masculine artisan and his vision, but remarkably little mention of women's experiences. And the formal and narrative means employed in his paintings – the use of geometry (with its allusions to the mechanical) to unite and mesh figures and environment, suggesting psychological and physical integration of figures into social and occupational spaces – may not be sexually neutral. For instance, *Le Mécanicien à l'Usine* (1918, collection of Mr and Mrs James W. Alsdorf, Chicago), picturing a worker in his cloth cap and overalls at the controls of the machine room, appears to reference the Taylorist ideal of the industrial worker: the dense configuration of line and form tightly locking the machine operator into the workshop space, integrating body and machinery.[14] But the geometric principle – symbolizing the ordering systems associated with technology (selection, adaption, standardization) – was repeatedly defined by Léger in terms of *masculine* subjectivity, which, as stated, was supposedly invested in the keenly polished and burnished components that the artisan produced in the workshop. A synthesis of masculine producer, production and product is insisted upon in the artist's rhetoric. Furthermore, in the early 1920s, Léger began to express the *hope* (if not the conviction) that the geometric or manufacturing principle, ostensibly already established in the popular consciousness, could subjugate and control the breasts and curves of the female body, thus conceptualizing the female body as a by-product of masculine process and agency.[15] The critical implication which can be drawn from these factors is that the sense of cohesion, unity and order produced in the machine aesthetic paintings is strongly underscored with masculine values: the feminine component threatens to disturb the order and, thus, requires management.

The superimposition of the mechanical principle upon the maternal bodies (the geometricizing of the breasts and curves) in *La Femme et l'Enfant* (Figure 4.2) and the contemporary painting *Femmes dans un Intérieur* (Figure 4.3)

may be read, therefore, as Léger's attempt to control and make safe the image of woman whilst according a modern treatment to the idea of motherhood. Whatever the artistic intention, it is likely that in contemporary perceptions of the paintings Léger's treatment of the theme sat ambiguously in relation to a conservative cult of maternity prevalent in the social realm. The importance of the maternal subject in avant-garde representations of this period (examples by Picasso, Gris, Severini and Dérain, as well as Léger, could be called to mind) may to some extent be accounted for in the framework of post-war ideologies of domesticity in France. The task of procreation and regeneration was made urgent in government rhetoric and anti-abortion and anti-contraception measures were enacted by law.[16] The pro-natal message surfaced in state-sponsored art exhibitions on the theme of mother and child, a major example being staged in Paris in 1921, contemporaneous with Léger's painting on the theme.[17] In state publicity, the shift in official conceptions of women's labour roles from the wartime to post-war situations is evident in a comparison of two posters, *La Femme Française Pendant La Guerre* (1917, Musée d'Histoire Contemporaine, Hôtel National des Invalides, Paris), commissioned by a military department and bearing the signature 'G. Caron', and a Peace Loan poster designed by Henri Lebasque (1920s private collection).[18] With its title incorporated into the text, Caron's poster is an unambiguous representation of the war efforts of French women, symbolized by the figures of three women grouped beneath the banner of a blazing Marianne. At the centre of the group, directly aligned with the spirit of Marianne, a nursing mother oversees the care of two young offspring. This matriarch obviously indicates the fundamental importance of women's reproductive function and their keystone positions as guardians of the home amid the turmoil and slaughter caused by combat. But other vital roles are represented by the figures that flank this symbolic mother. These characters – a factory machine operator and an agricultural labourer – demonstrate women's engagement in two types of essential public work. It is a reminder that, with the male population largely conscripted into the forces, women were indisputably crucial to the continuation of the vital areas of economic production – the survival of the nation depended upon their presence there. By contrast, the maternal role is considerably more pronounced in Lebasque's post-war representation, in which a mother-and-daughters group entirely dominates the foreground, the women's sphere emphatically separated from a scene of men's employment that occupies the remainder of the composition. The middle ground depicts the fervent activity of men working on a construction site in close proximity to a furiously productive industrial plant; a ploughman tills the soil nearby. With its picture of collective enterprise in a technological economy, this poster produces a clear division of gender roles annexed to realms of reproduction and

production. The diversity of women's occupations during the war era is subsequently narrowed, waged production becoming exclusively a masculine preserve as the nature of the nation's crisis shifts.

The pattern of changes in the sexual division of labour which is charted in this state-sponsored imagery appears consistent with the biases of Léger's machine aesthetic representations of men's and women's occupations. In so far as the spate of maternal themes in avant-garde art at this time can be taken to imply reflection on a topical social issue,[19] I suggest that there are other factors to be considered in accounting for the presence of the mother figure but the absence of the woman machine operator in Léger's machine aesthetic. As stated earlier, statistical studies indicate that although large numbers of women factory workers were laid off or willingly gave up their jobs once the war was over, the new patterns of employment increased the *proportion* of employed married women who were working in factories, light engineering workshops and the like (that is, it became more common for working wives to be based in factories). In the light of these statistics, it is pertinent to question why Léger, an artist intent on constructing a forward-looking vision of modern technological society, did not incorporate the woman industrial worker into his imagery. Drawing on socio-economic histories of the period,[20] we can speculate that there are two main reasons for this absence. First, the conditions of women's employment in factories had been exposed as highly exploitative and far inferior to those of their male counterparts, with the effect that this type of occupation lacked a positive or 'progressive' image. Second, as a consequence of those unsatisfactory conditions of employment, women factory workers (including those in the vital munitions industry) had headed a wave of unofficial industrial strike action that swept across France during 1917–18, creating a crisis for government at the most critical and dangerous point of the wartime operations and alienating the male-dominated trade unions, whose authority they flouted. Their dissent took a highly visible form and gained press coverage which revealed some of the prejudices of the time. Rallies of women from the clothing and textiles factories, traditional strongholds of women's employment and relatively less crucial to the war effort, were treated as entertaining, carnivalesque spectacles and girlish affairs, as suggested in this evocative description from the report in the left-wing journal, *Humanité*: 'On the grands boulevards a long cortège is advancing. It's the Parisian dressmakers with their blouses fragrant with lilacs and lilies-of-the-valley: they run, they jump, they sing, they laugh, and yet it is neither the feast of St. Catherine nor of mid-Lent: it is the war.'[21] Other accounts also stressed the decorative aspects of the sight of the marauding women. It was 'very rue de Paix ... style, gracefulness and smartness', reported *L'Eclair* and even the right-wing *Action Française* seemed unperturbed by what it termed 'this

pretty and short strike'.[22] By contrast, women strikers in the vital munitions factories (where women were widely perceived as contingency workers temporarily substituting for men) were more likely to be demonized and castigated as criminals, traitors, revolutionaries or even German agents-provocateurs.[23] They earned a lowly public image as enemies of the State.

Official forces of order were used to quell the militant factory women, but such was their negotiating power in these critical circumstances that they won many of the concessions that they demanded. Despite some public accolades for women factory hands who conscientiously held the fort in the absence of men, critics who reacted with hostility towards the reprobate women strikers tended to condemn the entire category of women labourers. Such prejudice fostered a picture of women's aberrance and deviancy. Written testimonies record general resentment about the supposed new-found financial independence of working women, accusations of greed and profligacy, and fears about the negative impact on the institution of marriage of these developments in women's emancipation.[24] The emotive and ambivalent reactions provoked by this (un)popular stereotype may explain why Léger did not incorporate the *mécanicienne* into his machine aesthetic.

The public fears which developed around women's invasion and disruption of industry were matched in the cultural sphere by panic surrounding a shift that was projected as a feminization of French culture during the First World War. Both reactions were fuelled by alarming images of transgressive femininities, of women's 'natural' restraint abandoned, of feminine desire out of control. Studies by Peter Wollen, Kenneth Silver, Romy Golan, Tag Gronberg and others have firmly established the grounds for the idea that certain tendencies within French taste – in particular, a passion for the decorative, the exotic, the Oriental – were associated by conservatives with notions of seduction, excess and indulgence and cast both as 'feminine' and unpatriotic: these 'foreign' traits were regarded as threatening to the true (classical) spirit of France – which, confusingly, was also usually symbolized as a woman (often in the guise of a maternal figure as 'guardian of the hearth') thus indicating the currency of belief in ambivalent femininities.[25]

Silver has made familiar the example of Lucien Métivet's satirical cartoon narrative of 'Marianne et Germania', which was serialized in the pages of the wartime journal *La Baïonnette*.[26] As the title suggests, the storyline was a battle between French and German cultural values, using feminine symbols of nationhood. One illustration encapsulates the sense of panic and foreboding as an utterly entranced Marianne is bedazzled and seduced by the excesses of the so-called 'boche' tendencies prevalent in recent Parisian culture: 'fantastic' Wagnerian opera, 'insane' Münich interior design, 'barbaric' forms of dance and 'ridiculous' formal distortions in painting.[27] The irony spins from the recognition that Marianne's deviant aesthetic pleasures were derived

from 'foreign' artistic forms that manifested qualities also indigenous to French culture: within rococo style, Romanticism, Symbolism and Cubism, for instance. Métivet's prose beseeches the dizzy woman – about to 'lose her rudder' – not to succumb to the enemy within herself: her own debased taste. The threat posed by this undisciplined Marianne was the unleashing of the same corrupt appetites across the French race, allowing the contaminating ('foreign') forces to erode cultural standards and undermine national stability.

The threat that feminine caprice metaphorically posed in the cultural sphere was paralleled in the social realm by women's accelerated realization of their own economic power, their ability to control the conditions of their own production and expenditure, which could potentially undermine the existing political and sexual orders. Thus, there was a perception of a dangerous feminization of culture operating alongside a debilitating feminization of industry. On both fronts, cultural and economic, critics adopted a similar strategy to simultaneously scapegoat women for undesirable, dissident tendencies within the national character and symbolically disarm femininity of its political potential. Feminine agency, whether imagined cultural intervention or actual industrial action, was rhetorically disengaged from its material base (thus overlooking the socio-economic and ideological apparatuses of sexual power) and recast in a realm of essentialist psychosexual behaviour: women's activism was taken to be a manifestation of (pathological) feminine subjectivity. The terms of the devaluation centred on the idea of feminine impulsiveness. Thus, by exerting control over the notion of woman as a desiring subject, femininity could be restored to its traditional position in the objectification of masculine desire. The tactic – liberally deployed across a spectrum of male critics, from union bosses to cultural commentators – exposes the sexual values and the relations of power underpinning attitudes to consumption and production in post-war economic and cultural orders.

Léger was evidently aware of the problematics implicated in contemporary concepts of the feminine and how these might impinge on his representation of woman in a technological order. Although he did not directly confront the issues that made difficult the imaging of the woman industrial worker, he was forced to deal with the public's complicated attitudes to female sexuality when some of his representations of the female nude met with a negative critical response.

Léger introduced the theme of the female nude into his machine aesthetic with the major work, *Le Grand Déjeuner* (Figure 4.4). It was clearly intended to draw together references to the classical tradition and to the odalisque figures of Ingres with metaphors of the machine; and as such it attempted to combine potentially conflicting codes: classical, oriental, technological. By

selecting for treatment the female nude – the most potent cultural symbol of sensuality and masculine desire – Léger apparently hoped to demonstrate his notion that the modern technological consciousness produced altered perceptions even of the most entrenched symbolic forms. The work initially met with a mixed critical reaction on being exhibited at the *Salon D'Automne* in 1921. Léger's Purist associate, Amédée Ozenfant, praised it for its quality of uncompromising *dis*pleasure, congratulating the artist for refusing to pander to those who expected art to be pleasant.[28] Léger's dealer, Léonce Rosenberg, purchased the painting but subsequently expressed dissatisfaction with the 'severity' of the treatment and returned it to Léger for revisions to be made. The revised work (which borrowed more formal and technical signifiers of sensuality from Ingres in the use of warmer and darker flesh tones) was not sold again until 1925. Léger was confronted by a similar problem with his painting of two women reading, *La Lecture* (1924, Musée Nationale d'Art, Centre Georges Pompidou, Paris). When he delivered it to Rosenberg, his dealer again pleaded with him to 'be reasonable' and to make revisions to the starkly geometrical figure on the right of the composition, complaining that the woman represented had no hair (the head being delineated as a clean sphere), which was not, in his opinion, an attractive sight. Léger gave due thought to the request but, despite being broke at the time and in need of a sale – which increased the price on the woman's scalp, so to speak – he concluded that the purity of his geometric conception would be unacceptably compromised by any alteration to the work.[29] But Rosenberg's advice to his protégé, offered with an eye on the market, confirms that there were problems of legibility for viewers of Léger's images of woman. His configurations of woman and machine would not signify in terms which were in keeping with traditional values and expectations regarding the representation of femininity; nor would they read as a comprehensible new language in Léger's terms.

Léger devoted some attention to this problem after it surfaced in a letter to Rosenberg in 1922. He noted there that what he was up against was an entrenched set of sexual, aesthetic and capitalist values invested in the female nude which thwarted any attempt to inscribe it anew: fantasies of possession and control were embodied in the nude, which was primarily a commodity; collusions and compromises inherent in the relationships between artist, model and connoisseur perpetuated this situation:

Basically, it's 'fruity' women who started off the rot [and turned everything upside down]. Sensuality is taken to excess. [What can be done to resist it?] From the moment that Messrs Raphael and da Vinci reproduced their mistresses on canvas because they were beautiful, the day was lost. Imitation won. The bourgeois, born to hearty eating and living in general, were not surprised … Demand calls forth supply … What decadence![30]

In effect, Léger concluded that the function of the female body in art was primarily to create a commodity, to be the product itself, whilst necessarily disguising the patriarchal sexual values, moral conditions and socio-economic processes that produced it as such. The industrial object, the modern sign of men's creativity and production, was locked into a competition with the allure of this traditional object, the female body, already moulded by masculine vision. He realized the limitations of his idealistic notion that the deployment of geometric devices might systematically 'subjugate', domesticate or 'make safe' the image of the female body, 'un-tainting' it and bringing it into a closer alliance with the purity of the industrial object. Steeped in a history of sexuality, the female body parts could not interchange with or become an equivalent for the machine. Even in Léger's most extreme attempts, therefore, to make over this material into a plastic component – as in a variation on *Le Grand Déjeuner* work, *Les Trois Femmes et la Nature Morte* (1921, private collection, Lugano) in which the body is radically and abstractly geometricized – it is unlikely that he perceived it in terms of insignificance.

Léger worked simultaneously on *Le Grand Déjeuner* and *Les Femmes à l'Intérieur* (Figure 4.3) and it is highly probable that the problematic aspect of representing the female nude was a conscious issue in both. In the latter painting, two female nudes, identical in appearance to *Le Grand Déjeuner* figures, are rather oddly set in the company of three clothed figures of indeterminate gender. The poses and gestures of the nudes suggest maternal and odalisque types, a combination which creates a strange alliance of femininities. Traditionally, the odalisque signified an erotic, narcissistic, decorative creature of display and the motif continued to function as object of masculine desire, even when, as in the case of Matisse's contemporary reframings, it was critically discussed in an expedient post-war rhetoric of sobriety and French colonialism.[31] When the two categories of femininity – the maternal and the odalisque – intertwine, as in Léger's *Femmes dans un Intérieur*, the territory occupied appears sexually ambivalent. The space bears the signs of domestication but reads neither as a purely maternal space nor strictly as a zone for private masculine pleasure. Léger might have hoped that the adaptions and associations mapped on to the odalisque in the *Femmes dans un Intérieur* would minimize the sexual tensions circulating around the figure but, as Rosenberg's response to *Le Grand Déjeuner* and later to *La Lecture* demonstrates, the contemporary public clung to some ingrained perceptions of the nude which did not disappear when the figure was represented as part of the modern household furniture (the consumables) in the technologized home. Nevertheless, it is revealing that more recent critics have dealt with the issue by setting the nudes into a system of 'ordinary' modern sexual and labour relations: they are unglamorous creatures of comfort 'as familiar as wives', according to John Berger,[32] whilst Robert

Herbert observes that the artist uses the sign of woman as compensation for work, and he reads the figures 'as symbols of release from [men's] labor, or even as the reward for labor'.[33] The attempt to 'maternalize' the odalisque and to situate the figure amidst the mixed cast of figure types in *Femmes dans un Intérieur* involved some risk. The ambivalence of this type of maternal figure makes its meanings harder to pin down than the more readable *La Femme et l'Enfant* which was its parallel. Unwittingly, or perhaps intentionally, the odalisque/mother figure encapsulated the contradictory ideas about female sexuality which informed the post-war discourse of woman.

Léger explored further aspects of woman as spectacle in other paintings of the period. One of a thematic series, *La Femme à Mirroir* (1920, Moderna Museet, Stockholm) plays on enduring ideas of femininity and decorativeness in its Egypto-Assyrian stylization of a figure seated before a dressing-table mirror, preoccupied with her own image. The cosmetic products scattered across the dressing-table are reminders of the modern department store sales counter and the phenomenon of mass consumption. In Léger's writings, the few references to women's experience defined the world of shopping as a feminine domain in which the woman functions as 'victim' of persuasive, manipulative shopkeepers: 'A woman who goes into the store is half won over; she must buy, she will buy because her defences are destroyed by the 'shopkeeper's brilliant trick'. It's a spell, a fascination knowingly manipulated. The stores want a victim; they often have one.[34] But if the woman shopper is perceived as a victim, she is nevertheless a willing victim, according to Léger's description of a discriminating purchaser who understands the concept of spectacle: 'She too organizes her spectacle so that it will make its effect where she thinks necessary; she hesitates between the blue belt and the red one, indicates her choice, and accordingly worries about "the Beautiful"'.[35] Another of Léger's anecdotes images woman as a salesgirl and the artist's conceptualization makes clear how women's participation in the spectacle of modernity is to be understood: 'The pretty salesgirl behind her lottery booth at the fair fades before the bright multi-coloured ferris wheel – it is the beautiful object that is the attraction – each one has its time.'[36] In these vignettes, woman is presented simultaneously as purveyor, consumer and commodity in the public spaces of commerce. She constitutes the attraction; entranced and entrancing, enthralled by as well as in competition with the aesthetic allure of the manufactured object, she willingly organizes herself into a decorative spectacle. The representation articulates the idea of woman as sign of mass culture, situating woman on the side of consumerism in the system of modern production. In its casting of woman as willing victim of her own consumerist appetites, Léger's characterization bears some affinity to Métivet's Marianne, whose defences were also destroyed in a climate of seduction. In Léger's order, however, the consequences are

generally pictured as constructive (because principles of rationality and discipline prevail) rather than destructive, unlike Métivet's fiction, where the completely undisciplined protagonist 'lost her rudder' and risked sinking the nation.

It surely follows from these interconnected concepts of the female body – first, in competition with the aesthetic allure of the machine and, second, its sensuality subjugated and controlled by a masculine geometric-mechanical principle – that the idea of machine order is fundamentally a means to refetishize and not to defetishize (or make basic and unalloyed) the female body.[37] As such, it remains alluring and retains rather than loses its conventional meaningful function (sign of masculine desire) in traditional patriarchal terms of signification. This confusion of motives underpinning the act of regulating/deregulating female sexuality was at the root of Léger's problem and it explains the difficulties experienced by viewers regarding the legibility of his representation of woman.

The paradox inherent in the woman–machine relationship can be illuminated by juxtaposing Léger's representation of mother-and-child with the anarchic scenario of a slightly earlier Dadaist machinism work, Picabia's *Fille Née Sans Mère* (1916–17, Scottish National Gallery of Modern Art, Edinburgh) in which a rampant machine, depicted with its sexually coded parts in full motion, metaphorically usurps the mother's reproductive role (but not, apparently, the father's). Paradoxically, the reading of a mechanically *defeminized* scenario (in which the female body supposedly becomes 'neutral' or sexually insignificant/redundant as an effect of the superimposed mechanical element) depends upon a constant reiteration of the formal, technical and iconographical signifiers of the machine and their agency on the signs of the female body. Because the argument is premised on the logic that the processes of the machine act upon the body's sexuality, the (ostensibly) 'missing' female sexuality is ever present as the reference point for meaning. Sexuality is pronounced to exaggerated levels in the discussion of its supposed repression. The idea of the body's energies is simply reincorporated into the machine processes. The idea of sexuality is, therefore, never absent but simply displaced into the spaces between these mechanical processes and the final configurations of the representation. The invented mechanical–sexual charge is not 'neutral' because it is specifically the female body which fetishizes the machine and vice versa.[38] Whether wittingly or unwittingly, this paradox also surfaces in Léger's imagery, where it is merely less overt and presumably less intentionally ironic than in the Dadaist counterpart.

In summary, what order of technological and sexual relations is constructed in Léger's machine aesthetic and to what extent does his representation of femininity appear to challenge the attitudes to women prevalent in post-

armistice France? Overall, the range of women's occupations represented in the machine aesthetic imagery appears narrow and limited, centring on the domestic interior and situating women in terms of reproduction, consumerism and leisure. The omission of the woman factory worker creates a masculinized realm of industrial production. Femininity is simultaneously relegated to the margins of the modern technological order, signalling its decorative and sensual underside, and situated as its core competitive impulse – its source of sustenance. Given the social and political debates in France about women's actual participation in the labour market, Léger's machine aesthetic appears to draw a veil over the real conflicts of interest and power – between men and women as labourers, unionists and managers – within industrial relations during this period. But, within limits, his engagement with the sign of woman did reflect on that unsettled ground. The configuration of woman and machine disturbed the intended harmony of his artistic ideal of a body–machine equivalence by simultaneously reinforcing and refusing the conventional signs of femininity. The ambiguity of the reconfiguration presented problems of legibility for Léger's public; it constituted a point where meaning seemed to collapse. The jarring impasse which the contradictory signs of woman created in his artistic order reiterated sexual tensions arising in the broader social and ideological orders. The limitation, but perhaps also the strength, of his engagement with the signification of femininity was that it could neither be apprehended in terms of critical irony (as in Picabia's absurdist machinism) nor as a tendentious statement directed towards social challenge.

Notes

1. 'Here to Attend an Exhibition of his Cubist Art, Léger Advises Painters Not to Use Beautiful Women as their Models', *New York Herald Tribune*, 5 October 1935, p. 9.

2. Léger, F., 'The Machine Aesthetic: Geometric Order and Truth', reprinted in Léger, F., *Functions of Painting*, ed., E. Fry, trans. A. Anderson (London: Thames and Hudson, 1973), pp. 62–3.

3. Throughout this chapter, the term 'woman' is used to refer to ideological definitions and cultural representations of femininity and women except where it is preceded by a grammatical article or used to qualify a noun (such as 'woman factory hand'), where the statement is about biological definition. The term 'women' refers to actual social agents (such as in 'women's work' or 'women in the labour force').

4. Léger joined the French Communist Party whilst staying in New York in 1945. For a discussion of political hostility to Léger in the USA during the late 1940s, in the wake of Congressman George Dondero's campaign against communist influences in modern art, see Lanchner, C., 'Fernand Léger: American Connections', in C. Lanchner, (ed.), *Fernand Léger* exhibition catalogue (New York: Museum of Modern Art, 1998), pp. 63–4. For a broader discussion of Léger's political position, see Wilson, S., 'Fernand Léger. Art and Politics 1935–1955', in *Fernand Léger: The Later Years*, exhibition catalogue (London: Whitechapel Art Gallery, 1987), pp. 55–75. The ideological stances of A. H. Barr and G. Dondero are discussed by various authors in Frascina, F., (ed.), *Pollock and After: The Critical Debate* (London: Harper and Row, 1985).

5. Léger's comments on his conception of modern realities, included in a letter written in 1922, are cited in Cooper, D., *Fernand Léger et le nouvel éspace* (Geneva: Editions des Trois Collines, 1949), pp. 74–5.

6. Wood, P., and Batchelor, D., 'Popular Art: Rivera, Léger, Hal Foster ... Everybody's Friend: Public, Popular, Relevant and Effective', *Artscribe*, March–April (1988), p. 68.

7. Léger, *Functions of Painting*, pp. 132–6 and 143–8.

8. Berger, J., *Permanent Red* (London: Methuen, 1960), p. 122.

9. For example, see Green, C., *Cubism and its Enemies: Modern Movements and Reaction in French Art, 1916–1928* (New Haven, CT, and London: Yale University Press, 1987), p. 75.

10. Silver, K., *Esprit de Corps: The Art of the Parisian Avant-Garde and the First World War, 1914–1925* (London and Princeton, NJ: Thames and Hudson, 1989), p. 341.

11. Léger, cited in De Francia, P., *Léger's 'The Great Parade'*, ed., C. Weight (London: Cassell, 1969), p. 14.

12. Information and statistics relating to the social history of women in France are drawn from Becker, J.-J., *The Great War and the French People*, trans., A. Pomerans (Leamington Spa: Berg, 1985), and McMillan, J., *Housewife or Harlot: The Place of Women in French Society 1870–1940* (New York: St. Martin's Press, 1981).

13. Relevant examples of Léger's paintings are *Le Mécanicien* (1919, Munson-Williams-Proctor Institute, Museum of Art, Utica, NY); *Le Pont du remorqueur* (1920, Musée National d'Art Moderne, Centre Georges Pompidou, Paris); *Le Remorqueur* (1920, Musée de Grenoble); *Paysage Animé* (1924, Philadelphia Museum of Art).

14. Taylor's philosophy is expounded in Taylor, F. W., *The Principles of Scientific Management* (New York and London: Harper, 1914). For a discussion of attitudes to Taylorist systems in French industry, see Doray, B., *From Taylorism to Fordism: A Rational Madness*, trans. D. Macey (London: Free Association Books, 1988). For a discussion of the Purists's interest in Taylorism, see McLeod, M., '"Architecture or revolution"; Taylorism, Technocracy and Social Change', *Art Journal*, summer (1983), pp. 132–47. With reference to my argument regarding the gendering of Taylorism in French aesthetics of the early 1920s, note the view that a possible catalyst to the introduction of the Taylorist system in French factories was the wartime need of industrialists 'to adapt their methods of production to allow women to replace men at jobs which had previously called for the expenditure of considerable physical effort', McMillan, *Housewife or Harlot*, pp. 158–9. This suggests that Taylorist methods defined a standard of worker's productivity based on a masculine quota.

15. Léger, F., 'Correspondance', *Bulletin de l'Effort Moderne*, 4, April (1924), pp. 10–12.

16. See Huss, M. 'Pronatalism in the Interwar Period in France', *Journal of Contemporary History*, **25** (1990), pp. 39–68.

17. *Exposition Nationale de la Maternité et de l'Enfance*, Bois de Boulogne, Paris, June–July, 1921.

18. My discussion of Lebasque's Peace Loan poster draws on Silver, *Esprit de Corps*, pp. 282–3.

19. I have not presumed a simple connection between different categories of imagery which pictured the theme of motherhood, but rather have considered as distinct the objectives, interests and publics relevant to maternal imagery produced in different, though related, visual orders – in this case, propaganda publicity and vanguard painting. Obviously, the avant-garde painter's formal and technical means were the critical factor in any work, signalling particular and distinct 'radical' artistic dispositions at a time of constant competitive realignments and functioning in a highly specialized system of signification. The complexities of the avant-garde's relationships to the apparatuses of ideology need to be borne in mind and it would certainly be a misconception to assume that the social significance of the representation of maternity generally registered as an important issue in French art criticism of the period. The disinclination of the vanguard critics to address the possible social meanings in the iconography of motherhood is evident in their employment of idealist terms of reference, although their writings were often imbued with a nationalistic and moral tone and often stressed that the 'spirit of the epoch' was incarnated in works on this theme. This approach enabled the artistic representation of maternity to be regarded as simultaneously relevant but disengaged. For a fuller discussion of these issues, see the section on 'Avant-gardism and the representation of maternity' in chapter 10 of my M. Phil. dissertation, 'The Machine, the Body and the Representation of Woman in Léger's Theory and Painting, 1918–1925', University of London, 1997, pp. 222–35.

20. In addition to the social historical sources already cited, see Cobban, A., *A History of Modern France. Volume 3: 1871–1962* (London: Penguin, 1988).

21. *Humanité*, 16 May 1917, cited in McMillan, *Housewife or Harlot*, pp. 146–7.

22. Mlle Crabol, 'La presses et les grèves parisiennes de 1917', *Le Mouvement Social*, 53, October–December (1965), cited in McMillan, *Housewife or Harlot*, p. 150.

23. Ibid.

24. See Becker, *The Great War*, pp. 211–16 and p. 308.

25. See Wollen, P., 'Out of the Past: Fashion/ Orientalism/ the Body', *Raiding the Icebox: Reflections on Twentieth-Century Culture* (London: Verso, 1993), pp. 1–34; Silver, *Esprit de Corps*; Golan, R., *Modernity and Nostalgia: Art and Politics in France Between the Wars* (New Haven, CT, and London: Yale University Press, 1995); Gronberg, T., *Designs on Modernity. Exhibiting the City in 1920s Paris* (Manchester and New York: Manchester University Press, 1998).

26. Métivet, L., 'Marianne et Germania: l'histoire d'un bonnet et une casque', *La Baïonnette*, **4** (146), 18 April (1918), pp. 242–56. For a discussion of this work, see Silver, *Esprit de Corps*, pp. 13–24 and 180–81.

27. Métivet, 'Marianne et Germania', p. 252.

28. Ozenfant, A., ('De Fayet'), *L'Esprit Nouveau*, **13**, (1921), p. 1506.

29. Drawn from Léger's correspondence, cited in Schmalenbach, W., *Léger*, trans. R. Allen and J. Emmons, (London: Thames and Hudson, 1991), p. 90.

30. Léger, 'Correspondance', pp. 10–12 and adapted by the artist in various subsequent statements with additions as indicated in the bracketed phrases in my quotation.

31. For a discussion of critical perceptions of Matisse's 'odalisque' themes with reference to contemporary colonialist discourses, see Silver, *Esprit de Corps*, pp. 258–64.

32. Berger, *Permanent Red*, p. 122.

33. Herbert, R., *Léger's 'Le Grand Déjeuner'*, exhibition catalogue (Minneapolis: Institute of Art, 1980), p. 27.

34. Léger, F., 'Le Spectacle', *Bulletin de L'Effort Moderne* (1924), in Léger, *Functions of Painting*, p. 36.

35. Ibid, p. 45.

36. Léger, F., 'Ballet-Spectacle', *Bulletin de L'Effort Moderne* (1925), in Léger, *Funtions of Painting*, p. 73.

37. For an analysis of further contemporary Parisian cultural representations of the female body fetishized through principles of manufacturing and advertising, see Gronberg, T., 'Beware Beautiful Women: The 1920s Shopwindow Mannequin and a Physiognomy of Effacement', *Art History*, **20** (3), September (1997), pp. 375–96.

38. For a fuller version of this argument, see my M. Phil. dissertation, 'The Machine, the Body', pp. 222–35 and 244–5.

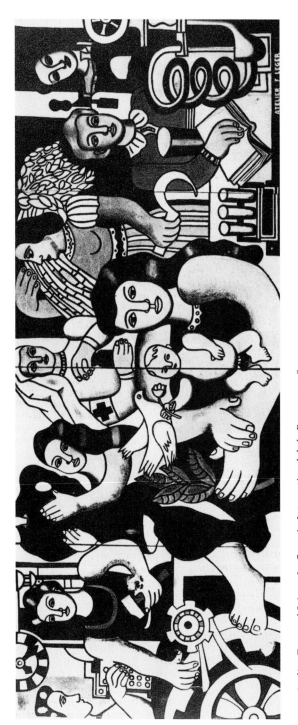

4.1 Atelier Fernand Léger, *Le Congrès International de la Femme*, 1948

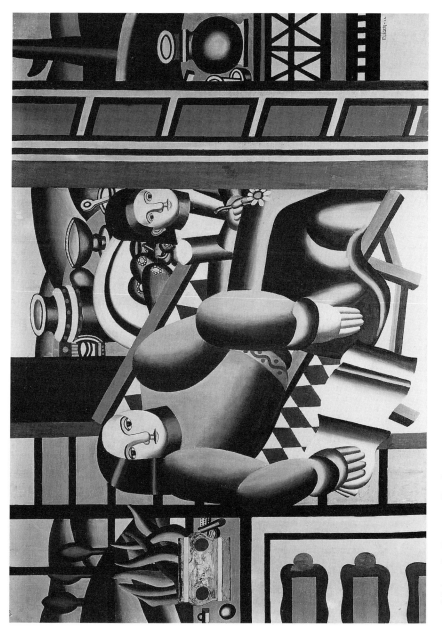

4.2 Fernand Léger, *La Femme et l'Enfant*, 1922

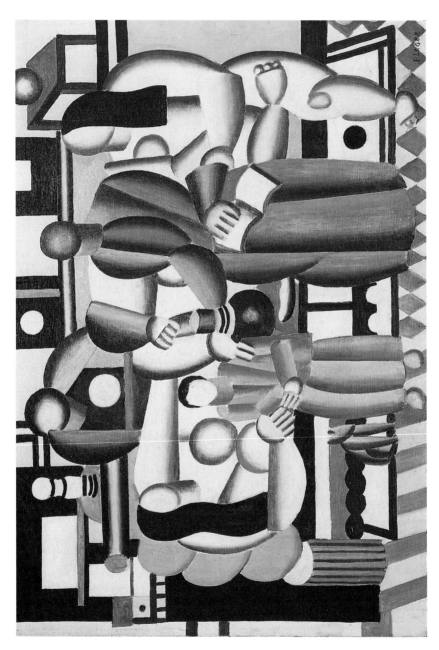

4.3 Fernand Léger, *Femmes dans un Intérieur*, 1921

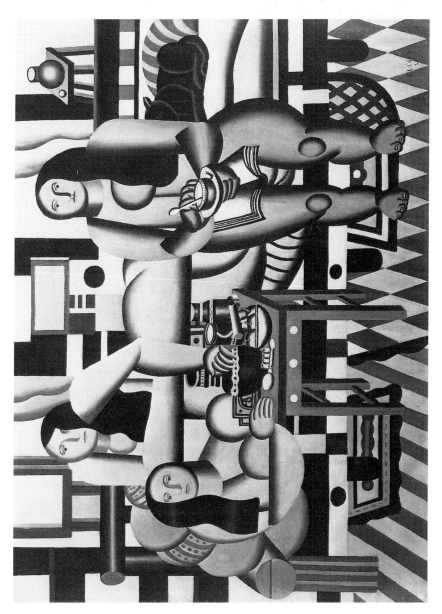

4.4 Fernand Léger, *Three Women* (*Le Grand Déjeuner*), 1921

'A progressive dematerialisation of labour power':[1] a problem for visual representation in Germany in the 1920s

Martin Ignatius Gaughan

The historical period being addressed in this chapter may be charted by the change in working practices, the nature of work and the role of the worker represented through images like those of Van Gogh's *The Sower* (1888) and the advertisement of the German motor manufacturer, Opel, in 1925 (Figure 5.1). This change marks a paradigm shift, from work and worker as part of a still significantly natural cycle, to work and worker as the increasing focus of investigation for the science of work and scientific work management. The transition may be generally characterized within the following two broad registers. The first is from Mark Seltzer's *Bodies and Machines*, where he describes the new forms of life that the human will–technological determinism polarity takes 'as the conflict between the logic of market culture and possessive individualism *and* the logic of machine culture and disciplinary individualism', a characterization of earlier and later forms of capitalism and its subjectivities.[2] The second register derives from the work of Anson Rabinbach, *The Human Motor: Energy, Fatigue and the Origins of Modernity.* Rabinbach characterizes the transition represented in these images as a shift from the consideration of the body as a machine to the body as a motor, now measured according to what he terms 'an energetics calculus'. It is the beginning of a process which may arguably be seen to be leading to 'a progressive dematerialisation of labour power', 'the end of a work-centred society' and what Rabinbach designates 'The Obsolescence of the Body': he writes, 'The displacement of work from the centre to the periphery of late 20th century thought can thus be understood by the disappearance of the systems of representations that placed the working body at the juncture of nature and society – by the disappearance of the human motor'.[3]

The particular focus of this chapter is narrower in location and period – Germany *c.* 1900–40, during which the 'human motor' is still being investigated as central to the working process. It is, however, a period in

which the theorization of work and worker makes these categories increasingly problematic: it is *the* social crisis in Imperial Germany, the Weimar Republic and the National Socialist state. As the status of work and worker became problematic so did their representation.

In the second chapter of *The Human Motor,* Rabinbach refers to a general recognition towards the end of the nineteenth century of the relationship between an epistemological crisis in the natural sciences and the dissolution of traditional modes of perception in the arts, before focusing more particularly: 'A case in point is the simultaneous impact of thermodynamics on the perception of the working body and on the representation of time and space in philosophy.'[4] Rabinbach's reference to the working body is here informed by the ideas of Helmholtz and Marx, from an earlier section titled 'The Marriage of Marx and Helmholtz'. Whilst Bergson and Duchamp are mentioned in relation to philosophy and art, the important figure here is Marey, a key mediator between social and cultural modernity. Rabinbach proposes that both Helmholtz and Marx conceived of the body 'as a field of forces capable of infinite transformation and conversion ... This body mediated the laws of nature with the laws of production: it dissolved the anthropomorphic body as a distinct entity and made the industrial body a sophisticated analytics of space and time'.[5] Marey's investigative practices realized in a sense those analytics of space and time, concerned as they were with raising questions about the nature of forms in this newly theorized spatiotemporal world. Embodying those discourses and practices constituting the emerging science of work – he was physician, physiologist, pioneer of medical measurement, student of hydraulics, and photographic and cinema pioneer – Marey introduced, Rabinbach writes: 'a new language to describe the body at work, a language of time and motion. He prodigiously invented complex instruments of graphic description', a kind of inscription further described as 'a sort of automatic writing (that) united the body's own signs (pulse, heart rate, gait) with a language of technical representation'.[6]

At this moment in the late nineteenth century there was, therefore, in place a set of discourses and practices that increasingly displaced theories of work based on a moral economy, an ethic of work, and made problematic the representation of work. It was not that workers at work would not be represented, as they continued to be in Naturalism and in the art of left-wing Weimar artists, but there was a sense that another process was in train, a kind of 'voice over', one which cannot be accommodated effectively within the more traditional media of visual production. The Helmholtz-Marey discourses and practices are the initial stages of what would become the Science of Work, founded on laboratory experiments and investigation, new techniques of measurement and photographic studies, a science in whose discoveries, Rabinbach writes 'the image of labour was radically transformed.

It became labour power, a concept emphasising the expenditure and deployment of energy, as opposed to human will, moral purpose or even technical skill'.[7]

This image of the worker wielding the hammer, (Figure 5.2) taken by means of a photographic rifle and comprised of 15 superimposed shots, is from the investigations of Charles Fremont, an engineer working in Marey's laboratory; it was published in the popular Paris monthly, *Le Monde Moderne,* in February, 1895. Here the investigator is concerned only with mapping labour power and the contours of energy flow, for which the working body is the transformer, the worker 'a ghost in the machine', as it were, dematerialized in the universal force field of energy, a particle in that continuum of 'cosmos, (the) factory, (the) worker', a scientific trope which Rabinbach sees as characterizing the thinking of influential investigators and propagandists of the science of work.

Crucial to the development of this science of work was the reconceptualization of the functioning of the body, from a model based on a machine analogy to that of the body as motor, whose powers and output may now be measured by 'a calculus of energetics'. Scientific materialism, Rabinbach writes, accorded to the body and to energy a 'trans-sensual' character: the forms of energy might still be manifest to the world of the senses, 'but energy itself was a hidden, invisible and secret substance embedded in all these forms'.[8] In this play of latent and manifest forms of energy's presence the work scientist's calculus was the crucial determinant of performance, a dimension which was not immediately available to tracking and tracing through conventional visual representation.

Before moving on to focus on Germany I want to return to the Van Gogh and the Opel advertisement images in order to address some of the complex ideological positions involved. We should not be surprised that the work scientists would enter claims for value-free objectivity and scientific neutrality. It was an attempt by liberal reformers to move beyond the traditional ethical and moral positions on work which, they argued, were inappropriate and inadequate in the later decades of the nineteenth century. Their aim was to mediate between capital and labour in the interest of conserving the nation's energy, maximization of output and optimization of input, the promotion of work practices that protected the worker from fatigue. Whilst these perceptions might be seen as naïve or self-deceptive, blatant evidence of false consciousness, there was not a simple ideological divide on the science of work. The reference in the Van Gogh may be accommodated within a moral economy of labour, with its biblical connotations. It may even span moments in the history of political economy, a primitive moment in Adam Smith, of whom Foucault writes: 'he unearths labour, that is toil and time, the working day that at once patterns and uses up man's life'.[9] There is a moment in the development of Marx's thinking which could also accommodate it. Quoting

Alfred Schmidt's study of Marx's theory of nature, Rabinbach writes that 'until he completed the preparatory work for the first volume of *Capital*, Marx conceived of the human relation to nature in terms of a metabolic exchange of matter, mediated through labour, which secured basic social needs and requirements', a position which reflected 'both the pantheism and "metaphysical" materialism of his generation'.[10] If in no more than a 'family resemblance' sense Van Gogh's sower may be seen as operating in a representational space opened up by Courbet, about whom Terry Smith writes: 'In general terms we can see in Courbet's art a profoundly serious exploration of how painted representation might stand to the complex internal economy of production itself, in all its aspects, emphasising now process, now presentation, but always examining both.'[11]

The tenor of this chapter is that this depth model is no longer available in that sense because of changes in the theorizations of work and worker. But Marx's position on this was to change – the marriage with Helmholtz and the laws of thermodynamics as characterized above. Rabinbach traces the shift in Marx's redefining of labour through the *Grundrisse* and *Capital*, from 'a metabolic exchange of substances between man and nature to a conversion of force', in which Marx now saw the labouring body as a natural force among others, 'united by the universal equivalence of *Kraft* (energy/power)'.[12] The Opel worker may be seen as standing on this side of that general development away from the natural metabolic exchange: the sower is now the human dynamo. We are informed that Opel uses the serial mode of production with the most rationalized work methods and that a completed car leaves the factory every 4 minutes 50 seconds. The gigantic worker apparently invites us to count (*Bitte zählen*), but in this context he himself seems to be merely part of that 'energy calculus' which the science of work, more particularly its Taylorist version, proposes. The clarity of an ideological position is confounded by the early Bolshevik enthusiasm for the Taylorist method, despite its levels of reification of the work process. Lenin recognized it as 'a combination of the subtle brutality of bourgeois exploitation and a number of its greatest scientific achievements … in the working out of correct methods of work'.[13] Marx's subscription to the concept of the 'human motor' and Lenin's to Taylorism were, of course, in the context of a political economy very different from that of its supporters amongst the scientists of work.

In their introduction to section 15 of *The Weimar Republic Sourcebook*, titled 'Imagining America: Fordism and Technology' the editors write, concerning Taylorism and Fordism: 'Both doctrines eventually integrated the ideas of a more psychologically oriented pre-war science of work (*Arbeitswissenschaft*) into a uniquely German theory of scientific management.'[14] I now want to focus on Germany, to trace what historians have called its special, if not unique, pathway (*Sonderweg*) to modernity,

culminating in the National Socialists' seizure of power as a response to a profound crisis in capitalism, more specific to Germany with the withdrawal of American investment after the Wall Street crash – the Opel advertisement standing for the high moment of the Americanization and rationalization of the German economy. The basic constituents which give rise to the *Sonderweg* supposition may be briefly summarized as Bismarck's authoritarian state, rapid and intensive industrialization, an economically powerful but politically impotent bourgeoisie, and the growth of a strong and disciplined socialist working-class movement. Correspondingly, within the arena of the science of work specific differences have also been noted: unlike France, German industry before the First World War, including many of the major concerns like Börsig, Bosch, Siemens and Daimler-Benz, was instituting Taylorist methods. There had been little development of a science of work in Britain before 1914. In a comment which brings art into relationship with the developing science of work, Charles S. Maier writes: 'Conversely, those places where the cultural avant-garde showed little response displayed less interest in the new doctrines in general. In England, before the war, schemes of scientific management awoke scant interest among engineers and managers.'[15] Post-war German developments further intensified difference: there was the November Revolution of 1918 and the formation of Soviets or *Räte* of soldiers, sailors and workers who ran many of the major German cities until February 1919, and the foundation of the German Communist Party by Rosa Luxemburg and Karl Liebknecht in December, 1918. Consequently, the theorizations of work and worker between *c.* 1890 and 1940 assumed an urgency which can be seen as particular to the German experience.

The outbreak of war facilitated the promotion of the two major strands of the scientific approach to the categorization of the work process, that is, the European science of work with its energeticist model and the American Taylorism with its scientific management, greatly accelerating, as Rabinbach claims 'the integration of the science of fatigue and psychophysics into the vocabulary of modern economic life'.[16] Central to this promotion was the role of the Kaiser Wilhelm Institute for Labour Physiology (Kaiser-Wilhelm Institut für Arbeitsphysiologie) founded in 1913. Its research focus was on the 'biophysiological aspect, the elimination of fatigue', its purpose 'to make practicable the discoveries of physiological energetics', through its investigations of the 'performance of the body as a work machine' (*Arbeitsmaschine*), its measurements of groups of muscles or individual muscles.[17] The institute also developed aptitude tests for evaluating the functional performance of military drivers, pilots and railway personnel. All of these constituted an array of methods which would be deployed after the war, as the institute's director, Rubner, predicted: 'psychological

testing and psychophysical aptitude tests could result in the selection of the most fit forces (*Kräfte*) for industrial work'.[18]

With the slogan 'the right man for the right job' psychotechnical aptitude testing, was to become a virtual craze in the immediate post-war period, a phenomenon which does not elude the perceptive eye of Walter Benjamin. Here, in his 'The Work of Art in the Age of Mechanical Reproduction' essay, in a sometimes ambivalent passage on the 'auratic' and cultic, Benjamin is writing on a sphere of activity somewhat distant from but not unrelated to that of the industrial worker in the rationalized factory, that of the 'industrialized' actor in the film industry:

> The expansion of the field of the testable which mechanical equipment brings about for the actor corresponds to the extraordinary expansion of the field of the testable brought about for the individual through economic conditions. Thus vocational aptitude tests become constantly more important. What matters in these tests are segmental performances of the individual.[19]

In describing the experience of the actor before the camera and her or his relationship as producer within a rationalizing economy, material and cultural, Benjamin also points up the more general condition obtaining: 'This market, where he offers not only his labour, but also his whole self … is beyond his reach. During the shooting he has as little contact with it as any article made in a factory'.[20] Benjamin compares the director with the examiner in the aptitude test.[21] By 1922 there were 170 testing stations operating in Weimar Germany and chairs were established in the polytechnic universities (*Technische Hochschülen*).

The First World War soldier, and highly influential conservative revolutionist, Ernst Jünger wrote in one of his most acclaimed books, *Der Arbeiter* (1932), of 'the amazing identity of process' in the conjoining of the war front and the labour front: 'The soldier's uniform appears ever more clearly to be a special case of a labour uniform.'[22] One of the government-appointed engineers for post-war planning, Moellendorff, saw Taylorism's function as 'a militarism of production'.[23] This conjoining may offer a site for access to a dimension of a representation of the science of work, but with its logic, as it were, inverted, a photographic negative. The image for Figure 5.3 is taken from the work of the French scientist of work, Jules Amar, illustrated in his book, *The Physiology of Industrial Organisation and the Re-employment of the Disabled*, published in 1919.[24] It may be extreme or at least over-dramatic to introduce Henry Ford into this conjoining, to quote from his fantasy of scientifically managed production in this context, but neither is it inapposite. He is describing the production of the 1923 Model T, which required 7 882 distinct operations: he estimated that only 12 per cent of the tasks involved required 'strong able-bodied and practically physically perfect men': '670 operations could be filled by legless men; 2 637 by one-legged men; two by armless men; 715 by one-armed men, and ten by

blind men'.[25] The calculus of the human motor is finely calibrated and tuned here in this grotesque dismembering of the body. Here we have what Mark Seltzer has termed the double-logic of the prosthesis, agency removed from the body but simultaneously the body's functioning apparently extended through technology.

Another but very different conjoining might be that of artists and writers on the left in Weimar Germany, in this case John Heartfield, his 'It all depends on where you're going' ('*Es kommt immer darauf an wohin die Reise geht*'), 1927 (Figure 5.4), and Bertolt Brecht. Brecht is writing about the problem of picturing reality – here he is being quoted by Benjamin in his 'A Small History of Photography':

the situation is complicated by the fact that less than ever does the mere reflection of reality reveal anything about reality. A photograph of the Krupp works or the AEG tells us next to nothing about these institutions. Actual reality has slipped into the functional. The reification of human relations – the factory, say – means that they are no longer explicit. So something must in fact be *built up*, something artificial posed.[26]

The reference is to the distancing of the epic or montage principle, which was to be deployed in *Kuhle Wampe*, the 1932 film on which Brecht collaborated, where the assembly-line working experience of the young women is fleetingly contrasted with their co-operative work within the local German Communist Party (KPD) organization. Heartfield indeed builds something up, poses something artificial, and also uncannily echoes the last two images and, eerily, the world of Ford's imaginary workforce. The politics are specific – the immediate focus is the German Social Democratic Party (SPD), with its newspaper *Vorwärts* (Forward) and its exhortation 'back to the free market', the separation of the KPD position on technology from that of the SPD; as Rabinbach reminds us, for a period of time 'the Taylor system was evidence of a Marxist faith in the automatic process of history in which every technological development is justified as a future benefit to the working class, while present dislocations are temporary "stages" on the road to increased productivity and expanded socialisation'.[27]

By the time Heartfield produced this montage the Americanization of the German economy (after the Dawes Plan of 1924) and the rationalization of industrial production had ushered in the era of the New Objectivity and its obsession with the surface appearance of the technological order – the Benjamin/Brecht quote above is a critique of the photographic work of that tendency. The Heartfield new man is the post-Dawes Taylorist worker, part stopwatch, part work study spreadsheet, part machine elements, a dis-articulated body. A more general gloss of the image might be provided by a quote from Siegfried Kracauer, concerned with the same phenomenon: it is from the essay 'The Mass Ornament', to which I will also be referring below, and like the Heartfield it is also from 1927: 'Personality and national

community perish when calculability is demanded; only as a tiny particle of the mass can the individual human being effortlessly clamber up charts and service machines.'[28]

Mark Seltzer quotes an interesting passage from *The Inside History of the Carnegie Steel Company*, published in 1903, which seems apposite here in the insight it provides into the application of scientific management. Seltzer quotes James Howard Bridge, who writes: 'The men felt and often remarked that the eyes of the company were always on them through the books ... the process of production is replicated in paper form before, as, and after it takes place in physical form.'[29] There is another register of invisibility in the work process, one which Heartfield attempts to address, producing a work which puts the traditional visual modes under strain, which demands thinking as much as looking. Another quote from Benjamin may provide an elaborated context for considering the implications of Heartfield's representational strategy: 'Thus is manifested in the field of perception what in the theoretical sphere is noticeable in the increasing importance of statistics. The adjustment of reality to the masses and of the masses to reality is a process of unlimited scope, as much for thinking as for perception.'[30]

Scientific management did not only colonize and construct the body at work, but as a number of contemporary German commentators, chief amongst whom was Siegfried Kracauer, claimed, was also instrumental in shaping the body's behaviour and performance during leisure time. As a practice Fordism offered a kind of alternative to Taylorism, it was less narrowly work centred in its approach: as Rabinbach remarks, 'Above all, Fordism divorced social "happiness" from the workplace', offering instead the possibility of consumerism and the distraction of leisure-time activities.[31] Not concerned with 'joy in work' or the 'ennoblement of work', two crucial concepts in German labour theory, leisure offered compensation for the activity of work and its rationalization through the rhythms of its conveyer belt production process.[32] This displacement of work in favour of leisure, or even more so, the colonization of leisure by the automated work process, was the dimension which attracted the attention of Kracauer, then writing as a regular contributor to the liberal daily newspaper, the *Frankfurter Zeitung*. His focus is the troupes of dancing girls appearing on Berlin stages, and featured in films and photojournals, troupes described as 'products of American distraction factories', 'artificially manufactured in the USA and exported to Europe by the dozens', ambassadors, as it were, of the power of American rationalized production.[33] Writing of the Tiller Girls and their rationalized, geometrical formation routines, Kracauer argues that they 'are never performed by whole, autonomous bodies ... Arms, thighs and other segments are the smallest components of the composition'. Like the Fordist system in which 'everyone goes through the necessary motions of the conveyor belt, (and) performs a

partial function without knowing the entirety', so with the routines of the dance troupes.[34] 'Distraction factory' and automated factory are brought into alignment by Kracauer: 'The hands in the factory correspond to the legs of the Tiller Girls', legs which are 'the abstract signs of their bodies', not 'natural units of their bodies'. 'Psycho-technical aptitude tests' he continues 'seek to compute emotional dispositions above and beyond manual abilities.'[35] In 'Girls in Crisis' Kracauer wrote,

When … [the Girls] form their undulating chorus lines they demonstrate the virtues of the conveyor belt. Their fast dance steps seem to proclaim: business, business; when they kicked their legs high with mathematical precision, they joyously affirmed the progress of rationalisation; and when they kept repeating the same movement without ever interrupting their routine, one envisioned an uninterrupted chain of autos gliding from the factory into the world (and believed that the blessing of prosperity had no end).[36]

This is the 'aesthetic reflex' (the term is Kracauer's from 'The Mass Ornament') of the world of the Opel advertisement.

Kracauer was not alone in such observations. Another contemporary, Heinz Ludwigg commented that 'nowadays when mass production and the Ford method of manufacture have become common practice the *girls*, too, become part of this process'.[37] One of the major work study proponents of the period, Fritz Giese, who wrote *The Philosophy of Work* in 1932 (influenced by Heidegger's philosophic reflections on technology and industrial labour), also published a study on the dancing troupes, in 1925, titled '*Girlkultur*: comparisons between American and European rhythm and life processes'.[38] This text adds to that body of observations linking 'distraction factory' to automated factory. A more recent commentator, Martha Banta, writes of 'the totalising logic of scientific management and its pervasiveness far beyond the factory floor to encompass every aspect of cultural existence'.[39]

In passages which are suggestive but nevertheless also problematic both Kracauer and Benjamin point to difficulties confronting the elaboration and deployment of adequate visual strategies at this specific crisis point in history. Benjamin writes that 'For the tasks which face the human apparatus of perception at the turning points of history cannot be solved by optical means, that is, by contemplation alone', a situation which is 'symptomatic of profound changes in apperception'.[40] For Benjamin film is the medium, distraction its mode of reception: 'That which determines the rhythm of production on a conveyor belt is the basis of the rhythm of film', a surprising conjoining in light of much of the above, a salvationary critique apparently being attempted on inimical territory.[41] Kracauer's articulation, too, seems contradictory, apparently supporting the culturally suspect, writing: 'When significant moments of reality become invisible in our world, art must make do with what is left, for an aesthetic presentation is all the more real the less it

dispenses with the reality outside the aesthetic sphere.'[42] The debased site of the mass ornament, of which the Tiller Girls is one element, for Kracauer nevertheless gives on to 'a degree of reality (that) is still higher than that of artistic productions which cultivated noble sentiments in obsolete forms – even if it means nothing more than that'.[43]

Both writers trace the problems from their origins in the colonization of work and leisure through scientific management and the science of work, the general drift of the modernization process towards massification. Kracauer's concern with the disappearance or non-visibility of 'significant moments of reality in our world' relates to his perception of the 'perishing' of 'personality' when 'calculability is demanded', when human beings clamber up charts and service machines.[44] Central to Benjamin's concern is the strain placed upon the 'optical' and the 'human apparatus of perception' by the historical moment and how the processes of apperception register that strain, essentially the demand for some mediation between social knowledge and visual registration. If the cultural representation of the high moment of the rationalization process is *Neue Sachlichkeit* (New Objectivity) photography, then a counter-discourse and deconstructive practice, however meagre, may be the only response. I have already quoted Brecht on the *Neue Sachlichkeit* photograph of the factory. Kracauer, in the same year that he wrote 'The Mass Ornament' essay, (1927), also wrote an essay on photography in the *Frankfurter Zeitung*: 'In order for the subject to be meaningfully represented, the mere surfaces offered by the photograph must be somehow disrupted … the likeness achieved by the photograph refers only to the exterior of the object, which does not readily disclose its internal meaning as it manifests itself to the understanding.'[45]

Both Kracauer and Benjamin advocate some form of intervention in the image: Benjamin with his suggestion of a caption, Kracauer with that of a disruption, strategies and systems of representation 'as much for thinking as perception', what Brecht would more generally designate as the epistemological foundation for a modernist realism. That these ideas should come to be articulated towards the end of the 1920s and in Kracauer's case in 1927, the year of Heartfield's montage, is not to propose a teleology which throws into crisis all modes of visual representation and privileges Heartfield's. But its claims may be forcefully advanced: writing of the mechanisms of collage as a site of resistance in his review of Banta's book, Jonathan Veitch states: 'Through its exploitation and analysis of this process (the engineer's disassembly and re-assembly of parts) the collage offers a powerful mode of social criticism, perhaps *the* most powerful mode of criticism available to those forced to live under a "Taylorised modernity".'[46] The issue here is the broad cultural effects of the theorization of work on the status of work and that of the worker, centrally crucial to the social order in general, but more

narrowly focused on its representation, a brief history of which might be sketched across three paradigmatic instances, the Van Gogh, the Opel and the Heartfield. The particular, if not unique, pathway of Germany through the modernizing process was to inflect the debate over the meaning of work: its Marxist informed artists and cultural theorists were to intensify further that question. Without necessarily overloading Heartfield's montage with historical or cultural pretension it did present the occasion, if not specifically, for questioning how problematic the representation of work became at an important ideological level. Heartfield's representational strategy would soon establish its context in the pages of *A-I-Z*, where Benjamin's caption and Kracauer's disruption, in a politics more concerned with the consequence of work, can find a space, one which might be termed factographic.

Notes

1. This part of the title is taken from Anson Rabinbach's study, *The Human Motor: Energy, Fatigue and the Origins of Modernity* (New York: Basic Books, 1990), p. 295.

2. Seltzer, M., *Bodies and Machines* (New York and London: Routledge, 1992), p. 83.

3. Rabinbach, *The Human Motor*, pp. 295, 300.

4. Ibid., p. 86.

5. Ibid., p. 87.

6. Ibid., pp. 87, 97.

7. Ibid., p. 4.

8. Ibid., p. 289.

9. Foucault, M., *The Order of Things* (London: Tavistock, 1974), p. 225.

10. Rabinbach, *The Human Motor*, p. 77.

11. Smith, T., 'Modes of Production', in R. Nelson, and R. Shiff, (eds), *Critical Terms for Art History* (Chicago and London: University of Chicago Press, 1996), pp. 248–9.

12. Rabinbach, *The Human Motor*, p. 77.

13. Quoted in Charles S. Maier, 'Between Taylorism and Technocracy: European Ideologies and the Vision of Industrial Productivity in the 1920s', *Journal of Contemporary History*, **5** (2), (1970), p. 51, n. 58.

14. *The Weimar Republic Sourcebook*, eds A. Kaes, M. Jay and E. Dimendberg (Berkeley and Los Angeles, CA, London: University of California Press, 1994), p. 394.

15. Maier, 'Between Taylorism and Technocracy' p. 37.

16. Rabinbach, *The Human Motor*, p. 259.

17. Ibid., pp. 262–3.

18. Quoted in Rabinbach, *The Human Motor*, p. 264.

19. Benjamin, W., *Illuminations*, ed. H. Arendt, trans. H. Zohn (Glasgow: Fontana/Collins, 1982), p. 248, n. 10.

20. Ibid., p. 233.

21. Ibid., p. 248, n. 10.

22. Quoted in Seltzer, *Bodies and Machines*, p. 222, n. 31.

23. Maier, 'Between Taylorism and Technocracy', p. 48.

24. This image is reproduced in Seltzer, *Bodies and Machines*, p. 159. Another image which can be brought into this context is a photograph from Ernst Friedrich's 1924 publication *War against War* (*Krieg dem Kriege*), titled 'The war-wounded proletarian at his daily "sport"'. This was a highly contentious publication whose images sourced artists on the left in Weimar. The volume was reprinted in 1987, Seattle: Red Comet Press. The image is reproduced in H. Foster, 'Prosthetic Gods', *Modernism/Modernity*, **4** (2), (1997), pp. 5–38.

25. Quoted in Seltzer, *Bodies and Machines*, p. 157.

26. Benjamin, W., *One Way Street and Other Writings*, trans. E. Jephcott and K. Shorter (London: Verso, 1985), p. 255. Rabinbach's comment that the European science of work and Taylorism shared the same focus, 'the body – not the social relations of the work place – was the arena of labour power' (*The Human* Motor, p. 11), complements Brecht's statement.

27. Rabinbach, *The Human Motor*, p. 257. Significantly, the Heartfield montage appeared in the KPD satirical journal *Der Knüppel* (The Cudgel).

28. Kracauer, S. 'The Mass Ornament', *New German Critique*, **5**, spring (1975), pp. 67–76, p. 69.

29. Seltzer, *Bodies and Machines*, p. 159.

30. Benjamin, *Illuminations*, p. 225.

31. Rabinbach, *The Human Motor*, p. 282.

32. Joan Campbell provides a richly detailed account of how these terms were deployed in the history of German work, particularly from their foregrounding in the industrial design philosophy of the *Deutscher Werkbund* through to the National Socialist era. See her *Joy in Work, German Work: The National Debate, 1800–1945*, (Princeton, NJ: Princeton University Press, 1989).

33. Kracauer, 'The Mass Ornament', p. 67.

34. Ibid., pp. 69–70.

35. Ibid., pp. 74, 70. His observations concerning the correspondence between the automated factory and 'distraction factory' are briefly represented in a short passage in Walter Ruttmann's 1927 'documentary' film, *Berlin, Symphony of a Great City*, with the appearance of the Tiller Girls.

36. Kracauer, 'The Mass Ornament', pp. 63–4.

37. Quoted in Berghaus, G., '*Girlkultur*-Feminism, Americanism and Popular Entertainment in Weimar Germany', *Journal of Design History*, **1** (3–4), (1988), pp. 193–219, 212.

38. Ibid., p. 217, n. 43. The original title was '*Girlkultur; Vergleiche zwischen amerikanischem und europäischem Rhythmus und Lebensgefühl*'.

39. Banta, M., *Taylored Lives: Narrative Production in the Age of Taylor, Veblen and Ford* (Chicago: University of Chicago Press, 1993).

40. Benjamin, *Illuminations*, p. 242.

41. Ibid.

42. *The Weimar Republic Source Book*, p. 407. This is a slightly better translation than that which appears in the *New German Critique*, p. 70. The German passage appears on p. 54, *Das Ornament der Masse* (Frankfurt am Main: Suhrkamp Verlag, 1977).

43. *The Weimar Republic Source Book*, p. 407.

44. Kracauer, *New German Critique*, p. 69.

45. Quoted in Eskilsden, U., 'Photography and the New Sachlichkeit Movement' *Neue Sachlichkeit and German Realism of the Twenties* (London: Arts Council Catalogue, 1978), p. 91.

46. Veitch, J., Review in *Modernism/Modernity*, **1** (3), (1994), pp. 265–6.

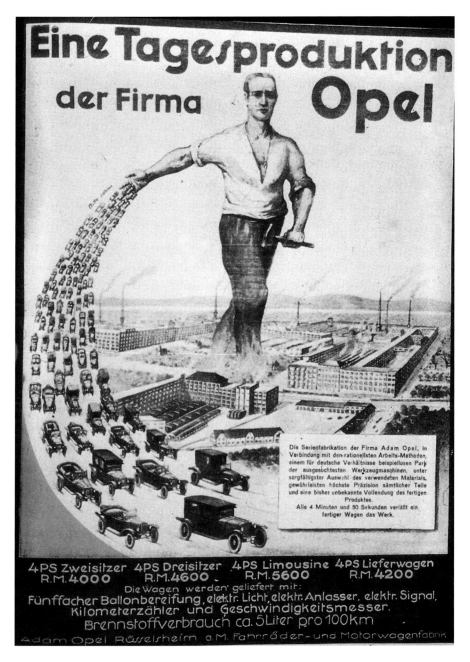

5.1 Advertisement for the German car firm, Opel, 1925

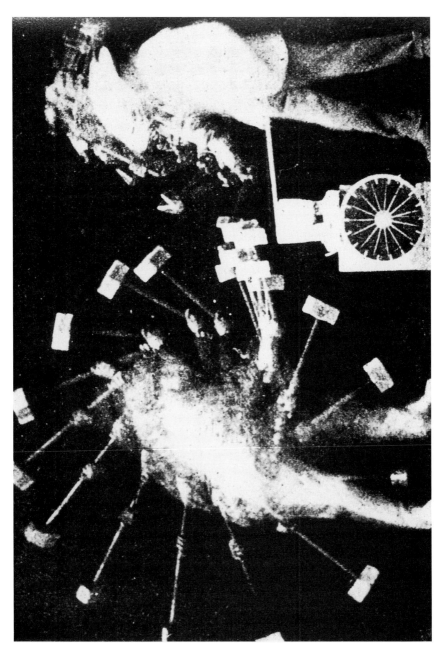

5.2　Photograph published in *Le Monde Moderne*, Paris, 1895

5.3 Photograph published in Jules Amar's, *The Physiology of Industrial Organisation and the Re-employment of the Disabled*, 1919

5.4 Photomontage published in *Der Knüppel* (*The Cudgel*), 1927

From cyborg to state worker: figures as/in technology

Annie Gérin

We, the Communists, are people of a special make. We are made of a special material. (Stalin, 1924)

Since the dissolution of the Soviet Union in 1991, images and rituals produced in the Stalinist period have been described, scrutinized and redescribed. Yet, so much remains to be asked regarding their social significance, and even more about how meaning was created in and through them. Explorations beg to be conducted on how Socialist Realist art mattered in the play and negotiation of hegemonic practices in the USSR. In order to do this, one needs to avoid searching for mechanistic reifications of the social sphere in the artistic production; moreover, one must escape the temptation of simply collapsing material culture into the ideology within which it is produced.

Bearing in mind these reservations, in this chapter I intend to map out different fields of established or fantasized relations that contributed to the formulation of a specific Soviet body in the moments surrounding the Bolshevik revolution, and induced its radical mutation into Socialist Realism. Through a discussion of representation and the production of meaning, I will try to define how and why certain strategies were adopted in the representation/creation of a Soviet corporeality, and how a new taste for these images was constituted in space and time. This study aims neither at denouncing nor glorifying art made under Stalin, but rather at finding more appropriate ways to apprehend it.

Figures as space and technology

The Western pictorial tradition which emerged from antiquity has trained viewers to see objects and space as divorced from themselves. This concept of space, the Euclidean metaphor, renders the world accessible through vision.

Hence, the modern subject functions outside its own space. However, this trope, like most notions in and about representation, was challenged by the iconoclastic drive of the Bolshevik revolution. It was, indeed, the ultimate logic of the revolution to seek new ways that transgressed the social, economical or formal structures of the past regime. However, these impulses have their origin not in the Marxist component of the Bolshevik ideology, but in texts of the nineteenth-century Russian radical intelligentsia. Examples of this search for a new consciousness can be found abundantly in the critical work of Chernishevsky, Dobroliubov and Pisarev. In the days of the 1917 revolution, iconoclasm found different outlets: crude ones in vandalism of churches or estates of the former ruling class, or more channelled and sophisticated ones in the art and literature of the avant-garde.[1]

Simultaneously encouraged and criticized by Anatoly Lunacharsky, the People's Commissar for Enlightenment (at *Izo Narkompros,* the commissariat assigned to culture and propaganda under Lenin), the avant-garde flourished in the cultural vacuum which followed the revolution.[2] Its aims of bringing about a new world through speculative practices, and of abolishing the elitist character of art for utilitarian pursuits, interfused well with the political and scientific utopias already present in Russian society.

In this context, while the power of visualization was acknowledged, science fiction was favoured and thrived as a literary genre until the first Five-Year Plan (1928). In fact, one of the most popular science fiction writers of the time was Aleksandr Bogdanov, a Bolshevik since 1903, friend of Lunacharsky, and the main theorist of the *Proletkult*[3] since its formation in 1906, until 1921. Although the genre of science fiction was open to many variations, some types prevail in what have become classics. They seem to constitute a coherent project for a Soviet corporeality, fusing the empirical, biological body with cultural and political ideas of what a body is and should be.

In 1908, Bogdanov published *The Red Star.* Greeted with enthusiasm by the Russian public, the novel depicts a socially and technologically more evolved Martian society. When Martians decide to take a terrestrial back to their planet, they naturally conclude that only a Marxist revolutionary worker has any hope of understanding their society. The Marxist utopia described on Mars conforms to the standard Marxist–Leninist text: shorter work days, unlimited access to material goods and free participation in leisure and culture of the mind and body. In this advanced state, the sexes have converged through the degenderization of social functions.

This theme also emerges in *Ariel,* published in the 1920s by the then fashionable science fiction author Belyaev. In this story (as in the former), the degenderization causes the terrestrial hero to question his own sexuality when he suspects he has fallen in love with a male Martian. Similarly, in Aleksey Tolstoy's *Aelita* (1922), which was made into a silent film in 1924, the body

inscribed with political transformation merges with concepts of technology when a Communist engineer flies to Mars. On the 'red planet', he becomes involved with a blue Martian princess in the organization of a 'Martian Union of Soviet Socialist Republics'. The myth of the engineer, present in all these literary works, is grounded in the multiple discourses of science, ideology and art. It connotes the new status of art and artists, as well as the marriage of convenience contracted between Russia's new revolutionary government and the scientific intelligentsia from the previous regime. Indeed, in the days that followed the Revolution, numerous commissions for the study of scientific-productive forces were established. The new precarious Soviet technostructure had to be constantly defended, by Lenin himself, against sporadic attacks from anti-intellectual forces.[4] Some important realizations in the broad scientific sphere included the dissemination of X-ray technology (for medical purposes or simply as entertainment) which rationalized the body by making its structure visible, as well as modern, optimistic mass-production projects culminating in a kind of 'scientific management,' inspired by American Taylorism and regulated by the Central Labour Institute.

The texts of science fiction were permeated by discourses about labour, family and sexuality. They challenged many values that the Bolshevik system was determined to either radically transform or altogether eradicate. In view of this, the ultimate mutation of the body was justified; the body (in representation) consequently became the site where new idealized relations could freely take place even if they could not appear in material existence. Trotsky himself had admitted that the liberation of the 'ideal' Soviet citizen had preceded the economical and technological means to effect it.[5] Nevertheless, it must be noted that significant freedoms had been granted to Soviet workers. In 1918 the Supreme Soviet decreed that from then on women would be equal to men in the eyes of the law.[6] In the following years, reforms of family and individual rights legalized abortions, rendered divorces easy to obtain and permitted free consensual relations. The human body was also to be theoretically liberated from domestic labour through communalization. Hence, becoming a part of the Soviet psychic reality, these relations established an abstract Soviet being, in and by new forms of consumption of both the subject and the object. Furthermore, a new relationship between space and time was imagined. This occurred not only in fiction, but also in the empirical world, through industrialization and the ensuing transformation of the rhythm of life. Following major improvements in transport technology, trips to Mars appeared to be a soon to be reached eventuality; and scientifically enhanced communal life was actually being planned to extend simultaneously the notion and the use of time and space. The Soviets had 'mastered time and space', as a popular slogan of the 1920s goes. As a consequence, corporeality asserted itself as an indispensable locus for utopian projections and interventions.

From all this emerged the image of the cyborg, an organic construction of mechanical and human elements, which rapidly gained visibility in the foremost left-wing organizations of artists working under Lunacharsky. Lissitzky's designs for the character named *Novy Chelovek*, (*The New One*),[7] for the 1922 production of Kruchenykh's *Victory Over the Sun*,[8] exemplifies this new incarnation (Figure 6.1). In this Futurist opera, subtitled by Lissitzky 'electro-magnetical peepshow', the New One is obviously more than technologically strengthened. As a cyborg, it combines within itself the power of the machine and the spirit of socialism. Reflecting contemporary desires about proper uses of the body, the New One has been ascetically degenderized as it has been mechanized. In Kruchenykh's script, when the New One appears on stage after having slain the sun, humanity's age-old enemy, the following words roll from its throat: 'Trust no longer the old measures of the world, the lake is harder than metal, everything has become male.'[9] The sentence emerges from a nonsensical flow spoken in a language based on pure sound relations, which robs words of their value as sign.

In summing up assumptions both about the body's needs and desires, Kruchenykh and Lissitzky had managed to merge the New One with the environment over which it had claimed victory. During the theatre re-presentation, it became difficult to dissociate the metallic cyborg from the industrial, kinetic backdrop against which it was located. Significantly, the body's liberation had been made at the cost of its gender or, more precisely, through the obliteration of the female body, the male robot-like figure standing in for a universal corporeality. Artificial selection[10] and the denaturalization of space had permitted, in representation at the very least, a folding of body and space, by means of technology. They had fused into an all-powerful subject, the cyborg.

In 1927, while reviewing the arts of the first decade under the Bolsheviks, the critic Tugendkhold remarked that the Leader was practically absent from representations of the new world.[11] One of his rare embodiments in the visual culture of the period is Lissitzky's *Lenin Tribune*, a utilitarian design which displays Lenin as a mere extension to the machine-environment which serves him of podium and propaganda tool (Figure 6.2). It is tempting to see Lenin as having willingly transfigured himself into a cyborg.

Figures in space and technology

While Lenin's well-documented ambivalence towards the avant-garde permitted it to flourish, Stalin's firm cultural policy prohibited all utopian and Futurist[12] experimentations on space and on the body. Much has been written about Stalin's general approach to politics and social practices, which

reveals his aversion towards utopia, and his love of codes and rituals. This contextualizes his fundamental conflict with Trotsky about internationalism and communism. When Stalin proclaimed that socialism had been attained in the Soviet Union and launched the slogan 'Socialism in one country' in 1925, all international long-term dreams were aborted for national and often local, more manageable, short-term plans. By the same token, it was understood that the State no longer belonged to history. 'In the USSR, Socialism, in the main, has been built.'[13] The Marxist dialectic had finally found its resolution. Having arrived at a break with the traditional experience of time and history, there was thereafter no more need for utopian projections.

The Soviet Union then entered an age of reform and systematization. Dreaming about the future shifted from a worthy activity to a social crime. Science fiction was even proscribed in 1931.[14] Soviet workers were expected to fulfil the Five-Year Plans[15] under the orchestrative guidance of Stalin, presented as the only and all-powerful creative engineer of Soviet reality. It was prescribed to avoid speculative activities whether in science or art, and to concentrate on homogenizing Soviet spatiality. Consequently, space and time uneasily caught up to each other. They were remoulded into a new equilibrium which was later on barely affected by the accelerated social activity and new production levels, achieved mainly by the creation of a massive centrally planned communication infrastructure, which included major projects such as the building of the Belomar Canal and the Moscow Metro, both initiated in 1932.

The utopian dream of transfiguring material reality by the breaking up of language and pictorial fiction had failed. In order to re-engage with the transformation process, the Stalinist regime built a concrete language-creating machine, through the restructuration of the hundreds of loose groupings of writers and artists into two main organs, the vast reconstruction of the capital city, and a multitude of other interventions, all aiming at a central-ization of the making of signs, and therefore of ideology. The results of this series of reforms were institutional and bureaucratic, or implicit and dialectical, like the practical question of a Soviet iconography and language (epitomized in *dubovy yazyk*).[16] They all contributed in changing the semiotic atmosphere of the country, more so than the avant-garde under Lenin ever could, by reason of its iconoclasm, but also of its fragmentation. Moreover, the visual environment of the country was transformed, as meaning was made available to the barely literate masses, mostly through material culture. Indeed, Stalin's rule championed aesthetic reforms over a radical mutation of values. The multiple alterations on the surface of everyday life eventually coalesced in the fabrication of an ideologically informed space, graspable through visually accessible devices. All aspects of material culture contributed to this planned intertextuality. For example, paintings of Stalin illustrated

the Leader reading the newspaper *Pravda*; *Pravda* discussed poster campaigns; posters used recently published novels as iconography; novels referred to Soviet celebrities, and this went on and on. This apparatus brought about unprecedented possibilities in informing the consciousness of the masses. The 'material' conditions, which Trotsky deplored did not exist under Lenin, had suddenly appeared under Stalin, not materially in the Marxist terminology, but in the materiality of the sign, in a centralized value-making system. Hence, under Stalin, the aesthetization of everyday life transformed Soviet reality into a full-blown spectacle, a space of representation in which new Soviet citizens had to somehow find their place. The Soviet population had to catch up and adapt to the ideologically saturated world created through central planning.[17]

At the First All-Union Congress of Soviet Writers in August of 1934, Gorky and Zhdanov officialized in their speeches the epithet 'Socialist Realism'. It became the general frame for all art forms under Stalin. Zhdanov set it forth in these terms:

Comrade Stalin has called our writers 'engineers of the human souls.' What does this mean? What obligations does this title impose on us? First of all, it means that we must know life so as to depict it truthfully in our works of art, and not depict it scholastically, lifelessly, or merely as 'objective reality'; we must depict reality in its revolutionary development. In this respect, truth and historical concreteness of the artistic depiction must be combined with the task of the ideological transformation and education of the working people in the spirit of Socialism. This method of artistic literature and literary criticism is what we call Socialist Realism.[18]

As Amei Wallach justly remarks, the prescription is vague enough to accommodate an unlimited variety of styles and conceptions.[19] In fact, although it was often presented as a hermetic style by both Western and Soviet scholars, the eclecticism of Socialist Realism is remarkable, at least in the few years that follow Zhdanov's speech.[20] Furthermore, in the context of the purges, which were at their most virulent between 1936 and 1938, when writers and painters who came to understand the dangers of misrepresentation requested more precise guidelines, officials responded vaguely: 'write the truth,' 'paint the truth'.[21] Stalin's period distrusted the very word 'style' which referred to formalism, or 'art for art's sake'. Therefore, Socialist Realism was never considered a style, but a method.

The concerted impulse to create a specifically Soviet body awoke yet again. In spite of its superficial resemblance to its pre-revolutionary and even pre-modern ancestors, I am still tempted to call it the 'New One'. According to Zhdanov's directives, the new type should clearly have embodied the most recent version of the Marxist–Leninist–Stalinist ideology. While breaking with the modernist tradition, it should also have found a form unprecedented in the history of art. Although there was no consensus

among artists, it was broadly assumed that a form of realism, securing homogeneity of vision, would be the path to choose. Indeed the production of a formally unified image of Soviet society, bound by ideology, could theoretically defend it from social disruptions. Because foreign elements were excluded from representation, they could be experienced as external threats. It was also implied that naturalistic mechanisms of identification would hail the viewer in the first instance, to better perform pedagogic functions later. But Soviet form and iconography were definitely never realist in a strict sense; they aimed at resolving contradictions impossible to resolve in the empirical world. Boris Groys calls the art 'superreal',[22] a more than empirical reality, a reality of short-term social desire.

The resulting body in representation was based on ideological fetishism and a certain degree of vagueness, since it only needed to demonstrate prominent values and ideals – as signs. Indeed, too much likeness could have excluded large sections of the population in a context where massive migration of people and values from the countryside to the city, and from different regions of the Soviet Union to the capital, were destabilizing the traditional societal balance. Furthermore, in the 1930s social mobility was at its peak. This phenomenon was due to many factors, such as the extended accessibility to education and the purges which decimated the establishment.[23] Stalinist power needed to create heroes that would match its representational needs and accommodate its conservative taste. Hence, the typified figures produced in this period tend to erase the culturally and socially diverse Soviet experience. This is paradoxically similar to what the avant-garde had aimed for, in obliterating through abstraction culturally determined codes. Yet, the aesthetic experiment of the 1920s had failed its political aspirations; the opaqueness of abstract or nonsensical art precluded the uninitiated public from grasping it. The codes had not been made available to the viewers.

Since Socialist Realism could not rely on a proper canon borrowed from the history of Western art lexicon, a new form embodying assumptions about mind and space needed to be produced in a struggle with/for/against stereotype. With the re-establishment of a space–time correspondence, the body was isolated from space and repositioned within the reassuring Euclidean metaphor. Bodies and space were thereafter constituted in a semiotic manner, in differentiation with all modes available, whether artistic or grounded in the experience of the material world. Through a regime of cultural terror which outlawed all Futurisms, art was composed in identification with and opposition to precedent naturalist and realist tendencies, such as tsarist academic art, the art of the *Peredvezhniki*,[24] or even French neoclassicism which relied on assumptions unacceptable for Stalin's polity. The construction of meaning significantly drew from the empirical world and general visual culture, as events taken up by the media and the transformations in everyday life incurred

by most Soviet citizens took the character of sign in the public's psyche. Centrally planned mass media disseminated types which cropped up in different contexts: official decrees, films, journals, children's books, postcards, stamps, circus acts, etc. These images were introduced into the iconography by the artists, and simultaneously served as the only codes of reference available to a public limited by their lack of experience in reading artistic images.

The Socialist Realist hagiography proposes a hierarchy of genres. The summit of the typology is, of course, occupied by Lenin as the father of Soviet Communism and Stalin, as the master engineer, the only artist, the creator of all that is Soviet (Figure 6.3). They both appear under so many facets that their pictorial personalities encompass the whole range of possible attitudes and emotions compatible with the ideology. Then appear portraits of party officials or heroes in historical or imagined revolutionary scenes. There follows a multitude of genre scenes, introducing workers, collective farm girls, soldiers, miners, etc. (Figure 6.4). It is this third category that interests us here since the image of the New One is created through these types. Finally, there are representations of the landscape, rural or urban, and still-lifes, allegories of the national land and its products, as transformed by recent technological progress. It is indispensable to underline, before we go further, that officially all these representations function in a metonymic chain always referring upwards to Stalin. All the figurations of bodies are an extension of the creator of the New One, the Leader who himself stands in for the spirit of socialism. In the art of the Five-Year Plans, the Leader is simply ubiquitous and polymorphous, hence contrasting with the missing Leader of the revolutionary period, whose absence had been noticed by Tugendkhold. In theory, Socialist Realism, is meant to collapse the artistic sensibility with the consciousness of the Leader. However, in practice, the art was created in a dialectical struggle which moulded and censored meaning through a dynamic interaction between artists, institutions and public.[25] Because large sections of the public were barely fluent in matters of politics, ideology and aesthetics, it is safe to say that viewers introduced to the process a certain degree of confusion and indeterminacy.

This second version of the New One had to be hardened through sports and constructive labour. Its body was fetishized by sometimes compulsory participation in sport activities organised around the factory and by youth parades on the many newly consecrated Soviet holidays. Under the institutional network of Stalin's period, sports events and art depended on the same umbrella organization, the Committee for Art Affairs (KDPI). Paradoxically, bodies in representation were re-sexualized and released from abstraction, while freedoms, which had been accorded to the material body under Lenin, were robbed from them in the 1930s. Stalinist culture, as Roger Pethybridge demonstrates, became conservative, almost puritan, in a social backlash

drawing from traditional and even tsarist culture.[26] The epaulettes, reserved for the military aristocracy of the pre-Soviet period, which suddenly reappeared in 1934 on Stalin's generals' shoulders, exemplify this reactionary phenomenon. In a matter of a few years, most revolutionary rights acquired during the early years of the Bolshevik regime were revoked. In 1934, homosexuality was recriminalized. In 1936, abortions were rendered illegal, while divorces were made difficult by a new Family Code.[27] Circulation in the streets was constrained by anti-assembly laws and movement in the country controlled by the emission of internal passports.

The restriction of spatial movement informs the question of the new relations established in representation between body and space. It has often been remarked that, in official portraits, the figures are disjuncted from space, which only appears as a generic industrial backdrop to the political figures gesturing in codified ways. This is only a symptom of their sign status. Not only are bodies made to connote the Leader and the spirit he embodies, but the Euclidean space (understood here more than ever as a conceptual, mathematically organized space) articulates meaning by anchoring the timeless spirit of socialism in an apparently rational environment specified by markers of real time, by the figuration of empirical progress, the power of the machine. The geographical elements establish allegorical links between the artistic experience and the empirical everyday experience of the viewer, who can then interpret the images through his or her own visual knowledge of a rapidly changing world. Hence the relationship between the body and its environment can no longer be naturalistic. As opposed to the pre-revolutionary under-standing of these terms, body and space each occupy a distinct signifying field. Surely informed by a memory of their collapse into one another, which occurred in the 1920s, they later engaged with each other in the dialectical creation of meaning in individual works of art.

Henri Lefebvre suggests that 'the reading of a space that has been manufactured with readability in mind amounts to a sort of pleonasm – that of pure transparency'.[28] His perceptive observation seems to invert in the context of Socialist Realism, where readability was the avowed ultimate goal. In a situation where all media contributed to the elaboration of a new set of codes, the public was surely conscious of the construction effort. Viewers of the 1930s were made aware of the syntactic character of the new art. As a result, transparency could never, and furthermore should never, have been achieved (it cropped up much later, with the passing of time and the erosion of memory.) The Stalinist representations of space ultimately ignored actual spatial practices, they signified. Avant-garde iconoclasm and syncretism had been superseded by sign-making and syntax.

Boris Groys proposes that Socialist Realism is a radicalization of the avant-garde project.[29] This claim, controversial in our field where most scholars

consider it a historical monstrosity, rings true in this context. Groys argues that Socialist Realism achieved the ultimate modernist goal as initiated by the avant-garde, that of bringing art to its degree zero. Indeed, the current display of avant-garde works in numerous museums proves that the desired utilitarianism, as well as anti-aesthetic stance taken by the artists, both failed. They were clearly never taken to term by artists such as Malevich, Lissitzky, Tatlin, or even by Rodchenko who turned to documentary photography under Stalin. But I would further argue that while the subject of Stalin's period was forced back into a viewer's position in the Euclidean space, the potential for transforming spatiality (at least the imagined one) has been fully realized in the systematization and semiotization of the art and its production of meaning. In its unassuming role as propaganda tool, Socialist Realist art informed the population, explained new social relation and scientific developments, contextualized uncanny events experienced in the empirical world. In this sense, Socialist Realism does not only conform to the goals of the Revolution and is an extension of the avant-garde, it takes a step further and interacts with the ideology and its multiple agents, with *partiinost'*.[30] It therefore has the power to transform the material world and its inhabitants. Stalin's time provides us with a genuine revolution of the sign (sign-making and institutional usage of the sign) after the avant-garde's missed attempt to abolish it. Hence, from the cyborg to the Socialist Realist figure in space, the apparently unbridgeable abyss does not lie in a shift in artistic conceptions, but rather in the semiotic practice of the 1930s.

In 1929, the Soviet semiotician, Voloshinov, argued that the domain of ideology coincides with the domain of signs, because it is built through differentiation of values, in relation and interaction between the consciousness of the State and the people.[31] Wherever a sign appears, ideology is present and vice versa. Hence, everything ideological possesses semiotic value. This observation is especially useful in working with intertextual material, since it accommodates signs coming from different fields. It also permits ideology itself to be taken up as an object participating in intertextuality (as opposed to strictly producing it.) Voloshinov emphasizes that the sign does not exist simply as part of reality, as the language of social life or a site of class struggle. It is not only a constituent of the material world; the sign interacts with the empirical world, transforms it, is transformed by it.

As the Stalinist generation dies out, it is taking along the always implicit codes of its most unstable creations, the Stalinist language and iconography. With hundreds of works and texts discarded in the 'destalinization' process, Stalinist art is becoming more and more difficult to decipher. Ironically, it now appears transparent. Except for the most demagogic motifs often and erroneously introduced as representative of the period, the keys to understanding Socialist Realism escape the outsider. The present viewer can never

experience the great optimism, the social involvement or the terror which originally haunted the representations (and served as their privileged mode of reading). A possible solution in deciphering significance in these works is dictated by the very way meaning was created in and around them in the first instance. Since meaning in Socialist Realist works was created (in visual culture as a whole) by trial, error and dialogue between artists, critics and viewers, one can view the art as a broad cultural text, fostering endless connotations, sometimes distorting reality, and creating unexpected chains of meaning when introduced in different contexts. This polysemous methodology inspired from theories of deconstruction and focusing upon the historical and material nature of the sign can best accommodate a reading of Socialist Realism that will escape the modernist art historical prejudice, which condemns it as aberration mainly for having done away with the centred creative force, the artistic genius. It will also elude reductive or strictly political approaches which were imposed on Socialist Realism by its contemporary Soviet critical practice. Linking artworks to their appropriate reference frame, this reading mode could then make allowance for inevitable distortions of the cultural network within which and in relation to which they were produced and evolved.

From then on, the canvas becomes much more than a fixed surface. It is the ground for unlimited play between historically bound signs, which are contemporaneously being created and re-created, in an exchange between different agents, always bringing to the fore the many faceted totality of Soviet culture, in a constant struggle for hegemony on one side and autonomy on the other. Furthermore, it must be stressed that the impossibility of transparent communication between the makers of signs and the viewers precludes a finite, stable interpretation. This awareness of opacity and intertextuality also recognizes the disfigurement or complete destruction of works, as people (or types) represented fell into political disgrace or were altogether obliterated from empirical space and history. This particularly dynamic quality of Stalinist semiotics and material culture renders them a fascinating field of inquiry for the social history of art. Of course, discussing the complexity of Stalinist culture does not trivialize the atrocities experienced at the time or negate their endless reverberations. Instead, it should compel a recontextualization of the Stalin era in the socialist project, and provoke more critical approaches to (so-called) realist images past and present, which are so often dismissed as mechanistic, therefore devoid of interest and consequence.

Lunch-break in the Donbass (by means of conclusion)

According to Matthew Cullerne Bown, 90 per cent of Socialist Realist works were commissioned on themes devised by committees and approved by the political leadership.[32] Works were routinely rejected. Their author was often ordered to revise them. In *The Seven Soviet Arts*, Kurt London gives an account of the April 1935 revision session of the *Vsekokhudozhnik* (All-Russian Union of Co-operative Comradeships of Workers of Representational Art) during which Solomon Nikritin's work *Old and New* was exposed to such a process by a committee formed of artists and critics, among which sat Aleksandr Deineka, Aleksandr Gerasimov and Sergey Grigorev.[33] Nikritin explained the iconography and the symbolism of his work; the representation aimed to contrast the New One with its predecessors in culture and age. The unfortunate artist saw his painting rejected on accounts of pornography, individualism, anti-Soviet sentiment and negative depiction of the New One. He himself was personally disgraced and attacked as an opponent of the regime. This is especially problematic, because a number of equally 'formalistic' or 'erotic' works were enthusiastically approved by such committees.

We have already glanced at how Socialist Realist representations of bodies paradoxically conform with revolutionary impulses, as theorized by the avant-garde. Now, it should be examined how some representations of the eclectic Stalinist period, which might seem unacceptable to the present viewer, in light of Stalin's puritan social choices and totalitarian politics, actually function within the Stalinist semiotic project. In order to explore this question, I have chosen a work by Aleksandr Deineka, which, although often reproduced, is very seldom problematized. The work entitled *Lunch-break in the Donbass*, first exhibited in December 1935, shows five young men playing football in the shallow water of the Don river basin (the Donbass.) Completely nude, they are set against an industrial background. A train crosses the horizon. The work is generally interpreted as a joyful celebration of the gifts of nature, and of Stalin's State, here respectively represented by the male bodies and the landscape. There are rather few examples of nudes in Socialist Realist monumental painting; the representation of nudity is quite surprising at this particular moment in history, when the dissemination of pornography entailed a five-year jail sentence and accusations of homosexuality could send a person to the labour camps. Furthermore, during the aforementioned *Vsekokhudozhnik* review of Nikritin's now lost work, Deineka himself was responsible for bringing up the question of eroticism in the painting that showed as its only nude a timeless Venus.

If the codes necessary to understanding *Lunch-break in the Donbass* are not readily available to the present viewer, one can find insight in dissonant elements in the representation – peripheral or marginal, inside or even outside

the frame – which are introduced in the play of meaning achieved through signs. In this narrative of a game, the ball itself throws off the superficial interpretation of this work as a representation of young men playing. More precisely, the boys's lack of interest in the object is revealing; all but one run in the direction of the viewer, and not towards the ball. The fifth vaguely follows the football, but although their shadows merge, he excludes it from his gaze and consequently appears totally indifferent to it. Although the ball permitted the artist to justify the men's movements in water, another action is most likely abstracted, and signs are clearly standing in for others. The disinterested attitude of the men towards the ball induces a deconstructive approach to this image which could otherwise be understood as Epicurean or merely formalistic; it opens up the picture for a polyphonic interpretation by instantly breaking the narrative drive of the painting.

The title of the work and the date of exhibition seem to be more useful in the organization of possible significance. There is no mention, to my knowledge, of a direct link between this painting and the cultural texts that I will briefly explore. However, there is no doubt in my mind that the work participates in a community of meaning of which the viewers, the artist and the agents of art and propaganda were well aware of by the end of 1935, when the work was first encountered by the public. In this specific context, inquiries into the Russian iconographical tradition serve little purpose. From one year to the next, specific signs could embody divergent versions of ideology, or be used for different purposes. Iconographical signs gained value by their intertextual proliferation and accumulation.

The first text that needs to be looked into is the construction of the Stakhanovite movement as a hero-building trend. This is how the story goes: 'during the night of 30–31 August 1935, a slim and pleasant looking twenty-nine year old, Aleksey Stakhanov, cut 102 tons of coal in one shift at a mine in the Don river Basin. This amounted to fourteen times the prescribed norm'.[34] The event was highly publicized as both means of motivation and coercion; workers declared Stakhanovites were rewarded for production above expectation with higher salaries and privileges. Consequently quotas were further heightened. This reactionary measure induced the creation of a privileged minority among workers. It marked an explicit break with the egalitarian thrust of the Revolution.

The event was endlessly referred to in novels, posters, songs, plays, sculptures, etc. It was therefore a very familiar theme for the general public. Stakhanov was further described not only as an exemplary worker, but also as an athlete (preferring group activities to individual disciplines) and an intellectual who attended lectures given for the benefit of the workers. He often borrowed books from the local Soviet library. The State-sanctioned campaign detailing Stakhanov's attributes was meant to provoke in the

members of the public a desire to imitate (or identify with) Stakhanov, and consequently transfigure oneself into the New One. In *Lunch-break in the Donbass*, the hero's athletic attributes are located not just in the representation of strong youthful bodies in play, they also haunt the symmetrical configuration structuring the spatial relationship between the men. The formation connotes to official physical culture parades in a context where sports left the amateur field to become a public spectacle.[35] From 1931, May Day celebrations and other popular events included such displays, in which miners, industrial workers, athletes, pilots or students participated, cantering up and down Red Square with their comrades, taking part in the Soviet spectacle. It also mimics the military show-parades and alludes to the daily presence of soldiers in formation in the streets. In doing so, it then directs attention to the general ritualization and militarization of social practices which occurred throughout the 1930s, and eventually to that of work ethics, optimized production, and the new ranking systems which allowed benefits to workers exceeding the production quotas.

We could go on and on following Stakhanov's traits throughout the multiple forms in which they were exploited by the centralized Soviet propaganda machine; reverberations of well-known Stakhanovite features would be likely to show up even in the seemingly most innocent elements of the representation. Yet, Stakhanov, as a signifier of the New One, was not an unambiguous figure in the 1930s. The mass glorification of his coal-cutting record (and the rewards which ensued) was perceived by many as a betrayal of the revolution.[36] For certain sections of society, Stakhanovists embodied the capitulation of the Soviet Union. They also personified the common enemy of the working class and of the dispossessed nobility, bourgeoisie and intelligentsia. In the absence of an iconographical tradition which could have stabilized meaning, the nude bodies therefore incarnate simultaneously positive and negative conceptions of Stalinist corporeality.

The idea of uninhibited group activity represented in *Lunch-break in the Donbass* might also engage with another prominent discourse, present in the propagandist visual and textual culture of the time. This one refers mainly to the social disapproval and apprehension of young men's individualistic attitudes which emanated from the New Economic Policy (NEP) period.[37] A literary description of this type is brilliantly sketched in the character of Prisypkin, in Mayakovsky's *The Bedbug*, shown regularly in Moscow theatres from February 1929 to May 1930. What was advertised as a new problem was brought to the attention of the general public in a national drive. The 1935 campaign of information and indignation about juvenile delinquency was used as a means of justification to crush all remnants of non-communal organization or independent communal enterprises. This was discussed in the media as an emerging phenomenon, in relation to the socially threatening

dissolution of family ties. The public stance against hooliganism announced the aforementioned 1936 reforms in family law, which many perceived as a loss of the civil rights given to them by the Bolsheviks in the years immediately following the Revolution. From there unfold conflicting discourses about child-rearing, relationships, family values, consumption of alcohol, health, sex, etc.

In this context, the full frontal nudity of the young men can no longer be understood as eroticism in the mainstream sense of the word. Instead, *Lunch-break in the Donbass* becomes an example of what Eve Kosofsky Sedgwick terms homosocial desire, a complex network of relationships derivative of patriarchal social, political and sexual organization (which here includes homophobia).[38] Yet, by the 1930s, the Stalinist regime had still not succeeded in creating social consensus. The 'complex network of relationships' is therefore especially unstable.

Absolutely opposed to the ascetic asexuality of the cyborg, the bare bodies painted by Deineka likewise exemplified what some have described as 'patriotic nudity'. This construct, which denotes freedom, honesty and community spirit, permits the sensual enjoyment of voyeurism while the representation remains ideologically sound. The unmarked youth and slenderness of the bodies, as well as the absence of distinctive facial features, furthers them from Stakhanov as a flesh-bound miner, but not as a sign. The bodies can then refer by their eternal youth to the implied text behind the publicly displayed body of Lenin, exhibited on Red Square, as father of the Soviet people and ultimate object of social desire. It certainly matches the old Russian superstition (encouraged by Stalin's hagiography) that the body of saints never perish. This idea of immortality in a very typified industrial landscape leads us back to the split between figure and space, articulated in a syntax that would require further examination of the forward movement of the train and the radical construction of a new infrastructure for transport and communication in Stalin's empire. It might eventually lead us to discussing perhaps divergent notions about nature, industrialization and the value of progress, as well as views on traditional culture, nationality, migration, etc. All these links can be unlocked for the viewer by codes made available through Soviet mass culture.

We no longer know which cultural discourse is speaking to us in this state of intertextual dependency. All texts are multi-voiced and lead us into infinite directions; in the absence of social consensus, they signify as well as disrupt signification. It is certainly not to say that signs are interchangeable or that the work has no meaning, but there is definitely a viscosity in meaning, which reveals the abyss between the thing fixed on the canvas and the representation caused by it. Hence, over 60 years after the fact, participating in a process similar to the dialectical creation of meaning in art under Stalin,

we could pursue these semantic chains, and many more, virtually ad infinitum. Indeed, no (historically pertinent) lead is worthless to follow, at least for a while. This viewer-oriented practice totally disproves the traditional understanding of Socialist Realism as a crude and mechanistic interpretation of the ideology. And besides, it is quite enjoyable.

Notes

1. The Russian avant-garde was by no means a homogenous group. In this chapter, I am concerned with the portion of the avant-garde which supported the October revolution and actively participated in the elaboration of socialist vocabularies.

2. In the absence of a cultural agenda in the aftermath of the Revolution, different groups were allowed to compete for prominence in the aesthetization of politics.

3. Organization promoting a strictly proletarian form of culture. For a history of the movement see Mally, L., *Culture of the Future: The Proletkult Movement in Revolutionary Russia*, (Berkeley, CA: University of California Press, 1990).

4. The struggle between science and society is carefully examined in Bailes, K., *Technology and Society under Lenin and Stalin* (Princeton, NJ: Princeton University Press, 1978).

5. Trotsky, L., *The Revolution Betrayed* (New York: Pathfinder, 1972), p. 144.

6. The terms of the successive Soviet Family Codes are listed in Goldman, W., *Women, the State and Revolution* (Cambridge: Cambridge University Press, 1993).

7. Usually translated as the New Man, this term is ungendered in Russian. It was coined in 1861 by Chernishevsky in his novel *Shto Delat'?*

8. The play was first presented in 1913. It featured costumes and scenic designs by Kazimir Malevich, who also concocted a metallic, robot-like, ungendered version of the New One.

9. Translation mine. Kruchenykh, A., *Pobeda nad Solntsem* (Moscow: Vena, 1993), p. 16.

10. This term was coined by Trotsky in 1924, in opposition to Darwin's 'natural selection'. It denotes a self-imposed process.

11. Groys, B., 'Stalinism as Aesthetic Phenomenon', in A. Efimova and M. Lev (eds), *Tekstura: Russian Essays on Visual Culture* (Chicago: University of Chicago Press, 1993), p. 124.

12. Term used during this period to designate all formalistic tendencies.

13. Shestakov, V. (ed.), *A Short History of the USSR* (Moscow: Co-operative Publishing Society of Foreign Workers in the USSR, 1938), p. 255. *A Short History of the USSR* was the official history textbook used in the Soviet Union in 1938.

14. This was mainly the result of a few years of pressure emanating from the Proletarian Writers Movement (RAPP). Science fiction was replaced by 'scientific fiction,' a genre which exalted scientific and technological progress, yet never proposed worlds where higher forms of civilization had been achieved. However, classical science fiction (Aleksey Toltstoy's *Aelita*, for example) were still recommended as children's literature in the late 1930s. See the annotated bibliography entitled 'What Schoolchildren Should Read', Bogomolova, S. *Shto Chitat' Shkol'nikam* (Moscow: Mogiz, 1938). Science fiction only reappeared in the USSR in 1957 with Ivan Yefremov's *Tumannost' Andromedy* (*Andromeda's Mists*).

15. The goal of the first two Five-Year Plans was the rapid industrialization of the country. A special emphasis was put on heavy industry. The First Five-Year Plan was inaugurated in 1928. It was completed in just over four years.

16. Literally 'language of oak'. It alludes to the codified jargon and style developed over time by the Soviet press. Stalin himself devoted some of his written work to the question of the creation of a new language. See Stalin, J., *Marxism and Linguistics* (New York: International Publishers, 1951).

17. It cannot be emphasized enough that the population of the USSR in the 1930s was culturally heterogeneous. Nicholas Timasheff charts out the diversity of the inhabitants of the newly formed Soviet Union, in terms of social origin, ethnicity, literacy levels, etc. See Timasheff, N.,

The Great Retreat (New York: Arno, 1972). It is also noteworthy that Soviet society lived through an impressive series of revolutions and ideological shifts in a very short period (1860, 1905, 1917, 1921, 1928, 1936). These changes affected different groups in various ways. By the 1930s, the Soviet citizens had not yet had the opportunity to organically form a unified Soviet culture.

18. Bowlt, J., (ed.), *Russian Art of the Avant Garde: Theory and Criticism* (London: Thames and Hudson, 1976), p. 293.

19. Wallach, A., 'Censorship in the Soviet Bloc', *Art Journal*, **50** (3), Fall (1991), p. 76.

20. Unfortunately, it is difficult to appreciate the full range of the pictorial production under Stalin. Western books tend to present a homogenized inventory of the Leader, always represented in the same codified way, while Soviet books tend to avoid images of Stalin altogether, to the benefit of idyllic images of working-class youth. No formal and thematic unity appeared until the institution of the 'Stalin Prize' in 1939, when models to be emulated were officially sanctioned.

21. Boris Groys quotes Stalin giving such a response to the recurrent questions of writers during the 1934 Congress of the Union of Soviet Writers. Groys, 'Stalinism as Aesthetic Phenomenon', p. 117.

22. Ibid., p. 124.

23. By 1932, two-thirds of proletarians came from peasant backgrounds. Countless Bolsheviks had been executed or invalidated, while workers of proletarian backgrounds profited from newly available access to education and became cadres.

24. Nineteenth-century critical Realist movement which set itself in opposition to the St Petersburg academy of art.

25. For example, a Central Committee resolution of 1931 instituted poster review committees among workers and peasants, in order to insure their readability. This measure was implemented by the Union of Revolutionary Poster Artists (ORRP), also created in 1931. On the first review meeting, 22 posters intended for publication were discussed. Half were rejected by their targeted public as being incomprehensible or unsuitable, while the majority of other images were subjected to severe criticism and subsequently redesigned. See Bonnell, V., *Iconography of Power* (Berkeley, CA: University of California Press, 1997), p. 111.

26. Pethybridge, R., 'Stalinism as Social Conservatism?', *European Studies Review*, **11**, (4), (1981), pp. 461–85.

27. A tax of 59 rubles was imposed on a person's first divorce, 150 rubles for the second, 300 rubles for any divorce thereafter.

28. Lefebvre, H., *The Production of Space* (Oxford: Blackwell, 1991), p. 313.

29. Groys, B., *The Total Art of Stalinism: Avant-Garde, Aesthetic Dictatorship, and Beyond* (Princeton, NJ: Princeton University Press, 1992).

30. Concept by which all activity should be thought out in function of the best interest of the party, which acts as the conscience of the Soviet people.

31. Voloshinov, V., 'The Study of Ideologies and Philosophy of Language', in A. Efimova and L. Manovich (eds), *Tekstura: Russian Essays on Visual Culture* (Chicago: University of Chicago Press), pp. 1–9. This text has also been attributed to Mikhail Bakhtin.

32. Cullerne Bown, M., *Art under Stalin* (Oxford: Phaidon Press, 1991), p. 95.

33. London, K., *The Seven Soviet Arts* (London: Faber and Faber, 1937), pp. 223–31.

34. Thurston, R., 'Reassessing the History of Soviet Workers' Opportunities to Criticise and Participate in Decision-Making, 1935–41', in S. White, (ed.), *New Directions in Soviet History*, (Cambridge: Cambridge University Press, 1992), p. 172.

35. The history of the relationship between sports, ideology, power and public is examined in Riordan, J., *Sport in Soviet Society. Development of Sport and Physical Education in Russia and the USSR* (Cambridge: Cambridge University Press, 1977).

36. As Trotsky notes, the anti-socialist incentive of better pay forced the workers into extending their labour period. 'Of the seven-hour working day, there thus remains nothing but the name', *The Revolution Betrayed*, Trotsky, p. 80.

37. The New Economic Policy was effective from 1921 to 1928. During this period private ownership of industry and business was coexistent with the centralized economy.

38. Kosofsky Sedgwick, E., *Between Men: English Literature and Male Homosocial Desire* (New York: Columbia University Press, 1985).

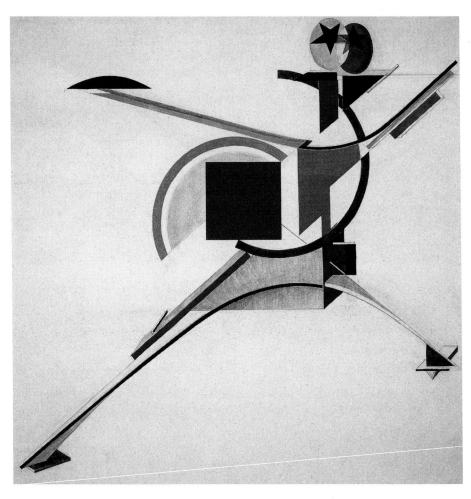

6.1 El Lissitzky, *The New One*, 1920/21

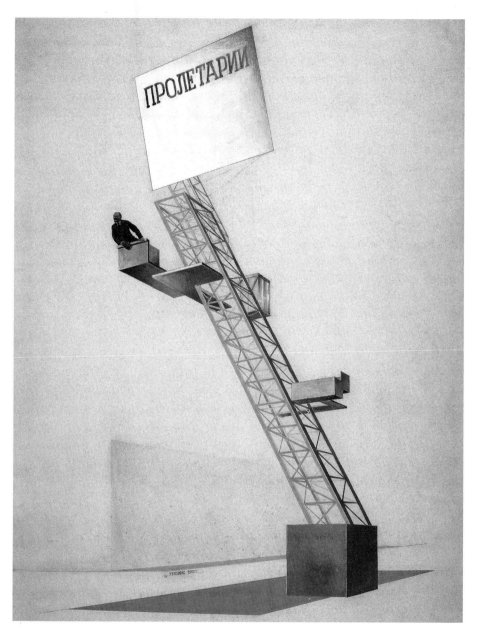

6.2 El Lissitzky, *Lenin Tribune*, 1920/24

6.3 Aleksandr Gerasimov, *Stalin and Voroshilov in the Kremlin*, 1938

6.4 Aleksandr Deineka, *Lunch-break in the Donbass*, 1935

Realism and ideology in André Fougeron's *Le Pays des Mines*[1]

Vivian Rehberg

In January 1950, the Fédération des mineurs of the Nord-Pas-de-Calais region asked André Fougeron to create a suite of paintings and drawings of Le Pays des Mines – mining country. Auguste Lecoeur, president of the Mining Federation, and acting secretary of the Parti Communiste Français (hereafter PCF), previously published a collection of poetry of the same title by Louis Aragon. Now it was hoped that Fougeron would become the 'Aragon of painting'. Fougeron already fitted the party profile of the militant artist. Raised in a working-class, anarcho-syndicalist environment, Fougeron had participated in Front Populaire efforts to democratize culture during the 1930s, was an active member of the Resistance during the Occupation, and an important presence in attempts to resuscitate a leftist political culture after the Liberation. Like Aragon, who had rejected Surrealism for orthodox communism, Fougeron, after winning the national prize for painting in 1946, would become the foremost proponent of engaged Realism supported by the PCF.[2]

Upon receiving Lecoeur's commission, Fougeron moved with his family to Lens, a mining town in the Nord-Pas-de-Calais, where he installed his easel in the dining room of a house owned by the mining federation. Given a salary which allowed him to live 'honestly', even 'comfortably', Fougeron's task was to descend into the quotidian existence of the mining community in order to 'set life and its meaning on canvas'.[3] Claiming the people as his patron, the artist remained in Lens until 1 May (according to his report in *Ce Soir*, Fougeron stopped working on France's 'Fête du travail'), where he frequented workers' meetings, drove around the countryside in the car loaned to him by the federation, and recorded in sketches and studies the mine workers and their surroundings.[4]

After four months in Lens, Fougeron returned to his atelier on the outskirts of Paris. With much of the preparatory work finished, he began working full time on the paintings in June, which he completed not in mining country,

but in his suburban studio. He returned to Lens in December, primarily to focus on the landscapes. One year later, with nearly 40 paintings and drawings completed, Fougeron rented, with the financial support of the party, the prestigious Galerie Bernheim-Jeune – chosen because its reputation was not tainted by collaboration with the Nazis, as well as for its location on ground-zero of Parisian chic, the crossroads of the avenue Matignon and the rue du Faubourg St. Honoré. The exhibition *Le Pays des Mines: contribution à l'élaboration d'un Nouveau Réalisme Français* opened on 13 January 1951.

Lecoeur claimed to have provided that artist with no other direction for the project other than its theme, but his investment in Fougeron was heavy, and the party subtly exercised critical control. Months prior to the exhibition opening, *l'Humanité* published reproductions of all of the major works, frequently with captions indicating their subject matter and emphasizing Fougeron's commitment to the working class. This not only demonstrated the party's prior approval of Fougeron's project, it removed the element of surprise from the 'new' French Realism. In tandem with *l'Humanité*'s photo campaign, the party and the Mining Federation published two exhibition catalogues – a small volume with photographs of Fougeron working in Lens, a dozen black and white reproductions of the works, and texts by Auguste Lecoeur and André Stil, as well as a deluxe version, introduced by Jean Fréville, which contained individual colour folios suitable for framing. Stil's and Lecoeur's texts, excerpted in *l'Humanité* prior to their publication in the catalogue explained the significance of Fougeron's painting to the newspaper's readers, and reiterated Lecoeur's authority.[5]

This publicity, coupled with Fougeron's daily presence in the gallery and the party effort to bus local workers into Paris, drove the public in. With nearly 4 000 in attendance the first weekend, the communist press claimed unequivocal success. On 19 January, a public debate was held between Fougeron syndicate leaders, workers and intellectuals, with the party again providing transportation, and with Lecoeur giving the inaugural speech. After two weeks the exhibition closed in Paris and began its tour of French mining centres. It is estimated that over 50 000 people saw *Le Pays des Mines*.[6]

Was Fougeron's exhibition about painting or was it mere propaganda? *Nouveau Réalisme Français* was certainly based on the Soviet notion that culture is an effective weapon in political struggles, and shared the Soviet model's goal to educate and elevate the public, but its rhetorical aims were distinctly related to France's historical present, and not to the glorification of a mythic past or utopian future. Its proponents were aware that New French Realism could not duplicate the aesthetic of an already achieved revolution. Thus, New French Realism was conceptualized, not as a replica of Soviet Socialist Realism, but as a current which 'without denying what has been gained from modern culture and techniques, denies the primacy of formal

research, advocates the return to objective reality and the subject, and stresses the social content of all reality'.[7] When pressed for a clarification, Fougeron's comrade Boris Taslitzky explained: 'realism is the sum of three conditions: the work's content, love for this content, the technique which serves to express this content, these three conditions being raised to an ideological level'.[8]

Such insistence that form is subordinate to content has led New French Realism to be interpreted as a systematic application of a preordained aesthetic programme. New French Realism was unquestionably politically and ideologically overdetermined. Yet, I will argue that formal issues were hardly secondary for Fougeron. While the PCF was indeed responsible for the subject matter of *Le Pays des Mines*, it was Fougeron who added the exhibition's subtitle: 'contribution to the elaboration of a New French Realism'. This qualification foregrounded the project's provisional nature and artistic motivation, and situated it both as a rupture with, and a continuation of a national painterly tradition. Furthermore, by basing *Le Pays des Mines* on a re-evaluation of the hierarchy of genres, Fougeron highlighted rather than evaluated the problem of form. While attending to the overarching priority of representing the miner's experience through a unifying, legible, realist aesthetic, Fougeron chose to operate with the added formal constraints of the different genres – portraiture, landscape, still-life and history painting. We can only speculate that the artist sought to legitimate his project by appropriating this vestige of French academic training. Yet, it is safe to say that the attempt to marry a specifically *French* artistic heritage to an increasingly dogmatic, *universal* ideological programme articulated by the Soviets was a principal characteristic of New French Realism, exemplified by Fougeron's *Le Pays des Mines*.[9]

As the PCF went from maligned political outlaw to legitimate participant in the reconstruction government it became increasingly image conscious. Between 1944 and 1947 the party's cultural politics were designed to convince a large constituency to participate in its humanist project for a *Renaissance Française*. At the height of its popularity, party strategies were characterized by tolerance and reconciliation, and art and culture were firmly linked to the interests of the nation.[10] This post-war trend confirmed the shift in values that had already taken place at the party centre during the 1930s a move away from radicality and counter-culture, and towards a belief in the integrity of the nation, its symbols and traditions.[11] According to Annie Kriegel, 'The republic, the tricolor, the *Marseillaise*, Victor Hugo, the student-officer corps – all these were re-invested with their original ambiguity and thus gave the proletariat, viewing them in a certain light, an opportunity to convert them into added attractions for use in their own camp'.[12]

It was during this period of relative openness that the PCF actively courted artists and intellectuals (upon the Liberation Paul Eluard rejoined the party, Picasso and Léger became card-carrying members not long after), and eagerly set about establishing its own critical press. Aside from the eponymous *l'Humanité*, the party's influence was evident in such journals as *La Nouvelle Critique*, *Les Lettres Françaises*, *Arts de France*, *Europe* and *La Pensée*, with Louis Aragon, Jean Kanapa, Henri Lefebvre, Pierre Daix, Jean Cassou, Eluard and Vercors acting as editors and contributors. In order to house its cultural coterie, the party created a Section des intellectuels of the Central Committee, the Direction nationale des intellectuels communistes, and the Comité d'honneur des intellectuels communistes. A certain taste for the worldly spectacle developed within the ranks of official party culture, to such an extent that Dominique Desanti referred to the Communist demi-monde as 'La Très Haute Société Communiste'.[13] Aragon and Elsa Triolet led this high society, presiding over the Congrès des Ecrivains, whose weekly meetings were held, not in a Parisian working-class neighbourhood, but in a Second Empire salon at the Maison de la Pensée Française, a *hôtel particulier* constructed by the Empress Eugénie for her mother, close to the Elysée Palace.

In part because of its Resistance credentials, but also due to its role in constructing the nascent Fourth Republic's policies of social and economic reform, the PCF had consolidated a seemingly secure position of political legitimacy in the eyes of a large portion of the population. However in 1947, an abrupt about-face would take place. East–West relations had degenerated considerably, the war in Indo-China, which was opposed by the communist ministers of Paul Ramadier's government, was causing new tensions at home, party adhesions were declining, and social conditions were stagnating, especially for the working class. With strikes proliferating, three days after an impressive demonstration of worker solidarity on 1 May 1947, the PCF ministers were ousted from the government and reconsigned to the political periphery.

The founding of the Kominform in 1947 delivered the final blow to the brief period of entente between Moscow and its international relations, and the political strategy that developed henceforth had a lasting effect on the PCF's cultural politics. Generosity of spirit towards cultural production was abandoned as the party closed its doors in order to redress its ranks, and attain greater political and ideological cohesion within them. Andrei Zhdanov's infamous 'two-camp' discourse, delivered in September and published as 'Sur la situation internationale' in the October/November issues of *Cahiers du Communisme*, inaugurated the PCF's most dogmatic phase.[14]

Zhdanov's definition of Socialist Realism, elaborated at the first Soviet Writer's Congress in 1934, called for a tendentious, class-oriented art, based not on an objective, or naturalistic, perspective on reality, but on the artist's

total knowledgc of reality as it proceeds in its revolutionary movement.[15] At the Eleventh Party Congress of the PCF, held in Strasbourg in June, cultural mouthpiece Laurent Casanova went on the offensive. Insisting that the class struggle be the foundation for all engaged art, Casanova maintained that the party work toward the 'elaboration of an aesthetic cohesive with the revolutionary action of the proletariat, and more directly driven and inspired by its revolutionary ideology'.[16]

'To be a Communist or a Socialist no longer means anything definite. We have reached a level of political nominalism of which there is perhaps no other example in French history,' remarked Maurice Merleau-Ponty in 1948.[17] The PCF counted on Fougeron to construct a visual language for communism which would compensate for this titular confusion. The fluid and versatile legacy of symbols provided by the French Revolution provided a convenient lingua franca with which the PCF could respond to collapsed national identity and revolutionary disenchantment.[18] Aragon might have preferred that Fougeron emulate a populist Realism à la Courbet, a Realism suitable for representing the so-called revolutionary action and ideology of the proletariat. Yet, in his article 'David et nous', written during the genesis of *le Pays de Mines*, Fougeron dismissed Courbet as having 'died with the Commune'.[19] Instead, Jacques-Louis David, who incorporated revolutionary consciousness with artistic savoir-faire, and Théodore Géricault, whose *Raft of the Medusa* was the 'first' realist history painting of a contemporary subject, represented the summit French painting for Fougeron.

As a good communist should, Fougeron understood that the successful transmission of ideological content depended on the legible articulation of form, on the discovery of a painterly model which would at once make sense to and elevate the masses. As the most authentic 'painters of national history', David and Géricault provided references for the most dramatic of the 'Pays des Mines' paintings.[20] Fougeron especially admired David's perfection of a technique suitable for the most commonplace, as well as the most noble subject matter, and identified with his willingness to take on any social command. It seemed to him that a reworking of Davidian neoclassicism, which was both historically bound to the originary revolution and rooted in the *peuple*, might provide the right balance between form and content.

Fougeron was explicit about his intention to express 'national aspirations', and the propagandistic ends of *Le Pays des Mines* were naturally bound to the vicissitudes of labour relations in post-war France. After the Liberation, the miner became a veritable cult figure, crucial to the industrial reconstruction of the nation, and to the political visibility of the PCF. Cultural renewal was explicitly linked to pleas for increased production in the mines: 'Without an augmentation of our production [of coal], there can be no economic renewal, no industrial rebuilding, no national Renaissance.'[21]

Images of the working class, especially of miners, were already firmly entrenched in a tradition of nineteenth- and twentieth-century French painting. Within Fougeron's own circle, Fernand Léger's construction workers and Edouard Pignon's miners complemented the work of Taslitzky and Jean Amblard, who had been commissioned by the Association des Musées de France in 1947 to document northern mine and metal workers for a proposed museum project in Denain. Lecoeur's interest in seeing Fougeron's project through had much to do with his own identity as a miner; he had been instrumental in the 1941 strikes, a mythic act of resistance against the Nazi occupier. Thus, it was hardly a coincidence that in 1950, representing the hero of the reconstruction and martyr of the crippling strikes of 1947 and 1948 – the national symbol of the proletariat – became the legitimizing centrepiece of an aesthetic quest.

In keeping with Fougeron's chosen framework, *Le Pays des Mines* proceeds in a linear fashion, and consists of fairly straightforward portraits of labourers, such as *Le Mineur* (the painting with which the exhibition commenced), landscapes, still-lifes, anecdotal everyday life scenes, and more complex allegories of oppression like *Défense Nationale*: a rendition of the class struggle in action (the painting with which the exhibition finished). According to Simone Flandin, the display was organized according to two axes. The first 'reported' on the life of the miner, the second emphasized the artist's aesthetic research, his sketches and studies exhibited so as to show the genesis of a painting.[22]

Fougeron's realism tends not towards photographic accuracy, but is schematic, and veers toward caricature. He was an accomplished draftsman who contributed acerbic political illustrations to such party publications as *Les Lettres Françaises* and *Ce Soir*. We know from his studies, and from photographs of him working that he always moved from the sketch to the painting, delineating the outlines of his compositions on the canvas. The original drawn boundaries of objects and figures are amplified in the finished works, the forms built out of patches of neatly applied flat planes of colour contained by thick, controlled arabesque-like lines.

Such an emphasis on line is evident in the portraits. *Le Mineur* (Figure 7.1), whose blackened face and pale eyes are turned away from the slag heap and processing plant outlined in the misty distance, is the pendant image to the coquettish coal-sorter, *La Trieuse* (Figure 7.2), who, with her upturned lips and blue hair veil was considered by communist critics to be 'the Florentine virgin of our times'.[23] The ecumenical reference, ideological in its essence, removes the worker from her present reality. Situated within a classical art historical and religious context: she becomes eternalized and pure, blessed rather than burdened. Fougeron amplifies the coal-sorter's virtue by portraying her in a moment of rest. Her costume unsullied, she is an ideal

vision of femininity, just as her counterpart's masculinity is emphasized by his furrowed brow, and the visible traces of grimy labour on his face.

André Stil wrote: 'These faces are transparent mirrors, which above all put into relief the black light of our struggle', relying on similar metaphors – the mirror and the black light – used by Marx in *The German Ideology* to describe the workings of ideology.[24] In fact, the portraits waver in their depiction of specific traits and vague types. Not voluminous, nor modelled with any real sophistication, the miner and the coal-sorter are flatly synthetic, their individual subjectivity all but effaced.[25] Recognizable in their costumes, their identities remain elusive, they are not individuals, but 'every-miner'. The worker-spectator's crucial moment of identification hinges precisely on the totalization of the general and the specific. The political charge of the work depends on the successful depiction of 'the organic, indissoluble connection between man as a private individual and man as a social being as a member of the community'.[26]

The artist's emphasis on classicizing figuration is meant to shorten the distance and time it takes for the communist ideal to become legible to the spectator. Fougeron constructed a pictorial scene which manipulates resemblance and distance in order to idealize the worker. Close to the surface plane of the canvas, his labourers seem to leap out of their frames, and at the same time they look beyond us, they avoid our gaze. Referential and spatial remoteness are also at play in these images. *La Trieuse* and *Le Mineur* are not part of the scene of work (which the spectator is never brought in direct contact with), they are posing in front of it. They are quite literally represented as alienated from the place and products of their labour, which are sketched in their background, external to them. Avoiding a too faithful Realism, yet relying on art historical conventions of portraiture enabled Fougeron to establish the miners as 'types'. These conventions – the usage of a three-quarters or fully frontal pose, the presence of the landscape in the distance, the importance of costuming – take the worker out of her or his specific everyday context, at once conforming to and challenging the Soviet definition of Socialist Realism as the 'typical painting of typical characters in typical circumstances'.[27]

Fougeron plays with the rules in other ways too. According to the tenets of Socialist Realism, an artwork's form – each dab of colour, each compositional decision and each turn of a line – is meant to express as intensely and optimistically as possible a new reality for the working class. Yet, in Fougeron's paintings this new reality shamefully resembles the old. The miracle of socialism is nowhere in sight. The French miners are not victorious and heroic, but solemn, mining country is not productive but destructive, sinister and cold. Here, Stalin's dictum that socialism 'obliges a new content to momentarily inhabit an old form, provoking a conflict between them'

does not summon the past to the revolutionary aid of the present, but foregrounds an unbridgeable gulf between form and content, and perpetuates a distance between the then – Fougeron's art historical references, and the now – the contemporary life of the miner.[28]

While the portraits are grounded in observation and idealization, images like *Terres Cruelles* (Figure 7.3), and *Les Juges* (Figure 7.4), bring the spectator more deeply into the domain of rhetoricity, a rhetoric of misery, far from the glorious representations of labour normally associated with Socialist Realism. Not quite standard history paintings, both deal with the subject of mining accidents, the daily effects of the cruel earth (*Les Juges* was later used to illustrate an article on a mining accident in *l'Humanité*, an interesting choice in an era of the photographic image). *Terres Cruelles*, equally the title of one of Aragon's poems, expresses the suffering of the worker through visual narrative.

The asphyxiated miner is brought to the surface by his two comrades (the figure on the right is recognizable as the same miner as in the portrait), mechanically posed as if resigned to the presence of death. A coal-sorter, her *métier* recognizable because of her veil, embraces the dead miner's son, the couple stares accusingly at the spectator.[29] In the foreground placed between the viewer and the drama of the witnesses, lies the body of the dead miner, one shoe lost, left hand already stiffened. His wife, bare armed and hair loose, collapses over him in her grief. The scene is enacted at the exit of the mine, the landscape serving as backdrop. Our eyes are drawn in by the glaring couple, but they linger in the open space between the triangular formation of standing figures on the left, and the triangular formation made by the miner's cap as it angles toward the wooden pole.

While all the interpretative clues are provided for the viewer to unravel the story of the dead miner, *Les Juges* relies on a different theatricality, the theatricality of empty space and lack of temporal reference, the four mutilated figures and the child standing against the dark, indeterminate background, serving as stand-ins for all the wounded and dead of the mines. 'Look them in the eyes! This is much more than mere painting!'[30] Fougeron focuses deliberately on the hands, the utilitarian capacity of each miner wrenched away by the very work that sustains them. The corseted man, blinded and forced into a permanent pose of defiance, clenches his fist as an act of resistance, a sign of life. The biblical reference to the book of Judges in the title, is amplified by the religiosity of the figure of the coal-sorter/virgin mother, who gestures with her two remaining fingers.

The visual relationship of *Les Juges* to German *Neue Sachlichkeit* painting was remarked on in the press; it was viewed as 'macabre and Germanic', even suitable as an advertisement for orthopaedic shops by one derisive critic.[31] Stil retorted that 'this painting will never be displeasing enough to show in just five figures the hundreds of thousands of atrocious wounds,

broken lives, and wounded hearts; these colors will never clash enough'.[32] The wooden table and peculiarly placed orphan stand between the spectator and wounded figures, distancing the miners from the spectator, trapping them in the canvas. Yet, at the same time the two figures on the right summon the spectator's attention with their unavoidable gaze. They are meant to be the reflections of our actions, if we are not miners – our contemporary martyrs, if we are.

Issues of imitation and rhetoric, foundation to the traditional concepts of history painting, are brought sharply into focus in *Défense National* (Figure 7.5), considered the 'pièce de résistance' of *Le Pays des Mines*. Here, Fougeron's gestural histrionics incited the hoped for comparisons with Jacques-Louis David. *Défense Nationale* recounts a story already lived, the failed 1948 insurrection of miners. In opposition to lax safety measures and calls for increased production without increase in salary, nearly 90 per cent of all miners (60 per cent of all eligible workers), opted in a secret vote to strike on 4 October. On 18 October, the French government violently brought down the strikes, calling in the Compagnie Républicaine de Sécurité (CRS), the national force created by socialist Jules Moch expressly for that purpose. By November, order had been restored with nearly half the mining pits now controlled by the CRS.[33]

This painting, previously discussed by Sara Wilson as embodying the values of the best of French history painting, such as 'family ties, revolutionary fervor, patriotism, and resolve in the face of the enemy', does not show the miners in the process of winning the battle, but of being repressed, beaten back from the entrance of 'their' mine by the villainous, caricatured police.[34] In order to elevate the subject matter, Fougeron borrowed from David's *Intervention of the Sabines*.[34] The iconographical similarities between the two works begin with the foremost male figure who, bare-chested and muscles bulging as an antique hero, yet still prosaic in his torn trousers, is clearly modelled on David's Romulus, his shield substituted with the carmine, choking face of a CRS officer, and his effortlessly poised spear now replaced by an upraised fist. The intervening heroine Hersilia is absent, but the blonde male figure in the rear centre, entreating the viewer with his gaze and raising his fist in a communist salute, seems to be an amalgam of the haunting female fury in red at the centre of David's canvas and Rude's screeching *Marseillaise*. The blonde woman blocking the wolf-hound's bloody jaws with her broken stick, can be found in the David tucked behind the female figure in red.

According to Jacques Gaucheron, Fougeron entered the realm of the epic with *Défense Nationale*, a 'relatively successful painting ... if reality is not completely expressed, the painter at least managed to make the history of the mines and their present *emerge*, by suggesting the epic character, the

optimism, born of the class struggle'.[36] Optimistim? While vicious dogs attack the women in the right foreground, a child clings stiffly, his face rather untroubled, to his mother's breast. She, in a red blouse and brown skirt – street clothes – embraces the boy wedged between her and the two flags, the French tricolour and the red standard of communism, held upright by a peculiarly sized comrade standing just behind her.

The tricolour motif is repeated in the combination of the woman's red blouse, the bare-chested male figure's torn blue trousers, and his pale white foot, which contrasts starkly with the dark uniforms of the CRS, as well as the intense colour of the fallen officer's face, on which the miner's foot rests. These miners are not associated with the red flag – with no hammer and sickle visible the boundaries between the flags are blurred – but with the republican values embodied in the tricolour. They are not only defending their livelihood, but waging a battle for the protection of France. At the precise moment when French communists' relationship to the Soviet Union was harshly criticized, the association of the miners with a national symbol of such importance could only be a strategic move, an attempt to gain sympathy for the miners' cause from an increasingly antipathetic public. *Défense Nationale* therefore makes evident to what extent the artist was responding to Communist General Secretary Maurice Thorez's long-standing desire to 'reconcile the tricolor of our fathers with the red flag of our aspirations'.[37]

Unlike the disorderly miners whose composition is held together by the arc of a swinging fist, the CRS, are a mass of darkness, punctured by grimacing faces and gesticulating hands in the first rows. Behind those directly engaged in the fight, the police force is neatly ordered and extends beyond the picture plane, creating an illusion of distance and reinforcing the perception of their size and symmetry. The miners are abutted against the gate to their mine. State treachery is highlighted by their weapons, and contrasted with bravery of the miners, which is accentuated by their bare fists. Elements of great chaos and confusion seem to be in place, but Fougeron forestalls the action, and presents us with a static image of arrested movement, where even the fabric of the flag does not tremble.

Ultimately, the 'Pays des Mines' system of signification seems uniformly geared toward evoking the French miner's saintly suffering, but Fougeron's pictorial debt to David's *Intervention of the Sabines* problematizes the project's ideological message.[38] Was the artist aware that he based his ultimate battle-scene on an image which symbolized *reconciliation* between warring factions? Not only was this message historically inaccurate, for an artist meant to emphasize the importance of class struggle, it was counter-revolutionary.[39]

As an allegory, *Défense Nationale* operates less straightforwardly than the portraits and landscapes of *Le Pays des Mines*. Jacques Gaucheron remarked that the work's structure reveals

a disjunction between the diverse elements at the heart of this painting ... there is a shift of register, despite any precautions taken, between this painting and the others. Let's not condemn the painter! If the form here separates, to a certain extent, from the content, it is not only because of him, it is not strictly a personal problem.[40]

The disjunction revealed, between idealism and realism, as well as between form and content, forces the viewer to negotiate a polysemic message meant to be clear. Here, Fougeron's failure to achieve a totalization of form and content is commensurate with the failure of the miner's cause. Failure is legible in Fougeron's choice of subject matter (a *failed* strike), in his art historical model, and in his inability to render realistically the sense of the miner's defeat. Furthermore, the aesthetic which seeks to express a 'reality in becoming', expresses a reality which had already become. Without a clear historical marker in the representation of the event in question, *Défense Nationale* repeats and reinscribes the loss.

Like *Les Juges* and *Terres Cruelles*, *Défense Nationale* echoes reality, but through its formal characteristics – its allegorical structure, its reference to painterly traditions of the past – it manifests itself outside of real time, outside of the present. And the image takes too much time for the spectator, it is not instantaneously accessible as it should be, it demands to be read, to be situated, in its formal structure, simplified figures, complicated action, vague temporal referent, it signifies too far beyond its preordained limits. Its theatricality and bombast function as ideology does. In the words of Sarah Kofman, who deconstructs the notion of ideology as camera obscura as follows:

Rather than a transparent copy obeying the laws of perspective, ideology functions as a simulacra: it disguises, travesties, confuses real relations. Marx opposes to it values of clarity, of light, of transparence of truth, or rationality. The camera obscura functions not as a particular determined technical object which has the effect of inverting the presentation of real relations, but as an occulting machine which plunges consciousness into obscurity, evil, error, gives it vertigo, makes it lose its equilibrium; a machine which renders real relations enigmatic and secret.[41]

Fougeron's task was precisely to find a way to rip the veil off these real relations, to render them visible, unengimatic. But an ideologically over-determined Realism would not allow for it. The reception of *Le Pays des Mines* recognized his dilemma. It was decidedly mixed. Victorin Duguet, secretary of the Federation of Sous-Sol, thanked Fougeron for his 'rare and isolated image of the life of a miner', for a 'real' image, 'accusing those responsible for this life at the same time that it pays homage to the victims who do not accept this mode of living, and who struggle with indomitable courage to abolish it once and for all'.[42] André Chastel suggested that if one actually *liked* painting, a visit to *Le Pays des Mines* was pointless. If the miner's difficult life was among one's foremost preoccupations, well, better

to reread Zola's *Germinal*. Fougeron's harshest critic, Jean Texcier, who compared the *Pays des Mines* to Nazi Realism, wrote:

When looking at a painting, it never occurs to me to take political or sentimental sides for or against one of the characters represented. In front of the *Justice of Trajan*, am I for Trajan on his horse, or for the poor woman holding her child and pleading on her knees in front of him?

I am, simply, *for Delacroix*, because he is a great painter. Is it my fault that Mr. Fougeron is neither Delacroix, nor David … nor even Valotton?

With regard to this exhibition of paintings so *gauche*, so cold, so pretentious, and at the same time, so vulgar in their execution, the Communist Party speaks only of the class struggle and communist politics. The question of painting is never raised. Are we in front of a painter, or an orator at a meeting?[43]

Party critics indirectly responded to Texcier's puzzlement as to Fougeron's status as a painter or as orator by consistently employing a language in which the painting is anthropomorphized and given a voice. Realism, as opposed to mute abstraction, employs rhetoric, and *speaks* the content of the work. But how does it speak? And to whom? In keeping with the realist programme, Fougeron's project was to 'evoke the misery, the oppression and the struggles of the worker' in a language which would do honour to the subject matter, which would 'speak with as much justice and power, the same power of communication, as a speech by Maurice Thorez. The same simplicity, the same conviction'.[44] But, the rhetoric of paintings like *Les Juges*, *Terres Cruelles* and *Défense Nationale* – and all three were referred to as allegories in the critical press – rely on a mode of address that refigures the message, and interrupts its direct transit, as allegories necessarily do.

The Soviet critic V. Prokoviev criticized Fougeron's appropriation of David, as well as his use of allegory in *Le Pays des Mines*:

There are two ways to go from the sketch to the painting. The first deepens and enriches the content, reinforces the living clarity of the image, brings one closer to life: it is authentic Realism's way. The other is the schematization of the sketch, the transformation of the painting into a chain of logical symbols, the transformation of images drawn from reality into abstract allegories. This way of going beyond the sketch has a purely formalist character.

The dangers of the second way are not always avoided, even by Fougeron, leader of 'New Realism', who often, to reach completion and generalization, pays the price of a certain schematization of figures and situations. Those of Fougeron's paintings that suffer from this problem are, in genre, montages of a series of figures or groups – No variety of sentiments, no diversity of movement: in each figure everything is brought back to the leitmotiv, and all characteristic details, everything that individuals live is rejected. But because of this each character becomes an abstract symbol. The painting loses much of its lively convincing force. The painter arrives at asceticism by making an absolute of certain, limited aspects of David's artistic system.[45]

Fougeron is not reproached for his subject matter, but on stylistic grounds, for his chosen rhetorical structure, and for his artistic models, which do not

conform to the demands of Soviet Socialist Realism. The artist had schematized and totalized his figures in order to make them accessible, but is now accused of being too formulaic. His representations are too general, while he, as an artist seems to be too individualistic, too eclectic. Far from fulfilling the demands of Socialist Realism, his images veer off course, as he picks and chooses motifs from a variety of painterly precedents which tend not to cohere when composed together on canvas, a tactic which would prefigure his shift to a montage composition in *Civilisation Atlantique* (1953).

New French Realism's ideological wish was to create a 'tendentious, class painting' – which would 'provide new weapons for the proletariat and more confusion for the enemy'.[46] It depended on the assumption that the realist art object, as the material incarnation of communism's ideological ambition to unveil the real conditions of working class existence, is the mediating tool par excellence for the transmission of that truth. In this way, its conceptualization remained consistent with Marxist theories of Realism which argue that an enlightened consciousness is impossible within the realm of immediate experience, that appearances are false reflections of reality, and that a form of mediation is necessary for the proletariat to attain its full class consciousness.

According to this perspective, art and literature have the capacity to totalize and reconstitute everyday experience and transform the proletariat's partial, fragmented, and insufficient viewpoint of that experience. By emphasizing the art object's use value, residing in its content born of the class struggle rather than in its form, the realist art object is assumed to escape the inexorable logic of exchange, the economy which subtends alienation. Through the successful communication of its literal message, the realist art object is that which can mend the rifts between form and content, universal and particular, spirit and sense.[47] With so much at stake in the successful achievement of the realist work it will be no surprise that Realism ends up having little to do with 'the real' at all. Nor is it shocking that, for both contemporary critics, as well as historians of the period, this enterprise fails.

Rather than reading Fougeron's failure simply as a symptom of communism's political bankruptcy, or as evidence for arguments in favour of artistic liberty, it seems to me that we might equally consider the relationship between realist art and politics by articulating it in structural, as well as in political terms. For, the realist art object conceived of in this way, cannot come to terms with its paradoxical relationship to ideology, which is structured *not* as a faithful transcription of reality, but as illusion. Ideology – fluid, transhistorical, and omnipresent, undoes the work of forms of representation that intend, as Realism does, to be historical, punctual and specific. Ideology is necessary because it makes obvious that which we should see, it 'hails the subject', to quote Althusser, but at the same time it functions as *misrepresentation*.

Ideologies, 'appearances, but somehow real, pretenses, but effective ones'. represent imaginary relationships between individuals and their real conditions of existence.[48] Realism was meant to serve as a corrective device, interpreting and making intelligible that which ideology mystifies. At the same time, because it is itself ideological, Realism cannot be a pure 'reflection' of reality. It must unmask reality's contradictions and ambiguities, but in order to do so it must halt its fleeting temporality and freeze its movement. Realism must distort reality while never revealing the distortion.[49] Thus, there is a perpetual formal and temporal displacement between the real and its image in this politics of representation. Realism's goal is to instil class consciousness. But if we follow the logic of communism, which aims not only for the destruction of the capitalist economy, but the end of ideology, Realism, ideologically determined by communism, seeks its own demise. Fougeron's paintings of *Le Pays des Mines* attempt to come to terms with such tensions between the ideological and the real. *Inspired* by Socialist Realism and indebted to a peculiar understanding of French tradition, Fougeron relied upon a utopian faith in the reconciliation of the ideological and the real, the universal and the particular, the temporally remote and the present – all the while evincing the impossibility of this ideal as a prescribed representational and political strategy.

'They dream of Courbet who would salute the Vendome column. Since this sort of Courbet doesn't exist, we will take this realists that reality offers us', wrote Jean Milhau with regard to Fougeron's critics. His communist supporters triumphantly supported the artist's dedication to the working class. It was clear that the artist was devoting as much energy to political references as to aesthetic questions. Yet, in the realm of the aesthetic, their enthusiasm was far more measured. Fougeron's 'contribution to the elaboration of a New French Realism' was taken as just that – a small step in a much larger struggle to muscle ideology into a legible, univocal, instantaneously accessible, re-presentational scheme. André Stil's essay, titled 'Avance Fougeron!' admitted that the works could not be considered altogether successful;[50] J. Gaucheron remarked that ground had been gained, but work remained to be done;[51] Auguste Lecoeur equivocated, 'they aren't bad paintings, really'.[52] The conclusion? Fougeron was a mere 'explorer' who had not yet discovered the door leading to the harmonious aesthetic totality that is the marriage of content and form into a unified, realistic and ideologically effective image. Having abandoned this goal shortly after *Le Pays des Mines*, perhaps Fougeron realized that, 'Painters know better than politicians that just asking for something does not make it happen, things need time, maturation. Now, the great tragedy is that politicians, and this is normal, are people in a hurry'.[53]

Notes

1. This chapter is a condensed version of chapter 4 of my dissertation, 'The Rhetoric of Realism: Painting, Politics, and Commitment in France, 1940–1956'. I would like to thank Valerie Mainz and Griselda Pollock for inviting me to participate at *Work and the Image* (Leeds University, April 1998). I am grateful to the late André Fougeron, Lucie Fougeron, Joann Morra and Marquard Smith for their generosity and hospitality. Boris Belay and Michael Stone-Richards made helpful comments on an earlier version of this chapter. Translations are mine unless otherwise indicated.

2. *Les parisiennes au marché* (1947), shown at the 1948 Salon d'Automne, is considered Fougeron's first Socialist Realist painting, although it is not his first Realist work. For a periodization and contextualization of the artist and issues surrounding French Socialist Realism, see above all Wilson, S., 'Art and Politics of the Left in France, 1935–1953', PhD, University of London, 1991. Wilson was the first to take Fougeron's work seriously, and I very much profited from conversations with her early on in my dissertation research. Among her numerous articles, see on post-war communist painters in particular, 'Martyrs and Militants: Painting and Propaganda: 1944–1954', in M. Scriven (ed.), *War and Society in Twentieth Century France* (New York: Berg, 1991), pp. 219–46; 'Débats autour du réalisme socialiste', in *Paris-Paris, 1937–1957* (Paris: Centre Georges Pompidou and Editions Gallimard, 1992), pp. 308–19. See also Flandin, S., *André Fougeron: Le parti pris du réalisme 1948–1953* (Mémoire de maîtrise d'art comtemporain Université de Clermont-Ferrand, 1981–82), and Perrot, R., *Esthétique de Fougeron* (Paris: E. C. Editions, 1996). The exhibition catalogue *André Fougeron pièces détachées 1937–1987* (Paris: Galerie Jean-Jacques Dutko, 1987) is the best source for reproductions, giving a representative sample of Fougeron's stylistic incarnations.

3. Plat, J., 'Le Pays des Mines d'Andre Fougeron et les problèmes de l'esthétique', *La pensée*, supplement to **35**, March–April (1951), p. 166.

4. The nature of the commission is mentioned in Wilson, Flandin, and Perrot, *Esthétique de Fougeron*, p. 142, n. 4. Fougeron details his year in Lens in Dupuy, H. J., 'Pendant un an j'ai été le peintre le plus heureux de la France', *Ce Soir*, 22 January (1951), p. 2.

5. *L'Humanité* published three texts by Auguste Lecoeur on Fougeron's Pays des Mines: 'Le peintre à son créneau', 28 November 1950, pp. 1–2, 'Le peintre à son créneau', 8 December 1950, p. 5., and 'Le Pays des Mines', 12 January 1951, p. 5. See also Stil, A., 'Avant l'exposition d'André Fougeron 'Le Pays des Mines', Les terrils ont aussi leurs papillons', *l'Humanité*, 5 January 1951, p. 5.

6. These are the numbers calculated by the party. Simone Flandin details the itinerary as follows: Lens, Douai, Denain, St Etienne, Marseille, Alés, Carmaux, Montceaux-les-mines. It appears that *Le Pays des Mines* was exhibited only for several days in each town.

7. Milhau, J. 'Pour une tribune du nouveau réalisme', *Arts de France* **23–4** (1948), p. 35. Milhau's rubric was meant to encourage the participation of the reviews readers in discussions about Realism.

8. Taslitzky, B., 'Entretien', *l'Humanité*, 6 October 1948, p. 5.

9. But this tendency can be traced to the Front Populaire, see Aragon's 'Réalisme Socialiste et Réalisme Français', delivered October 1937, published in *Europe*, **46**, 15 March 1938, and in *Les Lettres Françaises*, **388**, 15 November 1951, reprinted in *Ecrits sur l'art moderne* (Paris: Flammarion, 1981), pp. 54–63.

10. See Roger Garaudy's and Georges Cogniot's interventions at the Tenth Congress of the PCF, 26–30 June 1945 published as *Les Intellectuels et la Renaissance Française* (Paris: Editions du PCF, 1945). The PCF announced a never realized project for an Encyclopédie de la Renaissance Française; *Arts de France* was conceived as a pendant to the encyclopedia.

11. Sarah Wilson has pointed out that the term 'Jacobinization' was used to describe this shift, but further unpacking of the post-war communists' identification with the Jacobins is unfortunately beyond the scope of this chapter. Nevertheless, it importance should be noted, especially with relationship to painting of the epoch, and in light of Fougeron's use of David as a model (*post-revolutionary* David). One source worth consulting is Kriegel, A., *The French Communists: Profile of a People*, trans. E. P. Halperin (Chicago: University of Chicago Press, 1972), p. 216. Originally *Les communistes français* (Paris: Editions du Seuil, 1968).

12. Kriegel, *The French Communists*, p. 111.

13. Bernard, J.-P. A., *Paris Rouge, Les Communists Français dans la capitale* (Paris: Champ Vallon, 1991), p. 180.

14. Zhdanov, A. 'Sur la situation internationale', *Cahiers du communisme*, November (1947), pp. 1124–51.

15. Zhdanov's intervention at the first Soviet Writer's Congress was published in French in *Sur la littérature, la philosophie, et la musique* (Paris: Editions de la Nouvelle Critique, 1950). The definition of socialist realism is as follows: 'Cela veut dire, tout d'abord, connaître la vie afin de pouvoir la représenter véridiquement dans les oeuvres d'art, la représenter non point de façon scolastique, morte, non pas simplement comme la 'réalité objective', mais représenter la réalité dans son développement révolutionnaire.' For a discussion of 'tendency' see Robin, R. *Le Réalisme Socialiste, une esthétique de l'impossible* (Paris: Payot, 1986), pp. 86–9.

16. Casanova, L., *Le communisme, la pensée et l'art, discours au XIème congrès du PCF*, Strasbourg, 25–28 June (Paris: Editions du PCF, 1947), p. 11.

17. Merleau-Ponty, M., *Sense and Non-Sense*, H. L. Dreyfus and P. A. Dreyfus trans., (Evanston and Chicago, IL: Northwestern University Press, (1964), p. 160.

18. One must not overlook the centrality of the French Revolution both to Marxism, and to the symbolism of the Bolshevik revolution.

19. Fougeron, A. 'David et nous', *Arts de France*, **35**, June (1950), p. 39. Written during the genesis of *Les Pays des Mines*, this text was a contribution to a celebration of the one hundred and twenty-fifth anniversary of David's death. The issue includes illustrations of David's preparatory drawing for the *Sabines*, Tardieu's engraving after David's painting of the death of Le Peletier de Saint-Fargeau, David's drawing of the dead Marat, among others. And additional text, 'J-L David, homme, peintre, citoyen', precedes the Fougeron. It is a reprint of selected letters written by David. See also Aragon, L., *L'exemple de Courbet* (Paris: Editions Cercle de l'Art, 1952).

20. Ibid.

21. Maurice Thorez in a speech given in 1945 cited in Andrieu, C., Le Van, L. and Proust, A., *Les Nationalisations de la Libération: De l'utopie au compris* (Paris: Presses de la Fondation Nationale des Sciences Politiques, 1987), p. 299.

22. Flandin, *André Fougeron*, pp. 67–72.

23. Abraham, P., 'Un vernissage', *Les Lettres Françaises*, 18 January 1951, cited by Verdès-Leroux, J., *Au service du parti: Le parti communiste, les intellectuels et la culture 1944–1956* (Paris: Fayard, 1983), p. 306.

24. Stil, A., 'Avance, Fougeron …', in A. Lecoeur and A. Stil, *Le Pays des Mines* (Paris: Editions Cercle de'art, 1951), p. 24.

25. Perrot informs us that Emile Fontaine posed for *Le pensionné* and Julien Huleux for *Le mineur*. See Perrot, *Esthétique de Fougeron*, pp. 143–4, n. 12.

26. Lukás G., 'Preface', *Studies in European Realism* (London: Merlin Press, 1972), p. 8.

27. Robin, *Le Réalisme Socialiste*, p. 87.

28. Stalin's quote, from *Anarchism or Socialism*, was used by several authors, including Jean Plat, André Stil, and Jacques Gaucheron to justify the return to Realism. Cited in French: 'Nouveau contenu est obligé de revêtir momentanément une vieille forme, ce qui provoque un conflit entre eux.'

29. There is a question as to whether this couple are brother and sister. In 'Martyrs and Militants', Sarah Wilson has likened the dead miner to Hans Holbein's *Dead Christ*, as well as a corpse from Géricault's *Raft of the Medusa*.

30. Stil, 'Avance, Fougeron …', p. 16.

31. Texcier, J. 'A propos de l'exposition de Fougeron, Peinture de la misère? Non, Misère de la peinture', *Le populaire de Paris*, 24 January 1951, p. 4.

32. Stil, 'Avance, Fougeron …', p. 25.

33. Wall, I. M., *French Communism in the Era of Stalin: A Quest for Unity and Integration, 1945–1962*, (Westport, CT: Greenwood Press, 1983), pp. 75–89.

34. Wilson, 'Martyrs and Militants', p. 227. Wilson reads *Défense Nationale* as 'triumphalist', while I am claiming its focus is failure.

35. Thanks to Valerie Mainz for addressing this to me and encouraging me to take the analysis further.

36. J. Gaucheron, 'Sur l'exposition "Le pays des mines", *Europe*, **66**, June (1951), p. 144.

37. Speech of 1936, quoted in Kriegel, *The French Communists*, p. 216.

38. See *David Contre David*, R. Michel (ed.), (Paris: La Documentation Française, 1993). For recent interpretations of the *Intervention of the Sabines*, see Grimaldo-Grigsby, D., 'Nudity à la Grècque in 1799', *Art Bulletin*, **80** (2), June (1988), pp. 311–33 and Lajer-Burcharth, E., 'David's *Sabine Women*: Body, Gender and Republican Culture under the Directory', *Art History*, **14**, September (1991), pp. 397–40.

39. This argument is worked out in much more detail in my chapter 4.

40. Gaucheron, 'Sur l'exposition', p. 144. On allegory, see also Wurmser, A., 'Suite du dialogue entre André Wurmser et Francis Jourdain', *La pensée*, **36**, May–June (1951), pp. 131–2.

41. Kofman, S., *Camera obscura de l'idéologie* (Paris: Galilée, 1973), p. 28.

42. Duguet, V., 'Merci à Fougeron', *l'Humanité*, 19 January 1951, p. 5.

43. Texcier, 'A propos de l'exposition', p. 4.

44. La querelle de réalisme socialiste', *Révolution*, **64**, May (1981), p. 27.

45. V. Prokoviev in *Iskoussivo*, March–April 1953, quoted by L. Aragon, 'Toutes les couleurs de l'automne', originally in *Les Lettres Françaises*, **490**, 12 November 1953, pp. 1, 7 and 8, reprinted in *Ecrits sur l'art moderne*, (Paris: Flammarion, 1981), pp. 115–34.

46. Lecoeur, A., 'Le peintre à son créneau', *l'Humanité*, 28 November 1950, p. 5.

47. Rifts which are embodied in the commodity fetish. See T. Eagleton, *The Ideology of the Aesthetic* (London: Basil Blackwell, 1990), p. 208.

48. Lefebvre, H., *Critique of Everyday Life, Volume 1*, trans. J. Moore, (London: Verso, 1991), p. 145. Originally published as *Critique de la vie quotidienne 1: Introduction* (Paris: Grasse, 1947). It is notable that Lefebvre contributed two articles, 'Introduction à l'esthétique', to *Arts de France*. See issues 19–20, 23–4 (1948)

49. Lefebvre discusses the inadequacy of 'reflection theory' as an analytical tool in a way that is pertinent to this study: 'Consciousness reflects and does not reflect: what it reflects is not what it seems to reflect, but something else, and that is what analysis must disclose. Precisely because the activity that produce ideologies was exceptional and specialized, they came out of social practice – of everyday life – in two senses: it produced them and they escaped from it, thus acquiring in the process an illusory meaning other than their real content. The problem of ideologies is as follows: how can consciousness be mistaken about itself and its content – its being – when it is that very content and that being which determine it? *Only by taking the formal structure of consciousness and its content as inseparable and submitting them to a complex analysis will we be able to understand any particular form of consciousness, or any particular ideology* (my emphasis), *Critique of Everyday Life*, p. 94. See also Eagleton on Lukác, 'Works of realism know the truth, but pretend in a crafty act of prestidigitation that they do not: the work must first of all abstract the essence of the real, then conceal this essence by recreating it in all of its supposed immediacy. The realist artifact is thus a kind of trompe l'oeil, a surface which is also a depth, a regulative law everywhere absolute yet nowhere visible', *Ideology*, p. 324.

50. Stil, 'Avance, Fougeron …', pp. 17–28.

51. Gaucheron, 'Sur l'exposition', pp. 143–50.

52. 'Aprés l'exposition de Paris. Extraits du discours d'Auguste Lecoeur devant une assemblée des travailleurs de Paris' in *Le pays des mines*, pp. 17–21.

53. Unreferenced citation of 'militant artist' in Verdès-Leroux, J., *Au service du parti*, p. 42.

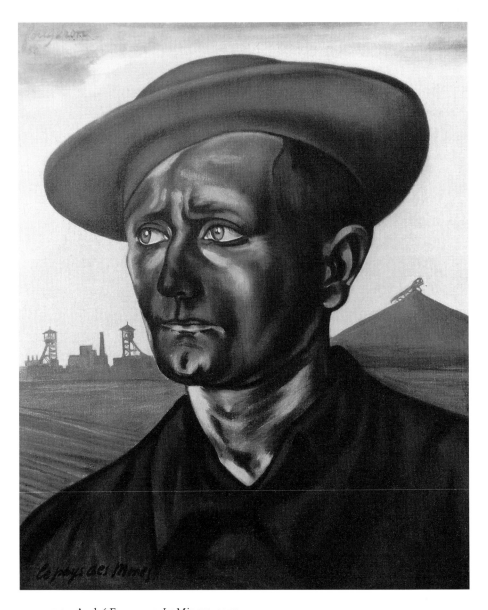

7.1 André Fougeron, *Le Mineur*, 1950

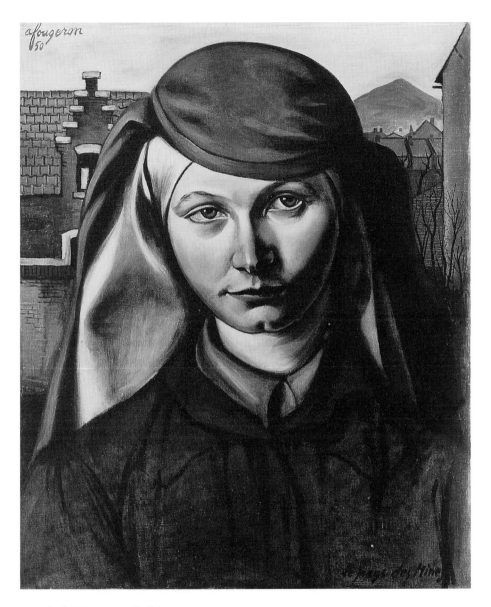

7.2 André Fougeron, *La Trieuse*, 1950

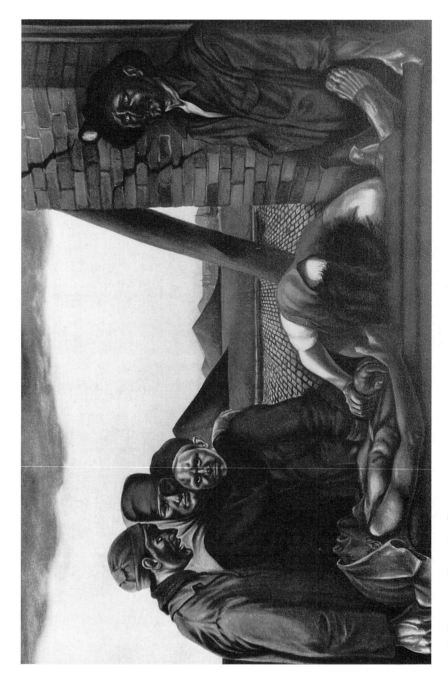

7.3　André Fougeron, *Terres Cruelles*, 1950

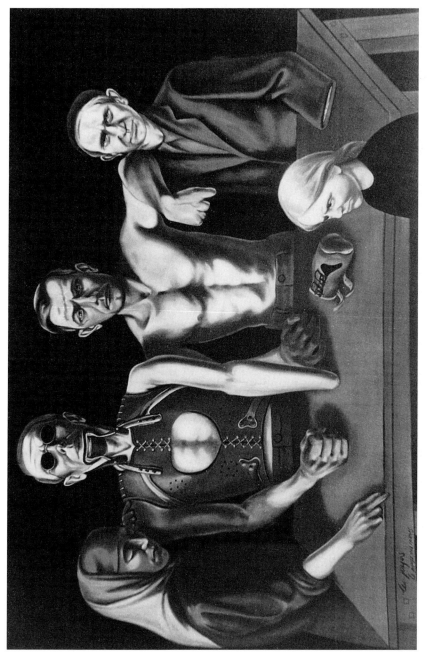

7.4 André Fougeron, *Les Juges*, 1950

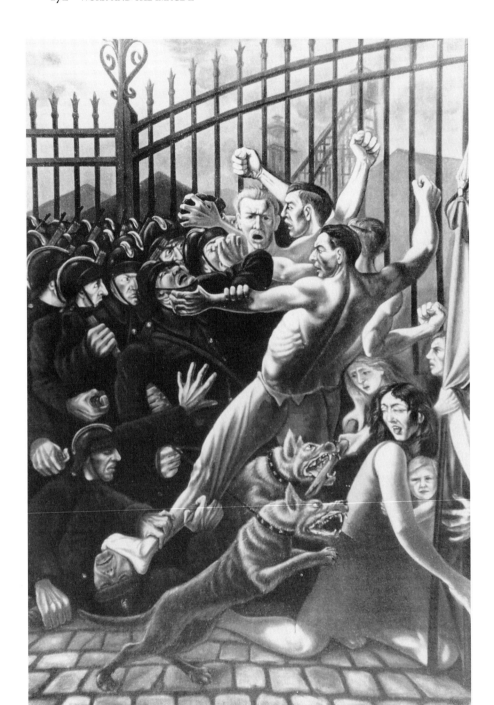

7.5 André Fougeron, *Défense Nationale*, 1950

Working images: the representations of documentary film

Elizabeth Cowie

The role of vision as access to a reality denied by modernity has been a central concern for art and politics in the twentieth century. Modernity and its industrial processes of production have transformed the conditions of both work and the look, expanding enormously the scope and scale of productivity through labour as well as the imaging of the world through photography, cinematography and video. Yet each is also subject to a continuing and intense ambivalence. A conflict or opposition has been perceived between the new freedoms offered by these developments in modes of production and in the mechanical and electronic forms of imaging and the dehumanization produced by modernity's regulation and exploitation of the worker and the gaze through mass industrial processes. 'Modernism' names the movement in the arts and literature which has challenged tradition in culture and society, not only demanding that we see anew but also devising new ways of seeing whereby such seeing anew would also be a truer 'seeing'. At the same time, modernism has opposed the alienation of modernity, attacking 'the loss of reality, which makes experience ever emptier and reality itself ever more impenetrable'.[1]

Film entered these debates both as a modern visual technology, and as the proponent of a visual realism that was ever less real.[2] The documentary film, arising as a project of film-makers in the 1920s, sought to oppose the perceived illusionism and deceptions of the fiction film and it did so as an extraction from and organization of reality – as, in fact, a fabrication, but a fabrication which thereby brought forward a new reality.[3] Film, and the photograph, as simple record of reality did not in and of itself produce an understanding of reality. In Brecht's famous words 'As a result, the situation is becoming so complex that less than ever does a simple reproduction of reality tell us anything about reality. A photograph of Krupps or the AEG yields hardly anything about those industries. True reality has taken refuge in the

functional'.[4] This chapter explores the attempts to give us access to the 'true reality' of work in documentary film.

In his film, *Spare Time* (1939), Humphrey Jennings describes this as the time we have for ourselves between work and sleep.[5] In showing the pleasures, fun and dedication of individuals and groups, *Spare Time* takes seriously people's use of their free time just as other documentary film-makers in the 1930s had sought to give dignity and prestige to human labour and industrial work. In this chapter I reverse Jennings's focus and centre instead on the domain of work and its representation, reviewing the ways in which images of workers and working have been produced in documentary film. I will be concerned with two questions here which, while apparently distinct, are in fact fundamentally interrelated. On the one, hand there is the question of how representable is work and working, and, on the other hand, there is the question of the signification of such images, of what the images mean as facts and as historical information; as subjective testimony; and, finally, as art, that is, as an emotional and thereby aesthetic experience.

The nature of work

Work is not an entity, a thing or an object. It is a concept, an abstraction which distinguishes and defines a portion of human activity and interaction. Work is that labour we do which is not play or recreation. It includes not only physical labour distinguished from the exertions of sport, but also so-called 'mental labour', or intellectual work. Work is serious; it involves a focused and directed activity with an intended and planned outcome constituting a material or cultural benefit. Work therefore produces value. Work is labour we do that produces a living. Human societies as economic, political and cultural entities are characterized by their relation to the amount of work in time and effort producing a living requires. Depending on the amount of time and effort, a community may have more or less non-subsistence work time – more or less time for non-work activities, or for producing an economic surplus which it can trade or exchange. The means of work and subsistence in human societies always includes the use of tools and natural resources as well as physical labour. These tools and resources, and the rewards of work they make possible, may belong to a group, a family or an individual.

The organization, and thus control, of access to and use of tools and resources of work – including land – and the surplus which can be produced is central to the story of human societies. The institution of such organization and control is the domain of politics and economics, of the control over and thus rights to the exchange of goods and services, including people as goods

and services. The ways in which such a surplus is deployed becomes the basis for the divergence, difference and complexity of human social organization and culture. In modern societies the products of our labour are sold rather than exchanged, and most of us sell our labour rather than the direct products of our labour. It is worth while for an employer to buy labour because – with the right tools or equipment, and with the right deployment and combination of skills – it can produce more economic value than is required to provide a living for the worker. The owner of the means of production can collect the value of his or her own labour, and the surplus value of his or her employees' labour. This, of course, is capitalist economic production. The surplus value of our work is hidden, in Marx's famous words, and the wage or salary paid does not necessarily correlate with or reflect the amount of surplus value produced. Rather, in a free market, labour is valued just like any other commodity in terms of demand and supply. If labour supply exceeds demand the wages fall, regardless of the cost of living or the productive (as distinct from exchange) value of the labour.

Work is for most of us, therefore, waged work; we no longer work to live but to earn a living, an income, and one which we expect to enable us to purchase more than the bare essentials for life, that is, to allow us to consume as well as produce a surplus. But because money can earn as well, paradoxically people can make a living from money itself, formerly called 'unearned income' in the tax office's language. In contrast large amounts of labour are expended in activities which are neither leisure nor within the domain of the waged economy, for they do not produce an income for the worker, namely housework and parenting. As a category of labour, work thus depends on a series of distinctions which are economic and social; it is discursively constructed. The discourse may be government statistics or planning, economic theory, socialist ideals or a discourse of equality and rights from women or ethnic minorities. Film can reproduce images of labouring, but 'work' must be signified and discursively constructed. This chapter examines the signifying of work in cinema and the ways in which factual and documentary film – 'working images' – produce such defining discoursing.

Representing work

Work is a process, a physical activity in time and space. Cinema as a medium of representation for the first time captured this process of work as motion, as the transfer and transformation of energy into movement and action. The film document as the recording of actuality presents an indexical trace of the

reality before the camera at the moment of recording. This actuality may be a constructed set and actors playing roles before the camera – 'played' film – or it may be unorganized 'wild' or actuality, filming – 'unplayed' film. But in each case the camera necessarily frames and hence cuts out from the wider ongoing contingency of the world just this scene, this event, this action. This 'cutting-out' nevertheless produces the impression of an ongoing world just to the side of the screen, momentarily out of view but which could be seen by just a turn of the camera or the viewer's head. We infer a continuing and continuous world for the film of which we view just a part. (The fiction film similarly depends on such inferences by audiences, even though at the same time viewers are aware that this is an illusion.) Cinema's invention arose from the experiments of scientists such as Eadweard Muybridge and Etienne-Jules Marey who were each concerned to understand human motion by recording and thereby analysing it. Film can record human labour and activity but the pertinence of what we see – precisely its communication *as* process and not merely as the play of colour, movement, sounds – must be produced in addition. Bearing an indexical trace of the movement and actions of people and animals, film *shows* physical exertion as movement but it cannot thereby tell or narrate the process of work involved. In addition the recording must become 'a film', an organized series of sounds and images in time and space whereby it can signify intentional actions within a larger frame of interaction, and thus the 'cause and effect' of process which is not only duration but also a commencement or beginning, and a production or endpoint. Documentary film therefore not only reproduces the actions recorded by the camera but also *produces* a statement or discourse which constitutes those actions as knowable. It transforms the document into a documentary discourse, a narrative or story. Thus, Philip Rosen has argued, the fuzzy, indistinct footage of the John F. Kennedy assassination in 1963 needed commentator Bill Ryan to 'explain' what audiences were really seeing, 'and in so doing he synthesised moments of reality' producing coherence and sense from unmediated, unorganized indexical reality.[6] Of course the 'reality' of the document, as shown by its very fuzziness which is read as an indicator of the reality of the moment of recording, is central. As such, that is, as an index, this fuzzy film has also become a convention used by fiction and non-fiction film-makers alike. Rosen emphasizes, therefore, that there is an opposition between the 'reality' of the film or photograph and its meaning which only appears through the historian's or commentator's emplacement or emplotment. This may give us a sense of loss, of reality *before* its fall into interpretation, narration, presentation. This is a fundamental fallacy, however, for we have no direct and full access to either contemporary or historical reality, there is no 'Ideal Chronicler'. Rather our access to reality is partial and framed. What photographic and cinematographic recordings introduce

is the *fantasy* of such access, of unmediated recordings of reality providing a total record, as if through the camera we might create a record of all that an all-seeing God might have surveyed. The early panoramic photographs are precursors of cinerama and with computer-controlled cameras it is perhaps now possible to produce a total record in all four dimensions of an event, though it would only be apprehendable by an individual person through a process of selection and montage, or by serializing the images in time and hence losing the simultaneity of the images of the event, limited as we are to eyes fixed in one plane only.

The documentary film, therefore, must signify in some way in order to convey that the activity recorded is work rather than play, or a religious or social ceremony, or a sport or leisure activity, and to do so the film must define work as such within its own discourse. In *Spare Time*, which has a voice-over only at the beginning, information is indirect but we will probably infer as a result of the film's title that the steel workers are unpaid for their work in the brass band, whereas in Jennings's *Listen to Britain* (1941) we might assume that Dame Myra Hess is paid to play at the lunchtime recital either because we know that she is a famous concert pianist or because we recognize the context as a public performance by a professional musician, that is, someone who earns her living by her music. To represent 'work' a film must engage not only with images of work in the already organized definitions of economics, politics, unionism or whatever, it must also engage with its own processes of defining.

Hans Richter has summed up the dilemma of film and realist representation for film-makers in the 1930s:

If the forces that determine men's destinies today have become anonymous, so too has their appearance. Hence today we are obliged to look behind the façade – if facts are to be revealed.
 The cinema is perfectly capable in principle of revealing the *functional* meaning of things and event, for it has *time* at its disposal, it can contract it and thus show the development, the evolution of things. It does not need to take a picture of a 'beautiful' tree, it can also show us a growing one, a falling one, or one swaying in the wind – nature not just as a view, but also as an element, the village not as an idyll, but as a social entity.[7]

In *Las Hurdes* (1932) Luis Bŭnuel documents the circumstances of life, and death, of communities in the Hurdes Altas region of Spain, notorious for the poverty of its land and people. By a strange irony in the context of Richter's admonition, in order to travel in the area to film *Las Hurdes* Bŭnuel had received official permission to make a 'picturesque' documentary about the area. Taking notes over a period of ten days, Bŭnuel then recaptured these observations on film very closely: the goats, the bee-keeping for the wealthier neighbours of Hurdes Bajas, the malaria-carrying anopheles mosquitoes, a

child sick with diphtheria, a funeral party carrying the coffin for miles over the hills because there are no churches. But these images cannot as such show what Buñuel also observed, a 'land without bread, without songs'.[8] The images remain obstinately enigmatic without the voice-over narration. How else to convey how precious goats are, and how vulnerable they are to the dangers of the sheer mountain cliffs? Or that transporting the bee-hives to the mountains for the summer is a dangerous and risky journey for the men and animals carrying the bees? We see a harsh but awesomely beautiful landscape, yet we cannot see the physical and economic difficulties of scraping a living from this same landscape until it is intellectually rather than visually observed for us. In a sequence showing men preparing some ground for growing a crop we can see the human labour involved and probably recognize its agricultural role, but we cannot see the scale of exertion required, nor the difficulties involved, in order to produce a crop. We cannot necessarily anticipate either abundance or scarcity for these farmers. This, however, is central to the workers themselves. That is, while the work may be the same as that of thousands of other peasants, here in Hurdes Altas the return on that labour is very small and may not be enough to feed a family. The work of these men must therefore be understood and defined not only in terms of its physical labour but also in relation to the scale of return on that labour.

The work – and poverty – of *Las Hurdes* is simply narrated, however, without placing its story in a wider context through which we can understand the causes – it is not explained as either natural and God-given, or the result of the peasants' ignorance, or solely due to the calumny of the exploiting classes of government and landowners. Instead the film's epistemological stance is scandalously neutral; it states just 'the facts' without making 'sense' of them, for example, by resolving them into an account of the justice and injustice of the plight of the Hurdes people, and thus the possible routes of action. Buñuel described not just the voice-over but also the text itself as deliberately neutral: 'Pay attention to the end: "After so much time in Las Hurdes, let's now return to Madrid." That's how the commentary is, very dry, very documentary-like, without literary effects.'[9] Work and peasant labour is 'made strange' by the film; unexplained it is inexplicable – how and why can people go on without work, without producing enough food to eat, let alone the medicines and education of modern society? The horror the film relentlessly states is senseless, absurd in the perspective of modernism. That is, irrational, surreal. Thus while many have seen this film as in contrast to his earlier films made with Salvador Dali, *Un Chien andalou* (1928) and *L'Age d'or* (1930), on the contrary, Buñuel, insists that in filming reality he was remaining within the spirit of surrealism and says that although these first two films are 'imaginative' and *Las Hurdes* is taken from reality, 'I feel it shares the same outlook'.[10] In making apparent the nonsense of reality Buñuel

challenges us to consider how we construct the sense of reality, how we find meaning in the facts, that is, interpret it.[11]

The documentary film is not only an assembly of facts and of a filmed reality but also an interpretation which can become established as a convention. Documentary film, however, may as well produce challenges to such 'interpretations', renegotiating the established meanings.

The quality of work

Not only must work be signified as such but it will also be contextually placed and qualitatively defined. Work, or workers, might be heroic in the face of physical hardship or muscular in terms of demands for endurance and strength as suggested by *Coalface* (Alberto Cavalcanti, 1935); the hardship endured might be represented as victimization (industrial sweat shops), or as ennobling and natural (peasant labour). Skill and craft might be emphasized as in *Night Mail* (Harry Watt and Basil Wright, 1936), or the focus may be the machines, rather than human labour, which enable mass production, and the worker portrayed as just one element in the industrial process. This might be celebrated in an embrace of the modern and of American methods and efficiency seen in Ruttman's *Berlin, Symphony of a City* (1928), or countered, as in Flaherty's *Industrial Britain* (1931–32).

The first decade of cinema saw the development of the American economic philosophy of Taylorism and the detailed division of labour in assembly-line production adopted by Henry Ford which deskilled workers, reducing the role of the human worker to a small number of specific and delimited tasks. (It was also adopted by the developing film industry, however there the division of labour led to specialization and increased skills in many areas.) Work in the twentieth century has, therefore, been under continual redefinition in terms of the skills – if any – involved and the kinds of activities required. At the same time workers, through unionization, have successfully intervened in the definitions of work, for example, in the regulating of casual labour by dockworkers, or instituting overtime payments for hours beyond a 'normal' working day or week. This success has, however, been represented as a danger, namely, that the power of the unions restricts the free market and hinders economic development, and is anti-democratic, for example, in the claim that the General Strike of 1926 in Britain overrode the democratic processes of Parliament. Thus the definition of work is also part of an ideological, as well as economic, struggle. (The role of the infrastructure of 'unearned' income for the economy and work has been relatively un-represented though it is no less crucial.) Indeed fear of popular unrest and strikes led to censorship of these topics in British feature films so that, before

1945 workers, or the unemployed, were rarely the subject of such films except as comic and/or benign elements in the story. By contrast in the USA both blue-collar and white-collar work and their vicissitudes were regularly shown in the movies, albeit often as part of a love story and with a happy ending. As Hollywood films constituted 80 per cent or more of all films screened in Britain in the 1930s, British audiences saw images of American workers but not British except for films such as John Ford's *How Green is My Valley* (1941), which adapted Richard Llewellyn's novel on coal miners in Wales at the end of the last century, though it could have as easily been set in the 1930s.

Instead it was in documentary films and actualities that images of work and workers might appear. Such images were popular topics for early silent actualities and formed a genre called 'industrials', while workers were a focus of the new 'documentary' film movement conceived by John Grierson and first realized in his 1929 film, *Drifters*, about herring fishermen in northeast Scotland. *A Day in the Life of a Coalminer* (Kineto, 1910) is a typical example of an early 'industrial', while *Coalface* is a central film of the documentary movement's concern to image Britain to itself, focusing on coal as one of the foundational industries for British manufacturing and trade. The two films, separated by just 25 years, nevertheless present very different portrayals of colliery workers and the working of the mines. Their differences tell more about the history of representation, however, than about changes in coal mining as such, for it is through the filmic discourse of each that social knowledge and understanding is organized, and through which the individuals portrayed are produced as workers.

A Day in the Life of a Coalminer presents scenes from a Northumberland colliery. The film opens with a miner saying goodbye to his wife and child at the garden gate, firmly locating waged work as an activity of married men and fathers. At the same time this scene institutes a narrative structure of events and action in a related order of time as well as introducing a fictional level not only in so far as the scene is clearly staged for the camera but also because the focus on an individual worker and his family 'novelizes' the social reality as 'their story'. Although the penultimate scene shows his return in the evening, this personal focus is not sustained for we do not see the collier in the main part of the film. Instead typical scenes from a day's work at the pit head and down the pit and are shown. The film commences with the men collecting Davy lamps, explaining their role briefly, and travelling down in the lifts to work the coal seams. We see shots of coal moved on the rail wagons, pushed by hand, and of some men hacking at the coal face (this raises some questions of fictionality, given the problem of lighting such a scene underground, yet the shot appears extremely realistic in terms of pit props, coal seam and general conditions). Other shots show

work above ground, collecting the coal wagons from the lifts and pushing them to the sorting area. This work is done by both men and women but the latter are introduced as the 'belles' of the mine in a collective 'photoshot' which is not accorded to the male workers. Scenes are filmed in longshot with a single fixed camera position and movement is by social actors towards or away from the camera or across the frame. The spaces are not shown as having any specific relation to each other. All the elements of the process of coal mining are presented, from hewing the coal from the earth, its movement up above ground and the processing of the coal, in sorting rollers, and transfer to the locomotive trains which will transport it around Britain, to the fireplaces of the nation – or at least a middle-class nation, as imaged in the film's final shot where a maid adds coal to the brightly burning fire and the family move nearer it to enjoy its warmth in a cosy scene of parents and children. This is not, of course, the family of the coal miner of the film's title and opening scene.

The film shows exemplary events but it does not tie these up into a seamless reality. Instead events are very much displayed, in Tom Gunning's sense of a cinema of attractions.[12] The film focuses on social actors, allowing shots to remain where someone is looking straight into the camera, thus including an acknowledgement of the film-making process within the scene. Moreover the coal miners are shown as wage-earners, in a scene of the men – but not women – collecting their weekly pay packet. Here arises the first of two moments in the film which function I suggest in the manner of the 'punctum' described by Roland Barthes.[13] As one man steps away from the pay booth and walks towards the camera he examines his pay carefully, checking the amount and, perhaps, the deductions for food, or rent or whatever (as well as for tax and the social pension introduced a few years earlier). This action of scrutiny takes over the larger scene of the queue of men, each waiting to collect his own pay, so that the emblematic scene of paying the wages is taken over by the issue of the sum – sufficient or insufficient – of pay. The second 'punctum' involves a woman worker caught in medium-long shot for a few moments, smiling broadly into camera, then suddenly her expression changes, her smile disappears and is replaced by a worried stare, while behind her a boy looks first at her and then at the camera. The woman is perhaps 30 years of age with a strikingly plain face, her smile a broad span of gums and teeth, and she contrasts with the image of the 'belles' conjured immediately after by the film's intertitle and the subsequent photoshot. What disturbs the film at this moment is the woman's disturbance. It is given no motivation, but it interrupts the film and the spectator's look, a look which commences by consuming the woman as a spectacle – as a working-class lass, and as 'plain as old boots', whose broad open smile appears naïve, as if she is as innocent of the camera as of her

uncomely looks. The boy's look mirrors the spectator's and his expression – which seems to be a wry or mocking smile – affords an internal comment on the woman. He thus functions as a kind of surrogate for the spectator and with whom we collaborate in our gaze. Of course, in fact he cannot see the woman's face, but we may transpose on to the boy a response *as if* he, like us, were looking at her, a projection quickly plausibly supported by the thought that certainly he must have known her as a fellow worker. Nevertheless any subsuming of the boy's look to our own remains, precisely, a projection. The woman's change of expression thus seems a response to our gaze and view, a sudden realization of the camera *as* gaze, a look from elsewhere which she is suddenly alarmed by in a moment of consternation and, perhaps, self-consciousness.

As a result, the film displays rather than narrates, despite its framing story. But these displays are not simply 'viewings' but 'views' in the sense of including a perspective. The workers – especially the women – are exotic by the fact of their femininity as well as, although being women, their lack of 'femininity' in conventionally coded terms. The film produces very little in the way of a discourse of work, however. *A Day in the Life of a Coalminer* does not explain its images beyond the barest intertitle. The film is a kind of old-fashioned museum tour of the industry involving a series of exemplary scenes. We learn nothing of the process of mining, for example, the erecting of pit props, or of the process of work, including the dangers of mining (notably emphasized in the later *Coalface*). Nothing is explained of the women's work, except that it is physically hard labour, involving the women working in pairs to carry what may be pit props and pushing along the wagons of coal for sorting. Here, for a modern audience and perhaps as well for a contemporary audience in 1910, there is the pleasure of reality revealed, caught unawares in the atypical picture of women's physical labouring in an industrial setting (as opposed to the more typical agricultural and domestic service setting). But, as the film's discourse clearly reiterates, women are not only workers but female, objects of sexual scrutiny and enquiry.

Coalface, a film of similar length, not only adds sound to the picture of coal-mining but also a specific discourse through which it constitutes an image and definition of the miner as worker and employee within the industry as well as of the importance of coal as a foundational industry for Britain and her empire. It is a highly organized composition of sequences of reality-filming from scenes at the colliery, workers homes, and images of the wider role of coal not so much for the individual consumer, but rather in the larger context of Britain's world trade in shipping and the steel industry, as well as the role of coal in providing both gas and also electricity to turn the wheels of industry as wind, water and steam had in the past. The film is exemplary of the British Documentary Movement of the 1930s. Directed by Alberto Cavalcanti, it was

edited by the painter William Coldstream, with verse by W. H. Auden and music by Benjamin Britten. It is formally experimental, combining a poetic and lyrical montage of sound and image representing the sweat and toil of work underground, as men tramp to the swelling chorus off-screen. It shows as well as the interrelation and interdependence of the men as a community, whether at the coalface or transporting the boulders of coal. It is socially committed, concerned to fashion a new image of the manual labour of the coal miner as muscular rather than brutish; as heroic endurance in the face of appalling working conditions underground; and as tragic when the dangers of that work bring illness, injury, maiming and death. The film functions to include the coal miner in the image of British industry and empire and to extend to this group of workers the idealization of physical labour and manual exertion, as well as the ethic of work, which were part of, for example the sports and fitness movements from the turn of the century. Edgar Anstey, another member of the documentary film movement, has described their concern to see 'the working man … as a heroic figure', to celebrate 'the ardour and bravery of common labour'.[14] In a more intimate moment, originally filmed for Flaherty's *Industrial Britain* and included again in this film, we see a couple of men take a break to have their 'snap', sandwiches and a drink, eaten where they rest their tools, at the coalface. Robert Colls and Philip Dodd have described this as 'a moment when the male body absorbs attention without regard to its function … foregrounded on the left of the frame in the blackness – lit and shot from above – is a radiant face and body of a miner'. This moment is held for some seconds; appearing stylized, it displays and *images* the miner as 'noble body', and, argue Colls and Dodd, 'Concentration on the splendour of male working-class bodies (a simple complement to a matching obsession with their animality) fixes such men's concerns and competence and ratifies the distinction between mental and manual labour'.[15] This image, however, is Flaherty's – the steel workers are similarly 'displayed' in *Industrial Britain*, but that film also emphasizes the skill of craftwork and not simply the brute strength of the workers represented. These scenes are part of a wider image-making, and a related mode of representation can be seen in, for example, the wartime paintings of Graham Sutherland as well as Henry Moore's drawings of coal miners. This aim of 'ennobling' labour, while no doubt also involving an intellectual condescension and a masculine narcissism as well as a fetishization, nevertheless does thereby oppose the 1920s image of miners as a threat to the nation (following the General Strike of 1926). *Coalface* was produced as national 'propaganda' or promotion for Britain and the Empire and its inclusiveness rewrites images of work and workers as part of the social concensus of 'new Britain'.

Coal mining is presented not only as a national industry but also as a matter of communities, of workers and their families dependent on the mine

for their homes – often enough also owned by the mine company – and their livelihoods, as the voice-over states. The film works on a number of levels which interrelate to produce a satisfying filmic discourse and a document of fact and information. This film more than any other has given us the image of coal mining this century, most visibly and monumentally with the image of the winding tower at the pit head, but also the slag heaps, the ponies pulling wagons, and the sweating men bent double wielding pickaxes and mechanical hammers to hew the coal. Only the last of these images are part of *A Day in the Life of a Coalminer*, while the women and the other pit-head workers are now gone. Absent, too, is any direct address by the workers themselves; not only – as in *A Day in the Life of a Coalminer* – are the workers silent, but the look at camera and thus address by social actors seen in *A Day in the Life of a Coalminer* has now been banished, while the frugal intertitles of the first film have been replaced by an expansive voice-over narration in the second. The miners are presented primarily as a *body of workers*, and while union banners and marching bands are absent they might easily be added, in contrast to the particularity of *A Day in the Life of a Coalminer* which focuses on individuals and groups of individuals. *Coalface* articulates an image and meaning for coal-mining, organized as an aesthetic audiovisual experience through the rhythm and pace of its sound and image editing. *Coalface* is, nevertheless, not simply discursively closed, as later critics have often argued. The replacement of the miner's voices by the chorus and by music, as well as by the rhythmic marching, stands aside within the film from the organizing statements of the voice-over. These elements are anti-naturalist in a way similar to Vertov's juxtaposition of images in *The Man With the Movie Camera* (1929) and are not fully contained by the film in the way that the later *Night Mail* (1936, Harry Watt) integrates the poetic and the functional within its story of the nightmail train.

In *The People Who Count* (Geoffrey Collyer, 1937), a quite different account of work, working and workers is produced. Like *Coalface*, this 16 mm sound film made by the London Co-operative Society is also 'propaganda' – in the sense used by John Grierson – for an informed and committed citizenry. Its address – to 'the people who count', namely ordinary workers – is similarly inclusive but it is also partisan, for the film promotes the project and ethics of the co-operative movement as opposed to private ownership and capitalist modes of production. It is not, therefore, apparently consensual; it does not address or appeal to 'one Britain' as *Coalface* seems to. *Coalface*, however, writes in the miner as a key image of the role of coal for Britain and her empire. This, I suggest, is a redefinition. In that film the coal industry was no longer simply a matter of mines and owners but also of the men and their families who live, and die, by coal. Of course, this was also the image in *A Day in the Life of a Coalminer*, but with the difference that there the miner was

represented in his and her particularity, whereas in *Coalface* the miner and his sacrifices are a universal, a component of the success of the British Empire. The 'interests' of Britain are being redefined as inclusive of the wider working population, rather than exclusively an elite of owners and this thereby redefines the position of the owners as employers, mitigating their 'absolute' power implicitly and, as seen with hindsight, laying the basis for the wartime national collective interest and the post-war national-ization of the coal industry. The notion of a state of responsible and informed citizens now includes the worker in the 'national interest', producing a redefinition of the 'national interest' as more than the interests of the economic elite.[16]

The People Who Count, by its very title, is part of this new discourse of inclusiveness and its debates. The film opens with a series of questions posed in the voice-over narration by the Right Honourable A. V. Alexander, PC, MP: 'Who will achieve a higher civilisation and how will they do this?' It will be achieved by co-operation, Alexander replies, and this is illustrated by egalitarian images of co-operation in nature, sport and industry. Describing what is needed in the world – peace and prosperity – over shots of street scenes, in a reprise of Lumière's *Workers Leaving the Factory* of 1895, and images of a woman worker at a milk-bottling factory, the voice-over asks again 'Who will achieve this ideal state? The answer is all around us, in offices, factories, shops'. It is 'the workers, mothers and wives'. The film thus distinguishes three groups of persons – 'workers' included both men and women, for we have just seen images of women workers. The categories of 'mothers' and of 'wives' are two further groups of workers, but dis-tinguished here by their marital and maternal status, unlike the related, but here not cited, categories of 'husbands' and 'fathers'.

The People Who Count is also an advertisement for the co-operative retail movement, and specifically the growing retail development of the London Co-operative Society. Through a brief re-enacted history viewers are directly encouraged to support the movement and its ideals of worker co-operation while the success of the movement as a retailing enterprise is shown in the modern new department stores being built by the London societies, especially Royal Arsenal and the Woolwich Co-operative Societies, and in the numerous stores taken over and reopened as co-operative ventures, as well in the range of services offered, including dentistry and opthalmics. What is sought, however, is not simply shoppers and consumers for the new complexes and services but supporters of the co-operative ideal; it is this that is being 'sold', rather than goods and services as such, and it is women's participation, both as workers and as consumers and primary purchasers for the family, which is solicited in the film. It is here that the film offers a new discursive construction of the worker and specifically the woman worker. This worker, whether she

has a paid job or is running a household as a wife and mother, consumes, and she does so in bright new stores in which she is offered the latest and newest goods and services at excellent prices. The film shows a different London emerging with the modernist architecture of the new stores in the remodelled high streets. The department store was not, of course, a new concept in retailing, but its origins and early development was as a middle-class and upper-class facility. The co-operative movement's successful entry into of this form of marketing organization, thereby extending it to a wider class, was part of a transformation of consumerism in the 1930s fuelled not least by the emergence of cheap food as the result of changed techniques in world agriculture, and which freed a portion of the ordinary worker's wage for other kinds of purchasing. (In contrast the international slump in demand for food and raw materials did not always lead to cheaper prices, as producers resorted to the dumping of food etc. in an attempt to keep prices high.)

The film exemplifies its themes through the example of a store taken over from private ownership, describing the reopened premises as efficiently organized as well as being a pleasant place to work and shop in. This, we are told by the voice-over, is the result of people working for themselves, in their own co-operative business. The camera cuts between high angle views and medium shots of a ladies clothing department before cutting to a medium close-up of a young woman who speaks directly to camera. This is the only inclusion of direct address by a social actor within the film and her voice contrasts with the male voice-over of Alexander, who is never seen. The woman's speech is no doubt scripted and well rehearsed, yet her halting way of talking and awkwardness in front of the camera confirms her as real and ordinary, and not an actress. She says, acknowledging the problem of believability, 'Although it's almost too good to be true, but', and goes on to affirm that it is really the case that her working conditions have improved since the store became run by the co-operative movement. She describes the better relations with colleagues, better pay and hours, and the better relations with customers based on equality and service, not servitude. In these brief words the shop assistant defines what matters to her as a worker and a woman while the film illustrates her words with shots of women at work, and at leisure, as well as showing staff and customers enjoying, equally, the open-air roof-top restaurant.

Women at work was also the concern of a wartime propaganda documentary *Five and Under* (Donald Alexander, 1941). This film centres on working mothers and their children, but it is concerned not with women as workers but only as mothers in so far as their primary responsibility for childcare prevents them from being workers enough for the war effort. The solution, the film shows, is nurseries for working mothers. But it poses itself a further question, namely, how to ensure good mothering, and its answer is

to make the children into weekly or monthly boarders at nursery homes in the country – with air, light and the 'proper' care of professionals. Women as workers – including as mothers – are not addressed. Instead care of children becomes the work of *other* women, while their mothers' work in the factory or elsewhere is simply assumed. While the difficulties of separation for both the mother and her child are shown in a scene where a visiting mother is not recognized at first by her small daughter, such problems are quickly passed over by the film's emphasis on the greater good for the child of its improved environment, away from its mother's poor housing etc., and the greater good of the national war effort itself. In Britain after the war, despite the returning soldiers who re-entered the workforce, there was a post-war shortage of labour, leading the government to seek to retain women in the workforce. Not only, however, was the wartime provision of nurseries quickly eroded, but wages for women's work were too low to enable mothers to afford paid childcare. Meanwhile the new definitions – and requirements – of mothering were 'professionalizing' the work of women as mothers. Through the work, for example, of John Bowlby,[17] the earlier government-promoted concern with hygiene and diet, healthy environment, sport and play, was augmented by an emphasis on the mother–child relationship and the psychological development of the child in its first years. As a result nurseries for children came to be seen as a second-best provision and a last resort since the child was deprived of its biological mother's attention and psychological interaction.

The working and family lives of three generations of women in Manchester are explored in *Shifting Times*, a documentary produced and directed by Lucy Jago for BBC Community Programme Unit and broadcast in 1998 in a series entitled 'Having it All', which looked at the problems and successes of women who seek to continue to work while having children, that is, who are trying to 'have it all'. The film's title punningly refers to not only the shift hours the women work at the factory but also the shifts in family and work expectations which have occurred in the past 40 or 50 years. The documentary adopts the form of oral and visual testimony; it shows each woman engaged in domestic labour at home – the grandmother rolling out pastry dough (she had worked as a cook), the mother preparing tea for her husband on a day shift before she goes to work on the night shift, and the daughter, Catherine, collecting her son from school – and at work at the factory. The film does not aim to expose a social situation, as in *Las Hurdes*, nor does it have a propaganda aim, as in *The People Who Count* or *Five and Under*, which each have an explicit political or social agenda. Work for these Manchester women has been a job, not a career, and for both the mother and her daughter their working life has been with Player's cigarette factory (formerly producing 'Senior Service', the name still continues to appear on the factory roof, an

image which resonates with the women's stories of work). The women talk to camera both individually and together about their home life and work, what their paid job has meant to them, as well as how they each have managed their working time in relation to their childcare responsibilities. Discussions between the mother, her daughter and fellow women workers in the factory canteen reveal more stories as well as the importance of the factory's system of shift work which enabled them to fit in their domestic and their paid work. The mother and a friend worked alternate shifts so that they could baby-mind for each other.

Both mother and grandmother had returned to work once their children were at school, and Catherine, the granddaughter, remembers how she and her brothers each had a rota of jobs to do at home to help out. The grandmother and mother both characterized their work not as a necessity for the family – theirs was the second income in the household – but in order to provide what they described as 'the extras': the clothes and toys and the general comforts of modern society. The work of these women appears to themselves and their families as supplementary to their role as primary childcarers, yet without their income their children would have no access to the goods, services and activities taken for granted by families in Britain today. Because the film's portrayal adopts an observational documentary style, without a voice-over, what is revealed here remains only implicit, namely a continuing and fundamental uncertainty and tension for both the women themselves and society at large over the economic and social justification for working mothers. Women are still not seen as equivalent workers to men in most forms of employment, producing the continuing gross discrepancy in pay between men and women in Britain today. From the women's accounts, however, Player's appears to have been an employer which sought to attract and retain women workers, with its policy of equal pay, and in the past through supporting its women workers with children, with, at one time, a weekend nursery.

Expectations around work are nevertheless shown to be changing for while the mother and grandmother see the Player's factory as a good job and worth while, despite the repetitive hard work, Catherine, herself a mother with a small son and separated from his father, sees working as a lifelong activity and seeks something better. She wants a form of work which is rewarding both financially and intellectually – though she hesitates to call it an ambition for a career – and as a result she is now following a course in further education part time. Neither her mother nor grandmother, however, had ever seen a role for education for themselves or their children. In contrast Catherine wants her son to go to university.

Through their life histories and their discussions together the film shows the range – and the limits – of opportunities and expectations of many

working women. In the course of the making of the film the mother learns that Player's are closing the factory down, putting both her and her daughter out of work. Filmed sitting on her bed at home, she talks about the news, saying how hard it is for her to have to tell her daughter that she has lost her job. At this she stops and breaks down, crying, gesturing to the camera operator to stop the filming. The sense of loss she feels is vividly conveyed, even more so because she speaks of being distressed on behalf of her daughter, rather than simply on her own behalf.

The women make apparent through their oral testimony what the film cannot show visually, namely that work is endured or enjoyed not because it is simply inherently pleasant or rewarding but because of the value it comes to have in their lives – the money, social contact and friends it brings them, and as a result a sense of self-worth beyond simply providing domestic labour and care for their families. Discussing their plans after the factory's closure they speculate about retraining since, as they say, no one wants to be on the dole. They all want to work for their living. They are in the business, therefore, of selling their labour and are assessing their own skills and potential. The film shows that their identities, as well as their livelihoods, are bound up with their working lives in a way which has been traditionally only associated with men's work. We see the women workers themselves engaged in a process of reflection about their working lives. As a result the film is also a record of the terms by which the women describe and think through their working lives, that is, how the women articulate themselves as workers. But the direct address style of the documentary naturalizes the women's speech as simply 'theirs', outside of political debates or union activities, etc. The work of memory and of speaking one's own story is, however, itself an act of mediation and of representation. As a result the film occludes the discursive and material processes and structures within which these women as speaking subjects – and their words and stories – are enabled and produced, including the processes in the making of this film – the agenda-setting of the film-makers and the questions they may have posed to the women as well as the contextual discussions not recorded or, if recorded, not part of the final edited film.

The film is not only oral testimony; it also figures a visual world of work. This figuring is a visual testimony articulated by the film rather than by the women themselves and they thereby become the objects of its representation. In views of the factory seen through windows in long shot, the women's work appears both mechanical and repetitive, while the repeated appearance of these and similar shots in the course of the film produces an imaging of the women's labour which is both more distanced and more monumental. Here the particularity of the stories of individual women becomes absorbed in the universal of the images of their paid work. The film shows the women as working subjects in two quite different senses, therefore. As waged workers

each woman carries out a series of allotted tasks as physical and mental actions organized in concert with others, and her labour is one component amongst many in the production process as a whole. As a working woman, with a physical and mental sensibility, she experiences fatigue and boredom, companionship with fellow workers, and the satisfactions of the purchasing power her pay packet affords her. Her very subjectivity becomes the objective concern of the film, re-presented for our understanding and empathy. The inclusion of the filming of the mother's distress at the news of the factory's forthcoming closure clearly serves this goal. There is another history here, however, which remains unspoken and unaddressed yet which is determining of the women's stories, namely of the tobacco industry, its fostering of its women workers and its decline in Britain and the Western world in the face of the health risks of smoking which governments and the medical profession have proclaimed.

Working images

The films I have been discussing produce and organize meanings of work and workers at particular historical moments. They record not, or not simply, a process of labour, but also and more importantly they constitute ways of *viewing* the worker, and hence also produce an identity for labouring. Moreover it is not only what is included but also what can be inferred as excluded which determines this identity. The history of labour in these films is a history of the terms and their limits in which labouring is thought. If these images are not simply facts of a past reality we can consume as history, if they are not true and meaningful by virtue of the reality recorded, what is their value or role for us? It is precisely as constructions which we can read *historically*, in as much as work and workers are conceptualizations of human labour and its social and economic value. At the same time there lies in these images a story of meanings and thus identities which continues to move us, that is, to interpollate us, and we can find ourselves addressed not only as working subjects, but also as sons and daughters of workers. Alternatively, these identities and meanings may be the basis for a critique through which we institute – or represent the desire for – other identities and meanings. These are both fundamentally aesthetic functions.

Notes

1. Buci-Glucksman, C., *Baroque Reason: The Aesthetics of Modernity* (London: Sage, 1994), p. 75.
2. The history of cinema has from early on been characterized as split between two possibilities

represented by on the one hand the magician-film-maker Méliès, and on the other hand the scientist-inventors, the Lumière brothers. John Grierson, the founder of the British documentary film movement, thus describes two different possible cinemas: 'First principles. (1) We believe that the cinema's capacity for getting around, for observing and selecting from life itself, can be exploited in a new and vital art form. The studio films largely ignore this possibility of opening up the screen on the real world. They photograph acted stories against artificial backgrounds. Documentary would photograph the living scene and the living story ... Cinema has a sensational capacity for enhancing the movement which tradition has formed or time worn smooth. Its arbitrary rectangle specially reveals movement: it gives maximum pattern in space and time' (Grierson, J., *Grierson on Documentary*, F. Hardy (ed.) (London: Faber and Faber, 1966).

3. John Grierson, the 'father' of the British documentary film movement, first used the term 'document' to describe a film in his review of Flaherty's *Moana* in 1926. On the history of documentary film, see Winston, B., *Claiming the Real: The Documentary Revisited*, (London: British Film Institute, 1995), and Barsam, R. M., *Non-Fiction Film, a Critical History* (Bloomington, IN: Indiana University Press, 1992).

4. Brecht, B., in 'Der Dreigroschenprozess, ein sociologisches Experiment', in *Gesammelte Werke in 20 Bänden* (Frankfurt-am-Main: Suhrkamp Verlag, 1967), Band 18, p. 161. Quoted by Richter, H. in, *The Struggle for the Film*, trans. B. Brewster, foreword A. L. Rees (Aldershot: Scolar Press, 1986), p. 47.

5. A painter and a poet as well as a film-maker and photographer, Jennings was associated with the surrealists in the 1930s and he was also the co-founder with Tom Harrisson of 'Mass Observation'. For many of his contemporaries as well as later viewers and critics, Jennings's film represents an alternative to the mainstream of British 1930s documentary. This arises not so much from its lyricism and poetical mode (already familiar in, for example, *Night Mail* (Harry Watt and Basil Wright, 1936) and *Song of Ceylon* (Basil Wright, 1934) but rather from its concern with images of people and their experience of the everyday and the popular.

6. Rosen, P., 'Document and Documentary: On the Persistence of Historical Concepts', in M. Renov (ed.), *Theorizing Documentary* (London: Routledge, 1993), p. 58.

7. Richter, *The Struggle for the Film*, p. 47.

8. The film was shot silent. A sound track of voice-over commentary and music (Brahms) was only added in 1936, after the ban on the film was lifted.

9. Luis Bünuel discusses *Las Hurdes* in *Imagining Reality*, K. Macdonald and M. Cousins (eds) (London: Faber and Faber, 1996), p. 88.

10. Ibid.

11. William Rothman reports that in American universities the film has been alternately taught as a social documentary, and as a parody of documentary, a mock documentary. However I do not think the narration, or the film, need to be labelled ironic or mocking, rather as Rothman himself argues, the film only seems ironic because its documentary representation of reality 'makes strange' that reality, that is, makes us apprehend the extent to which reality is 'estranged'. In Rothman, W., *Documentary Film Classics* (Cambridge: Cambridge University Press, 1997), pp. 37–8.

12. Gunning, T., 'The Cinema of Attractions: Early Film, its Spectator and the Avant-garde', in T. Elsaesser (ed.), *Early Cinema: Space, Frame, Narrative* (London: British Film Institute, 1990).

13. Barthes, R., *Camera Lucida* (New York: Hill and Wang, 1981) p. 27.

14. Quoted by Stuart Hood in 'The Documentary Film Movement', in J. Curran and V. Porter (eds), *British Cinema History* (London: Weidenfield and Nicolson, 1983), p. 107 and p. 86.

15. Colls, R. and Dodd, P., 'Representing the Nation: British Documentary Film, 1930– 45', *Screen*, **26** (1), (1985), p. 25.

16. This redefinition was not unilateral or singular, but part of an intense debate on the extent of the role of the new citizen and of state intervention and a progressive civil bureaucracy. Nevertheless the documentary movement, including Grierson, was clearly identified with this centre-left position, As Ian Aitken points out, however, the new move of what I am calling a 'consensual politics' was not confined to the centre-left, for example the later Prime Minister, Harold Macmillan, attempted to establish a new Centre Party with the aim, as described in his book *The Middle Way* (1938), of obtaining a fusion of all that is best in left and right. Aitken, I., *Film and Reform: John Grierson and the Documentary Film Movement* (London: Routledge, 1990), p. 171.

17. Dr John Bowlby, a child psychotherapist at The Tavistock Clinic, was influenced by the work of the psychoanalysts Melanie Klein and David Winnicott in developing his view of the importance of the early mother–child relation. Bowlby produced a study entitled *Maternal Care and Mental Health* in 1951 for the World Health Organization which was published by the organization in Geneva, and by Her Majesty's Stationery Office, London, and in New York by Colombia University Press. His work was widely disseminated subsequently. Denise Riley has addressed these developments in *War in the Nursery* (London: Virago, 1983).

The pathos of the political: documentary, subjectivity and a forgotten moment of feminist avant-garde poetics in four films from the 1970s

Griselda Pollock

At the movies

Unlikely as it is as a starting point for a consideration of women, work and the image, I want to start with the Hollywood movie, *Gentlemen Prefer Blondes* released in 1953 (Figure 9.1).

Based on a novella from the 1920s by Anita Loos, the film starred Marilyn Monroe and Jane Russell as a pair of nightclub dancers and singers who go on a trip to Europe and get in a spot of bother with the law over a diamond tiara before being suitably married in a huge double wedding. Beneath the gloss and glamour of a major Twentieth Century Fox musical directed by Howard Hawkes, the film is about two working-class women, from the wrong side of the tracks, as their opening song informs us. Their route out of Little Rock is sex, a polite form of prostitutionalization that is naturalized by the fact of their being showgirls in the plot, a fictive scenario that doubles the fact that these characters are played by, in the case of Marilyn Monroe, a working-class factory girl who made it as a pin-up and a movie star. This reflexivity of the fictive and the concrete makes any viewer consume the sexualization, commodification and specularization of working-class women so naturally that it becomes almost synonymous with cinematic pleasure. While the axis of sexual difference on which this creation of woman as icon has been thoroughly explored, its class dimensions remain less visible. Laura Mulvey has written:

This was the time when, in the context of the Cold War particularly, advertising, movies and the actual packaging and seductiveness of commodities all marketed glamour. Glamour proclaimed the desirability of American capitalism to the outside world, and, inside, secured a particular style of Americanness as an image for the newly suburbanized white population. In this sense, the new discourse of marketed sexuality and the new discourse of commodity consumption were articulated

together, reinforcing each other as though in acknowledgement of a mutual interest. These themes mesh together in *Gentlemen Prefer Blondes*.[1]

Lorelei, played by Monroe, is all shiny blonde, typically dressed in glittering costumes, with hard surfaces like the diamonds she herself claims as her best friends, although the 'rocks that don't change their shape' will maintain a stability and an unchanging value in complete contrast to the merely transient sparkle and desirability of any actual woman's body or looks. The second leading character, Dorothy, played by Jane Russell, is dark haired, and characterized as genuine, down to earth, level-headed, and looking for true love irrespective of money. This duo of the light and dark facets of the modern 'working girl' perform their dance routines in perfect synchronization, offering their industrialized images as both commodity and spectacle in a (dis)embodiment of the concept of mass ornament that Kracauer discerned in capitalism's anti-humanist work-disciplining of the body-machine.[2]

It is against the invisibility, within this highly sexualized and gendered regime of visual representation, of work, and what it signifies: social relations and arrangements we could call class, an invisibility spectacularly produced by the distraction factories of Hollywood, that my selection of four films made in Britain in the 1970s needs to be read as diverse but theoretically attuned feminist attempts to articulate relations between the economies of labour and desire. For all the necessary ambition to construct a counter-cinematic language in which to produce a feminist knowledge, these films were equally productive of a feminist subjectivity elicited by the feminist spectator's proposed relation to the transformation of the relays between woman, work and image. Again Laura Mulvey has explained how this led to a specific cinematic aesthetic:

A woman's place in past cinematic representation has been mystified as at once a lynchpin of visual pleasure and an affirmation of male dominance so that feminists have become fascinated by the mysteries of cinematic representation itself, hidden by means of the sexualised female fantasy form: a tearing of the veil but no ready-made answers lie behind it. The absence of answers combined with fascination with the cinematic process led to the development of a feminist formalism. Politically a feminist formalism is based on the rejection of the past and on giving priority to challenging the spectator's place in cinema. From the aesthetic point of view the space and time of realist and illusionist aesthetics have immense limitations; they cannot satisfy the complex shifts feminist imagery desires.[3]

In complete contrast to existing cinematic conventions that linked any overt address to issues of class with documentary, this group of feminist films I shall discuss drew upon avant-garde aesthetics to explore how, cinematically, the relations of woman to the image were a condensed sign and site of social and psycho-sexual relations, obscuring precisely what socialist feminist theory desired to articulate: the relations between class and sexual difference within

a historical capitalism economy and its cultural forms. Despite the many important readings of this archive of avant-garde British feminist films, few have addressed their relations to each other, and in doing so, placed them along this thread of an avant-garde poetics that addressed the representation of women and work.[4]

Let me first introduce the four films that form the archive.

THE NIGHTCLEANERS

The Nightcleaners (1970–75) was made by the Berwick Street Film Collective initially for the Transport and General Workers Union as part of a campaign led by May Hobbs to unionize women working as contract cleaners in large office blocks at night. Commissioned as an agit prop film, the work of Mark Karlin, James Scott, Humphrey Trevelyan and Mary Kelly rapidly turned the documentary footage and interviews they had filmed into what was claimed by Claire Johnstone and Paul Willemen at the Brecht Event at the Edinburgh Film Festival in 1975 as 'the most important political film to have been made in this country'.[5] These authors based their argument about the film's radicalism on an analysis of the way it interrupted the documentary model with an authoritative voice-over that, typically, frames and regulates the images of the objectified, oppressed, working-class other. Through inter-weaving discontinuous scenes, *The Nightcleaners* established the play of competing discourses that traversed antagonistic and elective relations between white middle-class male employers, women workers, white and black, white middle-class women from the emergent Women's Liberation Movement, male union leaders, women trade union activists and the film-makers themselves. Using typical documentary footage, grainy black and white shots filmed in difficult conditions, at night, in confined and sometimes secretive conditions, the unexpected final effect of the film was the product of radical editing. The film-makers opted for montage, with a rhythmic insertion of black spacing, discontinuous voice and image, reworked images, slow motion, and silence that self-consciously announced itself as cinema, as a scene of representation whose relation to the 'real' it was attempting to discover would lie in the viewer's active reading of this complex 'image' of work as social relations and lived experiences within the socio-economic structures of advanced capitalism. I use the word 'discover', for it was in the process of making the film, according to the clear influences of an emerging interest in Brechtian strategies for cinema, Godard's films, as well as the radical cinematic practices of German film-makers Straub and Huillet, that the scene of work was revealed as a site of desire, subjectivity and what I call the pathos of the political, in all its ambivalence.

RIDDLES OF THE SPHINX

Riddles of the Sphinx (1976) was written and directed by Laura Mulvey and Peter Wollen as a British Film Institute (BFI) production. In seven segments, the film opens with *the image* of Woman as *femme fatale*, enigma, other, represented by the Greek Sphinx as an archaic, monstrous and menacing threat always outside the polis, according to patriarchal culture. This visual economy that stretches from the ancient world to Hollywood cinema's face of Greta Garbo, is countered by giving the Sphinx a *voice*. This voice, a voice-off, functions as the repressed articulation of both how the feminine is lived within patriarchy and of how else feminine subjectivity might be formed and known. The Sphinx is thus an equivocal trope used throughout the film to signify the predicament of femininity: the riddle as it is experienced by women who must live it under a the law of the father, in contrast to the masculine fantasy of woman as enigma and riddle for men. At the centre of the film, presented in 13 discontinuous episodes each shaped by a single 360-degree camera pan that interrupts narrativity, suspense and both the sadism and curiosity encoded in the cinematic gaze, is the story of a woman and her child. These 13 segments trace the domestic labour that seals their early intimacy which leads to the breach when the husband leaves the home, feeling excluded. This obliges the mother to separate from her child in order to work, exposing the conflicts around childcare and conditions for working mothers, conflicts which are at the heart of the revelations of *The Nightcleaners.* The mother then engages in political and union activity around those issues, and develops another relationship with a woman. In one moment of reflection within this sequence, the voice-off (partly the Sphinx and now partly the voice of the mother's emerging political consciousness) asks:

Should women demand special working conditions for mothers? Can a child-care campaign attack anything fundamental to women's oppression? Should women's struggle be concentrated on economic issues? Is the division of labour the root of the problem? ... How does women's struggle relate to class struggle? Does the oppression of women work on the unconscious as well as the conscious? What would a politics of the unconscious be like?[6]

A scene that follows this one takes place in a film studio where the husband, a film-maker, is editing a sequence in which the artist Mary Kelly appears presenting material from her concurrent project, *Post Partum Document* (1976–80).[7] The initial development of this project to document the reciprocal socialization of a mother and child in the first five years of its life overlapped with the artist's collaboration on a collaborative project called *Women and Work* (1975), itself contemporaneous with the making of *The Nightcleaners.* In *Woman and Work,* Margaret Harrison, Kay Hunt and Mary Kelly analysed the impact of equal pay legislation on the division of labour in a South

London factory between 1970 and 1975.[8] Again, as in the film, a frame of investigative documentary, however, produced unexpected knowledge when organized by the aesthetic modes of emergent conceptual art. Another text was found embedded within the social surface that documentary merely reports. The artists had invited the workers to produce diaries of their typical working days. What emerged from this exercise was an unexpected site of sexual difference, traversing the conflicts between necessity and desire. Men recorded their activities at work in detail, leaving home-time as a dead frame for sleep and food. Women, on the other hand reported being at work in a single line while listing in detail all their domestic tasks associated with childcare. This text was like an unspoken voice – another instance of the Sphinx? – that registered sexual difference in different degrees of psychical investment in the spaces of work in childcare and the spaces of work in the factory. This text from working-class women who were mothers caught the 'hum' of subjectivity and desire, shaped within a patriarchal capitalist division of labour. The discovery, not of women's bald submission to the ideology of motherhood, but of the way its differential economy of desire plays out on the stage of the socio-economic real, encouraged Mary Kelly to examine what ideologically remains the domain of the private and the natural, motherhood, in relation to its function as both concrete and psychological labour and as a semiotic stage for the intersubjective relations that mutually, but contradictorily, form both the becoming-mother and the infant as subjects of desire and loss. Here was another moment of intertextuality that reflected the extraordinary attempt to conjugate social and psychological levels of analysis, to pose the question of a politics of the unconscious by allowing a psychoanalytical ear to listen to the discourse the documentary eye collected.

Thus the central section of the film ends with four episodes that specifically elaborate imaginary and unconscious dimensions of the formations of feminine subjectivity in relations between women. The sequence concludes with a scene set in the Egyptian rooms of the British Museum. Although the visual track shows us the mother and her toddler daughter, the voice of the Sphinx becomes a voice of difference acknowledged by an adult feminine voice that imperceptibly shifts into the daughter's future place and articulates her memories of the childhood the film had represented initially from the mother's point of view. The relation between the investigatory impulse to seek to know of and represent what the dominant culture in its material, socio-economic as well as psycho-symbolic represses – in this case feminine subjectivities (pluralized by issues of class, generation, sexualities and cultural difference) – and the experimentation with a filmic poetics is as marked as in *The Nightcleaners*. In both the attention to the process of cinematic signification is the very site of a differencing, an introduction of what is not represented

in either narrative cinema with its Greta Garbo film stars or in documentary with its anonymous working women.

The Song of the Shirt (1978) was made by Jonathan Curling and Sue Clayton under the aegis of the Film and History Project. This three and a half hour film traverses the contemporary situation of working-class women and the welfare system in the 1970s, in which women were dependents of men. The ideological naturalization of woman as non-working mothers supported by a family wage arose in the mid-nineteenth century. That definition of women's secondary relation to employment was forged through the competing discourses of paternalist Tory reformers like Lord Ashley (later Shaftesbury), defensive men in semi-skilled trades who feared the use of cheaper women's labour, radical working-class politicians and writers who indicted the sexual exploitation of impoverished working-class women in ways which performatively construed women's presence in the labour market only as an opportunity for sexual exploitation. Using montage, switchbacks between past and present, between costume drama, and actresses' direct address to the camera, the film produces, visually and discursively, a layered analysis of the contradictions of early capitalism that first drew women into urban factory work and then sought to define the relation of women to work as unnatural or secondary to their sexual destiny. The film tracks what feminist social historian, Sally Alexander, has investigated in her work on gender and the unconscious of the political languages that emerged to confront, propose or oppose what capitalism did to labour. Sally Alexander has asked why sexual difference emerged as such an important issue as a result of the disordering by capitalism of existing masculine and feminine social and imaginary identities defined in relations to work, skill and roles. In addition to this Marxist question, Sally Alexander insisted that the historian needs to understand the force and place of subjectivity with its gendered formations, and that history and politics need to be opened up to the unconscious.

It is not my intention to reconstruct the individual unconscious, or individual subjectivity (which may be glimpsed nevertheless by the historian through autobiography, memory or speech.) Merely to emphasise that the Symbolic [defined above in Lacanian psychoanalytic terms as the laws and order of culture and society instituted through language] sets the terms within which any social group must position itself and conceive of a new social order, and that the Symbolic has a life of its own so too does the individual (and perhaps collective?) unconscious, and both the unconscious and the symbolic are changed in the course of their encounter. Human subjectivity shapes, as it is shaped by, political practice and language – it leaves its imprint there.[9]

Like the other two films, *The Song of the Shirt* also stages an interrogation into the complex relations between the worlds of work as the site of the social, economic and the political forces that determine social being and con- sciousness, and as the scene of desire, the scene of subjectivity for the study of which psychoanalysis has provided the initial theoretical tools. Subjectivity, however, is always understood as being socially staged through contradictory representations. In *The Song of the Shirt*, there is a movement of alternation and repetition between scenes in a bourgeois drawing room of a young debutante being passively measured and then dressed for her display and sale at the marriage market that is bourgeois Society, and scenes in the workshop of the impoverished women slop workers at the lowest end of the millinery trade. This opposition is mediated by the circulation of a serialized melodramatic story about a poor young seamstress who is seduced, made pregnant and abandoned by a middle-class student. Brought into the bourgeois household by the dressmaker who comes silently to measure the passive feminine body of the bourgeois debutante, the serial is read breathlessly by the debutante as a romantic tale that awakens her to an implicitly sacrificial and sadistic web of veiled eroticism, while, on the other hand, the same story is read aloud in the workshop, ironically and knowingly, exposing the 'romantic' script to a counter-reading by women who 'see through' the ideology that sustains this image of the fragile feminine body and psyche. Their pantomime of its unreal melodrama counters a classed woman's point of view to that from which the story originates, a Chartist newspaper whose purpose is to denounce sexual exploitation of the vulnerable female poor by asserting sexual vulnerability in lieu of class exploitation. Even in its radicalism, this emerges as itself an unwitting enunciation of bourgeois society's construction of gender difference – woman as inherently weak, sexually vulnerable when she is exposed through the necessity of work to the eye of masculine desire and the power of money. Produced as the pathos of masculine left-wing propaganda, the tale, nonetheless, incites different readings for this representation of the historically specific configuration of sexual and economic exploitation of woman that both differentiates and aligns different socio-economic moments of femininity within capitalism while, at the same time, it articulates the complex interface of sexuality and political economy in a form that, as a result of the film's strategic use of film to represent history, has to be defined as patriarchal capitalism.

THE GOLD DIGGERS

The Gold Diggers (1983) was made Sally Potter, a dancer, performer and film- maker whose previous film was a different form of rereading against the

grain of a story of the seduction and death of a poor, consumptive working-class woman. In *Thriller* (1978) Sally Potter brought Mimi back from her premature death in Puccini's opera, *La Bohème*, to ask why the narrative required her death, and to place the blame for it on the culture that disguises its deadliness towards women beneath a romanticizing pathos that draws the audience into complicity with what, like Cathérine Clément before her had also argued, was culturally endorsed murder.[10] In *The Gold Diggers*, the object of analysis and critique is not opera but cinema itself and this takes us back to *Gentlemen Prefer Blondes* (1953), a film which paradigmatically represents the very problematic of woman as icon of the cinematic and its specular economy that *The Gold Diggers* will deconstruct, but not by turning to the traditional opposite of glamour cinema, documentary. Instead it stages its own intervention specifically at the site of subjectivity.

Using a poetics of condensation, and repetition, akin to both dream analysis and Freud's theory of the archaeology of subjectivity, this black and white avant-garde film contrasts the erasure of woman as a subject through her conflation with an image (signified by the iconic movie star, Ruby [Julie Christie]) with the *work* that needs to be done on and against cultural narratives and their forms, codes and tropes in order to inscribe into culture a counter-representation that is fuelled by the dynamic dissidence of a desiring and working feminine subjectivity played out across the rifts of class and race (signified by the black investigator and ally of Ruby, Celeste [Colette Laffont]). Marking its debt to a genealogy in feminist interventions in cinema, the film opens with a riddle that only the alliance of a will to knowledge and a will to self-understanding, signified diversely by both Ruby and Celeste, can solve by their finding paths to social knowledge of imperialist capitalism and to self-knowledge as they battle to deliver themselves from a phallocentric psycho-sexual definition of woman as cipher of masculine desire.

I would like to suggest that not only is *The Gold Diggers* a continuation of the project initiated in *Riddles of the Sphinx*, it is a negative refraction of the film with which I opened, *Gentlemen Prefer Blondes*. Shot in a finely tuned black and white, *The Gold Diggers* is not an intentional, but a structural reworking of the latter film's underlying thematics. It is a rewrite of the place of woman in cinema, understood as both spectacle and industrial machine, which is paradigmatically captured in *Gentlemen Prefer Blondes*, that itself was a reworking of the backstage Ziegfeld musicals of the 1930s actually titled *The Gold Diggers*. It is also an attempt to get behind that condensation of woman as industrialized and specular image that denies women representations of their psychic particularity and desire which must be otherwise *worked through*, if women are not to remain the puppets of an alien psycho-social system.

Sally Potter's film opens on a desolate, snow-covered landscape, in which we see a woman staggering in the windswept snow, and the ruins of a tiny

house, that will repeatedly function as both memory and dream *mise-en-scène* for the daughter's tragic Oedipalizsation. These wastes are a visual metaphor for the melancholic plight of femininity, both deprived of pleasure by phallocentric cultural narratives and left psychically derelict by such a culture that offers no narratives through which to comprehend or rework the formations of feminine subjectivity in relation to the Mother. Abandoned by the Mother who is lured by the Father's gold (phallus), the little girl, so uncomprehended in psychoanalytical theory, is a frozen subject, depressively trapped in the riddle of repetition as a value for man but not for herself for lack of a culturally provided narrative through which to work towards a resolution in creative labour. Over this chilling landscape a woman's angry voice demands that cinema and literature give her back her pleasure.

Two voices, one English, a second French accented, pose and repose a riddle which reframes Freud's famous question: what does a woman want? as the more fundamental one: what is woman in the patriarchal spectacle?

I am borne in a beam of light.	You are borne in a beam of light.
I move continuously yet I am still.	You move continuously yet you are still.
I am larger than life	You are larger than life
Yet I do not breathe.	Yet you do not breathe.
Only in the darkness am I visible.	Only in the darkness are you visible.
You can see me but never touch me.	I can see you but never touch you.
You know me intimately	I know you intimately
and I know you not at all.	and you know me not at all.

We are strangers, and yet you take me inside you.

We are strangers yet I take you inside me.

What am I?

Soon we find ourselves in a ballroom scene, in which the smiling doll of a blonde woman, Ruby (Julie Christie) is passed passively from man to man in the circuit of exchange that is echoed by scenes of this same woman being carried as a living effigy into a bank where her value is measured out in gold. Suddenly the dance is interrupted by the entry of Celeste (Colette Laffont) on a white horse who carries off the dancing belle to a bleak room where they begin the double track of investigating the diverse dilemmas of women under an imperial patriarchy.

As Louise Parsons has shown in her brilliant analysis of this film, the crucial trajectory of the film moves through a series of analytical tableaux in which the white woman and the black woman, now not mirrors of one icon, but historically situated aspects of the difference within and between women, have to work through the complexities and enigmas of the world of white men, signified as commerce and rationalized knowledge (in the Foucauldian sense of *savoir*) to find a way to access the patterns of their subjectivities and desires.[11] Their two journeys are shaped by the different conditions of a woman of colour determined by the legacies of slavery and imperialism and

an invisibly classed white woman trapped as an image of masculine desire and an object of their exchange in what Luce Irigaray called a hom(m)osexual economy.[12] Both are bound in diverse ways into the political economy of the Western capitalist state, but both need to examine and realign their places within its psychic economy. The point of convergence is the excessive visibility of the one and the absence of the other as any kind of icon of subject position within the cinema.

At the conclusion of the film's central transformation into a feminine detective movie, the ballroom scene is restaged, but with a subtle difference. Everything is no longer in order and routinized. There is a hardly repressed excitement and humour threatens the passivity of the women-dolls. Men start being rejected by the dancing belle until, as the black woman on the white charger reappears, the mask of unresolved mourning that is identical with the masquerade of femininity cracks and Ruby (Julie Christie) laughs out loud Medusa's laugh as she is joyously carried off on the white horse.[13] Its purpose is no longer part of the fairy-tale fantasy of 'one day my prince will come'. It is the means of transport to a different kind of sociality.

The film ends with the two women, Ruby and Celeste swimming through a glittering liquid. The frozen wastes have melted to allow movement and passage. They swim towards the figure of a welder, working to secure a seaworthy ship for the voyage out. This welder turns back to look at the viewer, now in the place of the two women, to smile. She is a reclaimed Rosie the Riveter, the documentary icon of a moment in the 1940s when, during Second World War, women were summoned into heavy industrial labour in munitions and traditionally male industries. Here this image of the woman factory worker is also allowed to function within a psychic space of meaning. The mourned Mother of the Oedipal script – whose laughing face repreatedly haunts the desolate Ruby – is replaced at the conclusion of the film with the *femina laborans*, who is also *femina ludens*, the smiling face of the woman as engineer and builder (Figure 9.2). Her returned look from the film back at the spectator aligns a relation to labour and thus class with a shifted relation to a psychic script, a subject position of desire, that can now be released into creativity, productivity and sociality.

The delusional beauty of Marilyn Monroe's glittering smile (Figure 9.1) and this working woman's welcoming laugh at and with a feminist 'us' created by the film have to be placed in an oblique genealogy. They are different facets of the feminine predicament and possibility mediated through the work of the cinematic image and the image of work in both the material and psycho-symbolic realms. These four films all deserve much more extensive analysis. In this chapter, my brief résumé serves to create the necessary depth of archive for acknowledging the central place of work and the issues of class in the discourse of avant-garde British feminist films of the

1970s. The distinctive feature of that engagement with class was that it could not be severed from the desire to construct cinematic, and theoretical languages that displaced the specularization of woman as sign and icon, with the articulation of woman as subject, of femininity and its socio-economically framed conditions of subjectivity. Conjoining socialist and Marxist analyses with psychoanalytical frames on the site of avant-garde poetics produced a singular avant-garde moment that had unexpected effects. In this chapter I can only develop this case in relation to one, the first of these films, *The Nightcleaners*.

The rubric under which these four films are here assembled is gender and the image of work. A number of different senses of women's relation to work is a domain within each film that is shared between them despite their apparently different projects and strategies. There is work in the conventional sense of having to sell one's labour on the market. There is also the psychoanalytical sense of work as what analysis assists, working on and working through knots and enigmas that halter and disable the feminine subject. There is the self-advertisement of the film itself as a work, a working over and through the conventions of cinema which itself embeds a notion of woman not as subject but as image. There is work as the site of social and personal affirmation and creativity, both signified by the film's own making and by the cinematically staged narratives of transformation.

The overlap between these senses of work and the films' various ways of working produces across the quartet a common problematic that is historically tied to the moment of their production in Britain in the 1970s, within the avant-garde fraction of the cultural politics of the Women's Movement that is, now, retrospectively called feminism. The interplay between gender issues and those of its political economy reminds us that we should not reify gender or sexual difference outside the social relations within which they must always be tracked. Gender is always imbricated with relations of class and race to which it cannot be reduced but from which it must, sometimes, be theoretically distinguished all the better to grasp the living complexity of its perpetual interface with other formations of power. Work invokes the material social relations of production that were, however, within capitalism, significantly overdetermined by preceding historical arrangements of gender, sexuality and reproduction. These legacies of family, kinship and relations of reproduction were, in turn, refashioned according to the shifting needs of capital, and the pressures of the various interest groups it created or displaced. The outcome was the contradictory relation of women, bourgeois and working class, black and white, to the new, capitalist relations of production signified by the word, work. However much and wherever women worked, the definition of woman came to be synonymous with 'not working', that is to say, with being by definition outside paid employment beyond the domestic

sphere or, in the case of enslaved African woman, being without human status, being reducing to the laboring body whose gender was sexually abused to create more property for the owner in the form of new slaves.

The re-emergence of both a political and a theoretical engagment with the repressed question of gender in the 1970s identified the need for a specific line of enquiry beyond existing theorizations which, typically, elaborated the relations of class in a manner that was *indifferent* to questions of gender, sexuality and race. But without a founding theory, a canonical authority, feminism's intellectual project had of necessity to be undertaken in a diversity of forms of self-critical enquiry that used, while it also critiqued, tools uncomfortably appropriated for the job.

One of our fundamental needs was for a kind of feminist ethnography, a documentation of actually existing women's experiences upon which to work with our still tentative theorizations. The documentary impulse involved consciousness raising as well as an array of related cultural practices in film and photography. It was only at the intersection with other debates around the politics of representation at the time that the inherent contradictions of using uncritically a documentary approach emerged to challenge the possibility of a positivist or empirical desire to grasp the 'truth' of women's lives. Thus, against the grain of the populist democractic direction of the Women's Movement and its preferred cultural forms, a feminist counter-cinema precariously emerged, in Britain and elsewhere during the 1970s, creating for a brief but highly significant moment, a politically charged, but aesthetically avant-garde scene for the investigation of the contradictions of women's place in the capitalist world. Work became a topic for a radically reconceptualized theory of the relation of image to knowledge.

The combination turned the impulse to know, conceived through the unproblematized concept of documentary/documentation, into an investigative and interrogative *signifying practice* – a term I shall shortly explain – that revealed hitherto unexamined dimensions of what was specific about asking these questions about work through the prism of sexual difference. These necessitated a move from the subject/object relations of the documentary model of knowledge to a psychoanalytical concept of subjectivity that opens the socio-economic plane conjured up by the word 'work', to the psycho-symbolic register, where we 'work on' and 'work through' aspects of ever shifting and never fixed psychic formations signalled by the psychoanalytic term, subjectivity, namely, the human subject as a process caught between unconscious and conscious dimensions structured by the loss occasioned by coming to language that creates desire.

To explain this point I shall elaborate on the question of signifying practice and its relation to the definition of avant-garde I want to employ here. Second, I shall close-read a section of *The Nightcleaners*, setting the case study in a

wider context of art history and film history that plot out the contradictions between woman as image and the image of the working woman.

Subjectivity and theories of the avant-garde moment

I first saw *The Nightcleaners* in the mid-1970s as a keen feminist activist and a decidely ignorant cultural analyst. Like many others, I initially found the film hard to watch and even more difficult to read. When I saw it again in 1998, I was moved to tears. I was puzzled not only by the ease with which I could now follow the structure of the film but by the power of that structure, now experienced as a rhythm, to affect me as a viewer 20 years after its making. This could not be because films of this kind are any more prevalent now than in the 1970s. Indeed part of my argument concerns the very defined time limits within which this moment of feminist avant-garde cinema occurred. Some of my perplexity then was certainly due to unfamiliarity with the cinematic archive from which *The Nightcleaners* was drawing, Brecht and Dudow's *Kuhle Wampe* (1932) for one, and the films of Straub-Huillet and the other radical cinéastes of the new European cinemas. But had I been as alert as the more mature critics and readers of the film, I still would only have been able to receive the film in terms of analysis created by the existing cultural discourses on political cinema, which made for the largely Marxist and Brechtian reading of the fim as construction and as discourse.

One of the film's first commentators, however, was Claire Johnstone, a major thinker in the field of a feminist counter-cinema. Her analysis stressed the intelligent ways in which the film-makers addressed the fundamental contradiction between the typical cinematic means of producing a 'truth' about working-class life (the British documentary tradition founded by John Grierson) and the political aesthetics of a film that advertised its own manufacture. Claire Johnstone also highlighted the way that the central problematic of the representation of work, namely class, was redefined by issues of both gender difference and sexuality. These themselves reconfigure issues of representation and cinema, in which the image of woman and the spectator's positioning in relation to viewing that imaging are founding devices. Thus, while a critical film practice that reworked the typical form of documentary for the representation of working-class people and experience might challenge the naturalization of those tropes as 'truth', a practice that did not examine the relations between, on the one hand, representations of working-class women as 'truthful' precisely because these women were represented as visually unpleasurable, and on the other, the representation of an invisibly classed femininity as masquerade that secures the excessive and fetishistic visual pleasure of dominant narrative cinema, would certainly

miss a politics of sexual difference that is actually articulated in popular culture through the visual encoding of a gendered, class difference or equally a classed, gender difference. Furthermore, any cinema that, while seeking to explore class consciousness amongst working-class women did not attribute levels of subjectivity, desire, agency, to its working-class subjects, who would also have to be figured in relation to sexual difference, would fail to examine what British feminism of the 1970s placed on the agenda: precisely the complex articulations between sexual oppression and class exploitation.[14]

It has taken over 20 years for what was perceptible through an aesthetic configuration (within the film) to be theoretically elaborated in such a way that a retrospective viewing of the film finds them yet again to be one step ahead, and at the same time, timely and legible in their address to current burning questions. It is as if we are, at last, and belatedly, theoretically advanced enough to comprehend the traumatic and shocking events of the revolt of women that burst upon the world in the 1970s. Far from being dismissed as another short-lived episode of the continuing saga of 'the woman question', the 1970s was a moment that not only inspired major legal, political and social changes to the status and rights of women. Its cultural politics made possible the equally necessary shifts in the fields of meaning, subjectivity and those privileged sites of the making and staging of subjectivity, both working spaces and spaces of representation.

I call this moment one of avant-garde poetics under three definitions of the concept of the avant-garde. First, I must stress that the term 'avant-garde' should not be mistaken for a synonym of modern art. It should be specialized, and it refers to three possibilities:

- *the notion of an avant-garde moment* as a transitory period of engagement with and disengagement from both dominant forms of social and economic life and dominant modes of representation and self-representation that is based on a series of postures, gestures and practices by a self-defined group undertaken to differentiate itself from current social and representationational practices while also intervening in them.[15] Such moments would include Art in Paris in the 1860s–1880s, New York in the 1930s–1940s, and I am suggesting the aesthetic practices associated with the Women's Movement of the 1970s.
- *the notion of the avant-garde as a specific formation in the 1920s–1930s around dada and Surrealism that struggled to force the re-encounter between art and life creating politicized aesthetic practices with real intentions to intervene in social experience.*[16]
- *the notion of the avant-garde as a revolutionary poetics confronting the historic consolidation of an alliance between State, Family and Church by a creative dissidence at the level of signification and subjectivity.*[17]

Julia Kristeva thus defines the moment of the avant-garde in the later nineteenth century, largely associated with the radical symbolism of the poet Mallarmé in whose apparently aestheticized formalism, she reads a profoundly political force. Later arguing from the Freudian premise that the subject is a split subject, riven by the unconscious and the accession to language that severs the subject from the archaic field of drives and rhythms of the body, Kristeva proposed that the play of subjectivity, spoken by, but also always in excess of, language, could be tracked in certain forms of art and literature. Poetry, music, dance and painting were for Kristeva, *signifying practices*. Not simply constrained to deliver communicable meanings as in a legal statement (signification proper), *signifiance* in poetry, art or music functions as a more permeable filter between language (the symbolic, cultural law) and a prelinguistic corporality with its fantasmatic structures and unformulated energies that are harnessed by the symbolic while always exceeding its drive to fixity. The signifying practices, while always operating within language and the realm of communicable sense, were also resourced by the *semiotic* impulses that underlie language, tipping signification towards meaning as patterning and play. The interplay between the structuring, regulating law of language and its creative underside allows both for the constant renovation of meaning and for the shifting of the subject who is the point of transaction between unity (symbolic) and process (semiotic). At times, at the historic moment of the avant-garde's secular, formalist dissidence, however, this play could effect a revolution that would necessarily operate at the level of subjectivity.

We shall call signifying practice the setting in place and the cutting through or traversing of sign systems. The setting in place or constituting of a sign system requires the identity of the speaking subject in a social institution in which the subject recognizes the support of his [her] identity. The traversing of sign systems takes place when the subject is put on trial and cuts across, at angles as it were, the social institutions in which it has previously recognized itself. It thus coincides with moments of social rupture, renovation and revolution.[18]

Subjectivity refers here to this play of fixing and shifting at the point where human persons experience themselves, their desires and socially determined limits. To become a subject we must enter the community of language, but this cuts us off from dimensions of psychic experience and its formative narratives which continue to determine us from the unconscious they now form. Signifying practices loosen the bonds of language as culture's law and allow a play on the frontier with what we imagine we lost which yet holds affecting traces of our own becoming. Julia Kristeva's theory of the avant-garde moment allows us to think the links between the social-economic structure: the State, the organization of gender and sexual difference; the Family, the realm of ideological and aesthetics; the Church, and the signifying

bond that links them and passes them through the body and psyche of their subjects: both the unconscious agents of the system, and the product of the system of subjectification. She also allows us to see the role of aesthetic practices in the rupturing and shifting of these bonds.

If there are these avant-garde moments, however, can their revolutionary effects be immediately grasped or are they necessarily deferred? This question has two aspects. First, I would want to suggest that this traversing of sign systems was part of the event that was the cultural side of the Women's Movement in the 1970s. Second, I would have to argue that the dislocation between the masculine moment of the avant-garde between Mallarmé and Joyce and a feminine moment was historically occasioned by deep-seated historical factors. Although historically, the coincidence of the emergence (a) of Kristeva's avant-garde working on language, (b) of psychoanalysis, theorizing subjectivity, sexuality and the unconscious, and (c) of the revolt of women in the suffrage campaigns should alert us to their deep inter-relatedness, women could not fully participate in the avant-garde moment of the 1890s–1910s because they had been thrown backwards, out of time and history, by bourgeois society in its totalizing imprisonment of women within the concept Woman, within the empire of gender. As social subjects, women had to struggle back to the level playing field of even bourgeois concepts of the bourgeois political subject before being able to engage with the other forces of dissidence, in poetry and psychology, that contested the bourgeois order's alliance of State, Family and Church. By the 1920s, however, there was an extraordinarily rich intervention within modernist culture by a feminine avant-garde in profound alliance with sexual dissidence.[19] But this moment was prematurely crushed by the rise of the anti-feminist forces of fascism and totalitarianism that were internalized, at least in their gender politics, by the victorious allies. Thus *Gentlemen Prefer Blondes* of 1953 symptomatized the twisted logic of the double indemnity of woman as both erotic fantasy and domesticated wife with no imaginable space for the concepts of women as subject, a concept that must align women and work, creative and otherwise, and women and their own desire. The re-emergence of the feminist project in the 1970s was thus the resumption of the unfinished business of femininity's relation to an avant-garde rupture of the prevailing order of sexual difference at the socio-economic-legal, linguistic-cultural and psycho-symbolic levels. This disrupted temporality can be further considered by a digression into the early writings of Freud on what he named *nachträglichkeit*, deferred action.

In 1896, Sigmund Freud wrote to Wilhelm Fliess: 'I am working on the assumption that our psychical mechanism has come into being by a process of stratification: the material present in the form of memory traces being subjected from time to time to rearrangement in accordance with fresh

circumstances – to a retranscription.'[20] This construct radically undoes the typical mode of historical analysis as a disinterested journey back to the past, the archive, which, untempered by our present status as its product, awaits pure narrative recovery. None of us accept that anymore. Yet my re-encounter with *The Nightcleaners* once again reminded me of the difficult issues of that relation of past and present. Can a film or artwork be both so radically of its moment that we must, as good social historians attend scrupulously to it its specific historical coordinates, and yet so radically beyond its moment, that its immediate consumers or readers can only glimpse it through perspectives not yet transformed by its own existence – its own transformative effects and its poetic and rhetorical power to shift perception and understanding? This seems to me to underline the necessity to read continually for that dialectic of the force of the historical event that remains, like a trauma, incompletely assimilated at the moment it arises while it, nonetheless, determines the belated terms of its perpetual reconsideration through other artefacts or cultural events that allow us to retranscribe it, always otherwise.

Facing death: sentimentality, ideology and the trauma of subjectivity

The Nightcleaners is adamantly a text of the 1970s and was read in its own moment, astutely and intelligently in relation to major debates about the politics of representation to which it made so momentous a contribution, yet one that was for the most part, illegible in ways which are now hard to imagine. Viewing the film in 1998, I found most of what made its first viewing almost impenetrable – its failure to function as documentary – fall into transparency while what had been invisible to my extremely ill-educated eye in 1975 became overwhelming now. Let me make it clear what that was: the film was about the subjectivity of class.

The only way to explain this reading involves a series of frames that I want to place around a moment of pathos that overwhemlmed me in my reviewing the film in 1998. It concerns the role of the face in the film.

Let me talk you through an early scene in the film. It begins with a close shot of a middle-class man speaking with a heavily upper-class English accent. He is the employer, the capitalist, and he speaks his own false consciousness by patronizingly commending his employees for their loyalty to his company. Then there is a long shot of a building at night in which a woman is seen working. The elongated windows and the brightness of the illuminated interior mimic the cinematic wide screen. The woman is cleaning but seems aware of the watching camera across the road; her anxious look out the window underlines the act of viewing and interrupts her objectification. Over this

disconcerting scene a middle-class woman's voice talks about the importance of feminist questions about sexuality since capitalism sells so much on sexuality. These two points of embodied and disembodied discourse are succeeded by an interview with two of the women cleaners that is led into over the black interspacing by a woman's voice decrying her husband and complaining about her poverty because of the family wage. She declares that she would be better off financially as a single mother. The unseen male interviewer/film-maker addresses questions to the two women who slowly reveal information about their working lives and its impact both on their sex lives and their health. They talk about the hours they work, the lack of sleep, the reasons they take on these awful hours. One woman, Jean Mormont, has been doing this job for 15 years. Her doctor had told her it would kill her. She gave up, but was forced back into the job because she could not survive on what her husband gave her. After a nine-hour shift at night work, she gets possibly an hour's sleep a day because she has young children for whom she must care during the daytime. Asked why she works such hours, she declares that she trusts no one else with her children.[21] As this sequence ends the camera slows and stills on to her face (Figure 9.3). This moment of Brechtian-Godardian focus on the face of one working-class woman whose story has just unfolded before us oscillates between two poles: an attempt to produce a revealing excess of what I would call psychic realism by an extended visual attention to the face as the site of this particular, historical subjectivity and a guarded avant-garde modernist strategy to interrupt identification with the human face by insisting on the fictionality of the film as manufactured effect. It is exactly in the undecidable gap between the intensification of the gaze that is allowed to pause at the site of a human face and the reminders of an intent to slow us down and force a reflection on the relation between the life described and the body that lives such physical exhaustion and abuse that the moment we call subjectivity can be incited as a transfer/transference between this absent woman and the contemporary viewer that occurs via the semiotic of lapsed time and the stillness of the camera at the place we contemplate being and nothingness.

In the debate that followed the first showing of the film at the Edinburgh Film Festival in 1975, some anxiety was expressed about this scene. What was seen then was only the sentimentality of this shot, namely its content or overt intent. An independent film-maker, Martin Walsh commented:

The freeze frame and slow motion ... seemed to me to sentimentalise and romanticise the issues in a manner of German New Objectivity in the 1920s and Dorothea Lange/Eugene Smith in the 1930s in their photographs of poverty. There's a high angled close up of a cleaner in which her eyes gradually close in resignation. It's so emotionally loaded that it begins to eliminate the level of the opening scenes that stress cinema as discourse.[22]

Paul Willemen replied to the question with the admission that there is always a tension between humanism and sentimentalism in cine-verité. But he refused the idea of sentimentality and instead, defines the effect of this sequence as *emotion* which is framed and used within the overall structural principles of the film. 'The sentiment is generated by the fact that you know she is going to die because of that contradiction.'[23] Sentiment is hardly strong enough for this statement. We are looking into the face of a woman for whom work means premature death and what it should do to any viewer is something more disturbing than emotion. The slowing down of the film and the prolongation of her eyes closing and reopening *opens* the film to a moment of trauma, of almost-encounter with the real that is death. This trauma may then be disavowed by the intrusion of affectivity on the part of the viewer, my bourgeois tears for instance, or Martin Walsh's professional impatience with sentimentality that allows him to disavow the shock. Both were pathetic responses, in both senses of that word.

To support my assertion that the significance of this long-held freeze frame and slow motion image of the face lies, however, in the inscription of a politicized pathos because of its near encounter with the trauma of a classed death, I would, however, like to suggest another line of argument, partially rooted in an art historical archive of representations of class and labour from the nineteenth-century foundations of the documentary impulse in the disciplinary society.

The Nightcleaners was commissioned as a good old-fashioned campaign film. This should have meant treating film both as a transparent medium for passing information about 'real' state of things and as an affective medium for arousing people to outrage at the exploitation of those who could only be shown as its passive victims. Such films depend upon historically developed tropes for the semiotics of class: black and white photography, a certain naïveté and avoidance of self-conscious style, the showing of silent, suffering victims framed by authorative bourgeois voice-over. Such films are the product of a long history of modes of social and political investigative and adminstrative disciplining of heterogeneous populations within capitalism. In mid-nineteenth-century Britain, conservative anti-capitalists such as Lord Ashley (later Lord Shaftesbury) spearheaded commissions of enquiry into major industries like the sewing trades, or mining where they documented and decried the abuse of child labour but where they also discovered the 'impropriety' and immorality attendant on women's industrial labour underground in jobs often done by ponies. One of the most interesting and arresting scenes in the film, *The Song of the Shirt*, dramatically reconstructs the script of one such investigation by Lord Ashley into the sewing and millinery trades in 1842. Three men form the commission of enquiry interview two working-class seamstresses in a large room. Formally circling the space

in a vast chequered floored hall, the camera prevents the spectator from identifying with any one position. Its tracking across the space around and between the bourgeois men and the working-class women, however, cinematically establishes the unbridgeable gap between the desires of the two classed subject groups whose dissonance is further created by gender. Lord Ashley is only concerned with the morality of the women workers – do they get time off to go to church? – while the women want to speak their concerns about the real difficulties of managing work, health, their own sexuality and their care of their children. He disavows the vulnerability of the working body by addressing only the immaterial sign of social control, the soul. They worry about food, sleep, blindness and love. The film makes the women's energized voices speaking their pent up frustrations trail away as the camera distances us from them, moving in on the bourgeois investigators, whose interest has waned so that they no longer hear the evidence the women want to speak, and they do not want to know. The space the camera opens up visually and acoustically signifies the political and psychic gap that formally enacts what we must grasp as the simultaneity of class and gender contradictions.

After the 1840s, however, commissions rarely solicited the words of working-class women. They were spoken of and for. They became objects of representation, including visual images. For instance, in the 1867 enquiry into the continuing employment of women in some mines in Lancashire where women worked on the surface while wearing men's breeches, the officials of the newly formed mining unions appeared in order to condemn this practice. They decried its immorality, while revealing that their real anxiety lay in the fact that while women worked, men did not get their suppers cooked. In addition, the clothes these women wore to work were seen to disorder what was claimed as a natural and visible order of difference between men and women that led to women's primary domestic duty. To prove this point, and for the first time in a parliamentary commission of enquiry about work, photographs, showing the women in trousers and work clothes, were produced as evidence of the immoral and unnatural state of affairs when women looked like men. The employers, however, keen to preserve their access to the cheaper labour of women, produced a counter series of photographs, showing the same women in appropriately bourgeois feminine dress.[24]

These contradictory photographs that themselves undermine the truth claims they were both adduced to support, have been preserved for us in the archive of an independent investigator now held in Trinity College, Cambridge. Arthur Munby made regular visits to the Lancashire pits between 1853 and 1887 to speak with the women miners, to learn of their lives and experiences. He collected cartes-de-visite of them in both work and Sunday

clothes and documented his conversations in copious diaries. He also made less publicized sketches of them, which have, however, rarely been shown. They are traumatic and traumatizing images (Figure 9.4). Through the untutored drawing of the amateur, these sketches expose the otherness that Munby fantasized, or imagined he saw when he spoke to women who were his friends over 30 years. In grotesque form, they reveal Munby's 'vision' of a fantasmatically deviant femininity that could only be visualized through contemporary racializing and bestializing tropes from which any recognition of shared humanity or subjectivity was radically erased.[25] Something of this need to convey the otherness of class experienced by the bourgeois subject through the resort to the animalistic inhabits another major precedent in the archive for the faces emiserated and transformed by labour, Van Gogh's *The Potato Eaters* (Figure 9.5). Prematurely aged and reduced to a leathery lumpenness that the artist himself brutally compared to the surface of the potatoes that the peasants relied upon as a daily diet, these faces were, for their initial viewers, too disturbing to acknowledge within the realm of art.[26] Van Gogh was chastised for his incomprehension of the need to manage aesthetically the encounter with pain and exhaustion through the rhetoric of naturalist sentimentalization, asserting the moral of stoic fortitude and visual confirmation of the peasants' exemplary acceptance of the biblically defined fate of man to earn his bread by the sweat of his brow. Here the bourgeois gospel of work served to conjure away any physiological inscription of class as bodily pain and subjective erasure, of the social contradictions written in a ruined face. But Van Gogh's painted peasant face can only register the externally observed effect, that makes its subject, Cornelia de Groot or the rest of her assembled family, an object of another class's fear or fascination and never a subjectivity whose body is marked upon its exterior by what another class has done to her.

In contrast to these faces upon which is projected the class-bound fantasy of bourgeois men when confronted with what proletarian labour does to Woman, we should contrast Edouard Manet's monumental face of a working-class woman at the core of his last painting, *Bar at the Folies-Bergère*. (Figure 9.6). Here is the avant-garde counter-tradition that, on the one hand anticipated, while it critically equivocated about, the commodification and specularization of woman paradigmatically encoded in the face of Marilyn Monroe. On the other, it prepares us for the aesthetic strategies of *The Nightcleaners*. The critical arguments about Manet's treatment of the face of Suzon, the barmaid, distils into a double analysis that suggests that this is the face of fashion and commodification. But it is at the same time a cosmetically created death mask from which almost all humanity is leaching, the sign of the traumatic loss of humanity in the world of commodities that is colonizing bodies and persons to the level of their becoming simply more

objects of exchange and use. After this face of the erotics of the commodity, Picasso would turn, in his *Demoiselles d'Avignon* (1907, New York, Museum of Modern Art), to a misappropriation of another culture's formal ordering of the face to signify that absenting of the human and the role of formalist abstracting.

Manet's self-conscious assertion of painting as a site of manufactured representation that refuses complicity with the illusion and fantasy that the café-concert peddled also works to allow this image of the face of a working-class woman at work to hover between that which turns it into an object of contemplation, appraisal as a sexually invested sight, and the residue of an unsignifiable otherness of the subjectivity that Manet, the bourgeois artist, cannot know. He could, however, admit its possibility in Suzon, the model behind his image of a barmaid, and find a way for his painting to register its trace as the spectral dissonance created paradoxically by the literal self-insistence of his painterliness.

Where does sentimentalization fit between this divided genealogy of the face of class and/as femininity as we return to the prolonged contemplation of the face of Jean Mormont in *The Nightcleaners*? I am suggesting that *The Nightcleaners* was heir to a long and complex history of representation, work and a judicial mode of enquiry. Anything we reclaim from that film about the politics of its representation will have to be considered in terms of its relation to, or intervention in and against, that compromised origin. Let me underline that I am not rehearsing the debate about documentary that emerged in the 1970s which was concerned with the ethics of the relations between makers of documentary and their subjects. This is more about deep structures, the historical legacy that makes the present act possible while compromising it by its often unknown political origins.

As I understand the history of the making of *The Nightcleaners*, a great deal of footage was shot of the cleaners at work and on their breaks, of the series of meetings upon which the struggle to unionize the women who worked as nightcleaners slowly took shape under the committed energy of May Hobbs, of the demonstrations, etc. These are typical signifiers for documentary film-making. Given the poor quality of much of the footage and the essential aimlessness of such 'recording', any signification will only emerge in the editing process, a process which was itself unguided except by a negative impulse: not to let the film remain what such footage could only be imagined to be – a visual evidence that would support by its seeming factuality the discourse of the authoritative commentator who could take one of two positions for or against – thus replaying the classic instance of the 1867 commission or the 1842 enquiry. The film is closer to the 1842 in so far as the women themselves are the speakers of their own condition; in contemporary terms they give testimony and we are made witness to the

delivery of that testimony from within a world that the film shows to be a silent and relentless round of labour obscurely punctured by the desire that only rebounds against the women in their concern for their children. In the same way that a commission on the mines of 1842 brought to light the conditions of labour in the underground darkness so the film brings its lights into the darkness of night work, revealing its conditions as not only exploitative – to be remedied by unionizing and a better wage, but deadly and knotted.

I suggest then that the film is not the film it was intended to be – documentary or agit prop – because it ceased to operate in that space of production of knowledge about work within the social economy of its management on behalf of capital. It works more the space of Manet's painting, one that advertises its own process of production and catches in its visual field the invisible foundations of patriarchal capitalism. In the grain of that self-indulgent modernist play it, nonetheless, vouchsafes what the whole documentary tradition obscures: subjectivity. That is the encounter with the relations of production of class as a crime against the person who lives their effects in mind and body.

Thus I want to draw attention to the role of the face within this film as an unexpected effect: I suspect that it is accidental and that the repetition of certain footage was overdetermined by the lack of understanding of what to do with the filmed material that was collected at a moment of a major paradigm shift. Again and again, the film interrupts its evidential trend to rest upon faces that the viewer comes to know through a prolonged looking that undermines the face as perfect surface, icon or mere object. The film interrupts the logic of any kind of exposition or heroic narrative to which it does sometimes threaten to succumb by returning to the faces of the women and especially of this woman.

What do I mean by subjectivity interrupting documentary?

The film signifies the trauma of work for women caught in the triple bind of the capitalist relations of production, of reproduction and of gender and class as inseparable. As people defined as women through the sexual division of labour, they are mothers whose role involves them in daytime work for which they are unpaid. To care for the children, that is to satsify the desires of the other economy that makes them want to do well by their children when they have no income separate from the family wage, they take up the only work that coincides with that patriarchal family economy, forged in the nineteenth century. They are driven into the money economy: into work for wages, work that can only be performed when the masculine economy sleeps. Far from being then a momentary documentary about a particularly hard-pressed group of workers, this film uniquely reveals dimensions of the intercalation of class and gender that makes the conjunction of terms women

and work immensely problematic and yet critical to any historical under-standing. Where that intolerable contradiction is finally inscribed in the film is the face of one woman oceanically represented by some purposely grainy technical work that is needed to allow a badly filmed moment to function as the traumatic core of the film's re-created encounter with the pathos of subjectivity – the place of desire and the horror of the real, death, in the modern patriarchal and capitalist relations of work.

Notes

1. Mulvey, L., 'Close-ups and Commodities', *Fetishism and Curiosity* (London: BFI, 1996), pp. 48–9.

2. Kracauer, S., *Das Ornament der Masse* (Frankfurt Am Main: Suhrkamp Verlag, 1965). First published in 1927. Translated as 'The Mass Ornament' in *New German Critique*, **4–6** (1975), pp. 67–76 by Barbara Corell and Jack Zipes. Kracauer begins his essay with an analysis of the Tiller Girls' 'indissoluble female units whose movements are mathematical demonstrations' (ibid. p. 67).

3. Mulvey, L., 'Film, Feminism and the Avant-Garde', *Visual and Other Pleasures* (London: Macmillan, 1989), p. 119.

4. Leading amongst the important readings of at least two of the films I shall discuss is Silverman, K., *The Acoustic Mirror* (Bloomington, IN: Indiana University Press, 1988).

5. Johnstone, C. and Willemen, P., 'Brecht in Britain: The Independent Political Film', *Screen*, **16** (4), Winter (1975–76), p. 104.

6. Mulvey, L. and Wollen, P., 'Riddles of the Sphinx: Script', *Screen*, **18** (2), (1977) p. 69.

7. Kelly, M., *Post Partum Document* (London: Routledge, 1983) offers this artwork in a specially designed book form. See also *Rereading Post Partum Document*, S. Breitwieser (ed.) (Vienna: Generali Foundation, 1999).

8. For a recent reassessment of the *Women and Work* project see Mastai, J. (ed.), *Social Process/ Collaborative Action: Mary Kelly 1970–1975*, (Vancouver: Charles H. Scott Gallery, 1997).

9. Alexander, S., 'Women, Class and Sexual Difference in the 1830s and 1840s: Some Reflections on the Writing of a Feminist History', in S. Alexander, *Becoming a Woman and Other Essays in 19th and 20th Century Feminist History* (London: Virago, 1994), p. 109.

10. Clément, C., *Opera, or the Undoing of Women*, trans. B. Wing (London: Virago Press, 1989).

11. Parsons, L., 'An Analysis of *The Gold Diggers* (1983) by Sally Potter: Feminist Film, Julia Kristeva and Revolutionary Poetics', unpublished PhD, University of Leeds, 1994.

12. Irigaray, L., 'Women on the Market', *This Sex which is not One*, trans. C. Porter (Ithaca, NY: Cornell University Press, 1977), p. 171.

13. The reference is to Hélène Cixous's important essay, 'The Laugh of the Medusa', trans. A. Kuhn, *New French Feminisms*, E. Marks and I. de Courtivron (eds) (Brighton: Harvester Press, 1981).

14. At least two of the four films under consideration, already insisted upon registering race and cultural difference as an equally crucial element of all analytics and politics.

15. Orton, F. and Pollock, G., 'Avant-Gardes and Partisans Reviewed', in F. Orton and G. Pollock, *Avant-Gardes and Partisans Reviewed* (Manchester: Manchester University Press, 1996), 142.

16. This concept is advanced by Peter Bürger in Bürger, P., *Theory of the Avant-Garde* (Minneapolis, MN: University of Minnesota Press, 1983).

17. Kristeva, J., 'Signifying Practice and Mode of Production', *Psychoanalysis/Cinema/Avant-Garde Edinburgh Magazine*, **1** (1976), p. 64. This text is the translated introduction to *La traversée des signes*, ed. J. Kristeva (Paris: Editions du Seuil, 1975). The idea is also elaborated in her *Revolution in Poetic Language*, trans. by M. Waller (New York: Columbia University Press, 1984).

18. Kristeva, ' Signifying Practice and Mode of Production', p. 64.

19. See Benstock, S., *Women of the Left Bank: Paris 1900–1940* (London: Virago Press, 1986).

20. Freud, S., *Correspondence with Wilhelm Fliess, Standard Edition of the Complete Psychological Works of Sigmund Freud* (London: Hogarth Press, 1953–73), vol. 1, p. 233.

21. This point was treated critically at the time of the film's production because the film did not question her total submission of the ideology of family. In retrospect, and from the perspective offered by feminist analysis, this is a moment not of blind ideological interpellation but of contradiction between the economies of desire and necessity. In what is woman's desire invested and how does the social dvision of labour by gender work upon that desire to appropriate it for capitalist profit. It is here that the resistance of desire also makes itself felt in the fact that its drive will lead to her death, not because she should find no meaning in motherhood, but because of the social conditions in which she must live that motherhood.

22. Johnstone and Willemen, 'Brecht in Britain' pp. 114–15

23. Ibid., p. 115.

24. For a selection of these images see Hiley, M., *Victorian Working Women: Portraits from Life* (London; Gordon Fraser, 1979).

25. I have analysed this archive in my article, '"With my Own Eyes," Fetishism, the Labouring Body and the Colour of its Sex', *Art History,* **17** (3), (1994), pp. 342–82; forthcoming in Pollock, G., *Looking Back to the Future: Essays from the 1990s* (Newark, NJ: G & B Arts, 2000).

26. For analysis of the response to this painting see Pollock, G., 'Van Gogh and the Poor Slaves: Images of Rural Labour as Modern Art', *Art History,* **11** (3), (1988), pp. 408–32.

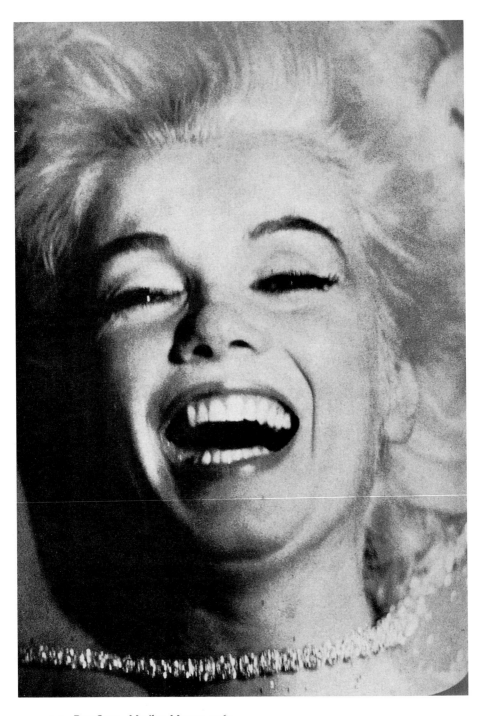

9.1 Bert Stern, *Marilyn Monroe*, 1962

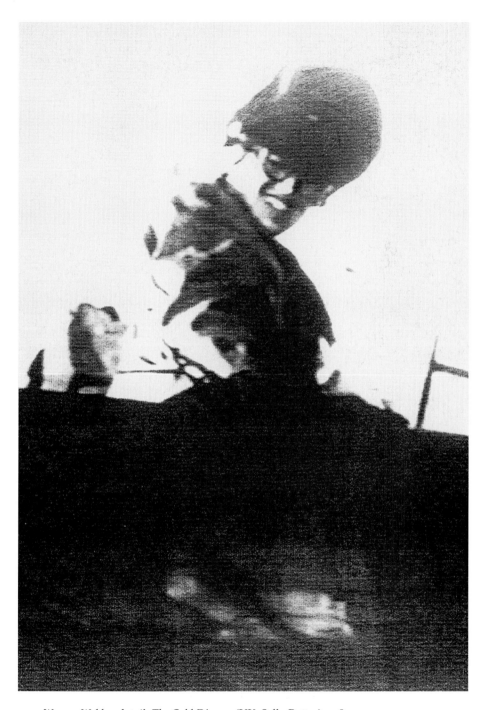

9.2 *Woman Welder*, detail, *The Gold Diggers* (UK, Sally Potter), 1983

9.3 *The Face of Jean Mormont*, detail, *The Nightcleaners* (UK, Berwick Street Film Collective), 1975

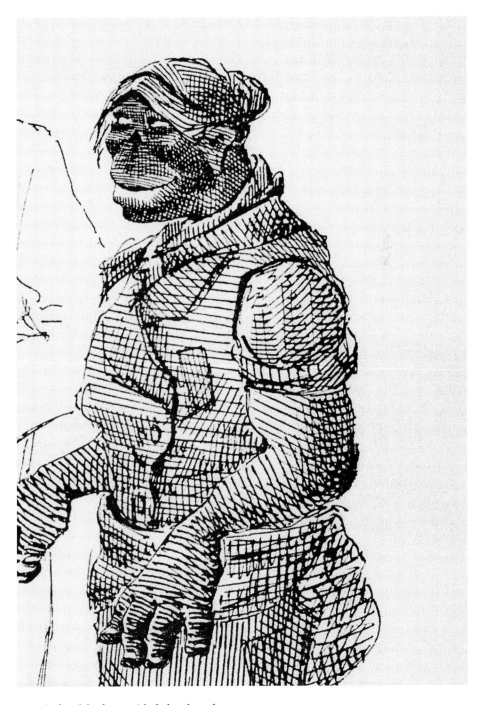

9.4 Arthur Munby, untitled sketch, n.d.

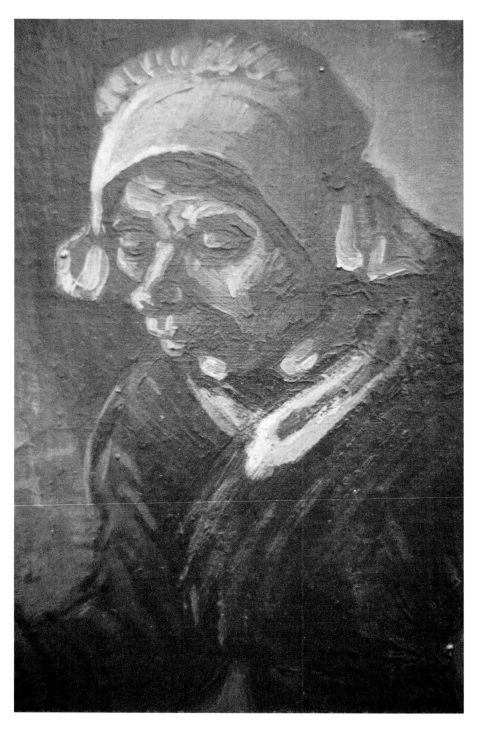

9.5 Vincent Van Gogh, *The Potato Eaters*, detail, 1885

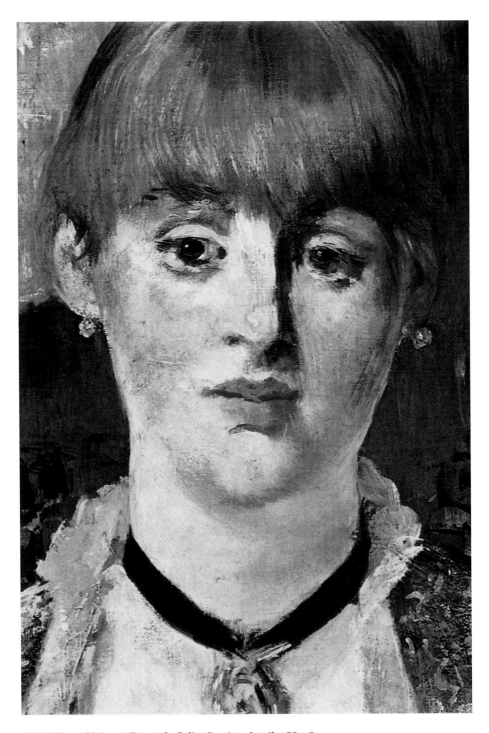

9.6 Edouard Manet, *Bar at the Folies-Bergère*, detail, 1881–82

Teletales from the crypt

Nancy Barton

You who are the father of letters … have been led to attribute to them a quality which they cannot have … [what] you have discovered is an aid not to memory, but to reminiscence, and you give your disciples not truth, but only the semblance of truth; they will be the hearers of many things and will have learned nothing; they will appear to be omniscient and will generally know nothing, they will be tiresome company, having the show of wisdom without the reality. (Socrates)[1]

The end of memory

Throughout Plato's texts, the work of memory is represented as a vital force, continuously engaged in the reconnaissance and retrieval of lost truth. In this model, wisdom is developed through speech, in active dialogue with an audience – a live connection which the encroaching technology of writing threatened to sever. The memory's essential task is that of 'unforgetting' what the soul has seen; if it fails in this charge, it capitulates to a death sentence as a warehouse of lifeless information. Although Plato compares the philosopher to a wise farmer patiently awaiting his harvest in order to emphasize the painstaking effort required in both occupations, the two professions have had very different pictorial histories. While manual labour, has been repeatedly mythologized in paintings, sculptures and photographs, mental work has resisted visualization. Over the past 40 years, however, the balance has begun to change. Television has begun to transmit images of public speakers to the general population with increasing regularity. This vast stream of talking heads represents the work of memory to mass audiences in a new way. Through its absence.

Now spoken performance is made to appear effortless, as through an identification with the speaker's image, the audience develops an appreciation for the rightness of predictability, and a distaste for the potential rupture

caused by an unrehearsed gesture or remark. The key to seamless repetition seems, at first, to lie in memorization, yet the memory's reach can extend too far, unearthing buried associations which threaten an anticipated scenario. As the simulation of perfection becomes our aim, we seek, instead, to replicate an ideal image while bypassing the active engagement of memory.

As power accrues to speech which is increasingly smoothed by artifice, the ambitious worker has been reborn in the image of 'the player'. Past images of labour featured the muscular heroism needed to dominate machinery in the steel age, but workers at Bill Gates's Microsoft complex or George Lucas's special effects compound, Skywalker Ranch, are seamless props in the new factory as amusement park. While intellectuals and artists once made dishevelled public appearances, demonstrating their constant preoccupation with work, and executives and politicians thought aloud in response to impromptu comments, to show their concern for issues, now these models have been retired in exchange for a game where the labour required to perfect a public performance is carefully buried beneath a flawless façade. The real work involves creating a likeness which precludes spontaneity; speech becomes performance rather than discovery, and the best employees have become those who can affect the pose of not working at all.

Prequel

In the early 1950s, Fred Barton, an actor who became an inventor, created a prompting device for performers working in live television. As preprinted words, cues and gestures scrolled down its glowing face, the teleprompter initiated a new model for public speaking, installing eloquence and authority within the reach of anyone who could read a script. This technically enhanced superego was designed to prevent slips of the tongue, and advertisements for the early teleprompter focus on its ability to eliminate the 'fear of forgetting' for its users. This slogan, which was lifted from its inventor's early writings,[2] proved an uncanny epitaph for his life, which vacillated between the fear of forgetting and the fear of remembering, ending finally in the disappointment of being forgotten.

Fred Barton was my father, and like many of his generation, he was a positive thinker. As long as the belief that nothing could go wrong prevailed, anything seemed possible, particularly escape from the oppressive memory of depression-era poverty which made up his early life. His invention replicated his desire for a closed circuit which could bypass negative associations, but his shame over the past, pursued him through recurring fantasies of destitution – making his fear of forgetting the optimistic new script inevitable. The technology he created allowed him to evade his fears

temporarily, yet in facilitating the illusion of perfect performance, his invention set the stage to broadcast the fear of failure into businesses and homes worldwide.

Within the moment of speech itself, the teleprompter substituted a transplant-ready technology of writing for the active energy of remembering. As the prompter's script rolls past, mirroring the exact pace of the speaker's own voice, the letters become a textual double, casting the shadow of mastery over random perceptions and obscuring spontaneous thought. This alienating split recalls Lacan's metaphor of a helpful 'orthopaedic' vision of the self,[3] a fantasy structured in the child's first imaginary identification with it's mirror image. But this time the structure is not designed to be outgrown, it becomes an inflexible mold, binding the speaker tightly within the fabric of a preordained narrative.

Star wars

In the 1950s, the business of America was business, and my father's enthusiastic inventiveness was no match for the newly unleashed forces of corporate capitalism. He lost control of his invention when it was liberated from the fictional realm of film and television by his partners. They saw a more lucrative market in public speaking, and, with the addition of text projected on to one-way mirrors (Figures 10.1 and 10.2), the teleprompter allowed 'the speaker to read his address while apparently looking the audience straight in the eye'.[4]

Politicians were the first non-actors to make use of the teleprompter. Beginning with Herbert Hoover's televised speech at the 1952 Republican National convention, the device became a mainstay for American politicians. Harry Truman, known for his bravado in throwing aside prepared notes towards the end of a talk to launch into a well-known 'give 'em hell Harry' routine, was, nevertheless, secretly reading the duration of his speech from the teleprompter's reflective glass.[5]

An enhanced potential for duplicity was, of course, inherent in the prompting mechanism, which was originally designed for actors, but it took on a new dimension in the political arena. Throughout the twentieth century, the voluntary suspension of disbelief with which audiences conventionally viewed a theatrical production was increasingly proffered as the model for all relationships between public speakers and the masses. Candidates who could read convincingly from the teleprompter inspired more trust than those who revealed the sometimes awkward effort necessary to think on one's feet. Throughout the twentieth century, the voluntary suspension of disbelief with which audiences conventionally viewed a theatrical production

was increasingly proffered as the model for all relationships between public speakers and the masses. A 1957 issue of the *Saturday Evening Post* reports that both the Smithsonian and the National Archives requested the prompting equipment and scrolls of the speech in which President Eisenhower accepted his first presidential nomination. The magazine notes that by the mid-1950s, politicians and officials were already using the teleprompter in 'London, Mexico City, Paris, Italy, Spain, and Saigon, Vietnam', where the uncannily authoritative presence of American military personnel set the stage for wars to come.

By the end of Ronald Reagan's presidency, the teleprompter had redefined the necessary qualifications for political office to such an extent that a victim of advanced Alzheimer's disease could not only remain in office, but continue to be one of the most popular presidents in American history, simply because he was trained as an actor. The majority of American voters did not question Reagan's inability to remember authorizing the Iran Contra arms deal, neither did they find his absence of memory troubling. We had grown accustomed to the substitution of rehearsal for recollection; after all, news commentators reporting the story were not spontaneously responding to the events – they were delivering scripted responses as well.

Postscript

As the teleprompter's steady flow of cues gently drowns unconscious impulses, it is not the fear of forgetting that the mechanism assuages, so much as the fear of remembering that which must remain unspoken. The speaker who incorporates the scripted other both moves within and helps to establish the codes of culture, and if the mechanisms of power work to produce an entrapping knowledge, it is often the type of knowledge our own ambivalence prevents us from grasping. The broadcast of his own replaceability was a script my father could afford neither to remember nor to forget. In one of the classic gestures of the era, his business partners cast him aside with a commemorative gold watch, and barrelled on into the future.

Once the Teleprompter Corporation was delivered into the hands of my father's former partners, they focused on cultivating the demand for prompting in non-theatrical applications. Whether they came from politics, free enterprise or the armed forces, the most effective users of prompting equipment were those in whom the script encountered no resistance. Internal emptiness prepared the way for the unobstructed ingestion of cues, which, appearing to originate from within the speaker, tapped into an always available flow of recycled language. The interior void, the masked presence, and the spontaneous regurgitation of an incorporated other became features

shared by the most powerful figures in government and industry as well as the most popular monsters in horror films such as *Invasion of the Body Snatchers*, *The Thing*, *Friday the 13th*, and *Alien*.

Fred Barton was the carrier for a particularly modern strain of schizophrenia. The fear of the past, visible in the modernist repudiation of both ornament and sentiment, had begun to split the form of capitalist imperialism, severing paternalistic tendencies from newly stripped down models of human relations. He watched from the sidelines as his technology took on a cancerous new life, spreading from the world of televised drama into the management of governments and corporations. Displaced, Barton relocated to Los Angeles as head of Teleprompter's West Coast office, and I grew up in a pristine white stucco box cantilevered over a Hollywood hillside. The architecture itself echoed a scenario of ever increasing isolation; far below the plate glass windows, the world was reduced to a row of glittering coloured lights.

My father's anxieties had positioned him to tap into a futuristic vision of self-presentation, but as that vision evolved into big business, his fears became a liability. He came home from work every day at noon to lay by the pool in a folding plastic chair. Gradually the lunch hours got longer, and finally he stopped going to work at all. As the Teleprompter Corporation began to diversify in the late 1960s, it became a pioneer in the development of cable television. My father, too, began the rerun of his life on a closed circuit.

Rarely leaving his hilltop refuge, he began collecting mail-order youth potions, positive-thinking tapes and ill-fated investments. As Hollywood's promise faded into film noir, a generation of boyish Midwestern transplants would soon discover that 'in California there's only perpetual adolescence and then, suddenly and forever, limitless aging'.[6]

Proof

Even before his retirement, my father was an amateur photographer. Like the teleprompter, photography, with its repertoire of sanctioned poses, storyboards each shot through a subtle interchange of cues and responses. I was photo-graphed repeatedly as a child, responding to my father's directions in exchange for his attention, already caught up in the sado-masochistic bartering of photography's primal scene. As a teenager, I appropriated the camera. Although I was oblivious to the teleprompter's influence, I still felt the need to arm myself with a competitive technology to validate my alternative vision of a world where pleasant surfaces concealed an unnatural emptiness. I saw myself as a crime photographer, searching for evidence through the lens.

During the early 1970s, my experience of photography moved out of the living room and into a social landscape dominated by artists like Diane

Arbus, Robert Frank and Gary Winogrand. Through their work, I sensed the potential the camera offered for revenge. Photography presented itself as an ideal vehicle to unearth and document the painful substructure of everyday alienation. I became fascinated with photographers who routinely displayed this compulsive engagement. Weegee sleeping for years in his car with the police band radio on. Arbus, stripped down to the skin, stalking nudists through a seedy bog. Legions of photojournalists risking shrapnel, land mines and enemy capture to bring back images which prove that this war, too, is hell. Through its split seconds frozen for eternity, photography presented a nihilistic vision of anti-progress. This embalming mechanism seemed the perfect technology to jam the prompters.

Arbus, has been quoted as saying 'One of the things I felt as a kid was I never felt adversity. And this sense of being immune was, ludicrous as it seems, a painful one … The world seemed to belong to the world. I could learn things, but they never seemed to be my own experience'.[7] By interacting with her socially disenfranchised subjects, Arbus attempted to overcome this stifling sense of immunity. In delivering their likenesses into the underworld of photography's death cult, she tried to short-circuit her own alienation.

As time passed, I began to see that, often the photographer's pain is simply displaced on to specific groups of people whose circumstances have been hijacked to enact a sort of schizophrenic angst. The cathartic connection Arbus sought rarely occurs. The distractions inherent in taking the picture usurp contact. The spontaneous moment where insight might be triggered is deferred by the habitual pull of voyeuristic identification or nostalgic contemplation. The familiar script comes in through the lens, just as it scrolls past the screen of the teleprompter. The photographer, too, takes in suffering, even while trying to take it out on everyone else. The camera does not blink, its lens is the prosthesis that keeps us looking death in the face.

Die hard

The dead end of photographing strangers sent me back home to the teleprompted family life I had sought to escape. I photographed my parents in a variety of awkward scenarios, thinking that by reversing my father's script, which sought both to idealize and to forget, I could coerce them into revealing a hidden history. In my efforts to cast the positive in a negative light, I played into the hands of a master prompter, and it did not take long for my father to suggest that we should take some more 'artistic' shots. As he offered to pose for a series of physique photographs emulating ancient Greek and Roman statues, he was already nearing his seventy-fifth birthday. With these images, he envisioned a fitting monument to a teleprompted life. Now

the fear of forgetting could be eternally suspended through the alignment of his aging body with the icons of an idealized past.

The photographs which memorialize this encounter recall a lifetime of looking on at the spectacle of Oedipal display. As the past I had hoped to exorcise scrolled into the disorienting script of the present, I relived my own history as a conscientious technician. My father emulated the stances of Michaelangelo's David and the Roman Lancellotti Discobolus, while trespassing on expansive institutional lawns, and my search for hidden meaning in the past was recast as work – a safer, more well-defined activity, like reading one's lines, where the only conflict arises from one's inability to find masochistic pleasure in following the script.

Fred Barton never stopped equating meaningful activity with physical perfection. His body was a living testament to the models of positive thinking which had served him so well in his youth. His appreciation of Classical sculpture was mediated by the figure of Charles Atlas, whose magazine advertisements promised skinny young men the ability to stand up to the bullies who had kicked sand in their faces. Leni Riefenstal's Nazi propaganda film *Olympia* projected a vision perfectly in synch with my father's view that physical fitness not only prepared a man for the vigorous pursuit of business success; a flawless body signified spiritual superiority as well. Representative of a generation of poor and lonely young men who had weathered the American depression, outsiders like my father made best sellers out of books like *Think and Grow Rich* and *How to Make Friends and Influence People*. In changing his surname from the German, Barkau, Barton paid homage to Bruce Barton, author of *The Man Nobody Knows*, a volume which portrayed Christ an 'outdoor man' and 'model executive'. In his Classical poses, he commemorated a paraphrase which had been popularized by a chorus of spiritualists, bodybuilders, admen and fascists.

The teleprompted script goes beyond words, guiding the novice speaker by including cues for smiles and gestures throughout each speech. But to convey Dale Carnegie's 'smile worth a million dollars', the speaker must sell the audience on his absolute sincerity. Ironically, however, 'sincerity was a problem for the weak'.[8] Those who most needed to achieve success did not feel genuinely inclined to smile at others, especially those more privileged than themselves. Resentful or intimidated, they were at high risk for 'the fear of forgetting'. For men like my father, 'Trying to solve the problem of sincerity by self-manipulation involved one in an infinite regression, an endless effort to disarm oneself as well as others'.[9]

Art of the Classical Era sanctified this regression as the embodiment of a noble past where the conflicts and intimidation of the present could be held at bay. Recycling myths which had already been the subjects of endless revivals, my father's re-creations resurrected a nostalgia for past decades as

well as earlier centuries. In 'Ode on a Grecian Urn', Keats infers that the price of eternal youth is the eternal postponement of desire. Just as a masochistic obsession with physical perfection highlights the signs of approaching mortality, the cult of positivism was transformed into a death cult for its followers. The positivist script rushed to embalm its acolytes before their time, magnifying the risks of initiative and curtailing critical thought. In recent decades, thanks to the wider availability of surgical techniques, the faces and forms of Hollywood stars have begun to replicate the telltale uniformity of Egyptian sarcophagi, whose deathly ambitions infected the work of their Greek neighbours.

My father would die of his third heart attack a few months after these images were shot (Figures 10.3 and 10.4). Absorbed into the closed circuit broadcast of his teleprompted affirmations, he had been missing for a long time. Now, in death, he was reborn, and I became his monument. Although Greek sculptures were often carved to mark the graves of the dead, the most elaborate carvings were reserved for those who left no heirs, whose memory could be set only in stone. My father had no need for these measures. I had always functioned as a live transmitter for his broken dreams, and once he was interred, I found myself unable to switch off the broadcast. Like drinking vessels from the fifth century BC, especially crafted with holes in the bottom to provide a refreshing draught for the deceased, my elegiac psyche had been modified to serve the dead.

Reanimator

In high school, I felt most comfortable in desolate landscapes. There, I created my own design for living, adopting a punishing regime of self-discipline. Eating only two pieces of fruit each day, collecting guns and a room full of bottled water, I was preparing for a coming catastrophe. Later I began to realize that the catastrophe had been over for years.

As a child I was bedazzled by my father, and his vision that anything was possible as long as you refused the possibility of failure. In its enforced amnesia, this mantra of optimism had already sowed the seeds of future despair. As he moved backward, always searching for a time more remote than the memory of things gone wrong, I could not look away. I buried my father's ghost in an interior vault long before he died. As his absence continued to prompt my activities, my ambivalence kept me from the work of mourning. I could not admit to remembering my attachments, let alone reanimate them enough to finally let them go.

Sigmund Freud characterized the melancholic as someone who 'knows whom he has lost but not what he has lost in him'.[10] Ten years after my

father's death, realizing my own subjectivity was still haunted by his disappointment, I began to use my work as an artist to exhume and re-examine the ruins of our relationship. Through the exhibitions *Live and Let Die* and *Waiting for the End of the World*, I sought to map out this abject terrain as a way of beginning to unravel Freud's riddle. In exploring the effects of my father's depression, I stumbled onto the forgotten defensive structures I had created for myself as an adolescent.

Melancholia protects the self against the loss of a flawed love. In his work on aberrant mourning, Laurence Rickels insists that 'Melancholia results only when the ambivalence which disturbed the libidinal rapport with the object even before its departure now blocks mourning. In turn, the only method available for dislodging this blockage is the rapid internalization of the lost object'.[11] Wilful in its misrecognition, the fantasy of control trades in the vulnerability of mourning for the masochistic satisfactions of self-abuse, 'whereby the hostile feelings the highly ambivalent mourner cannot help but address to the departed are directed against himself'.[12]

In the piece *Bunker Mentality*, I created a simple concrete shelter, its walls plastered with photos, its floor strewn with bullet casings. During less stable times, this hideout had existed in my mind as part of a strategy for surviving the end of the world. The process of building the bunker physically for the first time initiated a space where mourning could move beyond self-reproach. During its construction, I was tormented by memories of my earliest moments with my father, thoughts which had been long buried by resentment and depression. I discovered that it was not only the despair of his later life which I had entombed, but the seductive vitality of his youth. In the same exhibition, *Patriarchal Landscape* shows my father as a young man, waving in blurred triumph from the top of a rocky peak. Little girls scramble upward to join him. The photographs used throughout this show repeatedly combine fantasy images of this beckoning figure with the hysteria and pain induced by his crumbling presence – a conflict literally represented by fragmented photographic shards.

As a child's first visual identification with its own image inaugurates a primordial process of self-definition, a conduit is opened which is readily patched into identifications from beyond. The melancholic connection between identification and self-destruction is based in a shattered attachment, which refuses to die, and is instead disguised and recycled as an unconscious identification. Once internalized, the ghost of this forsaken object refashions the ego in its own image. Like a parasitic invader, the intruder cannibalizes its host, and in our efforts to destroy this other, we cannot help but annihilate ourselves.

Over the edge

Junior high school telecommunications courses are one of the fastest growing markets for teleprompting equipment.[13] The production of soundstage-style student news broadcasts has become an integral part of the school curriculum. Video footage of the unskilled teleprompted actor, eyes zigzagging wildly in an attempt to capture and contain the elusive script, provides an uncanny record of the adolescent process where self-reliance is exchanged for pre-scripted polish. The recycling of students' daily lives as news broadcasts gives new meaning to Marx's concern for the alienated worker. His question, 'How would the worker come to face the product of his activity as a stranger, were it not that in the very act of production he was estranging himself from himself?'[14] takes on an added dimension when the product being produced is the adolescent himself.

Media-savvy teenagers have a pretty clear idea how their activities stack up within the hierarchy of mainstream news stories. In Columbine, Colorado, young gunmen, who acted out their suicidal tendencies on group members before turning the guns on themselves, had already completed a videotaped version of their rampage. In a neighbouring state, a young boy who wounded several classmates with a handgun, and then placed the barrel in his mouth, was described to television reporters as a 'nerd' by a more popular student in a live interview. The teleprompter presents an audience-friendly vision of teen suicide for a culture preoccupied with upping the entrance requirements for conformity. For those unable to act the part, the depiction of carnage and firepower in mass media cannot compete with the violence of a life scripted in advance. In school warfare, the loser as 'shell-shock victim resembles one who cannot stop mourning; like the melancholic he comes predisposed to take loss in, rather than simply, to take it'.[15]

May the force be with you

I am living out what horror films call 'the last girl scenario'. Like both of my parents, I once had siblings, but now there is no one else. *Halloween* queen Jamie Lee Curtis is a working girl whose job description as the final avenger venerates the dead. If she forgets them, they are history. When I was younger, I always assumed that I had been left alive by mistake, but I could not capitalize on the oversight. On screen, the heroine can never take the easy way out since, by definition, her escape ends the movie. In service to the greater goal of filmic suspense, she scrambles from one horrific revelation to another, displaying a relentless, if not always efficient, work ethic. Her triumph is simply outlasting everyone and everything else in the scenario.

Too naïve to switch genres, I had already volunteered for the graveyard shift.

Watching television in the 1960s, I learned from Mary Richards and Emma Peel that every single girl needs a career. As I began to navigate the firmly gendered space of academic politics in the 1980s, my father's experience in a man's world left me with a handbook whose references translated all too well into the feminine. Conflicting sexual and professional roles mandated that women be supportive and nurturing, yet ready to make the ruthless 'hard calls' whenever necessary. This familiar double-bind echoed the irreconcilable goals of spiritual integrity and monetary success which had haunted my father through the post-depression era. I found that female artists and educators who were engaged in a highly competitive arena, rife with political struggles over financial and academic recognition worked day after day with images of women depicted as the embodiment of domestic tranquillity, self-sacrifice and passive sexual availability. Facing the legacy of a representational history directly at odds with the skills required to pursue a successful career, I, too, was soon gripped by the 'fear of forgetting'. As I began to fully grasp the complexity of the forces which had defeated my father, I gained a more visceral appreciation for the shelter of a teleprompted façade which could conceal conflicting impulses behind a pre-edited text.

I began to see my father's anxieties reincarnated in the fantasies of failure, vulnerability and exposure fostered by business mergers and corporate downsizing. Institutional architecture and collapsing markets seemed to impel contemporary workers to relive unending scenarios of possible humiliation. The junior high television soundstage was only a rehearsal for the corporate presentation of an adult self which must always remember to forget the bad news. As my workload increased, it was not only my job to bury and eulogize the deceased, now, I began to share an appetite for the image of perfect recall.

My visions of the apocalypse spurred me on, and through sheer tenacity I began to make a place for myself within the institution. Like Ripley who carries the embryonic alien with her as she blasts off from the carnage of the past, I would carry my father's spirit into my working life as a teacher and administrator. In the installation, *I Spit on Your Desk*, I restaged a paternal legacy of defeat and submission, in homage to my father's posthumous guidance (Figures 10.5 and 10.6). Featuring two facing desks, inhabited by father–daughter photomurals, and shrouded in cobwebs, the piece reconfigures the workplace as burial site. A grid of filing cabinets in one photo, translates into a matrix of crypts in the neighbouring image. My students become the parents I am still trying to save from themselves. Audiotapes enshrine a voice over from the past: alive yet dead. As Foucault's concept of internalized surveillance and its presence in corporate culture is extended to include

micro-management from beyond the grave, my father's voice evokes the legacy of failure. Between the lines, I see a repetitive pattern emerging right on cue.

The teleprompted script drives us towards self-annihilation, encouraging us to remember to forget with a sigh of relief. As we let go of the urge for independence, slipping down into the slightly disorienting pleasure of mouthing the words, trance like, failure becomes a refuge. Ironically, we may be a great success with our newly passive persona. If surrender brings acceptance, it also demands maintenance. Once we have something to lose, we are back in the grind. Those who refuse to keep up appearances end up scavenging for survival. Some days you want to kill yourself, other days, you wish for Armageddon. Either way, it's all in the script.

Death race 2000

… the soul, then … having been born many times, and having seen all things that exist, whether in this world or in the world below … there is no difficulty in her eliciting, or as men say learning, out of a single recollection – all the rest … for all enquiry and all learning is but recollection. (Socrates)[16]

As 'unforgetting', guides us through both this world and the world of the dead below, it knowingly incorporates the work of mourning within the task of learning. Recollection pierces the surface of memory, to discover within a singular moment a proliferation of truths, each of which retains the visceral integrity of its generative insight. This restless labour, marked by repetitive searches and sudden leaps, proceeding unpredictably by trial and error, is the work our teleprompted culture allows to dissipate behind its smooth façade.

Teleprompting technology has become so ubiquitous that its influence has become as invisible as the mechanism's one-way reflective glass. Although its deployment provides a vivid illustration for post-structural paradigms of subjectivity, which emphasize the willing embrace of constraints and the individual's complicity within oppression, the teleprompter has resisted interpretation. The machinery is discussed only within the privatized domain of salesmen and technicians. Now that the original mechanized device has been transmuted into a software program, an Internet search leads only to a dozen commercial distributors of teleprompting equipment.

Prompting must confer its gift of mastery from a place of secrecy, but teleprompting machinery is often clearly visible in televised speeches and entertainment. Nevertheless, the audience, hypnotically in synch with the scenario, sees nothing. This vision of nothingness is, in itself, the goal; for the speaker who is severed from the reserves of unconscious experience remains haunted by the phantoms 'in the world below'. Fragmented scraps

of the self which challenge the stable fiction of the ego, or desires which threaten the group, rise up as underworld projections which must be neutralized. If all knowledge may be elicited from even a single recollection, the script must aim for total amnesia.

The prompter not only obscures the form of memory, it must also dispose of the emotional affect carried by recollection. The script itself transports this displaced negativity, now schizophrenically split from its source, and available for nihilistic conscription by the death drive. Speeches by business executives, for example, are laced with references to war and conquest, but these violent metaphors serve a dual purpose. While offering the promise of victory, the phrases themselves conjure up the constant, and perhaps more libidinally stimulating, spectre of submission and defeat. In this paradoxical economy, which Freud locates 'beyond the pleasure principle', the desire for a complete dissolution of tensions pulls inexorably towards the nirvana of physical disintegration, at the same time, mental anxieties multiply beyond the limits of tolerance, building towards implosion. As the teleprompter's enhanced capacity for internal surveillance becomes a blueprint for the mechanisms of power, it installs within each individual the technology to search out and destroy the eccentricity within.

Back to the future

What, then, is the work of art in this process of unforgetting? Kristeva's writings on abjection and rupture in poetic language suggest the crucial importance for art of the 'field of horror'[17] which underlies the presentable face of 'religious, moral, and ideological codes'.[18] In this work, she evokes the nihilistic spirit of modernism, a project which excavates memory but not mourning in its recollection of the 'world below'. With the turn of the last century, early modernists discovered the future of art by looking into the past, scavenging the traces of childhood and the arts of distant cultures. Picasso's description of his fear and loathing when first confronting the African artefacts displayed in the Musée d'Ethnographie conveys the affective power of visual art, while at the same time revealing the limits of Europeans' abilities to understand the works they had appropriated.[19] An artwork which is stripped of its memorial or ritualistic dimension loses more than its aura, it is reduced to a single word, rather than a term within a sentence. Modernism, enabled by the abstractions of antiquity, has never dared to come to grips with more than a truncated version of its sources. In focusing exclusively on the transcendent presence of individual artefacts, it has repressed the dimension of memory within the works themselves, limiting their significance to the prompts and projections of the present.

I have attempted to write a history of my father's prompting machine, while immersed in a historical moment driven by prophecies for a new millennium and haunted by the ghosts of disembodied relics. There have been many digressions; the narrative of my father's disappointment never comes to an end. Obsessively, I refer and repeat, deferring to the innumerable nuances of his sadness, crossing and recrossing the line between reminiscence and recollection. Word for word I retrace the mythology of the past, anxious that if I relinquish my job as crypt keeper, my usefulness will be at an end. My fear of forgetting, like my father's, is also the fear of being forgotten. In the miniaturizing vault of my camera's viewfinder, I once composed the image of a past in which my father wanted to see himself. It was the image of his immanent death. As I recycle these poses in my current work, I search for the clarity to elicit from this recollection, more than the reanimation of decomposition.[20]

As we face the end of the century, we are prompted by the hope that the coincidence of modernism with the beginning of the twentieth century will repeat itself in the production of an equally far-reaching artistic revolution for the occasion of the year 2000. In this anticipated cycle of future shock, the computer has inherited the role of the camera as the recently developed technology which promises to revolutionize vision. Once, photography freed art from the burden of representation, allowing painters to abandon realism for the abstraction they uncovered in the arts of Africa, Asia and antiquity. This time, the computer promises to liberate us from the labour of memory.

Digital memory stores its archives in a disinterested fashion, patiently awaiting retrieval, perhaps offering us the time and distance to look more deeply into the past. In providing an archive for the received conventions of modernism, and extending the reach of global communication, the computer may allow us to remember differently. But Socrates' concerns over the advent of writing may be equally prophetic. Educational research is already being channelled by the availability of topics on the Internet, and memory, as a commodity measured in gigabytes, operates like an in-home prompter, scripting fetishistic cravings for an empty flow of information. If we nevertheless find at this juncture the resources to explore the ritual and contextual associations which have been severed from visual art during the modernist era, art may once again gain access to material beyond the pleasure principle. As a site for the reanimation of the 'unforgotten', the visual arts may function in a rich and complex manner now reserved for written works.

Plato's assertion that all learning is but recollection links the knowledge of this world to the vision of a world below, and to the discovery of ourselves among the recycled souls of the dead who inhabit it. This perception, echoed in Freud's exploration of a death drive, common to all living things, which

searches for the restoration of an earlier inanimate state of being, casts the modernist commitment to progress in an ethereal light. If at some level, we must accede to Freud's observation that life is merely a circuitous path towards death, then his notion that the meaning of each life is to be found in the ability to die in one's own way, suggests a profound definition of freedom. This haunted utopia, presented without the delusions of positive thinking, or the denials of modernist nihilism, challenges the fictions of mastery. The work of art is bound to the work of mourning; inescapable loss exists within the very movement of desire and discovery. This labour, which separates memory from reminiscence, does not occur in a separate sphere, in other words, 'the work of mourning is not one kind of work among others. It is work itself, work in general, the trait by means of which one ought perhaps to reconsider the very concept of production'.[21]

By inventing the teleprompter, Fred Barton created an icon for the fear of forgetting. His legacy is double-edged, engineering a working model for the primacy of reminiscence over memory, yet marking the suppression of memory with a mechanical memorial, whose constant presence cannot help but remind us of an uncanny absence. The teleprompter thus becomes a placeholder for the labour it disavows; it is the work of mourning in effigy.

Notes

1. Thamus refusing the gift of writing offered by Theuth in Phaedrus by Plato, The Internet Classics Archive: http://classics.mit.edu//Plato

2. Barton, F. and Schlafly, H. J. 'TelePrompter – New Production Tool', *Journal of the Society of Motion Picture and Television Engineers*, June (1952), pp. 515–21

3. Lacan, J., 'The Mirror Stage as Formative of the Function of the I as Revealed in the Psychoanalytic Experience', *Ecrits*, ed. and trans. J. Strachey (New York: W. W. Norton, 1977), p. 4.

4. Jarman, R., 'Sure Cure for Stage Fright', *Saturday Evening Post*, 14 September 1957, pp. 52–3.

5. Ibid.

6. Rickels, L., *The Case of California* (Baltimore, MD, and London: Johns Hopkins University Press, 1997), p. 23.

7. Arbus, D., *An Aperture Monograph*, D. Arbus and M. Israel (eds) (New York: Aperture Press, 1972), p. 5.

8. Meyer, D., *The Positive Thinkers: From Mary Baker Eddy to Norman Vincent Peale and Ronald Regan* (Middletown, CT: Weslyan University Press, 1988), p. 180.

9. Ibid., p. 187.

10. Freud, S., 'Mourning and Melancholia', in *General Psychological Theory*, trans. A. Sheridan (New York and London: W. W. Norton, 1965), p. 245.

11. Rickles, L., *Aberrations of Mourning* (Detroit, MI: Wayne State University Press, 1988), p. 5.

12. Ibid.

13. Internet conversation with distributors for teleprompting equipment.

14. Marx, K., from an 1844 manuscript quoted by Ollman, B., *Alienation* (New York: Cambridge University Press, 1988), p. 141.

15. Rickels, *The Case of California*, p. 10.

16. Plato, M., The Internet Classics Archive.

17. Kristeva, J., *Powers of Horror* (New York: Columbia University Press, 1982), p. 208.

18. Ibid., p. 209.

19. Leighten, P., 'The White Peril and l'Art Negre: Picasso, Primitivism, and Anticolonialism', *Art Bulletin*, **61** (4), December (1990), pp. 609–30.

20. Rickles, *Aberrations of Mourning*, p. 349.

21. Derrida, J., *Specters of Marx* (New York and London: Routledge, 1994), p. 97.

10.1 Nancy Barton, *Teleprompter publicity showing one-way mirrored panels, c. 1950*

10.2 Nancy Barton, *Teleprompter publicity*, c. 1950

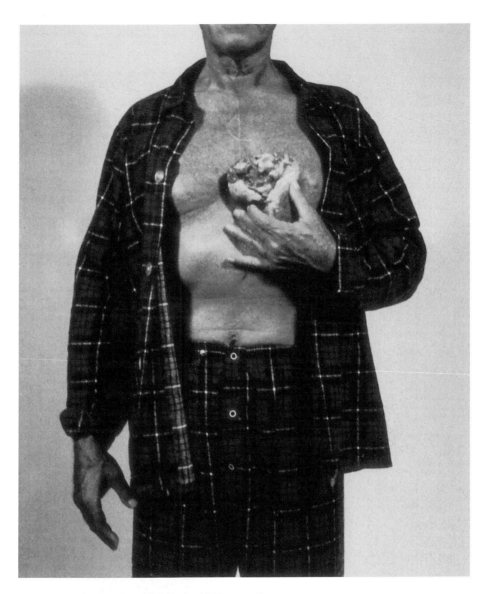

10.3 Nancy Barton, *Untitled, Dad with Heart*, 1984

10.4 Nancy Barton, *Image from work in progress 'Fred Barton'*, 1986–95

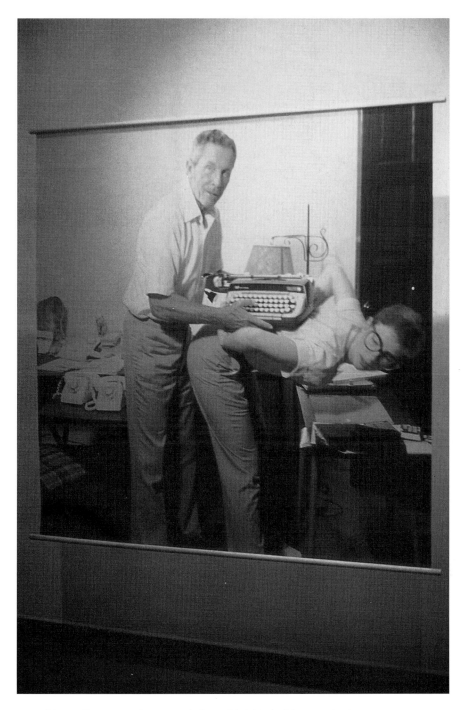

10.5 Nancy Barton, *I spit on your desk: untitled (Dad with typewriter)*, 1997

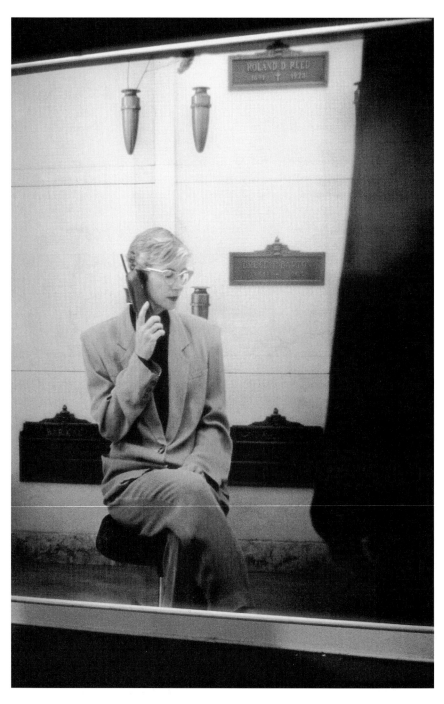

10.6 Nancy Barton, *I spit on your desk: untitled (Telephone to the dead)*, 1997

Index